VISUAL PIETY

VISUAL PIETY

A HISTORY AND THEORY OF
POPULAR RELIGIOUS IMAGES

·

DAVID MORGAN

UNIVERSITY OF CALIFORNIA PRESS
BERKELEY LOS ANGELES LONDON

University of California Press
Berkeley and Los Angeles, California

University of California Press, Ltd.
London, England

© 1998 by
The Regents of the University of California

Library of Congress Cataloging-in-Publication Data

Morgan, David, 1957–
 Visual piety : a history and theory of popular
religious images / David Morgan.
 p. cm.
 Includes bibliographical references and index.
 ISBN 0-520-20978-8 (cloth : alk. paper)
 1. Spirituality—United States—History—
20th century. 2. Spirituality—United States—
History—19th century. 3. Spirituality—
History. 4. Christian art and symbolism—
United States. 5. Christian art and
symbolism—Modern period, 1500– .
6. Christian art and symbolism. 7. Popular
culture—United States. 8. United States—
Religious life and customs. I. Title.
BR517.M67 1998
246—dc21 97-14354

Printed in the United States of America
9 8 7 6 5 4 3 2 1

The paper used in this publication meets the mini-
mum requirements of American National Standards
for Information Sciences—Permanence of Paper for
Printed Library Materials, ANSI Z39.48–1984.♾

CONTENTS

ILLUSTRATIONS

\\\|///

PREFACE

POPULAR CULTURE
AND HISTORICAL ANALYSIS

I am often asked why I work on this "stuff." My answer is precisely because it is stuff, the sort of thing that gathers on shelves and coffee tables. Popular culture is of great interest to me because I am fond of thinking of homes, churches, local libraries, and municipal buildings as the prosaic side of collective memory. In these often unassuming buildings are found the things that tell us who we are by shaping our memories of the people, places, institutions, and events that have formed our lives—often in utterly forgettable yet tenacious ways. Religious stuff is a particular category of the things that mark the halls and walls and countertops of everyday life. Why bother to study it? In a nutshell, because there is something irresistible about the fact that human consciousness owes so much to cardboard icons and plastic buttons.

But a scholar has to say more than that. The history of modern culture has been written and understood largely as the history of literature, philosophy, and the fine arts (poetry, music, and painting). Happily, historians in the second half of the twentieth century have moved to expand the scope of historical analysis to include popular culture. Yet any attempt to construct a history of the objects that have *not* mattered in most historical accounts—posters, broadsides, popular prints, snapshots, graffiti—will begin prudently by pondering why historians choose to write about what they do at all. At stake is an understanding of the power and meaning of artifacts generally. For to ask why we should study mass-produced, often ephemeral images will not elicit the same answer as asking why we should study "masterpieces" and works of sin-

gular "genius." In other words, if we accept the claim that history is what people called historians write about the past, then the problem of justifying the study of popular visual culture is the problem of justifying what historians do.

Academics and educators in modern democracies have been inclined to take one or more of three broad approaches to the study of visual culture, explaining their research on the grounds of either cultural formation, political resistance, or the enrichment of human understanding. I do not imagine that these three rationales are mutually exclusive; indeed, one finds all three at work in much scholarship. But each offers an important justification for what scholars study in human culture, and why. In addition, each offers something very attractive for the public significance of scholarship in a democratic society; and each impinges differently on the charter of the historian of visual culture, which is to describe and interpret the social functions of all images and to regard the history of taste as part of the subject of research, rather than as a principle regulating the study. Unfortunately, taste exerts a very restrictive force on what many historians of art have considered worthy of attention.

The first framework, cultural formation, urges the study of the arts as being of inherent worth, since the ("high") arts are taken to represent humanity at its most refined, at its aesthetic best. This heroic and commemorative historiography suits a host of familiar institutions in modern Western societies: liberal arts curricula, blockbuster museum exhibitions, endowed museums and university chairs, the proliferation of artistic hagiography on public television programming, the search for "national character" embedded in a nation's great works of art, the bombast of presidential inaugurals, and public funding for the arts. All of these welcome grand oratory and all the rhetorical excess that hyperbole and florid language can offer. But each can also become publicly definitive by helping to crystallize a communal self-awareness. Anyone who has studied art or taught aesthetics and the history of art knows very well the power of art to form a person's sense of self and the larger polities to which a person holds allegiance. By commemorating the past, historians bestow on a people a sense of identity for which both historian and nation may yearn.[1]

The second rationale for the study of the arts is a now virtual orthodoxy among many scholars committed to radical approaches in social history and cultural studies, approaches that stress opposition and intervention as a way of securing democratic freedom. This rationale begins with the assumption that the arts are used by those in power in or-

der to remain there. The arts, in other words, are ideological constructs that serve the privileged in human society. Beauty, ugliness, truth, value, authority—all are constructed by the class, race, gender, or state that seeks to enforce its dominance. The importance of this approach in a democratic society is undeniable if we are to grasp some of the most basic aspects of the image as an instrument of power. But the danger of reductionism is very real. I am inclined to believe that a cultural artifact is always about more than only class struggle and oppression. Furthermore, the deconstruction of history as an accumulation of social discourses of power may sacrifice too much, as Patrick Hutton has suggested in a thoughtful analysis of Michel Foucault's historical work. Hutton cautions that treating the past only as an array of rhetorical strategies deployed in the discursive formation of historical knowledge presents the danger of "losing touch with collective memory as it carries forward ideas and values that we might still wish to honor. . . . In discarding the ties that tradition renders familiar, we weaken our appreciation of what is worth caring for in the past."[2]

The third and last rationale for the study of the arts is the enrichment of human understanding. We are compelled perhaps almost biologically to explain things as a challenge to cliché, prejudice, and misunderstanding. The monotony and the threat of sameness move us beyond the boundaries of our familiar worlds and intellectual discourses to encounter other domains. Because scholarship is an ongoing conversation about human affairs, this third rationale for research arises from the perennial need to enrich the conversation and to reshape it with new facts, methods of analysis, and interpretations. Yet this desire to explain is not in fact a simple instinctual drive, but is deeply inflected within the social world of the academy. Knowledge and knowledge-making are hardly innocent. They are shaped by powerful institutions and the interests that exercise power and authority at any given moment.

Perhaps the most basic impulse at work here is the need to stake out a claim in the terrain of scholarly discourse, to become an active, contributing partner in one's discipline. The intellectual life is indeed an intense and ongoing conversation (occasionally even a brawl) into which young academics seek entry and from which scholars draw vitality throughout their careers. Scholars base a good deal of their identity on the daily practice of writing and reading and gathering data. Calling the terrain or membership of this collective practice a community may be presumptuous, but genuine community certainly happens within the social enclosure of scholarship and teaching. The principal products of this

profession are twofold: college graduates, whose character and intelligence ought to have been formed and informed by the work of genuine intellectuals in the classroom; and information, which, beyond the classroom, is of important use to state and municipal governments in making fundamental decisions, and to thousands of institutions—from museums to welfare offices—that use the produce of intellectual labor each day to conduct their work.

The need to enrich scholarly discourse, however, does not exhaust the motivation at work in the third rationale for history writing. Many historians wish to fashion a platform from which to understand other worlds or ways of life. Their work attempts to distinguish one world from another, as well as what their own worlds may or may not have in common with those they study. What I am proposing in this third rationale is not a value-free, objective historiography, nor a naive recovery of the past, but an interpretation of cultural realities that accounts for the differences between worlds with a degree of respect that the other two historiographical practices may not be inclined to observe.

There is inherent good in each of the three rationales. We need the first to assist us in the formation of a sense of public identity; we need the second to expose injustice, challenge misperceptions, and diagnose ideological myopia; and we need the third both to generate the enormous amount of information that a democracy needs in order to enrich and enable the lives of its citizens and to describe and explore the worlds among us and those buried in the past. Put another way, the first specializes in building identity; the second dismantles deceptions mounted by the first; and the third fuels education, self-formation, and the operation of countless institutions. No historian works without any of these, though each scholar will weigh and configure them differently. All three contribute to any act of historical understanding. I do not intend to imply that a normative constellation of the three exists or ought to be sought. My point is that scholars are implicated in their work by virtue of the rationale that authorizes their efforts, such as the choices they make in subject matter and method and the audience they address. Thus, "we" can celebrate "our" American heritage in the diverse popular imagery of stamps, chromolithographs, and daguerreotypes; or "we" can interrogate the dominant culture's marginalization of ethnic and racial others in book illustration, cartoons, or propaganda; or "we" can discern the lineaments and operations of the worlds of believers, immigrants, or working classes by analyzing the images that they display in their homes and give as presents on ritualized occasions.

Each of the three rationales informs this study, though I think the second two are most discernible. My reason for undertaking the present work is twofold: I want to understand how even the most predictable mass-produced religious imagery is invested with vital meanings in the lives of those who find it useful; and I wish to focus attention on areas of visual production that have not received enough attention—in most cases, I suspect, because the images simply have not been thought worthy of serious consideration. For those of us interested in the history of everyday life and the social construction of reality—the two conceptual schemes that frame this study—this historiographical prejudice is unacceptable.[3] The ideas and feelings that organize worlds and are articulated by popular images possess their own intellectual and cultural histories, which need to be described and analyzed by the historian. Moreover, the tripartite justification for historical analysis comes together in the investigation of how popular religious images contribute to the construction of reality, how, in other words, people use images to make and maintain their worlds. For in understanding how worlds are formed, secured, and re-formed, scholars can scrutinize the need for group identity as well as the institutional mechanisms that serve and shape communities. And what will enrich our understanding of the worlds in which we live more than a historically informed analysis of the artifacts that articulate the worlds of others?

ACKNOWLEDGMENTS

Several of the chapters that compose this volume originated as conference papers, and portions of three have appeared in an earlier and much abbreviated form elsewhere. Fragments of chapter 1 appeared in the *CIVA Newsletter* (March 1996); chapter 3 is a longer version of an essay published in *Men's Bodies, Men's Gods,* edited by Björn Krondorfer and published by New York University Press (1996). Chapter 4 was presented at a conference on religion, culture, and media at the University of Colorado, Boulder (1996). A shorter version of chapter 5 appears in *Art Journal* (spring 1998); in addition, one component of chapter 5 was given at the annual meeting of the College Art Association (1995), another at the annual meeting of the Society for the Scientific Study of Religion (1996). And chapter 6 was presented at the annual meeting of the American Academy of Religion (1994). To each of these venues and publishers I am grateful for helpful feedback. Yale University Press has graciously allowed me to reprint here the appendix from *Icons of American Protestantism: The Art of Warner Sallman* (ed. David Morgan, 1996), to which I have added additional information about the source material for much of my analysis.

The resources and staffs of several libraries and archives have been of great importance to this project, in particular the American Antiquarian Society, the New York Public Library, the American Bible Society, the Adventist Heritage Center at Andrews University, the Billy Graham Center Museum at Wheaton College, the Moody Bible Institute, the Jesuit-Krauss-McCormick Library of Chicago, the Joseph Regenstein Li-

brary of the University of Chicago, and Valparaiso University's Moellering Library.

I would like to thank several colleagues and friends for numerous conversations and for their helpful reading of different parts of this manuscript at various stages of its development: Nandini Bhattacharya, Frank Burch Brown, Betty DeBerg, Lisa De Boer, John Dixon Jr., Erika Doss, Paul Gutjahr, John Ibson, Jason Knapp, James Manns, Theodore Prescott, Sally Promey, and Paul Contino (to whom I am especially grateful for early encouragement to write what eventually became this book). Readers of this book have been well served by Doug Abrams Arava, Dore Brown, Nola Burger, and Anne Canright of the University of California Press, who did so much to improve this manuscript for publication. Several photographers were of great help in the preparation of prints for publication: Gloria Ruff, John Marguy, Samantha Bradtmiller, Phillip Morgan, and John Merrill. My thanks to each of them. And finally, the greatest thanks to my wife, Lorie, to whom I dedicate this volume in gratitude for her continuing forbearance and cheerful support.

INTRODUCTION

CONSTRUCTIVISM
AND THE HISTORY
OF VISUAL CULTURE

In a wonderful story from the oral culture of the radio call-in show, a pious listener objected to the use of cosmetics on the basis of scriptural authority. When the listener was asked to cite the biblical passage that supported her view, she referred to the story of Jezebel. "Could you point out where in the text it talks about makeup?" the radio host asked. "Well, it isn't actually in the text, but the illustration on page 89 . . . "[1] People of all kinds take illustrations seriously because an illustration, as the word itself suggests, is supposed to illuminate the proper meaning of the accompanying text. In this instance, however, the illustration supplanted the text by providing a meaning the viewer felt ought to be found there.

Popular images of Jesus offer familiar instances of a comparable evocation of meaning where textual sources provide none. Warner Sallman's *Head of Christ* (fig. 1) and the countless variations of the *Sacred Heart of Jesus* (fig. 2) portray a Savior whose appearance, though it is never described in the New Testament, is instantly recognized. These images and many like them have served as powerful symbols in American Protestant and Catholic piety because believers have learned from childhood to regard them as illustrations, as untrammeled visualizations of what they profess. Understanding why this is so and how it occurs requires that we see popular religious imagery as part of a visual piety, by which I mean the visual formation and practice of religious belief. In so doing we must attend not only to those religions that actively employ imagery, but also to the largely unwritten cultural history and aesthetics of popular reli-

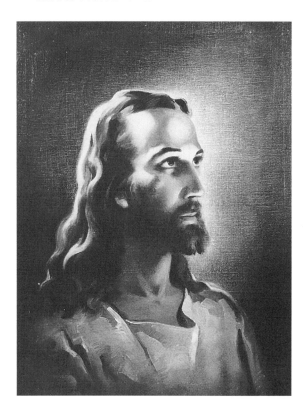

FIGURE 1. Warner Sallman, *Head of Christ,* 1940, oil on canvas, 28 1/4 × 22 1/8 inches. Courtesy of Jessie C. Wilson Galleries, Anderson University.

gious art. Only then can we begin to understand how images articulate the social structures of a believer's world. Accordingly, this study investigates the role of mass-produced religious images in the social construction of reality by those who exchange and display them.

MATERIAL THINGS AND THE SOCIAL CONSTRUCTION OF REALITY

The golden thread of this study is visual piety. Conventional wisdom takes one of two polarized views regarding the relation of art and religion: either art is the handmaiden of religion, or else the artist is an autonomous agent working out of his or her own inspiration, which may or may not parallel the specific concerns of religion. But surely the relationship is much more complex than this simplistic opposition suggests. Visual piety offers a different way of thinking about art and religion. As the set of practices, attitudes, and ideas invested in images that structure

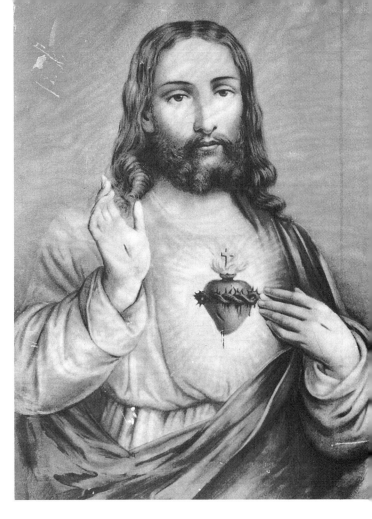

FIGURE 2. *The Sacred Heart of Jesus,* decal on pressboard, 15 3/4 × 11 1/2 inches. Photo by author.

the experience of the sacred, visual piety cancels the dualistic separation of mind and matter, thought and behavior, that plagues a great deal of work on art and religion. In a recent and instructive study, Colleen McDannell has rightly stressed the need for overcoming such dualisms.[2] I will argue that the act of looking itself contributes to religious formation and, indeed, constitutes a powerful practice of belief. This is apparent in many of the letters I received a few years ago in response to an ad placed in devotional magazines. I asked readers to indicate what they

thought about the work of Warner Sallman, in particular his *Head of Christ*. The resulting 531 letters provide much of the data for the analyses that make up this book.[3] Scores of letters offer direct evidence of what I call visual piety. For instance, one woman wrote that "by beholding [pictures of Jesus] we become changed and only in heaven will we know the extent of the heart's influences for good by the inspired pictures of Mr. Sallman" (463). Another woman sounded a common note when she wrote that Sallman's image "has offered me a comfort through just looking at it" (412). And one respondent from Kentucky reported that as a child she regarded Sallman's *Head of Christ* as "Christ, like with the KING JAMES version of the bible—that was the bible! God's words, no other book was true, same with this image of Christ, when we saw it, it was Christ" (531).

From the Catholic mystic who sees the Virgin or receives the wounds of Christ in the same manner that she has seen them in devotional images, to the Sunday school student who is drilled with charts and visual diagrams in order to memorize the catechism, we see that there is no single visual piety, but many.[4] I want to draw attention to the plurality of visual practices, which are distinguished one from the other by the history of theology, cultural politics, and ritual uses of the image, all of which are in turn keyed to the image's style and iconography and the historical circumstances of its production and reception. My approach to visual piety is historical in that I understand religious images as cultural products. Rather than restrict imagery to the rarefied state of aesthetic contemplation or submit it to theological critique or application, this study seeks to examine imagery in terms of the social worlds of those who make, merchandise, purchase, and use it.

Looking at images, giving and receiving them, conducting prayer and Bible study before them, displaying them in the home, handing them on to the next generation—these are some of the iconic practices of belief, acts of visual piety, that I will study. The concept of practice, as defined by social analysts from Karl Marx to present-day writers such as Pierre Bourdieu and Catherine Bell, is helpful here because it stresses that thinking, wanting, deciding, speaking, and looking, as well as ritual performance and gift-giving, are all part of the concrete world-making activities that constitute social behavior.[5] These are not mindless actions but embodied forms of cognition and collective memory that reside in the concrete conditions of social life. Notably, latter-day ethnography, history, and social analysis all refuse to subordinate the study of practice to such abstract discourses in the production of meaning as theology or

philosophy. As a result, the religious practices that constitute visual piety are able to receive the scholarly attention that theology, religious philosophy, and ecclesiastical pronouncements have monopolized heretofore. All devotional practices—whether the high ritual of Holy Communion or the display of devotional images in one's bedroom—are forms of collective memory that offer the scholar primary documents of the construction and transmission of everyday life, which is arguably for most people, most of the time, where character is formed and social allegiances are negotiated. Moreover, everyday life involves the daily practice of absorbing, testing, debating, and ratifying the vast and always-changing corpus of doxa—the opinions, assumptions, and inclinations that form much of what Pierre Bourdieu calls the habitus, the "system of dispositions" that comprises the symbolic universe in which we live.[6] But more about this shortly.

Basic to the study of religious visual practice are the world and self that visual piety helps to articulate. The work of several social thinkers has been especially instructive for me in this regard. In a fascinating essay that summarizes much of his fruitful inquiry into the important role material things play in the formation and maintenance of selfhood in modern life, Mihaly Csikszentmihalyi has argued that "the self is a fragile construction of the mind" that is constantly assailed by "psychic entropy."[7] Rather than being an inherently stable entity, that is, human consciousness is characterized by a tendency to fade into unfocused, chaotic activity; this process, however, is in turn powerfully countered by our dependence on things. According to Csikszentmihalyi, artifacts invest the human self with a degree of objectivity in three ways: by displaying power and social status; by securing the continuity of the self over time in terms of focal points in the present, traces of the past, and indications of future expectations; and by providing material evidence of our position in the web of social relations.[8] In each case material things assert our identities and maintain them in the face of an ever-present flux of sensation and mental activity.

Csikszentmihalyi's analysis is extremely helpful for understanding the importance of prosaic objects and commodities in everyday life. Decorating the home with background and mood imagery, for example, should be seen—among other things—as a vital component of mental health because it offers a "sensory template" for the self, a calming matrix that regulates the mind's activity by imposing a certain consistency or redundancy. The result is a secure sense of continuity, a baseline against which to measure all other activity—an outcome that certainly

conforms to the American experience of the home.[9] To this psychological insight historians can bring their research in such social continua as private and public domains, informal and formal behavior, and the sacred and profane in order to historicize the social construction of reality.

In this book I will seek to measure in any number of ways the social and historical world-making that is so deeply invested in the visual culture of religion. Investigation of the human self must be integrated with study of the world in which any self necessarily exists. Indeed, the two, world and self, bear a dialectical relation such that neither is conceivable without the other. To Csikszentmihalyi's continuum of radical aloneness/ complete entropy, therefore, we must add another axis ranging from self-determination to institutional determination of the self. My sense of reality, the world in which I live, is a social construction rather than an idiosyncratic, solipsistic invention or a purely objective state of affairs impinging on my consciousness. As sociologists Peter Berger and Thomas Luckmann put it in their classic treatise, *The Social Construction of Reality*, "The statement that man produces himself in no way implies some sort of Promethean vision of the solitary individual. Man's self-production is always, and of necessity, a social enterprise."[10]

Berger and Luckmann argued that worlds are the product of a threefold process—externalization, objectivation, internalization—that engages self and world in a dialectical tension. Humans work, represent, and interpret, that is, they expend their efforts in labor; encode and invest these efforts in certain products, and then regard or use these products as objective entities possessing personal value. A world is a relentless circulation of values, an unceasing exchange of labor for goods and goods for meaning. Each act is converted into the next, each presupposes the other. None of these moments is the absolute origin of reality, and none amounts to an ultimate aim, for every meaning that we derive from a product is reinvested in the unending quest for more or different meaning. The world is an ongoing production, Berger and Luckmann stress, and "the relationship between the individual and the objective social world is like an ongoing balancing act."[11]

Everyday experience follows the templates of "recipe knowledge," what Berger and Luckmann consider the "rules of conduct" in ordinary life, a "body of generally valid truths about reality." This knowledge matches what one expects to find with what the social world presents to us in its objective structures. That is, it "'programs' the channels in which externalization produces an objective world" and finds the objective world that is acceptable for the return moment of internalizing

what is "out there." For Berger and Luckmann this representation and legitimation of the reality of everyday life is conducted principally by means of language.[12] The burden of the present book, however, is to show that the process of social construction is profoundly dependent on images as well—in this case, popular religious images.

Although *The Social Construction of Reality,* published in 1966, is now somewhat dated, more recent studies of culture have built on it by developing the dialectical activity of social construction and applying it to studies of consumption in industrial society or to anthropological fieldwork in nonindustrial cultures. I will cite the work of two scholars who study how nondiscursive practices inform the construction of social worlds. In his very useful elaboration of cultural theory in the study of consumption and commodities, Grant McCracken regards culture as a creative, dialectical force that structures the world of consumers. For him, culture is a "lens" through which phenomena are seen as well as a "blueprint" that "determines the co-ordinates of social action and productive activity, specifying the behaviors and objects that issue from both." Culture, he contends, "constitutes the world by supplying it with meaning."[13] It does so by engaging both the medium in which it is experienced and the paradigm against which it is measured and imagined. McCracken's work focuses on the vital role that material goods play in this process of meaning-making.

Like McCracken, Pierre Bourdieu does not limit himself to language but examines artistic taste and appreciation, the household, and mythology in order to understand the formation of the habitus.[14] Defined as "an acquired system of generative schemes objectively adjusted to the particular conditions in which it is constituted," the habitus is both the collection of schemes informing practice and the generative source of new or modified practices.[15] According to Bourdieu—who argues that human practice, though it exhibits a collective structure, is not rigidly predetermined—the habitus is a "system of lasting, transposable dispositions" that integrates historical experience into a body of schemes that can be transferred analogously to new situations in order to solve new problems. As such, the habitus is "the strategy-generating principle enabling agents to cope with unforeseen and ever-changing situations."[16] The habitus, we may say, contributes fundamentally to the construction of the world that one takes for granted because it provides the range of conscious and unconscious codes, protocols, principles, and presuppositions that are enacted in the world's characteristic practices. This materialist version of Immanuel Kant's a priori categories of understanding

demands the historical contingency and social construction of memory, and conceives of this in dialectical acrobatics akin to those of Berger and Luckmann: "The mental structures which construct the world of objects," Bourdieu writes, "are constructed in the practice of a world of objects constructed according to the same structures."[17] Put more simply, Bourdieu regards the habitus as "history turned into nature."[18] In spite of Bourdieu's Byzantine explication, the concept of habitus is useful for understanding the dynamics of the social construction of reality. One of the principal aims of this study is to show how the process of naturalization occurs in the practices of visual piety.

The importance of material culture—including images—in the study of religion has been urged in several recent studies.[19] I will proceed along similar lines by focusing on images as a unique category of material object, a category characterized by the special ability to mediate imaginary, linguistic, intellectual, and material domains. I will argue in a number of contexts that this ability gives the image particular power in the dialectical movement from externalization to objectivation to internalization. Proponents of religious imagery have not failed to underscore the unique capacity of images to make real what they depict. One Christian pedagogue, Frederica Beard, writing in 1920, praised the use of pictures in religious education because "a picture is the mean between the thing and the word."[20] Beard felt that objects draw attention to themselves in the context of classroom teaching and that words are often too abstract to gain the student's attention, whereas stereoscopic images of biblical landscapes and subjects, she maintained, bring their distant subjects near.[21] Images, according to Beard, mediate distance in time and space and avoid the extremes of abstraction and distraction to rivet the student's attention to the task at hand, namely, spiritual formation. The use of photographs, prints, and mass-reproduced paintings in religious education and devotion has been very important to Christians ever since the nineteenth century because these images allow a subtle transition from artifact to world.[22] As Beard put it, "The imagination will very easily overleap the intervening time as we stand upon [the stereographic reproduction of] the site of the temple enclosure and look off to the Mount of Olives, to the modern Garden of Gethsemane." Beard reproduced modern images to make her point. A photograph of Mt. Gerizim, the Samaritan place of worship referred to by Jesus in John 4:21, for example, offered students an immediate glimpse of "the rock on which Abraham looked and David stood and before which Solomon knelt."[23]

What the child leaps into with such imagery, of course, is not ancient

Palestine, but the early-twentieth-century American Christian idea of the "Holy Land."[24] What the image depicts and what the devout viewer thinks it means merge seamlessly into a compelling presence. Among the most insightful writers on this subtle process is Roland Barthes, who described the power of the photographic image as its apparent ability to root a cultural message in the "natural" world. Barthes, however, limited this power of naturalization to photography. Speaking of the photograph as an analog of the world, as "an emanation of *past reality*," he differentiated the artifice of the painted image from the power of the photographic image, which possesses its referent within itself.[25] I propose, though, that we may recognize this power of naturalization in *any image* whose reception involves the magical sense of making the absent present.[26] In fact, there is ample historical research to show that prints, paintings, drawings, and even accidental patterns can render for viewers the ontological presence of someone or something.[27] Therefore, virtually all visual artifacts can do what Barthes wrote of photography: present as a "certificate of presence" the evidence that "the past is as certain as the present."[28] Images accomplish this by means of a visual rhetoric in which, as Barthes shows, images and language, rather than being discrete orders of representation, are intricately interwoven.[29] Thus, although language is a symbolic form that we all share, it should not be understood as an isolated or autonomous operator in the construction of reality. Language and vision, word and image, text and picture are in fact deeply enmeshed and collaborate powerfully in assembling our sense of the real.

A world is a social and a historical construction of things and other beings bearing a certain order with pretenses to objectivity and universality. Images, songs, and objects evoke the worlds that make them and seductively suggest to those whose world they share a totality and uniformity that is as reassuring as it is tendentious. In fact, a world is an unstable edifice that generations constantly labor to build, raze, rebuild, and redesign. To use a literary metaphor, a world is a story that is told and retold in order to fortify its spell of enchantment. And there is never just one story, never just one world. Worlds collide with one another as well as contain within themselves the contradictions and disjunctures that must be mediated or concealed for the sake of a world's endurance.[30] Material culture, such as imagery, tends to appear at these sites of disjuncture and contradiction: popular images often serve to mend them or conceal them, while avant-garde images tend to foment the rupture of such sites. The cultural work that popular images per-

form is often a mediating one, serving to bolster one world against another, to police the boundaries of the familiar, or to suture the gaps that appear as the fabric of a world wears thin. Popular images are often quotidian, tirelessly repeating what we have always known, as if the ritual act of repetition might transfigure a belief into a condition of nature. Scholars such as Csikszentmihalyi, McCracken, Bourdieu, and Berger are apt to point out that a culture is something that needs constantly to be cultivated lest it cease to offer its tenants the produce of a nurturing world. As Berger grimly put it, "Every human society is, in the last resort, men banded together in the face of death."[31] Or, in somewhat less eloquent terms: "The symbolic universe shelters the individual from ultimate terror by bestowing ultimate legitimation upon the protective structures of the institutional order."[32] In other words, the schemes of social order to which humans commit themselves offer in return a less chaotic universe. As we shall see, keeping chaos and the wasteland at bay is very much what devotional images are about in modern American religious culture.

The concept of the world and its social construction is difficult to define with precision for the historian's use and requires a degree of caution. One important study of the phenomenology of everyday reality defined the "life-world" as "that province of reality which the wide-awake and normal adult simply takes for granted in the attitude of common sense."[33] But what concerns me (and most historians by trade) is what separates one group's province from another's over time. Although we are all fond of assuming that our sense of reality is universal, in fact each of us defines and evaluates the worlds in which we live quite differently according to our age, gender, race, education, religion, class, economic status, and cultural tradition. Yet human reality is not carved up into fundamentally discrete worlds: the human situation is much messier than that. With the exception of a few highly charged frontiers, the boundaries of a world are usually not clear, but trail off into unconsciousness, ambivalence, and the indeterminate zones of overlapping worlds. Worlds are continually shaped by changes in such social and economic conditions as employment, residence, professional associations, marriage, and social status. In addition, a variety of geographical locales not only blur distinctions but also supply rich resources for both the contents and structures of a shared sense of modern life. Shopping malls, flea markets, fairs, public schools, amusement parks, and most sites of recreation and sport are places where distinctions in social status, gender, and race can be ambiguous and subject to rather sharp re-

definition. Scholars, in short, must approach a world as something indefinite and elastic, impure and inconsistent.[34]

A final word on the social construction of reality is called for. I do not imagine that a world is the product of a leisurely weekend's occupation. A world is not a lifestyle, not a cheap suit—or even an expensive one—that one dons at will. It may be that some critics of constructivism take too seriously twentieth-century advertising's promotion of the illusion that the self can redefine itself in some fundamental way simply by acquiring certain goods. In any event, a world is far too complex and vast for any single person to fabricate. By the same token, I do not mean by the social construction of reality that worlds are pure fictions in the sense that they have no relationship to anything outside of themselves. Just as no piece of literary fiction may legitimately claim this, neither may any world. A real world is not a fantasy but something that individuals share with one another and with the past. It is the universe of institutions, economic relations, epistemology, laws, and myths of all kinds that constitute the more or less systemic structure of collective life in a certain time and place. No configuration of signs—indeed, nothing in human affairs—strikes me as entirely arbitrary: the sheer momentum of history, self-interest, genetic inheritance, and the force of social institutions guarantees that, though shot through with chance, human experience is anything but pure happenstance. Although a sign may or may not bear an ontological relation to its referent (as a photograph does, whereas a word usually does not), the fact is that all signs are motivated by the history and system of meaning that produce them, that is, by the grammar and tradition of usage. While the social conditions in which we exist did not descend from heaven or emerge out of the earth, they did develop from the past and they do press us into the future. If worlds are invented, therefore, it is a long and collective process of invention and one that is inherently conservative. It is, in other words, one that we are always inclined to rely on, and at the same time to forget.

Yet as inertial, homogenizing, and impersonal as world-making and world-maintaining may be, the fact that worlds are *made* preserves the important possibility of human agency. Although we tend to spend most of our lives doing little more than sustaining the worlds in which we live, we exert considerable control over our lives in the host of choices we make each day; and certainly all of us mitigate and imaginatively transform the oppressive aspects of our worlds by reading fiction and watching films—or by practicing a religion. In seeking to discern the dynamics of world-making in the use of popular religious imagery, therefore, I do

not exclude in principle the possibility of ingenious and novel visions of reality; but this will not be the object of my attention. The histories of science, religion, and art as traditionally written have fixated on these transformative moments and offer them in abundance.[35] These histories should not, however, exclude the considerably more mundane but no less significant "making" that will concern us here. This prosaic sense of world-making consists in the transmission of a world from one generation to the next, a tradition or handing down that both *maintains* the world of the elders and *makes* the world of the children. Thus, making and maintaining are either side of a single enterprise.

THE AESTHETICS OF EVERYDAY LIFE

Two essential features of any world are the ordinary things people do again and again, and the extraordinary things people do in order to assert control over their worlds. On the one hand, worlds exhibit highly predictable patterns of behavior, which their inhabitants rely on without in most cases giving the matter any thought. I have in mind here such apparently incidental things as how we sit at work or at home, how we drive, the small conversations we conduct with others and ourselves, the glances that punctuate our conversations, the arrangement of objects on our desks. Most of the time these things do not command much of our attention, yet we are all well aware of their capacity to signify attitudes and relationships when we turn to decode their meanings in the behavior of others. On the other hand, human beings also do unusual things that contrast markedly with the ordinary but that in fact serve to safeguard the ordinary or to subvert its tedium. Nations conduct wars to preserve their autonomy; communities undergo religious revival in order to renew their beliefs; parents produce children in order to extend their world; and individuals submit to major surgery in the hope of reclaiming a healthy life. Even the extraordinary is ritualized, repeated behavior, but it steps outside the security of the familiar in order to secure the old foundations or to erect a new basis for the everyday world in which people dwell. In these two features, therefore, we confront the everyday and the extraordinary in human life.

What is the everyday, and why should we care to know? An obvious answer is that the everyday is whatever is ordinary, mundane, habitual, common, and generally shared in life; whatever occupies most of our day-to-day lives, from one year to the next. But what power do (or should) bank lobbies, gas stations, birthday parties, ball games, class-

rooms, shopping malls, and Sunday mornings exert on the formation of our identities? We are perhaps inclined to believe that such rare moments as hallowed rites and dramatic events enjoy a disproportionate role in shaping who we are.[36] Certainly an important aspect of scholarship in history and religious studies has stressed great figures and revelatory moments as being the most formative. Why, then, should scholars study the history of everyday life? Answers are not hard to find. If, for starters, we are to understand the nature and fate of the individual in light of modern theories of collectivity, social organization, and democratic egalitarianism, the everyday demands our attention. To that must be added the need to understand the uniquely modern experience of the masses and their unprecedented culture of consumption in a global economy that moves events as much as any monarch, reformer, savior, or general ever did. Finally, the everyday compels interest simply because human beings construct their social reality, and they do so to the prosaic rhythms of everyday life as well as in the rarefied events of catastrophes, epiphanies, and revolutions.

As a way of clarifying what is meant by the routines and rituals that each person performs, we may look to Erving Goffman's dramaturgical analysis of the presentation of the self in everyday life. Goffman argued that humans fulfill a variety of roles in their interactions with one another, constructing a self in each performance that is identical with the role. We are each concerned with managing the impressions that we project to others. Role playing occurs in various settings—in the workplace and at home; in leisure, commerce, and romance; on intimate terms no less than in larger, formal, collective circumstances. "The object of a performer," states Goffman, "is to sustain a particular definition of the situation, this representing, as it were, his claim to what reality is."[37] Roles, in other words, whether scripted or improvised, are defined by a setting and belong to shared social routines. They structure our interrelations by providing the guidelines of daily interaction. In so doing, roles promote the sense that reality is an objective other and that the self is fully present in the performance.

When an individual plays a part, he (or she) implicitly requests his observers to take seriously the impression that is fostered before them. They are asked to believe that the character they see actually possesses the attributes he seems to possess, that the task he performs will have the consequences that are implicitly claimed for it, and that, in general, matters are what they appear to be.[38] Everyday reality unfolds on the stage of interactions where one performs one's self (or oneself) with others; the

self is formed as the impression one's performance offers. Everyday life exhibits coherence, uniformity, and concreteness by virtue of the repeated performances of key roles each day.

Goffman's analysis of interaction rituals suggests that everyday life is essentially temporal in structure. But is there an artifact or a place that we can adduce as an indisputable specimen of the everyday—something as mundane, for example, as a domestic utensil? If so, what happens to the everyday when the utensil is placed on a pedestal in a museum, thus becoming an aesthetic object? Perhaps the everyday consists of an object's instrumental or functional capacity, as opposed to its ability to focus aesthetic contemplation. Yet what could be more everyday than a child's song, whose purpose is inseparable from its mere performance? Rather than the purpose an artifact serves or the formal structure it exhibits, we may wish to consider the effect of the item in order to determine the nature of the everyday. By "effect" I mean to suggest that the everyday is neither a thing nor an objective circumstance but rather a pattern of human consciousness. Furthermore, I do not mean what something makes us think of, feel, or want to do as much as what it makes us *forget*. Forgetting things is very common—forgetting a receipt, where I put the keys, when a book is due, what an acquaintance's name is, and so on. We forget because something else has claimed our attention.

As Mihaly Csikszentmihalyi and Eugene Rochberg-Halton have stressed, human consciousness and its physical environment, such as the household, constitute an economy (their term is "ecology") in which not everything can be the object of attention.[39] We must choose or have chosen for us what to pay attention to and what to ignore. Forgetting is therefore as important as remembering in the social economy of everyday life. Memory is a selective device, which suggests that forgetting is not accidental, but deliberate. I do not mean this only in the sense of Freud's psychopathology of everyday life, where forgetting results from the repression of unacceptable instinctual urges. I have more broadly in mind forgetting as the enablement of attention.[40] Scholars of *Alltagsgeschichte*, the German term for the history of everyday life, have stressed the importance of routine as a structural element in day-to-day life, since "routines function to relieve the individual of constant uncertainty or doubts."[41] This alleviation allows us to focus our attention on certain tasks or subjects in accord with the economy of consciousness. Put another way, we can say that it is necessary to engage in many repetitive tasks and behaviors in order to free up attention for those experiences that are more demanding, absorbing, sensuously rewarding, or critical.

I do not wish to suggest that the everyday is merely a set of routines; I do suggest, though, that it can be isolated for study as an apparatus that spans consciousness and unconsciousness and grants people the opportunity to interact with one another in lives that are more or less effective. The everyday is the domain not only of the unconscious routine repeated mindlessly through the day, but also of the quotidian tasks that the routine enables the person to perform. Thus we engage in small talk with fellow workers while changing a printer cartridge; we stand perfectly still as we listen to an instructor or superior; we drive home through busy traffic while mentally replaying a conversation with an associate. In each case we don't need to attend exclusively to the immediate environment of the conversation, the posture of the body, or the traffic because we have internalized the protocols that govern behavior in such circumstances so that we might pay fuller attention to what consciously interests us.

Excavating the many sediments of everything we forget would unearth an enormous mass of silent, invisible assumptions and codes that allow us to wend our way through a welter of stimuli that, were they allowed to claim our attention, would plunge us into confusion or render impossible whatever task we wished to attend to. This becomes palpably clear whenever we visit another society where our language is useless, traffic and currency are different, customs and laws alien. The world there is quite unfamiliar, we are estranged, everything is new, each taste, smell, and sight is novel. We are helpless and often become anxious in the most harmless situations. Every detail can claim our attention; every sensation, however insignificant, may become an object of our contemplation. The economy of consciousness is spent recklessly as we wander like children in that strange place. Eventually, as we assimilate new patterns of behavior and exercise simple means of communication, the novelty subsides, and we are able to organize our consciousness into gross forms of attention and inattention. As a result, a characteristic structure emerges that provides for more effective interaction with those whose world we now share. The everyday returns to us—as is often evident in the way tourists follow the same pathway to breakfast each morning, eat at the same table, visit the same beach repeatedly.

Novelty, however, is not the negation of the everyday. Indeed, the novel happens every day—in the newspapers and the mass media, in gossip, in chance events that could not have been predicted, in all the avenues that bring the extraordinary into the steady rhythms of the mun-

dane. Likewise, the novel quickly dissipates, rapidly becomes the contents of the commonplace. Nothing is more boring than yesterday's news. The novel and the ordinary are either side of a single coin, the coin of the realm of everyday life. The novel, in short, is whatever the submerged routines of repeated behavior permit us to hold in concentrated view.

Where the everyday is transcended, however, is in any experience that calls into question the conceptual and aesthetic structures of forgetting and remembering, the apparatus of attention itself. With the birth of a new framework, the previous apparatus becomes conventional, even dull. This we find in the avant-garde art form, the religious revelation or mystical illumination, the transformative rite of passage, and the trauma of war, violence, or emotional breakdown. These events sharply distinguish themselves from the everyday. Thus, it is necessary to differentiate the avant-garde from all other aesthetic experience. The effect of art in traditional and popular aesthetic experience is to absorb consciousness by concentrating it in the features of an object without transforming the parameters of perception—without, in other words, changing the way we see. Avant-garde art, in contrast, attempts to transform the conceptual structures and perceptual habits that make an experience appear the way it does. Avant-garde aesthetic experience focuses on the conceptual and emotional structures that define reality and not just on the physical features of a work of art.[42]

Aesthetic experience in the widest sense is a large category, one that includes the contemplation of progressive art and traditional forms as well as any object or moment in human society or the natural world. Moreover, although aesthetic experience tends to be defined by the absorption of consciousness in the "inherent qualities of the object," creating what Csikszentmihalyi calls "flow," it should not be limited to this contemplative gaze.[43] Csikszentmihalyi and Rochberg-Halton have presumptively reserved the term "aesthetic" to designate transformation, which they understand in terms of John Dewey's distinction between perception and mere recognition: just as "an act of perception means that the scheme through which we interpret an object is changed or enlarged," so, according to Csikszentmihalyi and Rochberg-Halton, does the aesthetic experience involve "something more than the projection of meaning from the person to the environment or vice-versa."[44] Recognition, in contrast, regards an object as a tag or sign and not in terms of its "inherent qualities." But we must object to this formulation on two counts. First, aesthetic contemplation need not transform perception but

only focus it, enrich our experience of an object or imbue it with certain meanings. Second, what I call the "apocalyptic glance" (chapter 6) that many believers give religious images is aesthetic even though it refuses to reside contemplatively in the present, since it longs restively for what will unveil itself only in the future. According to the definition of the everyday set out here, the "ordinary" aesthetic experience of objects engages consciousness in acts of attention that forget or submerge the apparatus of perception and evaluation. Avant-garde aesthetic experience calls this apparatus into question and therefore disrupts the everyday with sensations that problematize the most fundamental categories of thought and feeling.

IMAGES AND THEIR WORLDS

The significance and power of popular religious imagery resides precisely in its contribution to the social construction of reality, whether in the everyday domain of visual and epistemological recipes that guide people through the day or the liminal passages of crisis and transformation that dramatically shape their lives. Worlds are composed of both the ordinary and the extraordinary, and images serve to configure each aspect of experience. Through much of the twentieth century Warner Sallman's familiar imagery enjoyed a special power by virtue of its ubiquity. The same face of Jesus, which so many people fondly recall, was always there, hanging in one's bedroom, in the family dining room, in the neighbor's home, at church, in the YMCA. The image marked the sites of familial and communal life, transmitted institutional knowledge, and visually articulated the public rituals conducted at church or in the home. Sallman's pictures and a host of mass-produced images by other artists were not simply about the private sentiments of those who admired them; they were the very means of making concrete, uniform, and universal the memories and feelings that define the individual. This ubiquity and sameness, this pervasive familiarity, will seem militantly boring to those for whom the imagery signifies an alien world, but it is deeply reassuring for the image's adherents. Believers return to the same imagery over and over precisely because it reaffirms what they want to take for granted about the world.

As we shall examine in the first chapter, however, religious images and the worlds they assemble remain reassuring only insofar as the epistemological apparatus on which they rely can be submerged and naturalized. The fact that its submergence must be maintained implies that it is

constantly under threat of denaturalization. When the set of assumptions, the naturalness of daily practices, the history of belief enforcing a community's sense of identity must be consciously attended to or questioned, the foundation of the world becomes insecure. We see this occur most frequently in the tensions between generations. When young people leave home and learn to see the world differently, they often find it difficult to accept on faith what their elders trained them to believe, and thereby come to see such signifiers as religious images as anachronistic, unrealistic, or inadequate for their experience. As the epistemological schemes of youth change, young people redefine the horizons of their world under the collective influence of an alternative social milieu.

Other chapters of this book will investigate how the use of images has been rooted in concerns about the "passions," about the boundaries of gender and age, about the importance of complementary text and discourse, and about the organization of individual and communal life in the narrative strands and anecdotal bits of memory. Images serve as a material means of conducting the rituals that define the public, domestic, and private spheres in which believers discern their identity and the characteristic horizons of reality that link them to one another and gather their experience into coherent worlds. A number of questions will recur in this book in different forms: How do images evoke and mediate emotional ties in the family? How do images shape memory? How do images serve on the occasion of rituals? How do image and text interact in the different uses to which they are put? I wish to know how images—the cardboard and half-tone pictures that believers take so much for granted—do all of this as quietly and as inconspicuously as they do.

This book explores how popular religious images are understood by their admirers to distinguish one's own domain or group from others, to establish and monitor the perimeter of belonging. In much of what follows, I utilize Csikszentmihalyi's threefold analysis of the way in which artifacts objectify the self. First, images displayed in the home broadcast religious and cultural identity. Indeed, the same image may be variously interpreted and deployed by different religious groups as fitted uniquely to their own confession of belief. Second, the devotional image shapes memory—both personal and collective—allowing for the narrative assembly and interpretation of the life course, the lifelong, providentially blessed unfolding of the individual. Finally, the power of objects to symbolize relationships illuminates the importance of devotional images in domestic ritual and gift-giving, where the status of the self is secured and

one's relation to the community of belief rearticulated in the face of significant life changes.

My intentions, however, are more historical than sociological. A sequential overview of each chapter will briefly sketch out how my historical scrutiny of the many operations and effects of modern American visual piety will proceed.

In chapter 1 I distinguish visual piety from traditional aesthetics; I describe how and why religious images have been used, and in what a popular aesthetic of religious art might consist. Chapter 2 approaches the history of visual piety by identifying two paradigmatic relations configured by religious images—empathy and sympathy—following them from the late medieval world of European Catholic devotion to the eighteenth and nineteenth centuries in the New World. This chapter seeks to understand the dynamics of the relationship between viewer and image by focusing on the passions and affections that images evoke and help to control.

Chapter 3 follows an analysis of sympathy in nineteenth-century evangelicalism with a discussion of popular christology and its visual expression as part of the larger popular discourse on masculinity and friendship. Chapter 4 investigates the beholder's share in the interpretation of Warner Sallman's *Head of Christ*. Catholic and Protestant responses to the image are compared to one another and to a history of popular hermeneutics. In this chapter I scrutinize the relations of "high" art and "low," distinguishing the charters of each and their respective visual means.

The final two chapters focus on the common uses of images. Chapter 5 locates their reception within the home, where display is linked frequently to domestic ritual. If many Protestants feel uneasy about the use of images in devotion and in the worship space, they circumvent the iconophobic impulse by deploying imagery within the temporal alternative to space, the memory. This is the subject of chapter 6, which investigates the importance of memory in the popular reception of religious images. This chapter examines the special protocols that temporalize images in order to make them more than signs without appearing to compromise an often-invoked injunction against idolatry. Finally, a conclusion offers a reflection on religious images and the construction of everyday life.

In sum, this book makes the case for a historically rooted analysis of popular religious images and attempts to displace the highbrow and preponderantly aestheticist dismissal of such imagery. I believe that we can find within the visual piety of any period a great deal of information

about the economy of cultural power that shapes the sense of reality, indeed, that constructs the world of its native viewers. Theories of the popular image, however unarticulated in the practices of piety, are very much in force and need to be described and analyzed in order to assess an image's ideological function and world-making power. The theoretical focus of this book proposes an overarching theory of popular culture which probes the structures of thought and feeling that animate the popular visual culture of nineteenth- and twentieth-century North American religious piety.

This study comprises *a* history and theory of popular religious imagery rather than *the* history, and it applies only one theoretical model—social constructivism—to its subject. There are many ways to write history, and I make no claim for comprehensiveness or priority. My interest in understanding how popular images participate in the social construction of reality is not the only way to think about images, but one important way. Given these parameters, readers will not be shocked to find that many more things have been left out of this history than included. This study glides into the modern era by way of the later Middle Ages and is content to focus largely and selectively on the visual culture of American Catholicism and Protestantism, and primarily the latter. The stories to be told are many and by no means apparent to historians yet. The process has just begun. The important work of many scholars—a sample of which appears in the select bibliography at the end of the book—offers various approaches to a variety of subjects. Readers will want to consult many of these works in tandem with the present book in order to gain a view of the emergent historiography of the visual culture of popular American religion. The field shows every sign of rapid advance in coming years.

\\\|||///

THE PRACTICE
OF VISUAL PIETY

The persistent presence of imagery in Catholic and Protestant parishes indicates how important devotional pictures are for countless believers. The same sanctuary that is adorned with a wooden carving or original mural may very well display a large reproduction of the *Sacred Heart* (see fig. 2); and what Lutheran or Methodist fellowship hall is complete without a faded copy of the *Head of Christ* (see fig. 1)? *Christ at Heart's Door* (fig. 3) and *The Lord Is My Shepherd* (fig. 4) hang in church nurseries and Sunday school classrooms no less than in children's bedrooms at home because they are icons of the tender Savior devoted to his flock. High and low, elite and popular, exist side by side in most public, domestic, and mental spaces of belief. The human psyche is much more the postmodern pastiche than a pristine and seamless unity. The child is the father of the man, Wordsworth said, and it would seem that this parentage is never outgrown. Side by side, the child and the adult inhabit the same space, like multiple layers in a palimpsest, the most recent veneer never completely concealing the one beneath it.

Objections to popular imagery, however, are legion. The popular appeal of devotional visual culture among believers has often provided ecclesiasts with the occasion for lamenting the decline of taste as a threat to religious or theological integrity.[1] Yet what I propose in this opening chapter is not a refutation of theological opinion. People are entitled to the theologies they choose, and I am neither qualified nor interested in changing their minds. Instead, following the lead of many scholars working in communication and media studies, popular culture, and the

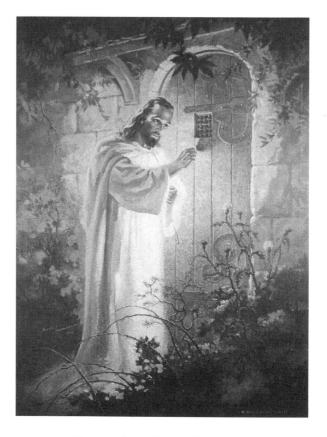

FIGURE 3. Warner Sallman, *Christ at Heart's Door,* 1942, oil on canvas, 40 × 30 inches. Courtesy of Jessie C. Wilson Galleries, Anderson University.

sociology of religion, I would like to examine why believers are positively attracted to devotional imagery, what they believe it offers them, and how scholars might understand this appeal in terms of a popular aesthetic of religious images.

HIGH AND LOW

Study of the reception of popular religious images like figures 1 and 2 has led me to conclude that their attraction is not merely a matter of easiness, a simple art for simple folk.[2] The matter seems more complex than that: the popularity of these images is based on the way they answer to

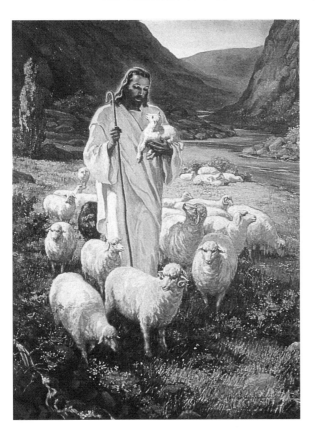

FIGURE 4. Warner Sallman, *The Lord Is My Shepherd*, 1943, oil on canvas, 40 × 30 inches. Courtesy of Jessie C. Wilson Galleries, Anderson University.

the needs of the devout, replying in a voice that is not grandiose, imposing, authoritative, or impersonal, but tailored to the stature of the believer's life. Traditional attacks on popular culture have lamented the loss of individuality to the homogeneity of mass-produced kitsch, together with the resulting political domination by those in charge of production.[3] Theological critics will object that many devotional images shrink God to an idolatrous human scale.[4] But the first thing to learn about the popular piety to which such images appeal is that, for most people, it is more important to cope with an oppressive or indifferent world than to resist or subvert it. Thus, the theology of the sublime and

sovereign Deity is subordinated by many believers to an apparatus of intercession. Jesus, Mary, and any of the many saints whose salient features are tenderness, sympathy, or accessibility offer a "personal relationship" with the individual believer. Divine sovereignty is less important than divine mercy.

The inexpensive, mass-produced broadside print, pilgrimage medal, dashboard saint, and offset-lithographic reproduction of Sallman's Jesus form a vital part of the material culture of Christianity without which many generations of believers could not have practiced their beliefs in the characteristic ways they have. The feelings or sentiments prompted by these objects may be what critics find most unacceptable. In a well-reasoned article, "On Kitsch and Sentimentality," Robert Solomon has suggested that the inability or refusal to value such feelings as sweetness, tenderness, and sentimental longing lies at the heart of contempt for kitsch.[5] If we are to understand the appeal of popular religious art for many, it will be necessary to attend to the centrality of these sensations, which are so apparent in countless depictions of such subjects as Christ blessing the children (fig. 5), the Nativity, and the infant Christ with the Madonna (see figs. 16 and 55). These images and the emotions they engender are an essential component of popular piety. Faith and popular images cannot be neatly separated by the force of towering architecture or Sunday morning art appreciation courses. Many churches and some of the world's great pilgrimage cathedrals have enshrined thousands of votive *retablos* made from cardboard or tin that pilgrims and parishioners bring to thank Mary or Rita, James or Jude, for their assistance (see fig. 15).[6] The sublime and the prosaic go hand in hand—they always have. This is the pastiche of everyday life.

Another frequent criticism of popular religious imagery is that it represents a simple-mindedness, that images belong to a childish stage on the path to spiritual and intellectual maturity. Yet an examination of how images are used by the devout shows that the image is part of a larger cultural literacy, one that includes pointing, verbal narration, oral traditions, singing, and pious devotion. Devotional images, in other words, participate in a visual piety that encompasses a range of interacting, interdependent forms of meaning-making.

The argument of bad taste joins easiness, feeblemindedness, and immaturity to oppose the use of popular images in religion. What taste shaped by high-art practice fails to allow, however, is the centrality of usefulness in popular visual culture. Usefulness, though, conflicts at the most fundamental level with the traditional definition of aesthetic value.

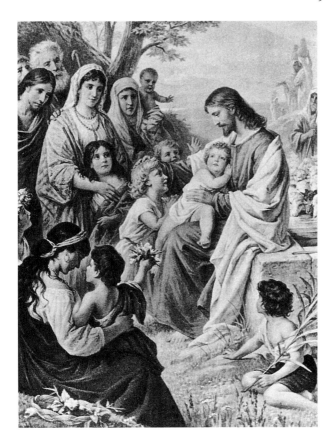

FIGURE 5. Bernhard Plockhorst, *Christ Blessing the Children,* 1885, oil on canvas; in *The Light of the World; or, Our Saviour in Art,* ed. Abram P. Elder (Chicago: Elder, 1896), pl. 99.

Unlike objects created for disinterested or "aesthetic" contemplation, designed to celebrate craft and the history of stylistic refinement, popular iconography is thoroughly "interested," "engaged," functional, and extrinsically purposive. For those who see in figures 1 and 2 the Savior and his reassuring presence in their lives, taste is misbegotten if it neglects the existential benefits of the imagery.

The question of interest and disinterestedness bears further examination because it informs what is meant by "aesthetic." Many writers identify the "aesthetic attitude" with the aesthetic of disinterestedness.[7]

By disinterested contemplation of works of art they mean a manner of looking that does not seek to satisfy a biological need such as hunger or sexual desire or a social need such as propaganda or the illustration of religious belief—all of which have come to be regarded as "nonartistic," incidental to the purpose of art. This implies that there cannot be a popular aesthetic if it does not practice disinterestedness. Ironically, disinterestedness itself derived in no small way from religious notions of selflessness and the piety of mysticism. If we are to proceed toward identifying a popular religious aesthetic, we must first review the philosophical grounds for aesthetics and the historical prevalence of disinterestedness in the experience and definition of art.[8]

THE AESTHETIC OF DISINTERESTEDNESS

The history of aesthetics since the eighteenth century has largely advocated disinterestedness as the basis for judgments of taste and artistic quality.[9] The experience of beauty is characterized by a noninstrumental enjoyment, which means that an object is beautiful inasmuch as it possesses its reason for being within itself, inciting no form of desire or use beyond its own enjoyment. Thus Arthur Schopenhauer objected to the depiction of "served-up dishes, oysters, herrings, crabs, bread and butter, beer, wine, and so on" in Dutch still-life painting because the viewer was "positively forced to think of its edibility."[10] Purged of the desire to possess, beauty submits to no purpose beyond simple contemplation. As an early theorist put it, the beautiful is that which is "perfect in itself."[11] According to Immanuel Kant, another important advocate of disinterestedness, aesthetic judgment pertained only to the representation of something taken up into the imagination and understanding, not to the object itself.[12] The experience of beauty, that is, incites no desire for a thing but enjoys only its representation in the mind.[13] I will argue, in contrast, that a popular aesthetic of religious visual culture should refuse to make this distinction because popular response to images often merges form and physical existence, representation and object, in order to experience the presence of Jesus himself. In other words, a popular aesthetic pivots on seeing as real what one has imagined, whereas the aesthetic of disinterestedness as Kant understood it consists of the excitement of the mental faculties of the imagination and the understanding into a harmonious relation, a free-play or nonpurposive mental state. The first attempts to meld inner and outer as reflective of one another; the latter turns inward and erects an

impermeable barrier between the mental state and actual existence. In the first, correspondence is paramount; in the second, self-contained form or appearance (*Schein,* to use Friedrich Schiller's favorite term) is supreme.[14]

The aesthetic of disinterestedness was elevated into a spirituality of art during the Romantic period in the work of several writers. Significantly, the discourse on disinterestedness was substantially indebted to theological and ethical reflections on selflessness, more specifically the abandonment of self-interest in the face of the divine or human other. Thinkers such as Karl Philipp Moritz and Arthur Schopenhauer in Germany transposed the theological discourse onto a self-consciously aesthetic mode of thought.[15] In Schopenhauer's work disinterested contemplation became a grand principle of redemption from the embodiment of the universal will ceaselessly instantiating itself in various grades of objectification. It was the artist who fashioned the occasions of transcendence in which the work of art expressed the idea of a species and thus became a Platonic idea made present for contemplation. The work of art was the product of genius.[16] Schopenhauer did not hesitate to assure his readers that "the common, ordinary man" was incapable of a "consideration of things wholly disinterested in every sense, such as is contemplation proper."[17] The very opposite of the egalitarianism, antihieraticism, and populism that fueled so much popular religion in the United States and went on to inform the visual piety of popular American Christianity, Schopenhauer's aesthethic of sublime self-effacement took disinterestedness to its logical extreme.[18]

In North America the association of disinterestedness and religion can be fixed most authoritatively to Jonathan Edwards (1703–58) and his followers in the eighteenth century. True belief was distinguished by the selfless, disinterested appeal of God's beauty: "That wonderful and unparalleled grace of God, which is manifested in the work of redemption, and shines forth in the face of Jesus Christ, is infinitely glorious in itself, and appears so to the angels; 'tis a great part of the moral perfection and beauty of God's nature: this would be glorious, whether it were exercised towards us or no."[19] This last comment is telling: true believers contemplate God's beauty without regard to their own benefit, that is, they do not apply God's goodness to their own interests, but contemplate it disinterestedly. Edwards elaborated on the experience of selflessness in contemplation of divine glory in a way that recalls the eclipse of the self in the tradition of Christian mysticism or the aesthetic contemplation later described by Arthur Schopenhauer:

A true saint, when in the enjoyment of true discoveries of the sweet glory of God and Christ, has his mind too much captivated and engaged by what he views without himself, to stand at that time to view himself, and his own attainments: it would be a diversion and loss which he could not bear, to take his eye off from the ravishing object of his contemplation, to survey his own experience, and to spend time in thinking within himself.[20]

The inward experience of God in this contemplation was deeply affective, to judge from Edwards's description of it. True saints are "inexpressibly pleased and delighted with the sweet ideas of the glorious and amiable nature of the things of God." It is "the spring of all their delights, and the cream of all their pleasures"; this "sweet and ravishing entertainment" provides the foundation of all subsequent joy.[21] The disinterested contemplation of God's intrinsic excellence constituted a selfless yearning for the beloved experienced as God's beauty. Edwards also wrote that one of the distinguishing signs of gracious affections was the increase of "a spiritual appetite and longing of soul after spiritual attainments,"[22] and in the autobiographical account of his own conversion experience he wrote of his "vehement longings of soul after God and Christ, and after more holiness."[23] Selfishness and satisfaction with the self were among the chief vices, according to Edwards's theology. Yearning for God and the loss or forgetting of the self in contemplation of divine beauty were the appropriate response to approaching God's holiness.

Edwards remained a Calvinist of the old school by starkly distinguishing innate human corruption and divine sovereignty ("The corruption of the heart of man is a thing that is immoderate and boundless in its fury").[24] Thus, he could not allow that the human heart was ever capable of pure disinterestedness. Self-interest was in fact what moved humans to seek salvation no less than what governed their relations with one another.[25] But it was not what produced genuine faith: "They whose affection to God is founded first on his profitableness to them, their affection begins at the wrong end [because they] . . . have no respect to that infinite glory of God's nature, which is . . . the first foundation of all true love." Edwards acknowledged, however, that self-love could move people to "high affection towards God," for in it they might recognize their own weakness and God's strength, goodness, and justice. True saints, however, did not begin from self-love; rather, they were moved by God's intrinsic excellence, by "what he is in himself."[26] Edwards spoke of God's glory, the end of all creation, in Neoplatonic terms: as an "emanation and remanation," an effulgence of light shining from God and

reflected in turn by God's human creatures. The genuine believer was one who sought to contemplate divine beauty as an act of reflecting the divine light back to its source. Edwards could even speak of this relation as "union" with God.[27] Thus, disinterestedness included an important mystical element for Edwards, yet it was not a state of dispassionate observation in the manner that Kant and others described aesthetic experience, but an abandonment, founded on a self-denying impulse, of the soul into divine grace. Even so, the similarities between Edwards's treatment of disinterestedness and European treatments of aesthetic experience are striking.

TOWARD AN AESTHETIC
OF POPULAR RELIGIOUS ART

Two objections should be raised against privileging an artwork's formal features in visual contemplation. First, distinctions between the aesthetic and nonaesthetic and good taste and bad frequently serve to enforce class distinctions. David Hume, for instance, praised the study of beauty in the fine arts (poetry, eloquence, music, and painting) because they improved the temper and provided "a certain elegance of sentiment to which the rest of mankind are strangers." The circle of friends that the fine arts generated was an important one, according to Hume, for delicacy of taste confines "our choice to few people, and [makes] us indifferent to the company and conversation of the greater part of men. You will seldom find, that mere men of the world, whatever strong sense they may be endowed with, are very nice in distinguishing characters, or in marking those insensible differences and gradations, which make one man preferrable to another."[28]

In a classic essay on "psychical distance," a modern version of eighteenth-century disinterestedness, Edward Bullough defined the aesthetic experience as one in which the work of art and its appeal are sufficiently distanced "from one's own self" by virtue of being "out of gear with practical needs and ends."[29] To illustrate his point, Bullough referred to "the proverbial unsophisticated yokel" who is forever unable to distinguish dramatic action on a stage from actual events.[30] We are led to assume that the aesthetic attitude properly belongs to the urban sophisticate, to the class that enjoys leisure and refinement as the sign of its privilege, in contrast to the uneducated and rural. In his study of kitsch and sentimentality, Robert Solomon points to additional motivations that serve the interest of status: "One cannot understand the at-

tack on kitsch, I propose, without a sociological-historical hypothesis about the fact that the 'high' class of many societies associate themselves with emotional control and reject sentimentality as an expression of inferior, ill-bred beings, and male society has long used such a view to demean the 'emotionality' of women."[31] In other words, the interest of the aesthetic of disinterestedness has often been the subordination of lower classes and women. While it would be rash to insist that this cultural politics is all that the disinterested contemplation of art amounts to, we should be alert to the politics of taste and suspicious of any claim for political neutrality in ranking the disinterested experience of art above the popular reception of images.

The second objection to the privileging of aesthetic contemplation in the analysis of religious visual culture is that we will probably overlook a great deal of religious experience and behavior if we accept that aesthetic moments as defined by connoisseurs and aesthetes constitute a distilled and timeless essence of religion. Indeed, the study of popular piety shows that essentialist approaches to defining religion in the tradition of Friedrich Schleiermacher's "feeling" or Rudolf Otto's *mysterium tremendum et fascinans* readily fail to appreciate the social and material practices of religion in everyday life. Neither, for that matter, should we privilege the recondite experiences of religious mystics in the construction of a hierarchy that places apophasis, or the negative approach to divine knowledge, at the "high" end and cataphasis, or the approach to God by such positive means as symbols and devotional aids, at the "low." In the following passage, Thomas Merton shows how disinterestedness, contemplation, and transcendence of the ego merge in the experience of "contemplative prayer" and reflect the historical relation between aesthetics and mysticism mentioned above.

> One has begun to know the meaning of contemplation when he intuitively and spontaneously seeks the dark and unknown path of aridity in preference to every other way. The contemplative . . . accepts the love of God on faith, in defiance of all apparent evidence. This is the necessary condition, for the mystical experience of the reality of God's presence and of his love for us. Only when we are able to "let go" of everything within us, all desire to see, to know, to taste and to experience the presence of God, do we truly become able to experience that presence with the overwhelming conviction and reality that revolutionize our entire inner life.

Merton expressly cautioned against dismissing image, symbol, art, and rite from the practice of prayer, for they served him as the "means to enter more deeply into the life of prayer and meditation." As *means,* how-

ever, their value was limited largely to "ordinary everyday life" because such "symbolic helps to prayer lose their usefulness in the higher forms of contemplative union with God."[32]

It should come as no surprise that Merton's experience of transcendence is not what most sympathetic viewers of Warner Sallman's work report. They find Sallman's images absorbing and commanding and worthy of a contemplation that must be distinguished from personal dissolution into the act of prayer or the work of art. Those who venerate the saint or Savior of popular images bring broken bodies to be mended, shattered nerves and sick children to be healed. The body of the believer is explicitly engaged in what we may call the visual piety of popular religious images. The transcendence they seek is deliverance from ailment and anguish, which is not different in kind at all from Schopenhauer's use for aesthetic experience, though the means differ considerably.[33] Desire is at the heart of this vision; there is nothing "disinterested" about it.

Yet neither is aesthetic contemplation purely disinterested; it can lay no claim to superiority on the basis of purity or dispassionate contemplation. The distinction between visual piety and aesthetic contemplation does not mean that visual piety is noncontemplative. The evidence of popular religious images and their reception warrants a careful distinction of the types of vision that characterize the visual piety of many Christians. The first genre of seeing consists of a gaze that fixes on the divine as present. Two specific forms may be distinguished: a yearning to escape the bounds of the ego and mingle with the object of the gaze, and a be-holding or gripping of the Other in the gaze to derive a favor from it. The second, more common and less spectacular form of beholding is an active beseeching, an act of seeing that invites the sacred into mundane existence in order to achieve a particular end such as a healing.

Beyond these two contemplative forms of seeing it is necessary to distinguish a visual protocol that is restless or transient. Here the eye becomes the avenue for the advent of the sacred, but not by virtue of stasis or kenosis. Rather than stillness, the glancing and scanning of a kinetic, aniconic eye leads the believer through the world on a pilgrimage toward the divine, toward an end that is never enshrined within the confines of existence, but is absent, the invisible destiny at the far end of a trajectory the eye seeks out furtively. It is not presence that this manner of seeing constructs, but presentiment or expectation. This way of seeing regards the devotional image as a promise, a restless sign, a harbinger of that which awaits.

Many devout viewers say that Warner Sallman's *Head of Christ* pictures the man they will behold in paradise, on the other side of death. The man pictured is not Jesus himself, others say, but for now the image will do to remind believers of him, to call to mind his promise of a second coming and life hereafter. What Jesus really looked like is irretrievable, so this image serves not to recover him, but to remind believers of what he stood for. The eye sweeps along in search of the absent Savior, but finds only a useful convention, a placeholder on the way to heaven. One admirer of Sallman's image, after stating that the picture "has meant very much to me and our family," concluded her letter with the following thought: "No one knows what Christ looks like. One day we will know. We worship him in Spirit and truth" (400). The final remark refers to John 4:23, where Christ instructs an auditor that neither a holy mountain nor a sacred temple would suffice as the proper manner of worship: "God is spirit, and those who worship him must worship in spirit and truth" (4:24). In other words, no sign is adequate to the divine. Others who wrote to me took a pragmatic view: "I know Jesus probably doesn't look like this picture. It doesn't matter. I thank Mr. Sallman for giving me this image to hang onto" (323). Yet another writer invoked divine benevolence as a way of dealing with semiotic inadequacy: "Even if it isn't a true picture of what Jesus looked like when He was on earth, it is the artist's conception of Him and I believe God honors that" (367).

Both the glance and the gaze operate on the basis of *recognition,* which goes to the heart of popular visual piety. When a believer judges Sallman's *Head of Christ* "beautiful," my research suggests that the picture's beauty consists in the satisfying experience of perceiving a particular understanding of Jesus adequately visualized. The image, in other words, fits a viewer's ideal. We may discern here a popular aesthetic rather than an elite one. Admirers of Sallman's work find in it precisely what they want, expect, or need. As one woman put it, "As a Christian, [I think] this picture is a beautiful portrayal of Jesus. . . . The picture is full of love, compassion, empathy, peace, kindness, gentleness. And it is very welcoming!! How very lovely—And isn't that what Christianity is supposed to be all about!" (350). Reassurance or reaffirmation is the principal concern in popular religious art, as in popular art in general. To quote a classical definition formulated thirty years ago: "Popular art is essentially a conventional art which restates in an intense form, values and attitudes already known; which reassures and reaffirms, but brings to this something of the surprise of art as well as the shock of recogni-

tion."[34] Sallman's image of Jesus confirms the traditional formula or convention of Christ's appearance, but tailors it to the modern evangelical notion of Christ as an obedient son and intimate friend, in a format that recalls commercial portrait photography of the first half of the twentieth century. The result is a variation on a convention that affirms the tradition but provides a sufficiently novel formulation. The *Head of Christ* is different enough to provide the pleasure of recognition yet similar enough to bind the viewer assuringly to the idea that a single historical reality resides in the face so often seen. An aesthetic of popular religious art accents the practice of reception that stresses content over form in the attempt to match what believers are predisposed to want with what they see in an image or hear in a hymn. The emotions associated with the experience of an image by Sallman tend to be those that accompany a sense of reassurance and safety, for example, the tenderness, sweetness, innocence, and warmth of a child's bliss or the nostalgia and sentimentality of an adult's longing for lost security.

Because the experience of a fit or adequate correspondence is the point in this popular aesthetic, originality and academically transmitted skill play a lesser role in much visual piety than in the tradition of the fine arts, armed as the latter is with venerated institutions of technical training, connoisseurship, and historical analysis, all of which are geared toward making judgments of taste based on professional competence. The point behind the visual culture of popular piety is not principally an admiration of skill, which pertains to the manipulation of a medium, but admiration for the object of representation, that is, what is seen *through* the medium. Although the manner in which the object is represented importantly shapes the act of visual piety, the production of the popular image and its reception are not rooted in the categories of taste as defined by the history of fine art. We can therefore speak of beauty in visual piety as consisting neither in artistic skill nor in contemplative disinterestedness, but in the reassuring harmony of the believer's disposition toward the sacred with its visualization. Aesthetic experience should not be limited to disinterested contemplation, but made to include the beauty that many either glimpse or gaze devotedly on in popular pictures of Jesus.

This, however, flies in the face of those modern philosophers of art who argue that the only legitimate aesthetic experience is an organization of feeling worthy in its own right, chartered with no purpose but its own enjoyment. By this definition, to look devoutly at images of Christ is to have a religious experience, not an aesthetic one. Yet is there ever in the warp and woof of the human psyche an aesthetic experience of the

purist order—indeed, does any kind of "pure" experience exist? Do we ever completely separate our feelings about food, the nude or naked body, the heroic leader, the hazy countryside, or the teeming urban landscape pictured in works of art from our experience of the form of these representations? The evidence is that most viewers do not do this even standing in front of a work of complete abstraction, such as a painting by Jackson Pollock or Barnett Newman. Certainly Kandinsky expected viewers to regard his abstractions not as devoid of content but as charged with references and associations evoked by color and form.[35] While the willed repression of unruly memories, fears, or desires may be a very important part of certain kinds of aesthetic experience—in the effort, for example, to focus on the formal structure of a sonata or the austerity of an abstract painter's nearly invisible grids of color—there is no reason to assume that this kind of denial is essential to art. Purity is a particular aesthetic ideal, not a universal one. Religious and aesthetic experience infiltrate one another, as we saw in Edwards and Moritz, where a religious equivalent of disinterestedness occurs (in Edwards) or an artistic impulse is derived from a religious one (in Moritz).

My argument here is that popular art (mass or folk) no less than elite art (academic or avant-garde) exhibits an aesthetic if by aesthetic we mean the apparatus of judgment presupposed when people enjoy what they do. To experience the correspondence between what the believer sees and what he or she wants or expects to see is the visual pleasure of popular religious art that is expressed in a number of operations. The first I have already named: recognition. To this we can add several others: interactivity, projection, empathy, and sympathy. I would like to examine recognition and interactivity at greater length in the present chapter and leave the others for consideration in later chapters.

THE PSYCHOLOGY OF RECOGNITION

We won't understand the power of popular religious art until we grasp how as well as what believers recognize when they see Jesus in imagery such as Sallman's. A fascinating epistemological process underlies this recognition, as letters from admirers of Sallman's images make clear. An elderly woman claimed that Sallman's *Head of Christ* is "an exact likeness of our Lord Jesus Christ" (50). A writer from Texas stated that the picture "depicts my imaginary picture of Jesus" (53), just as another Texas woman indicated that this was the Christ "in my mind's eye when I imagine His coming back, and when praying to Him" (254). A woman

from Wisconsin wrote that the image is "the earliest 'picture' that comes to mind when I think or hear His name" (203). A clergyman from North Carolina observed that this "portrait" has "become an icon of sorts, a standard representation of Jesus that millions of Christians carry with them in a conscious or unconscious way" (58). A woman living in Florida summed up her assessment of the image this way: "All the wonderful words we've always read and heard of Him—'There He is, Sallman's painting, in person'" (183). In each case Sallman's image is said to be identical to the mental image of Christ that believers possess. The match between mental and visual likeness is a striking experience of recognition. Another woman indicated the importance of the immediate, unambivalent recognition that Sallman's picture affords. Praising the *Head of Christ* as unmistakably identifiable, she wrote: "No one doubts or wonders who the picture is of. I had a lady stop by and ask if one [non-Sallman] picture of Jesus hanging in our kitchen was Nostradamus! . . . I've taken it down—permanently!" (463).

Images of Jesus have enjoyed considerable popularity for much of the history of Christianity. They tend strongly to conform to a certain physiognomic type—often even those by Asian, African-American, or Hispanic artists who render the first-century Palestinian Jew as a member of their own race.[36] A modern Chinese artist, Hsu San Ch'un, has painted *Christ, the Universal Savior* (fig. 6) seated by the well from which the Samaritan woman draws water. In this and many other portrayals by non-Western artists, familiar codes remain in force in spite of racial differences: Christ is almost invariably slender, solemn, emotionally subdued, inwardly absorbed, bearded, and ascetic; he may be set off from a crowd even while immersed within it, gesturing authoritatively as miracle worker, teacher, spiritual master. The same accommodation of history to the present occurs in the work of the Japanese printmaker Sadao Watanabe (1913–96), a Christian artist who produced an iconic portrait of Christ as Veronica's Veil (fig. 7), an image that, according to tradition, was lifted directly from the Savior's face as he paused on the way to Calvary. Watanabe portrays Christ as a Japanese man in a highly stylized manner that owes as much to the Caucasian Christ-type as to any native Japanese visual tradition, with long face, large eyes, beard, and quiet demeanor. Indeed, the long, slender nose and the prominent, almond-shaped eyes are reminiscent of Christ's representation in early Byzantine icons. An important balance between difference and similarity is struck in order to render Christ Japanese without forfeiting the image's recognizability as a Caucasian Jesus.

FIGURE 6. Hsu San Ch'un, *Christ, the Universal Savior,* n.d., ink and brush; in Cynthia Pearl Maus, *Christ and the Fine Arts,* rev. ed. (New York: Harper & Row, 1959), 757.

In the recent history of African-American Christian illustration the balance yields more of an edge, a resistance to the racial norm of the dominant white culture. Since the 1970s Fred Carter, an African-American illustrator and preacher, has produced illustrations for Sunday school instructional materials used by African-American children. In his image of Christ at prayer in the garden of Gethsemane (fig. 8), Carter employed African rather than Caucasian features and gave Christ a hairstyle and beard that seem quite modern. Yet these innovations do not impair the recognizability of the image, for the strong visual tradition of modern devotional illustration persists in Carter's picture. Sallman's depiction of the same subject (fig. 9), which is sometimes reproduced only in facial format, also foregrounds the portrait quality of Christ's anguish and situates a non-Jewish Jesus in an evocation of a Middle Eastern landscape. But Carter's image rivals Sallman's, whose pictures were often used in

FIGURE 7. Sadao
Watanabe, *Handkerchief
of Veronica*, 1985,
katazome stencil dye print,
13 1/6 × 9 inches. of the
Brauer Museum of Art,
Valparaiso University.

the 1950s and 1960s by African-American Baptists, particularly in the South. Indeed, in the wake of the civil rights movement it is difficult not to see Carter's work as deliberately displacing the dominance of the Caucasian Christ, from which Carter borrows aspects of pose and presentation only to transform the image of Jesus by rendering heightened expression and detail, such as the literal depiction of Christ's perspiration as drops of blood (Luke 22:44: "and his sweat became like great drops of blood falling down upon the ground"), and a masculinity that is more pronounced than in Sallman's Christ—a subject that will occupy our attention in chapter 3. Thus Carter's popular art affirms the visual tradition of portraying Christ, but modifies it significantly so as to inject it with a new relevance for African Americans.

Yet the enduring constancy of images by Watanabe, Carter, and many other popular artists—whether it is a conservative borrowing or an oppositional appropriation—counters the historical peculiarities of costume, race, and theological interpretation that situate any depiction of Jesus within a particular community, national tradition, or local ideology. Of course, this constancy itself is a historical phenomenon, but by resisting change, it figures Christ's transcendence, signifying for believers the one, the "real," Jesus behind the history of appearances. In spite

FIGURE 8. Fred Carter, *Jesus Praying in the Garden*, 1987, ink and pencil, 7 3/8 × 7 5/16 inches. Courtesy of Urban Ministries, Inc.

of all the variations in his depiction, artists have employed one underlying set of features to portray Jesus. As a result, most pictures of Christ operate within a dense intericonic space that recedes into the historical record of images, back to the fourth and fifth centuries after Christ's birth. This long record constitutes an ongoing visual discourse that has informed Christian piety in general and given it a strongly Eurocentric bias. What we see in a picture of Jesus is therefore not a rendition of an actual, historical figure, but an interpretation of an ongoing tradition of imaging Jesus. We see, in other words, a reference to virtually every other image of Christ that may ever have existed. Each image is an adap-

FIGURE 9. Warner Sallman, *Christ in Gethsemane*,
1941, oil on canvas, 40 × 30 inches. Courtesy of
Jessie C. Wilson Galleries,
Anderson University.

tation or variation on the same theme, tailored to the situation of an im-
age maker, the market that manufactures and disseminates the image,
and the public that beholds it. The ultimate effect, however, for many be-
lievers, if not all, is a corroboration of Christ's "real" likeness. Count-
less images form an array of sameness rather than difference. Believers
purport to see through the local features and apprehend the transcendent
Jesus who stands behind every instantiation of his image. A devout
British author expressed this view very clearly in a book published in
1905 by the Society for Promoting Christian Knowledge:

> What I mean by the Likeness of Christ is the Likeness common to all these
> [artistic versions]; the Likeness that painters and sculptors in all ages have had

before their mental vision when they attempted to portray His image; the Likeness that is known throughout the world, sometimes more perfectly, sometimes less perfectly rendered, to which we all unconsciously appeal when we think of our Lord in any act of His ministry, apart from any particular picture; the Likeness that enables us to recognise in any group of figures the face that is intended to represent the face of Christ; the Likeness that the reader of this book had in his own mind before he turned its pages.[37]

Some admirers of Sallman's *Head of Christ*, by contrast, considered it a "photograph" of Jesus, an image so accurately capturing the Savior's features that it might be a mechanical reproduction. In fact, this is not such a new idea, for the Veil of Veronica—the "true image," as the etymology of Veronica's name puts it—was supposed to be something like a spiritual photocopy of Christ's features transferred directly from his face to the cloth.[38] Thus, in addition to visual observation, attaining a likeness can take two other paths: the mechanical and the ideal. Correctness achieved by mechanical means such as the photograph, camera obscura, pantograph (a device for reproducing an image), or the skiagraph (a shadow-tracing apparatus) is the empirical method of fixing a likeness.[39] The ideal method proceeds by abstracting features from a class of particulars in order to arrive at a composite that represents the essential characteristics, the true likeness.

Apologists for the position taken by the British author quoted above might turn to idealist epistemology for support of the notion that such visual archetypes exist. A tradition going back at least to Plato has understood ideas as intellectual forms that serve as ideal models for the actual images created by artists. Plotinus related a story about the Athenian sculptor Phidias, who created a sculpture of Zeus after the god himself revealed his spiritual form to the artist. Cicero repeated the often-told story of the painter Zeuxis, who could not find a woman sufficiently beautiful to represent Helen, so he assembled beautiful parts of real models into an ideal whole, the better to represent how he imagined Helen should appear. And Raphael said the same of his depiction of "a beautiful woman."[40] The stories of Zeuxis and Raphael were often repeated from the seventeenth through the nineteenth centuries. Modern theorists on art such as Immanuel Kant and Joshua Reynolds had their own versions of the creative process, in which ideal form was likewise synthesized from particulars.[41] Kant, for instance, believed that the imagination deftly compared large numbers of mental images to arrive at a general representation.

Photographers in nineteenth-century America rendered the Kantian imagination's construction of figures in composite photographic por-

traits of members of such associations as social clubs, professional guilds, college graduation classes, and ethnic groups. In the case of the Boston physicians pictured in figure 10, to borrow Kant's description of the operation of the imagination, "one image glide[s] into another; and thus, by the concurrence of several of the same kind, [the imagination] come[s] by an average, which serves as the common measure of all."[42] In this instance, as in any idealist interpretation of mimesis, the ideal was more real than the material instance, the exemplar ontologically superior to the example. Indeed, the composite photograph in figure 10 represents a visual assemblage of identity based on class, race, and gender. The sameness imaged there was the key to power, prestige, and social authority in nineteenth-century Boston: no one was allowed into the visual calculation of the physiognomic average who did not already conform to the synthesis. The search "to establish types of national physiognomy," as the article that accompanied figure 10 put it in 1894, was in fact a search for secure racial distinctions, a sense of static racial homogeneity.[43] That likeness is a social construction becomes especially clear from the analysis of composite photographs conducted in this same article by H. P. Bowditch, a professor of physiology at Harvard Medical School. Bowditch compared three composite images of doctors, conductors, and horse-car drivers to find that each occupied a distinct place on a hierarchy of intelligence; he therefore concluded that, "as far as intelligence is concerned, the composite portrait fairly represents the typical physiognomy of the group to which it belongs."[44] This vicious circle, illogical as it is, accounts for the experience of a puzzling correspondence: I belong because I am alike; I am alike because I belong. Similarly, believers immediately identify Sallman's image as Jesus because they have seen him in other images that bespeak the same transcendent ideal contained in the picture hanging in their homes and churches.

The Christian claim to recognize the real Christ behind singular representations is therefore not without a grand philosophical tradition. For those of an empiricist persuasion, however, the epistemological affinity only makes the claim more suspect. The historian is apt to find in the reception of Sallman's Christ not the effulgence of an elusive ideal reality, but a powerful instance of the social construction of reality. The very ubiquity of the image, as well as its similarity to the type historically transmitted, enables devout viewers to forget or ignore those other representations of Jesus that do not corroborate the image they call their own. The authority of Sallman's rendering for many consists in the way the image is able to draw selectively upon previous depictions while

FIGURE 10. Boston physicians and their
composite portrait, ca. 1894; in H. P. Bowditch,
"Are Composite Photographs Typical Pictures?"
McClure's 3 (September 1894): 333.

riveting centuries of image making to the historical situation of mid-twentieth-century conservative Christians in North America. Bernhard Plockhorst's *Christ Blessing the Children* (see fig. 5) and Harold Copping's *The Healer* (fig. 11) both portray the familiar type, whether set in a biblical age, in the present, or in the bleary space of a fantasized, idyllic landscape. As I have discussed elsewhere, Sallman drew his inspiration from a French painting to which his *Head of Christ* bears a striking resemblance.[45] In light of this visual commonplace, Sallman's portrait of Jesus becomes a picture about pictures. Those who admire it assemble in the *Head of Christ* a cultural apparatus by which to conjure up the person of Jesus as the elusive presence immanent in and authorizing countless pictures. It is the task of visual piety to see in the image of Jesus a single referent, an enduring likeness embodied especially for a particular viewer in a particular representation. The response is unmistakable and widely repeated, as in the words of one two-year-old child looking at Sallman's image: "that's Jesus!" (99). The exclamation presumes to match a proposition to a visual likeness and posit an instantiation of the primordial image, which isn't an image, but the essence behind the image, inherent in it. The essence precedes the image and is named in the kinds of exclamations that people sent to me: "that's Jesus!" "that's Him," "There He is," and so forth.

What is most real: the image of Jesus? the historical Jesus? or the essence of Christ, the idea or spiritual reality that corresponds to the believer's recognition of the picture and affirming utterance? Believers don't have to choose among these; instead they compile them in their devotional gaze. The power of visual piety consists in enhancing the immanence of the spiritual referent through the image, reifying it, and merging it with a concept of the historical Jesus. This process occurs readily without imagery, but the shock of recognition and the response before an image like Sallman's only strengthens the sense of immediacy of the idea and facilitates its naturalization, its infusion with aura.

Pictures of Jesus are especially powerful for many when the image is more than a sign, more than a placeholder in discourse. When devout viewers see what they imagine to be the actual appearance of the divinity that cares for them, the image becomes an icon. The icon is experienced by believers as presenting some aspect of the real thing, shorn of convention, as if standing before the image is to enjoy the very presence of its referent. As an operation of perception that locates in an image the genuine character or personality of Jesus, the icon is the engine of visual piety.

FIGURE 11. Harold Copping, *The Healer*, n.d.,
copyright London Missionary Society; in Cynthia
Pearl Maus, *Christ and the Fine Arts*, rev. ed.
(New York: Harper & Row, 1959), 756.

Sallman's painting embodies the image of Jesus that hovers behind every picture, partially captured in each, but most present for many Christians in the *Head of Christ*. This particular representation invests, for those who grew up between 1940 and the 1960s, the many memories of Jesus into a single picture. The presence evoked by the portrait is a concrete interpretation of the Jesus who is manifest in countless images of two millennia. I do not wish to assert that the particular is more or less real than its many predecessors, only that the one is meaningless in devotional life without the other. It may be helpful to borrow from Kant's description of how the human imagination works: The viewer combines all the images of Jesus he or she has ever seen and abstracts certain features from these particulars to arrive at an essential Jesus, a mental construct. I am suggesting that during much of the twentieth century Sallman's image represented that synthesis.

Kant analyzed this process of abstraction in his *Critique of Judgment* (1790). He believed that the human imagination was capable of arriving at the average of a large set of particulars, such as a thousand men. The average physical size of these thousand individuals, in his view, was the "stature of a beautiful man," and he pointed to an ancient sculpture, the *Doryphoros* (fig. 12), as an eminent example of this idealization in art. Each race of human beings, Kant allowed, determined its own notion of beauty on the basis of its own features. The resulting "normal idea," as he called it, "is the image for the whole race, which floats among all the variously different intuitions of individuals, which nature takes as archetype in her productions of the same species, but which appears not to be reached in any individual case." This was a "rational idea" that, by itself, remained abstract and insensible, but when joined with the proportions of the human figure in a work of art formed what Kant called an "aesthetical idea . . . [that] can be completely presented *in concreto* in a model."[46]

The appeal to idealist philosophy from Plato to Kant to explain the power of symbolic representations has an important tradition in twentieth-century sociology. Looking to this will return our considerations to the social efficacy of religious images. Emile Durkheim, one of the founders of modern sociological method, availed himself of Idealism to bolster his explanation of the power of collective representations in religious practices. In his monumental attempt to show that religion was "an eminently social thing," Durkheim argued that social thought "can make us see things in the light that suits it; according to circumstances, it adds to or takes away from the real. Hence, there is a realm of nature

FIGURE 12. Polykleitos, *Doryphoros,* marble, copy after original bronze, c. 450–440 B.C., 78 inches high. Museo Archeologico Nazionale, Naples, Italy. Source: Alinari/Art Resource, N.Y.

in which the formula of idealism is almost literally applicable; that is the social realm. There, far more than anywhere else, the idea creates the reality." Durkheim used the comparison to idealist ontology to demonstrate the constructive power of religion as the "means by which individuals imagine the society of which they are members and the obscure yet intimate relations they have with it." Collective representations, he held, were not the autonomous acts of individual minds but the social practices that bound individuals together into characteristic groups such as totemic clans. Durkheim could even push this as far as endowing society with the status of a "special being" that "thinks about the things of its own experience" in the form of collective representations.[47] We might argue that the vastly repeated, ubiquitously displayed images of Jesus in modern America act as collective representations that, spanning from mind to mind, help form the social reality of Jesus; for this reason the historical person of Jesus assumes for many believers the features of Sallman's picture because it is the image that has so widely informed religious imagination. We mean "collective," then, in two senses: as a rep-

resentation of an entire class of particular images and as a mental image shared by many believers. An image of Jesus, therefore, becomes a powerful social reality when it joins these two senses of the term; the image synthesizes a hybrid from all the particulars of the class of Christ images and comes to represent the class in the minds of those who recognize their collective relations to one another in the features of the image.

Another, related way of thinking about the power of an image like Sallman's among believers is one that stresses its social function as the operation of collective memory. In his seminal work on collective memory, the sociologist Maurice Halbwachs, a disciple of Durkheim, argued that religious doctrine was the communal memory of the church, an ongoing social act of remembering the originary events of the faith.[48] The process of social memory analyzed by Halbwachs is a complex historical operation that resembles the hermeneutics of recognition we have seen at work in the popular reception of Sallman's picture of Jesus. Religious dogma, according to Halbwachs,

> resulted from the superposition and fusion of a series of successive layers like so many slices of collective thought. . . . Theological thought thus projects into the past, into the origin of rites and texts, the views of that past that it has taken in succession. It reconstructs on various levels, which it tries to adjust to each other, the edifice of religious truths, as if it had only worked on a single plan—the same plan that it attributes to the founders of the cult and to the authors of the fundamental writings.[49]

For Halbwachs no act of historical memory fully retrieved the past, in the sense of laying hands upon it directly. Memory does not preserve the past in the pickled solution of untainted religious doctrine, but reconstructs it with the dual assistance of traces left behind and the present needs and disposition of those conducting the work of remembrance.[50] Remembering is an epistemologically subtle process of assimilation and concealment, a selective matching of fact to expectation, historical trace to existential situation. Memory is neither an innocent retrieval nor a private act, Halbwachs insisted, but an essentially social and engaged one.

Seen in this light, the recognition of Sallman's picture as Jesus himself amounts to a socially encoded anamnesis, a collectively disseminated and enforced remembering of Jesus as the evangelical Savior that Christian communities have used to shape the imaginations and memories of its younger members since the middle of the twentieth century. All previous images of Jesus were superimposed in this one. Sallman's image came to represent its precursors inasmuch as the mental image of Christ in each believer corresponded to a collectively conditioned origin. This

image is a collective form of memory insofar as it supersedes all or many of those that came before it and is charged with the duty of signifying particular beliefs in the practices of visual piety. By "memory" I do not mean the recollection of an original trace, but the forging of another link in a historical chain of social acts of representation. Although an image like Sallman's operates under the spell of mimesis whenever its adherents claim for it such iconic status as authentic likeness or historical accuracy, the likeness that visual piety actually constructs consists of a mediation between the past and the world of belief of a given community of believers in the form of a particular image of Jesus. The image's power consists in its ability to conceal the historical difference separating it and its admirers from the distant figure of history whom the image portrays. The image, in other words, remembers by forgetting whatever its adherents claim Jesus was not. Moreover, as a collective or social act of memory, the image connects the devout viewer to fellow believers, that is, to those who see in it the same likeness. Visual piety, therefore, exerts a strong communal influence.

Why appeal to the various approaches of Kant, Durkheim, and Halbwachs? I am not suggesting an eclectic amalgamation of discrete analyses, but refer to each in order to illumine from different angles how it is that images may be understood to participate in the social construction of reality. Each in his own way, Kant, Durkheim, and Halbwachs stress the constructive nature of human knowledge and regard human activity as constitutive of human worlds—whether it is the Kantian transcendental ego, Durkheim's understanding of society, or Halbwachs's collective memory. Each urges a phenomenological treatment of the image as constructed, not given, as both product and producer of human thought and social relations.

Kant's epistemology, Durkheim's theory of collective representation, and Halbwachs's account of collective memory help us understand that Sallman's image of Jesus is powerful for many people precisely because it seems to condense many Jesuses into one. This hybrid Jesus serves in turn as a uniform act of remembering the Jesus of history. For millions of believers—and not just middle-class Euro-Americans, startling as that may be!—it is the most compelling expression of all the renditions of Jesus scattered over the ages. The thrust of popular religious culture has often been to treat the abstraction as photographically transposable, to see a literal trace of the transcendent in the image—whether it is an icon, Veronica's Veil, or Sallman's *Head of Christ*. Popular culture sets aside ambivalence, elusiveness, doubt, and suspicion in order to grasp with

certainty the thing itself. Devout response to Sallman's picture invests the ideal Jesus entirely within the familiar features of this ubiquitous picture. The image visually corroborates the already known: the intuition of the ideal Jesus is tailored to the concrete Jesus of the picture by the cultural formation of growing up in a Christian home in mid-twentieth-century North America.

The image of Jesus tailors the fit between what Pierre Bourdieu has called the "objective order and the subjective principle of organization." This fit is a harmony between natural and social worlds that appears self-evident. Bourdieu calls this self-evident relation *doxa,* which in ancient Greek philosophy referred to commonly accepted opinion rather than scientifically established knowledge of the world.[51] For practitioners of visual piety, however, such doxa embrace the commonsense, everyday reality of experience and are therefore much more reliable than what Plato called *episteme,* the refined and abstract fare of philosophers. The host of historical depictions of Jesus, together with Sallman's composite of them in his portrait-icon, create the impression of an "objective order" having a faithful, universal essence; in this manner they fashion a harmony between "history" and whatever "Jesus" may mean to a group or individual. The harmony between the two lies in the experience of doxa as self-evident. At the heart of popular response to Sallman's Christ is a sense of reassurance in gazing on what one immediately recognizes as "the savior I always knew." Every time an image of Jesus appears that does not contradict the long-standing paradigm of his physical appearance as a light-skinned Euro-American man (and images such as Copping's [fig. 11] are only the most blatant expression of this cultural appropriation), the paradigm becomes more archetypal, more transcendent, less historical. Each layer of visual sediment strengthens the persuasive power of Euro-American visual piety by corroborating the "truth" of Sallman's *Head of Christ* or any other "portrait" resembling it.

When the Caucasian appearance of Christ is replaced by characteristic features of other races, the visual negotiation of meaning that occurs in any portrayal of Christ is laid bare. The strangeness of these images to white viewers helps disclose the very artifice of representation, that is, how easily one's own race is naturalized as the appropriate basis for depicting any figure who wasn't light-skinned. The act of representation is an act of interpretation, a subtle racial appropriation. In figures 6–8 East Asian and African-American artists have portrayed Jesus for believers of their respective races. Yet they have done so according to standard icon-

ographic motifs. Since twentieth-century African Americans have inherited the conventional visual language of the Western pictorial tradition, Fred Carter (educated in a commercial art school) can use this even as he subverts the practice of depicting Christ as a white man. Viewers are able to recognize the figure as Christ in spite of the change because the image maintains a vital link to important aspects of the traditional understanding of Jesus (for example, that he obediently submitted himself to God's will at the personal expense of great suffering), but in a way that affirms black racial identity as part of what African-American believers share with Christ.[52] Through the use of such images as Carter's, Christian collective memory is made to accommodate racial difference rather than conceal or subordinate it.

INTERACTIVITY IN THE RECEPTION
OF POPULAR RELIGIOUS IMAGES

If religious images seem "real" to believers by virtue of incarnating the spirit of Christ that floats in myriad depictions in the history of Christianity, Christ is also made concretely real through physical interaction between viewer and image. Interacting with sacred images—dressing, praying to, speaking with, and studying before them, changing their appearance in accord with seasonal display—is a common and important way of making them part of daily life. This incorporation of imagery into the emotional lives of believers exhibits nothing in the way of aesthetic distance. Devotion to the friendly intercessor or personal Savior, so common in modern popular piety, does not allow disinterested contemplation to prevail. In fact, whether or not the contemplation of a work of art is actually as passive as the aesthetic of disinterestedness would claim, the way people look at devotional images, as in the case of the reception of popular culture generally, is best described as interactive.[53] Believers use, handle, move, speak to, dress, and proudly display sacred imagery.

This occurs in the home and in the public worship setting. At the Cathedral of San Fernando in San Antonio, Texas, examples of interactivity are abundant.[54] A mass-produced plaster image of the patron saint extends his left foot from beneath his robes; this gesture has been interpreted by the faithful as inviting physical interaction, for the foot is worn smooth by kisses and stroking. Near the sanctuary the Virgin of the Sacred Heart looks down on the viewer. She is painted with polychrome realism and gestures with one hand to the viewer and the other

to her heart, the emblem of her compassion. Fresh flowers are placed daily at the base of the image; an array of candles burns before the image, and a prie-dieu invites the devout to kneel in prayer and commune with the benevolent Mother of God who intercedes on behalf of her faithful. To the left of the church's main altar is another image of Mary, the Madonna of the Protective Shroud; although she stands several feet above the floor of the church, an actual shroud extends to the floor (fig. 13). The mantle descends from Mary's enthroned glory to the sublunar world of mortals, who take solace in her protective robe and literally pin

FIGURE 13. *Madonna of the Protective Shroud,* Cathedral of San Fernando, San Antonio, Texas. Photo by author. Courtesy of the Cathedral of San Fernando.

their hopes to it: those beseeching Mary's protection have affixed snapshots of children and family members inside the mantle.

Other images in the cathedral also offer themselves for tangible interaction with the devout. A wooden replica of a famous crucifix in Guatemala, the Milagroso Cristo Negro or Miraculous Black Christ, hangs in the narthex, where it gathers even more snapshots attached in votive thanks for deliverance or healing (fig. 14). Those who are thankful, as well as those seeking consolation and assistance, express their prayers by affixing photographs and other objects of personal identity to a dense deposit of images. The variety of tokens beneath the replica of the miraculous crucifix are telling: vacation snapshots, baby pictures, graduation portraits, passport photos, school pictures, military commencement photos, hospital identification bracelets, letters, inscribed photographs, and handwritten notes—all tangible traces of the person for whom intercession is sought. They are pinned four and five deep on the board as well as lodged behind the crucifix and between Christ's crossed legs. The great majority of images are of children less than twelve or thirteen years of age. With names, dates, prayers, and messages of thanks scribbled in English and Spanish on the back of photographs or to attached notes, the votive bulletin board gathers together hundreds of testaments to divine mercy and acts as a crucial link in the public ritual of intercession and its proclamation. One ex-voto photograph of a man no older than twenty or twenty-one was inscribed with the following, typical announcement of thanks: "Near death and totally paralyzed by polio / October 4, 199_ / Totally healed and fully recovered / by the grace of God and Virgen de Guadalupe / Janier Gonzalez of Mexico City / Father of 4 children." Two large racks of votive candles are arrayed before the board and crucifix, flowers are placed on the floor beneath, and two prie-dieux are stationed in front of the candles for prayerful meditation. During my visits many adult visitors paused to pray and light candles. Upon leaving they would cross themselves, frequently touching either the photograph of their loved one or the feet of Christ.

The photos beneath the Miraculous Black Christ in San Antonio are a convenient and personalized version of such older forms of visual piety as inexpensive votive retablos, which, painted on tin or cardboard by local artists, were purchased by pilgrims or commissioned by the devout and displayed in churches in gratitude for Mary's special assistance or as a means of drawing the favor of a saint (fig. 15).[55] These images were personalized by painted illustrations and narrative inscriptions that com-

FIGURE 14. *Miraculous Black Christ of
Esquipulas, Guatemala, of 1595,* replica, 1988,
wood. Underneath can be seen the votive board
of photographs. Cathedral of San Fernando, San
Antonio, Texas, 1996. Photo by author. Courtesy
of the Cathedral of San Fernando.

bined to relate the story of the person's travail and deliverance. In the case of figure 15, the retablo was dedicated to San Luis de la Paz in the hope that he would provide assistance in finding a worker's lost knife.[56] Whether as a votive offering or as a means of prompting saintly aid, the retablo remains a fundamental part of a ritualized exchange registered in the sacred and public setting of the pilgrimage cathedral. But the Polaroid photograph is a quicker and cheaper visual document and one that carries personal and affectionate connotations of the family photo album as well as the factuality of the photograph.[57]

Another example of physical interaction will strike readers as no less familiar. Many people in recent years have visited St. George Orthodox Antiochian Church in Cicero, Illinois, to venerate Our Miraculous Lady of Cicero, an icon of the Mother and Child that has been weeping since Easter of 1994 (fig. 16). To watch the faithful who silently beseech the icon is to witness how interactive this image is. The devout genuflect, pray, and light candles before the image of Mary, offer her flowers and money and speak to her, or simply gaze intently at the eyes and tears of the weeping Mother. A similar pious interaction often holds for devotional images in the home: many still dress the Infant of Prague or display nativity scenes and crucifixes during Advent and Lent. Images and statuettes glow in the dark, watch the viewer from all angles, or leap from the card as a three-dimensional hologram. Feast day processions

FIGURE 15. Mexican retablo dedicated to San Luis de la Paz, 1896, painted tin, 6 1/8 × 9 1/8 inches. Courtesy of the Brauer Museum of Art, Valparaiso University.

"THE MIRACULOUS LADY
OF CICERO, ILLINOIS"

FIGURE 16. *The Miraculous Lady of Cicero, Illinois,* St. George Antiochian Orthodox Church, Cicero, Illinois, 1994. Courtesy of St. George Orthodox Church.

with statuary, tableaux vivants, and public crèches are further examples of the life of images among Christians. All of these share the feature of physical interaction. They are not contemplated for aesthetic merits, but used to shape and prompt the daily drama of Christian life. Their presence is characterized by change, not stasis. Moreover, the variety of ritualized interactions with images of Jesus and Mary internalizes their collective reality by fashioning an interpersonal transition, a concrete relation between a collective ideal and a human individual.[58]

While some Protestants are fond of dismissing popular imagery and visual practices of belief, the fact remains that most Protestant traditions in North America have made use of mass-produced, inexpensive images in one way or another. My research into the popular appeal of Sallman's pictures confirms that devout Protestants interact with them in ways that approximate Catholicism's popular use of images. Analysis of the letters I've received regarding Sallman's work demonstrates the character of

popular interactivity and provides an opportunity to think about the use of such imagery in the church and home.

Response to Sallman's Christ is often focused on the eyes as the most significant feature of the portrait: it is in the eyes of this picture that Jesus reveals himself to believers. In such images as the *Head of Christ, Christ at Heart's Door,* and *Christ in Gethsemane,* one respondent relates, "the eyes of Christ . . . seem to penetrate one's soul" (84). An observation by a Methodist clergyman reveals how the *Head of Christ* has functioned as a relay in the act of visual piety: "His slightly upward gaze directed one's own eyes towards God and away from the hurts, the disappointments, the harshness of life" (43). The eyes of the figure also become animated for many viewers, who see in the picture a caring, sympathetic person. A young father wrote that he takes great comfort in hanging the picture on the wall of his children's nursery, where "Christ's loving, gentle gaze has watched over our daughter . . . and now our son" (104). "When I am tired, frustrated or anxious," a Connecticut woman wrote, the picture "gives me . . . a look of love" (177). The image returns the viewer's gaze with a message of encouragement: "When I gaze at it prayerfully, the eyes say, 'Go ahead. You can do it.'" A Seventh-Day Adventist Sabbath school teacher made extensive use of images by Sallman, Harry Anderson, and others by teaching her students "to look deeply into all portrayals and try to imagine that we were seeing Him face to face" (466). For others the eyes signify, indeed make present, the Christ who "saw me from this painting," and even "saw me anywhere and everywhere I went" (57).

And if it is not the eyes, then it is the ear of this icon. A Methodist woman from Pennsylvania once complained to her pastor that no one listened to her. The clergyman responded by giving her a wallet-sized image of Sallman's *Christ:* "he pointed to the ear of Jesus and said, it is always turned to you, he is willing to listen anytime you care to talk. The very same picture has been in my wallet ever since" (88). A woman who displays the image in her home stated that visitors realize "this is the Lord's house, that Jesus is listening and hears everything" (144). Another woman hung the image by her telephone in order to remind herself that "I can call on Jesus at all times" (247).

When the sympathetic gaze and ear of Jesus are installed in the home and church, Sallman's picture provides a sense of presence. As one letter already quoted put it, "when I look at it in prayer, and when I am the most in need, I see not only a painted portrait, but the face of the real, the living Christ" (177). A Protestant mother from Tennessee placed the

Head of Christ in her children's bedrooms because she wanted them "to have a picture they can look at, relate to, show reverence to, remember, and instill it in their minds" (379). "What has it meant for my devotion and worship?" a Sunday school instructor asked. "It made me feel more aware that Christ was right there in that room with us as we studied His word. I've tried to put myself into the picture and determine what might have been on His mind at the time" (71). A daughter wrote of her mother's final years as an invalid in a nursing home, with the *Head of Christ* hanging next to her bed: "As I would sit by her bed, feeding her, she would say she was never alone, He was by her side. The picture gave all of us strength to bear the hurt and suffering with patience and faith" (97). As another woman put it, "To have this picture in my home makes me be constantly aware of HIS presence and that HE is watching over me" (38). A mother of three children wrote: "When I'm feeling stressed out, I look on my wall and I know I'm not alone. It has a very calming effect on me. It also helps me when I pray. It makes me feel, because I see him, that he is really here with me" (171). To have an image of Christ that listens, an image that returns one's gaze or watches over one, is to have a Christ who is not simply represented by the picture, but is in some sense presented in it. Contemplation of this image is an encounter, an act of visual piety.

Popular religious pictures survive church renovations and migrate from demolished buildings to modern ones despite the architects, clergy, and liturgy committees who would rather eliminate them. The persistence of these pictures is not a matter of leisurely nostalgia. People find it difficult, even impossible, to worship comfortably without them. This persistence is, rather, an index of visual piety. The image creates a devotional space, a place to encounter or interact with the sacred. Many say that the picture corresponds to the mental image of Jesus that is present in prayer. Both homes and worship spaces are transformed by the images displayed therein. Images are the means by which a space becomes familiar and personal. People take their Sallman pictures from house to house as they move through life, hang them among the photographs of their relatives, place them in their children's bedrooms, and admire them in religious classrooms and the sanctuary. Such images have the power to make a place home by installing there a sacred presence, an icon that listens to believers and watches over them.

In the visual piety of Catholic and Protestant Christianity we can properly speak of a popular aesthetic, the features of which include

recognition as a condensation of historical precedents into a single, contemporary likeness; and interactivity, the embodiment of belief in response to the image as a real presence. The power of the image consists in its ability to insinuate itself into the very fabric or practice of belief. Certainly "high" art does this and always has. Yet insofar as it defines beauty and taste in terms of disinterestedness, high art underscores a contemplative distance at the expense of the restless and furtive glance or the passionate gaze that gets the devout through the day. Historians, therefore, will do well to decenter disinterestedness and realize that all images —high, low, and anything in between—are central to much religious life and offer concrete evidence of the life-worlds and histories of its adherents. I am reminded of a story recounted by art historian Michael Camille, who watched an irate Italian mother handily apply an aesthetic image to a mundane religious purpose when, seeking to rid her daughter's mind of evil thoughts, she repeatedly knocked the girl's head against a crucifix by Brunelleschi in a Florentine chapel.[59] The power of images, it would seem, particularly religious images, is measured by their relevance in solving problems and in coping with the problems that can't be solved. Sacred images—whether Sallman's or Brunelleschi's—are those that make belief work.

EMPATHY AND SYMPATHY IN THE HISTORY OF VISUAL PIETY

The practice of visual piety is much older than modern American Christianity. *Schaufrömmigkeit* (literally, the "piety of looking or seeing") was an important component of religious life in late medieval Europe, when small devotional images and altarpieces depicting the Passion of Christ were a vital form of worship, prayer, and devotion. This chapter will focus on the continuities and discontinuities in the history of visual piety, which I have gathered under two terms that are etymologically related to the *passio* or suffering exemplified for Christians in their afflicted and dying Savior. Empathy—projecting oneself into the situation of another—and sympathy—the correspondence or harmony of feelings among people—are similar emotional processes but ultimately quite different in their ethical and social consequences. They represent discrete configurations of the believer's relation with the divine and with other humans through or by means of the image. An examination of the relationship between viewer and image will illuminate the role of the body in the visual piety of different times: the medieval locus of suffering and likeness with Christ, and the eighteenth- and nineteenth-century site of moral control and the public presentation of a sanctified self. There are doubtless any number of variations on the historical forms of empathy and sympathy as I define them here; and there are surely other modes of relation besides these two. My purpose here is to move beyond the isolated image to the social and emotional space between the image and the body as the basis for understanding how imagery functions.

CATHOLIC VISUAL PIETY FROM THE LATE
MIDDLE AGES TO THE MODERN PERIOD

The importance of seeing in late medieval piety becomes clear when we realize that just looking upon relics afforded forgiveness of sin. The enormous visual culture of reliquaries, altarpieces, and church architecture that responded to the presence of the relic and the communion host was designed to convert the sacred into a visual experience. This piety of looking transformed the art and architecture of the later Middle Ages in Europe and approximated in the West the Eastern experience of the icon.[1]

It is surely significant and insufficiently observed that for virtually a millennium the church did not portray the Resurrection as western European culture has come to imagine it since the Middle Ages.[2] Early on, the Resurrection was referred to by such symbols as *chi* and *rho*, the first two Greek letters of "Christ," encircled with a victory wreath, or by portrayal on an empty tomb. The Byzantine method was to show a militant Christ harrowing hell or rescuing Adam and humanity from the prison house of limbo. It was not until the eleventh century in the Latin West that the now familiar motif of Christ emerging from the tomb became the accepted means of picturing the Resurrection. During this period in the West the body acquired a new importance as the basis for understanding one's relationship to God, to the church, to authority, to the social order. Now the representation of the miraculous bodily reconstitution of Jesus began to take precedence in Christian art. Artists from the later Middle Ages to the Renaissance and baroque periods reveled in showing as theatrically as possible that mysterious moment of Christ's return to an enfleshed presence on earth.

The affirmation of the body in the Resurrection recalls the important role that somatic miracles, resurrections, the physical sufferings of the saints, their dismemberment, and the dissemination of their bodies as relics came to play in the later Middle Ages.[3] Indeed, a fundamental shift occurred during the early second millennium, which turns our attention to the mechanics of the miraculous, to the nature of supernatural events manifest in the body. The image of the Resurrection begins to serve (paradoxically) the role of capturing that miracle as an empirical event.

Why did this new concept of the image arise? Perhaps it was linked to the rise of the cult of the saints and their relics and the new importance of the sacrament of the altar, both of which signaled the emergence of Gothic architecture as the appropriate means of housing the material

presence of the sacred as well as hailing large numbers of pilgrims from across the face of Europe.[4] These cultural developments were articulated within a rhetoric of display that accompanied the emergence of a devotional piety that stressed the human, corporeal aspect of Christ more than the triumphalist, post-Resurrection character of the earlier Middle Ages.[5] Closely connected to this was the ideal of *imitatio Christi,* in which devotional images picturing Christ's suffering and death played a central role. A fourteenth-century mystic, the Dominican Heinrich Suso, expressed the spirituality of imaging Christ in the life of the believer this way: "A detached person must remove from himself the form of the creature, become formed after Christ, and super-formed in divinity."[6] The verb "to form" in Middle High German was *bilden,* the noun form of which was *bilde* or image. The link to the image was explicit in Suso's mystical theology because, as one scholar has pointed out, Suso's conception of mystical union with God stressed a devotional piety informed by the cult of the *Andachtsbild* or devotional image.[7] A fourteenth-century disciple of Suso, a nun who applied her teacher's meditations to devotional life in the convent, even composed an image of the mystical path of the soul (fig. 17) to illustrate Suso's description in his *Little Book of Truth* (c. 1327).[8] The path moved from the divine abyss (*abgrúnde,* in Middle High German) of reality to the Trinity, then to creation. The soul turned from death to emulate the self-denial of Christ and became conformed, in Suso's words, "to the image of the Son of God."[9] According to Suso, this happened only by dying to the world, attaining detachment (*gelassenheit,* a term central to the mystical theology of Suso's teacher, Meister Eckhart) from rather than attachment to the world. This detachment was graphically depicted in the nun's form (the text was illustrated for the sisters of a Dominican convent at Ulm) in the lower left corner of the page. The figure, eyes closed, resigns in conformity with the gesture of the dead and crucified Christ. After this loss of selfish attachment the soul was "super-formed" (*úberbildet*) into the bosom of Christ, where it shared the image of the divine origin with Christ and the Trinity, though without losing itself in the divine essence, a doctrinal error for which Eckhart had suffered papal rebuke.[10]

In later medieval devotional practice the body was the means of participating in the life of God perfectly expressed in Jesus, whose incarnation, suffering, death, and resurrection were the material means of salvation. Later medieval piety and its instrument, the devotional image, seized on the body as the medium for identifying oneself with Christ. Recent scholarship has demonstrated the importance of the body (the be-

FIGURE 17. "The Mystical Way," c. 1363,
MS. 2929, fol. 82r, Collection de la Bibliothèque
Nationale et Université de Strasbourg; in Karl
Bihlmeyer, ed., *Heinrich Seuse: Deutsche Schriften*
(Stuttgart: Kohlhammer, 1907), 195.

liever's own as well as the body of Christ) in the spirituality of that era, particularly in writings about and by cloistered women.[11] The Passion and Resurrection of Christ visualized the threefold process of salvation: deforming, conforming, and superforming.

The body came to be understood as what humans had in common with God by virtue of the Incarnation and the Passion of Christ. Historian Caroline Walker Bynum contends that the emphasis on the body in the lives of saints was connected to a new understanding of the human

person as inseparable from the body.[12] The soul, in other words, was incomplete without the body. To this we can add the point that an important function of images of Christ's travail and pain was the healing of the bodily afflictions of believers. This was the case from the earliest days of the church, when Christ was imaged as a magus, able to perform healing miracles.[13] From the early church to the modern world, whether by virtue of a kind of visual homeopathy or miraculous cure or the psychosomatic influence of commiseration, Christ's suffering merged with the believer's and removed or mitigated it. The painter Mathias Grünewald (c. 1480–1528) rendered a grisly crucifixion of the tattered, discolored, tormented body of the Savior in an outer panel of his Isenheim Altar (fig. 18), in tandem with the purified, luminous body of the resurrected Christ on an interior panel. It is well known that the altar, dedicated to St. Anthony, who was traditionally petitioned for the healing of ailments, served in a monastic community and hospital that specialized in medical treatment.[14] As the Greek word *soter* or savior/physician denoted, the suffering body of Christ was not only the site of divine revelation, but the source of physical healing. Identifying with Christ's suffering as depicted by Grünewald was thought to render a cure of bodily as well as spiritual afflictions.

The corporeality of the tormented, dead, and resurrected Christ in late medieval images was keyed to the practice of devotion in the later Middle Ages. The bodily presentation of Christ developed in several important iconographic motifs that showed Christ in gestures of ostentation. The Virgin and Child, the Man of Sorrows, the Crucifixion, the Deposition, the Lamentation, the Imago Pietatis (the dead Christ at the grave), and the Resurrection were all distinct subjects from the thirteenth through the fifteenth centuries, presenting Jesus within a symmetrically organized, enclosed visual field.[15] The figures, displayed for the viewer, exhibited gestures that elicited an empathic response as part of Franciscan *compassio,* an identification with the suffering of Christ that found its highest expression in the Franciscan practice of the *via crucis,* or fourteen stations of the cross observed on pilgrimage and even in the church interior, and in the stigmata Francis and later followers received as the sign of divine favor—what amounted to the perfecting of a saint's imitation of Christ.[16]

Images of the Way of the Cross detailed Christ's torment, agony, and death. One thinks of later monuments, such as Grünewald's Isenheim Altar, as exemplary connections of the Resurrection with the Crucifixion. Images of Christ's Passion and the Resurrection occupied the center of a

FIGURE 18. Mathias Grünewald, *Crucifixion*,
Isenheim altarpiece in the closed position,
1510–1515. Musée Unterlinden, Colmar, France.
Source: Foto Marburg/Art Resource, N.Y.

devotional practice both private and public that aimed at imaging Christ
in the believer's body and imagination. The task was to transform the
pathos or suffering of Christ's Passion into a sensation of compassion—
a suffering with—in the viewer. This new form of piety, effected through
visual means, sought a vicarious participation in Christ's suffering,
death, and resurrection. If the devout viewer suffered and died with
Christ in empathic response to images of the innocent Jesus tortured by

grotesque guards and held up for ridicule, the believer was likewise resurrected and restored with the vindication of Jesus.[17] At work in the images of the Passion cycle and Resurrection was a rhetoric of immediacy that sought to present the believer with an untrammeled vision of Christ. By situating Christ frontally, facing outward, often gazing into the eyes of the viewer and gesturing for that person's sake, images addressed themselves to the viewer and solicited an empathic response. The historical events of Christ's life and death were withdrawn from the past and placed singularly before believers in the contemplative space of public worship and private devotion.

The Protestant Reformation exhibits two minds on the subject of images. Although the Veil of Veronica and the presentation of the dead Christ could be deployed in service of the late medieval practice of indulgences, and although these images appealed to a piety of personal devotion that Luther might have condemned as fanatical, they also deployed a rhetoric of immediacy that was a visual equivalent of the textual notion of *sola scriptura:* that God made himself plain in certain privileged forms of representation.[18] The idea that images were an expeditious avenue of disclosure—an illiterate person's Bible, to cite a Gregorian commonplace—had even been absorbed into medieval epistemology. In his 1286 defense of sacred imagery, William Durandus quoted Gregory on epistemological grounds: "When the forms of external objects are drawn into the heart, they are as it were painted there, because the thoughts of them are their images."[19] Luther's position on images expresses this view as well, and interestingly echoes the tradition of imaging the Passion. In an essay of 1525 written against the radical efforts of Andreas Bodenstein von Karlstadt and the image breakers (*Bilderstürmer*), Luther claimed that images of Christ were not intrinsically objectionable, for "it is impossible for me to hear and bear in mind [the Passion of Christ] without forming mental images of it in my heart."[20] Even so, for Luther the scriptural text alone was authoritative as God's revelation. Other reformers such as Zwingli and Calvin were much more suspicious of images as idols; they believed that human imagination thwarted the capacity of the image to reveal the original to which it referred, thus reducing God to something manipulable by humans and confused with a material form. The "original" in such representation remained sovereignly in heaven and was offended by human pride. Calvin saw images of divine subjects as instruments for manipulating God, for extracting favors from him, as a way of making God present for human use. This amounted in Calvin's mind to a technology of control that was

a supreme affront to divine sovereignty. Roman Catholics and Orthodox Christians, in contrast, understood God to make himself corporeally available in the Incarnation. They discerned a uniform, homogeneous continuity between this life and the next such that the merits that saints compiled here during their exemplary lives transferred, as it were, to a celestial account by which they could be accessed through a material economy of intercession and indulgences. From the late medieval world to the twentieth century, such heavenly assistance has been communicated through a variety of sacred acts and objects including the rosary, holy water, scapulars, medals, the Blessed Sacrament, pilgrimage, and icons.

Images offered the iconophile the prospect of sacred presence. In a metaphysics of presence, namely, representation harbors the yearning to overcome the difference between sign and referent and join the other to one's own body. It was the Savior himself who greeted the devout in the icon; his image was transfigured into something more, into a corporeal gaze, into a look that touches. This very gaze even became the subject for images visualizing the late medieval devotion of *imitatio Christi*.[21] The act of looking at an image elicited a visceral response: the body participated in an integrated devotional practice of imitating Christ, of imaging him in one's own body. Empathy fused the umbilical or ontological aspect of representation (my suffering is his suffering) with conventional aspects (gesture and facial expression, the visual devices of storytelling and spatial representation) to create the appearance of an identity. Gesture itself, being both motivated and discursive, was of fundamental importance for empathy, since it so readily naturalized its own code of meanings. Simply put, visual piety in the late Middle Ages was that cultural operation whereby images were transformed into something revelatory. The act of identifying one's sensations with those of a depiction relied on the body as an organ of knowing, the visceral bridge between self and other. Empathy was the visceral instrument of such knowledge. The knowledge the devout sought was the body's knowledge, expressed in the language of enfleshed sensations. The body of the believer became a powerful organ of religious knowing in late medieval visual piety.

The portrait format of Jesus in western Europe was invented during the late Middle Ages as a way of evoking an emotional relationship to God that privatized belief and made the image central to the practice of devotion. Empathy remained the principal emotional framework in the devotional lives of many Christians in Europe and North America from the sixteenth to the nineteenth century. The role of suffering in visual

piety therefore remained important in Roman Catholic Europe and the New World. One need point only to the penitential *santos* (holy images) of Mexico and Spanish territories in North America, the use of votive retablos in pilgrimage in Europe and Mexico, or the persistence of the illustrated Passion of Christ—all of which continued to situate divine revelation and the exercise of grace in the moments of great bodily suffering.[22] The late medieval emphasis on the agony of Christ's Passion as the basis for an empathic relationship with the Savior persisted in much popular piety in northern as well as southern Europe. One of the figures who has bridged late medieval piety and the modern day is St. Rita of Cascia (1377–1447), an Italian stigmatic who practiced a very painful mortification of the flesh. The saint of impossible cases, Rita enjoyed a growing cult following her death and into the twentieth century, when she was finally canonized by Leo XIII. Her holy cards are found in Catholic bookstores today (figs. 19, 20) and she is still the subject of popular biography.[23] On Good Friday in 1442, after hearing a fiery sermon on Christ's Passion, Rita returned to her monastery and prayed before an image of Christ. Asking to participate in the pain caused by Christ's crown of thorns, she immediately received from the image a wound in her forehead, which remained with her until her death.[24] Figure 19, probably an Italian image produced in the early twentieth century, portrays the saint receiving the wound of the thorn in a ray of light from the head of Christ. In rapt visual contemplation, Rita presents herself before the crucifix in an act of visual piety that binds her suffering to the Savior's.

Pain, as the basis of intimacy with Christ, particularly in connection with the Passion, remained a vital part of popular Catholic piety in the modern period.[25] In France, St. Thérèse of Lisieux (1873–97), widely known as "the Little Flower," understood suffering as integral to her piety, even offering herself as "a holocaust victim to the merciful love of God." Modeling her piety after her favorite book, Thomas à Kempis's *Imitation of Christ* (c. 1427), Thérèse emulated the late medieval practice of assimilation to Christ through self-sacrifice, humility, and forbearance of all suffering. According to her sister, who also served as her prioress in the Carmelite monastery of Lisieux in the 1890s, Thérèse longed to comfort the Sacred Heart of Jesus with the offering of her own suffering. "I hope," she prayed, "that when I get to heaven, I will be like you and will see the sacred marks of your Passion shining in my glorified body."[26]

A Spanish-derived visual piety in southwestern North America from

FIGURE 19. St. Rita
Holy Card, before 1930.
Courtesy of Augustinian
Press, Villanova, Pa.

the sixteenth to the early twentieth centuries focused on penitential
practices that plunged the devout into a protracted identification with
Christ's suffering through self-abuse, including flagellation, fasting, and
long pilgrimages. A spate of confraternities formed in sixteenth-century
Spain and Mexico dedicated themselves to a particular aspect of Christ's
torment during the Passion. A list of several of these groups, which var-
iously incorporated penitential practices, makes it clear how minutely
the process of Christ's pain, torture, and death were scrutinized: the
Blood of Christ (Sangre de Cristo), Christ's Agony on the Cross (Vera
Cruz), the Name of Christ (Santo Nombre de Jesús), the Afflictions of
Jesus (Las Augustias de Cristo), the Five Wounds of Christ (Cinco Lla-
gas de Jesús), and the Dead Christ (Santo Sepulcro and El Cristo En-
tierro). The list continues with confraternities dedicated to the pain of
the Virgin as well, such as Our Lady of Solitude and Our Lady of Sor-

FIGURE 20. Rafael de Soto, St. Rita Holy Card, c. 1980s. Courtesy of John Brandi Company.

rows.[27] This delineation of discrete moments of suffering and parts of Christ's body enhanced empathic identification among the devout by concentrating their attention on a unique aspect of the Savior. Many of these groups continued into the nineteenth and early twentieth centuries and are best known today for the impressive array of statuary and pictures that artisans (called *santeros*) produced for devotional use. *Our Father Jesus of Nazareth* (fig. 21), for example, was carved in about 1885 by a well-known santero named José Benito Ortega (1858–1941). An emaciated and bleeding Christ stands before the viewer, bolstered by vertical supports that allowed the figure to be transported during processions. An important market for Ortega's production was the Brotherhood of Our Father Jesus Nazarene, formerly called the Sangre de Cristo (Blood of Christ).[28] *Our Father Jesus of Nazareth*, then, was fashioned for a particular brotherhood's penitential practices, which included self-

FIGURE 21. José Benito Ortega, *Our Father Jesus of Nazareth*, c. 1885, carved and painted wood, painted cloth, and leather with metal, 30 inches high. National Museum of American Art, Smithsonian Institution, Gift of Herbert Waide Hemphill Jr. and museum purchase made possible by Ralph Cross Johnson.

flagellation using horsehair whips, miniature versions of which were often placed in the hands of the Christ figure.[29]

In Roman Catholic piety from the late medieval to the modern period, empathy stressed the believer's willed self-abandonment as preparation for divine favor. Sympathy, in contrast, placed emphasis on the saint's pity for the petitioner. Whereas empathy dominated the spiritual task of identification with the Passion of Christ among religious orders and penitential confraternities in which mortification amounted to a participation in Christ's suffering, sympathy prevailed in the daily piety of millions who pleaded with particular saints for benevolent intercession. Here the believer prays to a saint with whom he or she feels a special

affinity, related perhaps to age, gender, profession, nation, ethnicity, namesake, family history, or particular circumstances.[30] Favors are petitioned and secured on the basis of a saint's pity for or sympathy with the petitioner. While it is certainly true that empathy and sympathy may be and often are practiced by the same person, my argument is that they are discrete operations.

Petition and intercession worked in Catholic worlds of belief because, as Ann Taves has pointed out, death did not separate those who had left the living for the world hereafter.[31] The material and spiritual realms existed on a single continuum. This continuity allowed the dead to work for the benefit of the living. Thus, the influential Catholic polemicist Orestes Brownson argued in 1865–66 in several essays on the veneration of the saints that "[the departed] are present to our hearts, and we can speak to them, pour into their open and *sympathizing* hearts our joys and griefs, and ask and receive their aid, as readily and as effectively as when they were present to our bodily senses."[32] Although sympathy is more characteristically modern, its roots can be traced to the early modern world. As Kenneth Woodward points out in his fine study of the process of beatification and canonization, the definition of the saint as a wonder-worker was gradually replaced among the official hierarchy by the saintly ideal of the moral exemplar beginning in the seventeenth century, when Vatican procedures for canonization were set down by Pope Urban VIII.[33] Although this emphasis in fact originated in the midst of the great age of saints, the thirteenth century,[34] it was during the early modern period that ecclesial rules as well as popular devotional guides made a point of marking and enforcing the distinction. One of the most revered devotional manuals among colonial and nineteenth-century Catholics in America and Europe was the *Introduction to the Devout Life* by Francis de Sales (1567–1622). This devotional manual, intended for the cloistered and the lay Catholic alike, eliminated extreme practices, effectively displacing empathy with sympathy as the emotional vehicle of belief. The role of saints, traditionally paradigms of ascetical self-denial, was reduced in de Sales's manual to a brief section in which the devout were counseled to select "certain particular saints whose lives you can best appreciate and imitate and in whose intercession you may have particular confidence. The saint whose name you bear was already assigned to you at baptism."[35]

The psychology of sympathy is manifest in a prayer to St. Rita that appears on a twentieth-century prayer card with an image similar to figure 19, part of which reads:

Glorious St. Rita of Cascia! Accept the triduum [three days of prayer] that I devote to you with fervor; grant me the favor for which I plead and grant that I learn the practice of virtues that adorn you so completely. In the hour of life's troubles and hardships I wish to remember the pain that you suffered all your life with the wound of the Holy Thorn in your forehead, which emitted such a foul odor that you had to live alone. Be my comfort in those pains, glorious Saint; may I suffer all for the love of God, thinking of the cross and crown of thorns of good Jesus, who was your consolation and your love.[36]

It is not identification with Rita's pain that is sought, but an affinity with her, an affiliation that will incline her to pity the petitioner and intercede on his or her behalf.[37] In this view, the saint is a heroine to whom the devout claim allegiance and on whom they shower flattery in order to move her to help those who suffer as she once did. Sympathy, in other words, is premised on likeness or affinity, not identity. The image of the saint allows the devout to focus their attention on the saint alone, to contemplate her merits and to discern in her iconography the link the believer may establish with her in order to persuade her to render aid.

The role of the saint in the process of sympathetic intercession, however, has long been understood in two competing, though not mutually exclusive ways: according to ecclesial or hierarchical requisites and in popular terms. These modes are registered in both the iconography and the printed text of different versions of Rita's holy cards. Rita's beatification process in 1626 examined a painting of Rita, now lost but dating perhaps as early as 1462, in which a "bleeding spot" was pictured on Rita's forehead with no thorn as she kneels before an image of Christ.[38] Yet in 1462 she was depicted on the lid of her wooden casket at Cascia (where it remains today) with a thorn protruding from her forehead; and a century after her death there appeared the familiar image of the saint kneeling before a crucifix on a table, receiving a ray of light on her forehead from Christ's crown of thorns.[39] This became the standard iconography that circulated in prayer cards in the nineteenth century as Rita's cause was prepared by supporters, and has remained popular in the twentieth century since her canonization. In figure 19 we see the traditional iconography of the saint receiving the thorn from the crucifix. A lash rests beside her, symbol and instrument of her mortification. A much more contemporary depiction of Rita (painted in the 1980s) is shown in figure 20, where Rita receives a bloody mark, rather than a protruding thorn, from a ray of light that descends not from the crucifix, which she now holds but does not contemplate, but from heaven. In-

stead of an altarlike prie-dieu, she kneels before what looks like a plain podium or lectern. The prayer printed on the back of the card displays a remarkable difference from the prayer quoted above. Rather than addressing Rita, the prayer is directed to God, who is credited for the grace he gave Rita and asked to grant assistance to the petitioner by virtue of Rita's "merits and intercession."[40] Thus, while the traditional system of merits and intercession remains in place, the saint's agency has diminished; the devout now seek to rouse God's sympathy directly by calling on the example of the saint. Accordingly, the iconography no longer stresses Rita's pain and suffering, and it underplays the traditional role given to images such as the crucifix. Instead of the lash with which the fifteenth-century saint scourged herself, the more modern image of Rita pictures Christ's crown of thorns among roses. The crown of thorns represents Christ's Passion and Rita's participation in his suffering; the roses refer to the fragrance of Rita's body at death. The thorn is gone from Rita's forehead, and the stigmatum comes from above. As the prayer on this card indicates, the devout seek to contemplate Christ's Passion, not Rita's. The two cards may have been produced with different audiences in mind: those who would persuade God's intervention by appealing to the moral example of the saint almost as a kind of precedent; and those who remain invested in devotion to the saint herself as a personal agency to be moved by pity or sympathy into acting miraculously in the petitioner's favor.[41]

The difference seems more than incidental. Kenneth Woodward cites an Italian friar who stated that Vatican Council II (1962–65) discerned among Catholics a shift from devotion to Christ to the invocation of the saints.[42] In fact, Vatican II documents reaffirmed the Council of Trent's counterreformationary endorsement of the veneration of saints and belief in their intercession. Yet the official conciliar statement does express a pastoral and a theological concern:

> Let us teach the faithful, therefore, that the authentic cult of the saints does not consist so much in a multiplicity of external acts [i.e., miracles], but rather in a more intense practice of our love. . . . On the other hand, let the faithful be taught that our communion with these in heaven . . . in no way diminishes the worship of adoration given to God the Father through Christ, in the Spirit; or the contrary, it greatly enriches it.[43]

The final portion of this passage might be read both as an affirmation of Trent's position and as a cautionary insistence on the theocentric focus of devotion to the saints.

JONATHAN EDWARDS
AND THE AESTHETIC OF PIETY

Empathy draws the believer into participation in the sufferings of Christ, Mary, and the saints; sympathy is the force that moves a saint or the Virgin or God to work on a believer's behalf. In each case, the image functions differently. With empathy, broadly speaking, the image helps to establish the occasion for suffering and operates as the material means of identification with the sacred other who suffers. The lives of the saints are crowded with accounts of their intense contemplation of icons, crucifixes, and holy images as meditative means of sharing the agony of Christ or the torment of Mary. In sympathy, by contrast, the image directs the prayer of intercession as well as the prayers of thanksgiving after the believer has received a favor. The image is iconic inasmuch as it acts as a medium of communication. The petitioner who is faced with an impossible situation, for instance, may direct pleas to St. Rita's image in the attempt to rouse her sympathy because she herself faced repeated predicaments that seemed to resist favorable resolution. Neither empathy nor sympathy is monolithic, however; rather, they are constructed historically, as we shall see in turning to Jonathan Edwards's Calvinist version of empathy and the nineteenth-century experience of sympathy in the case of evangelical benevolent causes.

In the Protestant world alternative forms of empathy and sympathy informed attitudes toward images. Not surprisingly, Calvinist Protestants in North America in the late seventeenth and eighteenth centuries regarded the use of Passional imagery of suffering and emotional effusiveness as an idolatrous Catholic practice. In 1746 the Connecticut pastor and theologian Jonathan Edwards wrote a fascinating treatise on the "religious affections," in which he denounced as "imaginary ideas" that misled the believer those images of Christ which some, seized by the ecstatic conversions of the Great Awakening, proclaimed to behold: "Some have had ideas of Christ's hanging on the cross, and his blood running from his wounds; and this they call a spiritual sight of Christ crucified, and the way of salvation by his blood." Such ideas, he insisted, "have nothing in them which is spiritual and divine," but arise from "the weakness of body and mind, and distempers of body," and turn "the divine nature in the soul, into a mere animal."[44] For the pre-Romantic, empiricist Edwards the faculty of the imagination was deeply suspect because it easily produced mental images that bore no truthful relation to actuality, since the imaginary ideas could be mere inventions of a mind

infected by the passions, swayed by the "distempers" of the body. Because he sought both to secure the authenticity of the Great Awakening in New England and to bar from full fellowship those hypocrites who only feigned belief, Edwards rigorously distinguished between religious affections that were divinely inspired and passions that disrupted the mind's control over the body and its unstable fluids.[45] Imaginary ideas that believers proclaimed to be identical with the spiritual Christ could not be trusted, according to Edwards, and were no better than the visual imagery of Roman Catholics, whose abuse of images Calvinists like Edwards closely linked to the imagination:

> The image of Christ, which men conceive in their imaginations, is not in its own nature, of any superior kind to the idea that the papists conceive of Christ, by the beautiful and affecting images of him which they see in their churches (though the way of their receiving the idea may not be so bad); nor are the affections they have, if built primarily on such imaginations, any better than the affections raised in the ignorant people, by the sight of those images, which oftentimes are very great; especially when these images, through the craft of the priests, are made to move, and speak, and weep, and the like.[46]

How could the body be an instrument of grace for American Calvinists when it was seen as the unruly seat of the passions? By applying the psychology of the passions or affections to the experience of religious conversion in order to analyze the signs of authentic and feigned spiritual rebirth, Edwards came to the empiricist conclusion that such signs admitted of no final certainty from a human point of view.[47] The problem with the human imagination was its protean capacity for counterfeiting the effects of grace. The problem was inescapable because the body was understood as a medium of communication, a producer of somatic signs, a delicate system of fluids that are moved by divine and satanic prompting as well as self-prompting. Edwards wrote that no one, not even the most saintly, has the power to determine with certainty who is godly and who is not.

> For though they [the true saints] know experimentally what true religion is, in the internal exercises of it; yet these are what they can neither feel, nor see, in the heart of another. There is nothing in others that comes within their view but outward manifestations and appearances; but the Scripture plainly intimates that this way of judging what is in men by outward appearances, is at best uncertain, and liable to deceit.[48]

Edwards, nonetheless, went on to write over 450 pages of text on distinguishing true from false signs of religion. Although no means could

determine with certainty who was genuine and who was not, the Bible provided important guidelines for corporate use. More important, however, Edwards offered a reaffirmation of Puritan inwardness and argued strongly for the role of introspection and self-examination. If there were no way to secure authenticity communally beyond a shadow of a doubt because each person was locked up within him- or herself, relating to others only through the "outward manifestations and appearances" of bodily signs and actions, still each person could determine the truth or falsity of his or her own personal belief. And experience, particularly as recorded in the biographies of true saints, offered authentic indices by which to recognize genuine spiritual affections in others.[49]

Introspection had always played a central role in later medieval and early modern visual piety. Inner examination remained important for Puritan spirituality in the New World, and for Edwards as well. Despite the obvious difference in the elimination of devotional imagery, however, visual piety for Edwards did not forfeit the important role played by empathy in late medieval piety; indeed, empathy remained an essential ingredient in the contemplative practices of much European and American belief. Contemplation lay at the heart of Edwards's aesthetic of piety, and in it an intense form of empathy in which an almost Neoplatonic desire for the vision of the beloved precluded any form of visual practice.[50] In his *Religious Affections*, Edwards identified twelve signs that he considered less-than-certain indications of either genuine or false affections, and twelve signs that distinguished "truly gracious and holy affections." Of the first set of signs, several deal directly with the body as an inadequate basis for concluding the spiritual authenticity of a person's conversion. Noteworthy of the second set of signs is their relevance to contemplation. In fact, Edwards based the experience of "gracious affections" in the contemplation of "the transcendently excellent and amiable nature of divine things, as they are in themselves; and not any conceived relation they bear to self, or self-interest." The excellence and perfection of God consisted most importantly of God's goodness and free grace, especially manifest for humanity in the gospel of Christ's redemption. Edwards believed that this goodness and grace attracted humans not because of what it offered them, "but as a part of the glory and beauty of God's nature."[51]

Concern for what God offers the believer is selfish. As we saw in chapter 1, Edwards believed that authentic faith was reliably signified by the selfless, disinterested contemplation of God's beauty. The evacuation of the self, what Edwards called "evangelical humiliation" and defined

as "a sense that a Christian has of his own utter insufficiency, despica-bleness, and odiousness," amounted to a variety of self-effacing empa-thy. This was not a projection of the self onto another, but a projection away from personal interest in a self-eclipsing gaze upon the effulgence of deity. The self is dismantled in the face of the divine other and recon-stituted by the experience of conversion. Edwards stressed that one im-portant sign of genuine religious affections was "a change of nature." The true saint receives the Spirit of God and is transformed, promoting a meekness "as appeared in Christ," which will move the Christian to "pity and relieve their fellow creatures, that are poor, indigent and af-flicted."[52] True saints also model tenderness of spirit and express their faith in "Christian practice."

The model for all of these signs was of course Jesus Christ. Thus, the *imitatio Christi* remained central to Edwards's piety inasmuch as iden-tification with Christ followed from the destruction of the self. What dis-tinguished the evangelical form of empathy in Edwards's Calvinist view was the substitution of the protracted conversion experience and a sanc-tification rooted in scriptural study and introspection for the visual piety of images. Consistent with Calvin, Edwards could not give the imagi-nation a central place in his anthropology of the regenerated human be-ing because the imagination was bound to deceive by inverting the proper relation of humanity to its sovereign deity.

Yet Edwards modeled his spirituality on the aesthetic of disinterested contemplation and the aesthetics of taste and never eliminated the visual sensibility from his analysis of the true signs of faith.

> I have shown that spiritual knowledge primarily consists in a taste or relish of the amiableness and beauty of that which is truly good and holy: this holy relish is a thing that discerns and distinguishes between good and evil, be-tween holy and unholy, without being at the trouble of a train of reasoning. As he who has a true relish of external beauty, knows what is beautiful by looking upon it: he stands in no need of a train of reasoning about the pro-portion of the features, in order to determine whether that which he sees be a beautiful countenance or no: he needs nothing, but only the glance of his eye.[53]

According to Edwards, the believer did not see anything in a literal sense. Instead, Edwards used the act of seeing beauty as a metaphor to convey the elements of desire and pleasure that resided in the contemplation of God's inherent goodness. The aesthetic element underscored the inward and personal character of belief, locating the certainty of its reality in the individual believer. This did not mean that Edwards promoted a quietist

Christianity. Indeed, the final sign of spiritual affections and "the best evidence of a saving belief of the truth" was practice. But authentic practice was rooted in the vision of divine perfection; as Edwards put it, "seeing holiness is the main thing that excites, draws and governs all gracious affections."[54] What was it to "see" holiness? It meant to accept on its own terms, for no benefit to oneself, the sovereignty of God. Edwards considered this inward apprehension to be most akin to the aesthetic contemplation of beauty, a judgment of taste that recognizes perfection with an immediacy that makes no recourse to the human "train of reasoning."

SYMPATHY AND BENEVOLENCE IN NINETEENTH-CENTURY AMERICAN PROTESTANTISM

Edwards's notion of disinterestedness found a new degree of intensity is *The Life of David Brainerd* (1749), his biography of a young and largely unsuccessful evangelist to Indians in Massachusetts and western New York. The book was immensely popular among evangelicals in the United States and Great Britain from Edwards's day through the nineteenth century. As Joseph Conforti has noted, the hagiographical account "provided missionaries and other religious reformers with more than ample inspiration and instruction for enduring failure and for transforming it into a personal spiritual triumph."[55] If Brainerd, as we shall see, provided a powerful portrait of the self-sacrificing evangelist, another disciple of Edwards, Samuel Hopkins, developed his teacher's idea of disinterestedness into "a willingness to die and be damned, if necessary," for God.[56] Hopkins rigorously distinguished between disinterested benevolence or "affection" and self-love of any kind. Moreover, self-interest and happiness were always to be relinquished "when inconsistent with the public good, or the greatest good of the whole."[57] The subordination of the self to the good of others in the practice of benevolence advocated by Hopkins and the many Calvinist preachers who followed him has even been compared to the behavior of "medieval mystics" and "the self-effacement of the Jesuit missionaries" by one scholar of Hopkins.[58]

During the late Middle Ages, as we saw, pain served visual piety by identifying the devotee with Jesus; among admirers of Brainerd, pain functioned as a sign of the evangelist's selfless commitment to the cause of mission work and became an index of zeal for many young evangelicals yearning to convert the world's heathen. Brainerd (as did Edwards)

fashioned himself as a kind of modern Paul persevering great hardship and physical and emotional agony, lamenting the frailty of his body, and longing for the sweetness of death. During the final year of his mission efforts he wrote that "death appeared pleasant: so that I was in some measure in a strait between the two [life and death], having a desire to depart."[59] In less consoled moments, which appear quite often in his diary, Brainerd turned the instruments of Calvinist examination upon himself with relentless self-contempt:

> Thursday, September 26 [1745]: Was still much disordered in body, and able to ride but slowly. Continued my journey however. . . . This day, while riding, I was much exercised with a sense of my barrenness; and verily thought there was no creature that had any true grace but what was more spiritual and fruitful than I; I could not think that any of God's children made so poor a hand of living to God as I.[60]

The poetics of representation here is rather complicated. The fervent young evangelist tramping through the American wilderness in search of Indians who would listen to him through a translator is well exercised in the techniques of "evangelical humiliation." Brainerd was a devoted disciple of the Calvinist spirituality of long conversion—that is, a tenacious self-examination extending over rather indeterminate tracts of time, occupied with raising a "concern" for the state of one's soul, seeking conviction of one's sin, penitently beseeching God's mercy, awaiting the signs of rebirth, testing these signs, and continually searching for consolation and refuge in embattled prayer and scriptural study. And all this without ever receiving absolute certainty of personal salvation, locked, as Calvinists were, in the labyrinth of double predestination. Pain and spiritual angst were essential, inescapable ingredients in this piety, and Brainerd actively sought them out in his mission work.

He also documented them in his diary, an act that must strike modern readers uncommitted to Brainerd's spiritual aims as curiously self-obsessed, if not narcissistic, for a man so concerned to overcome selfishness. Or perhaps Brainerd's self-narration was a powerful means of identifying with the sufferings of Paul and Christ and should be seen as the instrument of an iconophobic Calvinist's *imitatio Christi*. Did the diary reconstitute the self after the aspect of Christ? Or did it allow the self to gaze upon the lineaments of its heroic pilgrimage and spiritual refinement? How often did Brainerd reread his diary? Brainerd handed it over to Edwards, had part of the diary published in 1746 (he died in October 1747 of tuberculosis), and worked with Edwards at the very end

of his life to prepare the entire diary for publication. In other words, Brainerd clearly intended to represent himself to others, presumably in the tradition of the evangelical autobiography.

As narcissistic or masochistic as his diary may appear, Brainerd, who was steeped in Edwards's practice of discerning signs of the spiritual affections, believed that the principal sign of a preacher's impact on his audience was the rousing of an affective response. He noted the effects of his sermons on Indians again and again in his journal entries. He observed with satisfaction that a number of old men listening to him one day cried aloud and that "their bitter groans were the most convincing as well as affecting evidence of the reality and depth of their inward anguish."[61] Preaching on the parable of the sower from Matthew 18 one afternoon in the late summer of 1745, Brainerd stressed the need to discern what kind of soil one provided the seed of the Word to grown in. His evocation and manipulation of affect, the rhetorical means of prompting distress and using it both to persuade his audience and as an index of their spiritual state, is all clear from this long but revealing passage:

> There were many tears among them while I was discoursing publicly, but no considerable cry: Yet some were much affected with a few words spoken to them in a powerful manner, which caused the persons to cry out in anguish of soul, although I spoke not a word of terror, but on the contrary, set before them the fullness and all-sufficiency of Christ's merits, and his willingness to serve all that came to him; and thereupon pressed them to come without delay.
> The cry of these was soon heard by others, who, though scattered before, immediately gathered round. I then proceeded in the same strain of Gospel invitation till they were all melted into tears and cries, except two or three; and seemed in the greatest distress to find and secure an interest in the great Redeemer. Some who had but little more than a ruffle made in their passions the day before, seemed now to be deeply affected and wounded at heart: And the concern in general appeared near as prevalent as it was the day before.[62]

The semiotic of anguish that Brainerd prompted and documented in his diary was part of a larger physiognomy of the affections that became essential for evangelical revivalism in the eighteenth and nineteenth centuries. But the idea of becoming "wounded" in the process of listening to a sermon as the beginning of the spiritual path to conversion can surely be traced to late medieval devotional piety and its empathy with Christ's suffering.

Nineteenth-century evangelicals modified the model inherited from Edwards and Brainerd. The American Tract Society, as Conforti has observed, issued thousands of copies of Edwards's *Religious Affections,* but

liberally edited the text both to shorten it and to purge from it passages including, among other things, the disinterested contemplation of divine beauty.[63] Tract Society editions surely found such material as the empathy of disinterestedness recondite and possibly ineffective in motivating voluntary benevolence among American evangelicals. In any case, the empathic pouring out of the self was replaced by the pity of modern benevolence as the principal feeling of evangelicalism among supporters of such benevolent societies as the Tract Society. In other words, sympathy as an affective relation to another, keyed primarily to social status rather than physical health, came to stand in the place of empathy—the visceral identification with Christ's bodily agony or the pain of another person.

Antebellum religious leaders were deeply concerned about maintaining the forces of social cohesion and order that were jeopardized by the disestablishment of religion, the explosive rise of variant Protestantisms, and the influx of non-Protestant immigrants. This concern is reflected in the recurrent praise for sympathy as a social bond originating in Christian family life. While the term *sympathy* was variously defined, definitions tended to be of two kinds: one that stressed a social harmony based on affinity of feeling, and another that promoted a social harmony of unequals. We will examine each here, but focus on the latter as an evangelical displacement of Edwardsean empathy.

As a strategy for resisting the threat of social disorder and the elimination of class structure, the second definition of sympathy clashed with the first when the conservative Calvinist establishment in New England faced off with the new revivalism conducted by Charles Finney (1792–1875). An extended public debate took shape in the 1820s and 1830s between Old School Calvinist clergy, represented by faculty at Princeton, and the pietistic Finney over the suitability of new measures in promoting and conducting revivals, and over the authority of Calvinist theology.[64] Finney's *Lectures on Revivals of Religion* (1835) amounts to a handbook on how successful revivals should be conducted. Finney, a master at group dynamics, described in detail how clergy and church leaders could create circumstances in corporate worship, prayer meetings, and congregational gatherings that would ignite the emotional flames of revival. Indeed, revival itself became for him the basis for all genuine religion. Finney built on the public consequences of affective preaching found in Brainerd's diary, but he dispensed with the protracted preparation for conversion practiced by Edwards, Brainerd, and Hopkins as well as their orthodox followers in Finney's day.[65] Instead,

Finney encouraged leaders of prayer meetings to compel the unconverted to undergo immediate conversion, bypassing the intermediate stages of awakening and conviction. This was to be achieved by means of direct pressure at the meeting. Finney's reliance on the power of social psychology moved him to embrace sympathy as a public sensation of great effectiveness. He described sympathy as a likemindedness or agreement between Christ and the church, but also as a union of God and the revived congregation of believers.[66] Both degrees of sympathy occurred, according to Finney, in public prayer. It was this public, unabashedly emotional experience of sympathetic union in Finney's revivals that bothered his antagonists, for it threatened, as William McLoughlin has argued, to dethrone the Federalist sensibility of the Calvinist clergy in favor of a Jacksonian egalitarianism and pietistic revival.[67]

According to at least one evangelical concern, the American Tract Society, sympathy consisted of two essential aspects, personal piety and social morality, and was not identified primarily with the experience of revivalism. Inappropriate sympathy, for example, was often produced by the excessive passions roused by fiction; the act of reading, consequently, needed to be censored and replaced by evangelical discipline. Hence the campaign against the novel, theater, and dance.[68]

As a matter of personal piety, sympathy informed the idea of friendship with Jesus that emerged as a prevalent christology among many evangelicals. Whereas friendship was barely mentioned by Edwards, the experience of redemption that it framed for nineteenth-century evangelicals accented Christ's tenderness and intimate accessibility.[69] The transmutation of empathy into sympathy is evident in the devotional imagery of Jesus in nineteenth-century American Protestantism. In the American Tract Society's *Family Christian Almanac for 1860*, an article entitled "Sympathy" articulated the christology of friendship as a moderated calisthenics of self-denying identification with Jesus, one in which pain was no longer the positive wherewithal for *imitatio Christi,* but the negative occasion for refuge, for flight to the trusted Friend, the Good Shepherd, who offered reassuring protection and gentle love. "Give me the Man of Sorrows for my friend. I want a friend who has been stricken, smitten of God, and afflicted."[70] Jesus suffered not to offer a meeting point between human pain and divine love, but to take suffering away: he suffered in the place of humanity. Certainly the Savior could empathize with humans because he had suffered, but the purpose of his sympathies was to assuage human discomfort, to commiserate and reassure. In this regard it is surely significant that among the early ad-

vocates of public benevolence were physicians who dedicated themselves to diminishing the physical pain of the poor as public acts of humanitarian sympathy.[71] In an age when physical comfort was becoming the ideal for middle-class life, the willed endurance of pain espoused by empathy was bound to be replaced by the benevolent attitude of sympathy.

The medieval desire to look upon Christ directly, to encounter the Savior face-to-face, may have produced during the thirteenth or fourteenth century an apocryphal letter, attributed to a contemporary of Pontius Pilate, that purported to offer a detailed description of Christ's face.[72] The late medieval Latin document remained of interest to later Christians. It was translated during the nineteenth century and circulated among evangelicals such as the Adventist Joshua Himes, editor of the Millerite newspaper *The Midnight Cry*, which published the letter in full in the summer of 1843. After describing Christ's features, the letter mentioned that while Jesus did not laugh, "so persuasive are his tears, that the whole multitude cannot withhold their [own] tears from joining in sympathy with him."[73] This passage, however, does not occur in any of the several Latin manuscripts of the letter.[74] The introduction of tearful sympathy with Christ may be the interpolation of an evangelical version of the popular cult of sentiment.[75] A once fashionable, now popular pity became in the nineteenth century the means of joining with Christ. Himes was fascinated by the possibility that the description might be authentic because it evoked a concrete image of the figure whom Himes, William Miller, and thousands of other Adventists expected to see return to earth at any moment in 1843.

Most evangelicals in North America did not share this immediate premillennialist expectation. Instead, as the nineteenth century passed, descriptions of their relationship with Jesus were often infused with a longing for a sympathetic, gentle, and tender savior. For instance, sympathy between Jesus and the devout could be likened to the relationship between the "Good Shepherd" and his flock. An item quoted in the *Family Christian Almanac for 1860* described the solitude of the shepherd and his sheep in the Palestinian wilderness and the complete trust the sheep had in their protector:

> How much in all this connection there is of heart, of real personal attachment, is almost inconceivable to us. It is strange how deep the sympathy may become between the higher and the lower being. Alone almost in the desert, the Arab and his horse are one family. Alone in those vast solitudes, with no human being near, the shepherd and the sheep feel a life in common. Differences disappear—the vast interval between man and the brute; the single

point of union is strongly felt. One is the love of the protector, the other the love of the grateful life; and so, between lives so distant, there is woven by night and day, by summer suns and winter frosts, a living network of sympathy. "The shepherd knows his sheep, and is known of them."[76]

If empathy meant identifying oneself with another, seeing in Christ's agony one's very own, then sympathy discerned a likeness between oneself and another—but only a likeness, a resemblance, a correspondence or analogy, with difference preserved, since the shepherd remains in charge of his sheep. While sympathy implied affinity or friendship between two parties, it was friendship with a difference built into the relationship. In *The Young Christian* (1832), a Christian advice book directed to youths, clergyman and tract writer Jacob Abbott explained friendship and the sympathy that characterized it in terms of young children seeking the protection of those older than them: "A protector and friend ought to possess two distinct qualifications, which it is very difficult to find united. He ought to be *our superior both in knowledge and power,* so that we can confide in his protection, and yet he ought to be *in the same circumstances with ourselves,* that he may understand and appreciate our trials and difficulties." The latter feature of the relationship was sympathy. Abbott stressed throughout his treatment of "The Friend" that the only friend able to offer protection is the one who joins power with sympathy. Christ himself was such a friend: "If we choose him for our friend, we may come to him on every occasion, sure of finding not only *sympathy* to feel for us, but *power* to relieve us."[77] Abbott pointed to a variety of examples of proper and improper friends— teachers, older children, parents, a ship captain—to underscore for his young readers the importance of coupling sympathy with power in religious faith and social relations.

In contrast to the effusive nature of empathy, the experience of sympathy for conservative evangelicals was subdued and conducive to middle-class Protestant concepts of domestic and social order.[78] This represents the other dimension of evangelical sympathy that I wish to point out: the social inflection of sympathetic feeling. Sympathy was advocated by the American Tract Society as a way of moving people of all kinds toward religious conversion and the support of universal evangelization. Inequity was the result of bad living and lack of belief. Strong passions —whether unleashed by drink, immigrant disorder, poverty, popular entertainment, or sectarian excess—were understood to take one away from the safety of the family and the domestic setting by being indulged in for their own sake. The promotion of sympathy in Tract Society pub-

lications was inextricably bound up with the task of benevolence, that is, with the evocation of a certain kind of socially coded feeling toward the indigent and lower classes and anyone from the middle class who had fallen from grace through the wiles of drink, gambling, or other social vices zealously denounced by benevolent associations. Condescension was inscribed in the new experience of sympathy, but so was fraternity with fellow members. The task for many supporters of the benevolent associations was an ecumenical merging of common interests for the sake of national unity and purpose, in short: the flourishing of a Christian republic rooted in American democracy.[79] Empathy may have worked for a mendicant like Francis of Assisi, another Christian committed to benevolence, but for antebellum Christians in the United States, sympathy for the underprivileged and unchurched served to reinforce a desired social order. By marking a clear path to and from an evangelically defined respectability, sympathy contributed to the social construction of reality as it was experienced by many.[80]

The management and evocation of the passions was a fundamental part of achieving the desired social order. Appropriate amusement or entertainment was something that the purveyors of evangelical morality spent a good deal of time thinking about. Editors of the *Family Christian Almanac* worried about the harmful influence of gratuitous amusement, what one writer defined as "the pursuit of pleasure for pleasure's sake."[81] Indulgence in such pleasure occurred most alarmingly in theater, dance, and the reading of novels. "All great amusements are dangerous for the Christian life," one announcement trumpeted, quoting Pascal; but none was to be feared more than drama: "It is a representation of the passions, so delicate and natural, that it rouses them in the heart; and the more innocent they are made to appear to innocent minds, the more they are capable of being moved by them."[82] Theater was associated with such social vices of excess as gambling, carousing, and tavern-going, as visualized in a wood engraving published in the *Almanac* in 1841 (fig. 22), an image designed to inspire antipathy, the very opposite of sympathy. Fiction exhibited the same indulgence of the passions. An item in the *Family Christian Almanac for 1863* complained that "so much news-reading, story-reading, and reading for the mere luxury of feeling, as is practised by our people, is about as bad as no reading at all. It is distracting, dissipating, and enervating to the mind."[83] The fact that each of these texts appeared in the *Almanac* in the early 1860s was no accident. The editor during these years was Helen C. Knight (1814–1906), an author of biographies of evangelical heroes,

FIGURE 22. Alexander Anderson, "The Highway to Death," in *Family Christian Almanac* (New York: American Tract Society, 1841), 20.

children's literature, and pious short stories that appeared in both the *Almanac* and *The Child's Paper,* a weekly newspaper for children published by the Tract Society. Although the campaign against secular fiction, theater, and dance had been carried out long before Knight's tenure at the *Family Christian Almanac,* she took up the issue in order to promote her own notion of sympathy.

Rather than stirring the passions, which was considered an inappropriate arousal, the proper task of amusement was "recreation, whose proper end is not self-gratification merely, but the means of gaining greater health, vigor, and usefulness."[84] The passions were to be subdued because their arousal deflected energy from sound health to useless and wasteful expenditure.[85] Instead of indulging in intense feelings such as rage, lust, or fervent romance, the Christian was urged by evangelical moralists to cultivate sympathy, which was consistently configured as a relationship between unequals—as a form of communication and harmony with animals, with the poor, or with domestic servants. Sympathy was also mentioned as the appropriate attitude of the healthy toward the sick or ailing.[86] By arousing the passions, one threatened to abandon the self to forces beyond its control, to consuming acts of pathos, whereas sympathy preserved the self by coupling it with an inferior.

Although the American Tract Society's *Family Christian Almanac*

did stress the importance of sympathy in friendship, it more frequently defined sympathy in terms of a relation with someone or something of lower status.[87] In an article on dealing with one's domestic servants, for instance, Helen Knight counseled homeowners to "believe in a warm, hearty, genuine sympathy between employers and the employed."[88] An article entitled "Washing the Disciples' Feet" similarly contended that there could not be "a symmetrical growth of Christian character without sympathy and intercourse with the poor."[89] Another article urged readers "to cultivate a reasonable intimacy with our dumb fellow-creatures [animals], to know their habits, provide for their wants, possess their sympathy and affection, and feel the mutual dependence there is between them and us."[90] This experience of sympathy helps account for the popular and elite taste for animal imagery in nineteenth-century popular and fine art, as well as sentimental portrayals of children and condescending views of the poor, the non-European, the immigrant—indeed, virtually any subaltern who, not regarded as hostile, became regarded as domesticated, simple, or quaint, that is, worthy of Christian condescension. Accordingly, the *Family Christian Almanac* praised the "living network of sympathy" between the "Arab and his horse," and among the Palestinian shepherd, his flock, and the passing days and nights. The same article went on to formulate the christological significance of sympathy: "Try to feel, by imagining what the lonely Syrian shepherd must feel . . . , and then we have revealed some notion of the love which Jesus meant to represent: that eternal tenderness which bends over us, infinitely lower though we be in nature, and knows the name of each and the trials of each."[91]

The relationship of the Good Shepherd to his flock, admired as the model relation between God and the believer, was characterized as friendship with Christ. This unequal relationship was in turn transposed to the American evangelical's relations with others. Images in the *Almanac* and American Tract Society publications were generally not calculated to incite pathos or evoke an empathic response from the viewer. In fact, Christ was infrequently depicted, and then not in any way that would arouse compassionate pity of the type that a fourteenth-century believer experienced before an image of the tortured Christ. One of the few instances in which Christ appeared in the *Almanac* was in a front-cover rendering of the Sermon on the Mount; here we see him holding forth in a manner that approximated images of evangelical preachers (fig. 23).

A good number of images in the *Almanac,* however, did set out to

FIGURE 23. Alexander Anderson, "Sermon on the Mount," in *Family Christian Almanac* (New York: American Tract Society, 1836), title page.

portray key relationships that exemplified sympathy as evangelical Protestants understood the notion. An engraving of a poor family victimized by the husband/father's drunkenness certainly aroused pity in the viewer, but it was a pity laced with indignation at the slovenly sot who abandons his wife and daughter for the ravages of drink (fig. 24). The picture, in other words, aimed at provoking righteous anger and antipathy rather than evoking empathic identification with those who suffer. The same emotional response seems to have been the intent in the depiction of an ancient Christian family "exposed to wild beasts in the arena" by sadistic Roman emperors "for the amusement of the heathen populace" (fig. 25).[92] The women and children of the family gather beneath the arms of the paterfamilias, who looks upward either in defiance

FIGURE 24. Alexander Anderson, "The Rum-Seller's Victim," in *Family Christian Almanac* (New York: American Tract Society, 1848), 39.

FIGURE 25. Phineas Annin, "A Christian Family Exposed to Wild Beasts in the Arena," wood engraving, in *Family Christian Almanac* (New York: American Tract Society, 1853), 19.

of Caesar or in firm resolve to God. Not a sign of violence is portrayed—the tiger seems held at bay by the authoritative gesture of the father and the grimace of his proud daughter. The fainting women certainly recall the pathos formulae of nineteenth-century academic painting. Yet the caption, which remarks that the family has been thrown into the amphitheater "to be devoured by hungry wild beasts, for the amusement of the heathen populace," seems intended to move the viewer not to a sense of tragedy, but rather to contempt for heathenism and its scorn for the true faith.

Other images in the *Almanac* conjured up a pastoral vision of humanity's harmony with the passing seasons, an agrarian sympathy between landscape and human presence, in which the earth was put to use for the benefit of humankind (fig. 26). It was in the nature of things, by virtue of a benevolent providence, to provide for humanity the sustenance required for a good life, and sympathy was a feature of that nature. Still other images focused on the experience of sympathy in human relations, so forcefully advocated by the authors quoted in the *Almanac*. Several early illustrations in Tract Society publications, for example, pictured what later writers such as Knight may have meant by "sympathy" with the poor. On the cover of an 1834 issue of the *American Tract Magazine* we see a well-dressed woman of the middle or upper middle class handing a book to a farmer, a person beneath her station but worthy of her compassionate effort to save his soul (fig. 27).

Sympathy and empathy, hence, must be carefully distinguished if we are to grasp the essential characteristics of the visual piety of nineteenth-century American evangelicals.[93] Sympathy, as we find it defined in the pages of the *Family Christian Almanac,* did not promote the loss of the self in any kind of emotional extreme; instead it called for the controlled investment of feeling in the spiritual welfare of the less fortunate or those unconvicted of their sinful state. Sympathy avoided pain and suffering as the experience of one's relationship to God because it did not posit an identity between self and deity (as illustrated in figure 17); rather, the configuration of likeness was stressed, an analogy that became complete only when the relation was mapped onto one's relation to the world of others. Implicit in sympathy, therefore, was the construction of an ontological and corresponding social hierarchy that could be expressed thus: God is to me as I, the evangelical, am to the poor, the unconverted, and so forth. This was a significant departure from "I am to Christ as Christ incarnate and suffering is to me." Whereas empathy leveled all barriers between self and other in a kenotic act of identification, sym-

FIGURE 26. "September," in *Family Christian Almanac* (New York: American Tract Society, 1848), 23.

pathy conserved a crucial difference between the two terms of the analogy. As a template for human relations, sympathy constructed the social arena vertically as an expression of one's relation to the Deity.

This is not to suggest that American evangelicals lacked any sense of empathy. There is evidence in the *Almanac* itself that this was not the case. But the experience of empathy to be found there was curiously detached from religious images, invested instead in the aesthetic experience of pictures of the landscape. Like the empathic images of late medieval visual piety, empathic response to the landscape was seen to offer a healing power by engaging the imagination in an act of self-projection. According to Helen Knight, pictures of landscapes, or of events set in landscapes, placed in the room of the sick enhanced convalescence. Consigned to a single space for the duration of illness, the eye sought leave from the dull "sense of sameness and isolation"; "the imagination

FIGURE 27. Alexander Anderson, Woman distributing tract to a farmer, in *American Tract Magazine* (New York: American Tract Society, 1834), cover.

angles in vain for pleasing fantasies" and "all forms of life people the [wall]paper." Faced with the monotony of the sickroom, the imagination sought release into worlds beyond the dreary present. Pictures, in Knight's own experience, provided this release:

> A single Swiss scene hung near our bed, of mountain heights and peasant life in the sunny hollows. Imagination never flagged climbing up its peaks and looking over *on the other side.* Sometimes a peak was Sinai; sometimes Pisgah; sometimes Carmel. Sometimes it was Hannibal, sometimes the storm-met Bonapartistes I saw crossing their passes. Then we sat on the panniers of the peasants, drove the cows to their pasture slopes, or strayed to the little church hid coyly among the trees.[94]

In this empathic experience, the viewer escaped the sickness of the body to enter into the pastoral bliss of the Holy Land, a great general's march,

or the serenity of peasants in a bucolic landscape. Nevertheless, by keeping this experience aesthetic rather than exploring its ethical implications, evangelicals could retain the social architecture of sympathy.

The evangelicals of the American Tract Society were possessed of a generally postmillennial view of the United States as God's millennial agent, a country with the sacred purpose of ushering in the final age of peace and prosperity. Their impulse, therefore, was not to seek well-being by fleeing the present world in empathic acts of self-negation, but to secure in Jesus an accepting refuge when times were difficult and a friendly companion in all one's endeavors. Consequently, their visual piety functioned as a corroboration of the social order, an affirmation of the sympathetic relation or analogy that existed between themselves and God and between themselves and those who were the object of their evangelical practice: children, the lower classes, unbelievers, Catholics, immigrants, and the poor. It was not the face of Jesus they sought, but the sense of an inviolate principle that would give their world its structure and character.

"HOME-SYMPATHY" AND CHRISTIAN NURTURE

Although the importance of benevolence in American Protestantism extends well beyond the nineteenth century, a new definition of sympathy arose at midcentury in connection with a visual culture that deserves consideration here. The emergence of so-called feminine Christianity and the great emphasis placed on the domestic formation of character has been well studied (see chapter 3). Without rehearsing that material, I would like to examine how the new emphasis on domestic formation redefined sympathy and found a particular genre and style of imagery to serve its purpose. In his 1847 book *Christian Nurture,* Horace Bushnell charted out an alternative to the conventional Calvinist understanding of the training and rearing of children. Dismissing the need for "long" conversion stressed by Edwards and his followers in New England, or the "quick" conversion of popular revivals such as those conducted by Finney, Bushnell focused instead on the formative and protracted shaping power of the home and the matrix of feminine influence there on children.[95] Control of the passions and the body remained Bushnell's goal for the work of nurture, but the means shifted from the intellectual stages of awakening, concern, and conviction to the molding of the young child's feelings.[96] Rather than isolating themselves as individual assertions of will, Christians should, he said, develop from infancy throughout their lives as part of an organic whole.

The domestic matrix of formation unified Christian society, providing a sympathy that allowed the development of true fellowship and communication. Children were the key to this achievement because they inherited the genetic disposition of their Christian parents. Character could be effectively molded, "plastic" as it was, and readily susceptible to the "contagion of another spirit." Bushnell therefore accorded greater significance to the material culture and practices of human life such as diet, dress, pictures of Jesus (which he believed shaped character more than the memorization of doctrine could), and games. He urged parents "to show a generous sympathy with the plays of his children," even to the point of temporarily forgetting themselves and entering "into the frolic of their mood with them."[97]

In a long book, *The Christian Home*, first published in 1859 (two years before the revised edition of *Christian Nurture* appeared), Rev. Samuel Phillips dedicated a chapter to "Home-Sympathy," which, like Bushnell, the author considered "an argument against the neglect and abuse of the nursery."[98] Phillips employed the rhetoric of benevolence more than Bushnell did, reflecting the legacy of Edwards's aesthetic of piety. Defining "active sympathy" as the law of adapting and assimilating domestic affections (and "passive sympathy" as the mere feeling of harmony in the home), Phillips located an aesthetic experience in the very heart of home life. In obedience to active sympathy, he contended, "the hearts and interests of the members [of the family] are bound up in beautiful harmony. The necessities of one are supplied by all. It is this which makes the members faithful to each other, and prompts them to deeds of disinterested love."[99] Aesthetics and ethics were indistinguishably intertwined and committed to the formation of character. The feeling of sympathy was thus a morally compelling sensation.

Unmistakable in Phillips's discussion of domestic sympathy was its feminine coding. The experience of disinterestedness praised in the lives of such male "saints" as Brainerd and Edwards was now recognized in the domestic duties of women. Wife and mother were the principal agency of sympathy, indeed, the domestic exemplar of Christ: "The wife will seek the salvation of her husband; the mother will labor with unwearied diligence for the redemption of her children."[100] But if the dominant female in the home was given the greatest spiritual responsibility, disinterestedness was redeployed in the ideology of nurture for the purpose of containing women within the boundaries of the home; for under the influence of sympathy mothers would "deny themselves the ruinous pleasures of a gay and reckless association with the world."

FIGURE 28. "Maternal Influence," in Rev. S. Phillips, *The Christian Home* (New York: Gurdon Bill, 1862), facing p. 50.

Home-sympathy was praised as awakening family members—but especially the mother and wife—to "the most self-denying and benevolent acts." "What mother, prompted by such sympathy, can be recreant to the duties of her household?"[101]

Thus, by the time of the Civil War Calvinst benevolence and Edwardian disinterestedness had been adapted to the domestic sphere of women in the form of sympathy. A striking image of the woman's domestic role in the nurture of the child appears in Phillips's book under the title "Maternal Influence" (fig. 28). Rendered in stipple engraving, a technique favored for its ability to approximate the nuances and light washes of paintings and drawings, the image accents delicacy in the cozy enclosure of the home as, in a moment of tender intimacy, the mother gently brings the child's hands together in prayer. The bare, fleshy legs of the child and the mother's exposed shoulder seem to suggest a corporeal link as well as a tenderness and affectionate relationship that Phillips and Bushnell saw as exerting lifelong influence. Phillips underscored a reli-

gion of the hearth in which family ancestors enjoyed a presence with the living: "Even the dead are with us there; their seats may be empty, and their forms may no longer move before us; but their spirits meet with us, and imprint their ministrations upon our hearts."[102] In the disastrous context of the Civil War, this notion doubtlessly consoled many who suffered through the loss of family members on the battlefield.

As easy as it is to agree with the modern emphasis on nurture and character formation in Bushnell and Phillips (as opposed to the stern-minded tactics of the older Calvinism), the dark side of their ideology is plain to see. Phillips understood sympathy as prescribing the place of women in society, while Bushnell saw in his concept of domestic unity and organic structure a system with larger implications for the social order. Indeed, Bushnell enthusiastically applied the idea of nurture to American imperialism in commerce and the propagation of America's Caucasian stock. "Commerce will go forth hence," he wrote, "to act the preluding of the Christian love, in the universal fellowship of trade."[103] In a paean to American progress, Bushnell equated piety with industry and business and the increase of New England Christianity and its colonization of the world. He did not endorse ambitious proselytism because he considered the conversion of Indians, Muslims, and Jews ill fated: "To make a graceful and complete Christian character . . . requires a Christian childhood in the subject."[104] In other words, one must be born Christian. The better strategy, according to Bushnell, was to outpopulate non-Christians by producing Americans formed in the wombs of pious family life. The seamy side of Romantic organicism is clearly apparent when Bushnell asks: "What if it should be God's plan to people the world with better and finer material?" In similar spirit, he characterized the church as "a spiritual nation . . . founded by a colony from the skies."[105] The strategy for social control of nonbelievers as well as children as prebelievers shifted from rebirth or conversion to what Bushnell called "in-birth" or propagation. Sympathy came to stress association with one's own kind and the gradual extinction of all others. In this strategy of racial attrition, all the Caucasian pictures of Jesus that Bushnell considered superior to memory-work preached his sermon of racial purity and national destiny as loudly as any revivalist's call to conversion.

THE MASCULINITY OF CHRIST

Popular American piety from the second half of the nineteenth century to the first half of the twentieth explored different experiences of Jesus as a male ideal, constructing his ministry and life in terms especially of his appeal to men. Christ's masculinity and its inflection in the relation believers enjoyed with him were not constant, but were defined in different and historically shifting ways. Some viewed Christ as a gentle, effeminate, occasionally even homoerotic friend; others portrayed him as an ethereal, mystical ideal; and still others saw in him a rugged, violent man's man.[1] Despite the apparently discrete nature of each of these characterizations, notions of what Jesus was like and how he might have appeared could embrace the same visual portrayal. Attention in this chapter falls on the important role that conceptions of masculinity have played in modern Protestant visual piety. Of greatest interest to me is the configuration of Christ in an age that came increasingly to hang its certainties and doubts about him on the wobbly nail of gender. What it meant to be a man was a hotly contested terrain that did much to shape visual piety when the multifarious discourse of masculinities was mapped onto the shadowy man from Nazareth.

This chapter will examine the visual conception of Jesus and the treatment of his masculinity. I wish to demonstrate the ambiguities inherent in the use of images to define Christ's masculinity and to show how images have participated in popular theological discourse and piety. In particular, I will explore the ways in which friendship and eroticism were linked in popular piety as a way of defining the believer's relation-

ship with Jesus. We might say that philia, eros, and agape, the three forms of love articulated in ancient Greece (friendship, erotic love, and charity), were configured rather fluidly in nineteenth-century American Christianity. The three intermingled in an experience of Jesus that, in the twentieth century, encountered contemptuous rejection as masculine Christianity moved to reclaim the church from what it considered an inappropriate feminization.

THE IMAGE OF MALE FRIENDSHIP:
JONATHAN AND DAVID

Friendship with Jesus offers an intimacy and privacy that many Christians since the nineteenth century and the rise of Dwight Moody's gentler form of evangelism have found appealing.[2] Informing any number of revivalist and evangelical hymns of the last century (for example, "What a Friend We Have in Jesus," "Savior, Like a Shepherd," and Ira Sankey's "I Am Praying for You") was the experience of Jesus as a tender savior, the comforting principle that mitigated the angry-father Deity of Calvinism and the older revivalism.[3] Although the popular conception of Christ as a friend was rooted in continental pietism, the idea that a personal friendship with Jesus was a refuge against life's difficulties became the major expression of salvation in the second half of the nineteenth century among many American evangelicals. The most apparent place to observe this is in the popular culture of hymns and devotional art.

The difference between the hymns of Isaac Watts and Ira Sankey offers a striking insight into popular christology. In a fascinating analysis of principal themes in the lyrics of each writer, Sandra Sizer found that the relative frequency of "repentance, atonement, damnation, and Jesus as mediator" between a just God and a condemned humanity was ten times greater in hymns published by Watts in the 1707–9 *Hymns and Spiritual Songs* than in Ira Sankey's *Gospel Hymns* of 1895. Conversely, the theme of Jesus as "refuge, guide, helper," and "loving and beloved" occurred about twice as often in Sankey's collection than in Watts's. The theme of God as "creator, holy, powerful" occurred almost twenty times more frequently in Watts than in Sankey, and "grace, salvation" almost four times frequently in Sankey than in Watts.[4] The nineteenth-century christology of friendship stressed the individual character of the believer's relationship with Jesus, often configuring it within the family setting of domestic Christianity and the home altar.[5] One of the most

widely read advocates of domestic Christianity at midcentury was Horace Bushnell, who, as we saw in chapter 2, proposed a theological endorsement of the family as the source and stronghold of religious faith. He urged parents to invite their children into "God's friendship" as the basis for their fellowship with one another and with their parents.[6]

Although family and friendship are two metaphors that seem discrete and irreducible, evangelicals freely mixed them in describing their christology. Helen Knight selected the following quotation, which she entitled "Christ's Friendships," for the 1860 *Family Christian Almanac:*

> Suppose that you to-day should enter into friendship with Christ. He would perceive in you a new object of love; and he would have feelings towards you which have never been excited towards any one else. We see this illustrated in parents of large families, each child exciting a love peculiar to itself. As your face appearing for the first time differs from every other; as your signature appended to the articles and covenants of the church is unlike the hundreds of handwritings on that most interesting record; so the Saviour's love to you will have something personal and special. What experience, then, Christ has had and will have as a friend.[7]

Knight followed this passage with a description of Christ as possessing a "brother's heart," a "father's heart," a "mother's heart," and a "Saviour's heart." Family and domestic piety had become the principal paradigm for understanding the true nature of one's evangelical relationship to Christ as an intimate friend.

But family and friendship were not the only important metaphors. To these a third was added, and likewise often intermixed. Jesus was also the soul's lover, the "Lily of the Valley," according to a hymn included by Ira Sankey in *Gospel Hymns.* The hymn compared Christ to a flower that was a symbol of the beloved in the Song of Solomon (2:1):

> I've found a friend in Jesus, He's everything to me,
> He's the fairest of ten thousand to my soul!
> The "Lily of the Valley," in Him alone I see
> All I need to cleanse and make me fully whole.[8]

Erotic imagery was not uncommon in favorite hymns. The popular hymn "In the Garden" by C. Austen Miles (1912) foregrounded a secret meeting between the soul and the "Son of God" that recalls the uniqueness of the friendship with Christ cited above:

> I come to the garden alone
> While the dew is still on the roses;
> And the voice I hear,

Falling on my ear
The Son of God discloses.

And He walks with me,
And He talks with me,
And He tells me I am His own,
And the joy we share as we tarry there,
None other has ever known.[9]

The erotic character of the evangelical's relationship to Christ was also articulated in popular theological literature, where it was linked explicitly to the idea of friendship. In a book published in 1911, aptly titled *The Friendship of Jesus,* the dean of a Bible school in New York described the spirituality of friendship with Jesus as one of privacy and what by that time would have struck many readers as homoerotic intimacy (for instance, such an advocate of "Muscular Christianity" as Bruce Barton, whom we shall discuss later). Speaking of his relationship with Jesus, Robert Wells Veach portrays Jesus and himself in terms of combined opposites—sweet and strong, brave and gentle—joined in a secluded quiet:

> We walk and work together, for He is ever with me. Apart from His strong sweet spirit I can be neither brave nor gentle. Very often we seek a quiet place; it is a sacred tryst where love meets love with every passion purified. Again, in the wild rush of the busy world where He loves so much to meet with those who toil, we mark off a little circle and talk together. Friendship with Jesus is the true sanctuary of the spirit; here we touch God breast to breast and live anew in His love.[10]

In language that perhaps wishes to emulate the erotic mysticism of Teresa of Avila but comes closer to the fantasies of Emma Bovary, the author seeks to portray friendship as erotic but not sensual, as "love with every passion purified." But the image of touching God "breast to breast" does not seem entirely purged of the sensual. That said, it should be noted that physical affection among male friends was socially acceptable during most of the nineteenth century, with attitudes beginning to change dramatically only in the 1880s and 1890s. As Anthony Rotundo has pointed out, "Men were in many ways freer to express their affectionate feelings than they would be in the twentieth century."[11] The ideal of male friendship could include passionate verbal and even physical expressions of love that, for Victorian men, carried no homoerotic content. "In the absence of a deep cultural anxiety about homosexuality," Rotundo states, "men did not have to worry about the meaning of

those moments of contact" such as sleeping in the same bed.[12] Yet Veach's rhetoric was dated: his image of "breast to breast" was an anachronism for his younger male readers who had responded to the call of Muscular Christianity, a version of later nineteenth-century Christianity in Britain and the United States that stressed the manliness of Christ in order to appeal to men.

An inherent ambivalence moved through popular religious culture: Jesus was mother and father, male and female, friend and lover, even heterosexual and homoerotic. Why? Perhaps since friendship or philia could so easily become eros, thinking of Jesus as one's brother, mother, or father both enriched the idea of friendship with new modes of feeling and affection and helped prevent the transfiguration of friend into lover. Moreover, the experience of surrender to a more powerful force, so characteristic of evangelical conversion, had certain parallels in the authority of parents at home and the romance of falling in love. In other words, the boundaries between friendship, erotic love, and charity were not fixed and distant, but fluid and proximate. As the configuration of husband and wife and parents and children, the family no doubt seemed the best matrix for containing the three forms of love as distinct yet closely related. The ambivalence of the three in popular religious culture may suggest that their intermingling heightened the experience of each as a claim on the believer/lover/friend. In any event, examination of the contested domains of love in evangelical belief illuminates the historical nature of popular christology as it was invested in such cultural forms as images and hymns.

A virtual unification of agape, philia, and eros occurred in the popular treatment of the relationship of Jonathan and David, which in turn was used to understand both friendship with Jesus and friendship among fellow Christians. A blackboard illustration published in 1921, for example, portrays Jonathan and David's friendship as exemplifying the qualities of a "worth while friend" (fig. 29). The image, which uses the amorous symbol of hearts knitted and enchained, cites 1 Samuel 18:1, the verse in which Jonathan was first smitten. As one quality of friendship, the diagram refers to the sacrifice of which Christ spoke in John 15:13—"Greater love has no man than this, that a man lay down his life for his friends"—thus tying the christological notion of friendship to the relationship of Jonathan and David and modeling it as a feature for all Christian friendships.

An engraving of the famous biblical friends, Jonathan and David, produced from a painting by Gustave Doré and used in the American

QUALITIES OF A WORTH WHILE FRIEND.

Constancy.
Matt. 28:20
I Sam. 18:1
Sympathy
Job 6:14

Candour.
Prov. 27:6
Jonathan
David
Service.
Matt. 20:26,27

Sacrifice
John 15:13
Prayer.
Job 42:10

Love.
Prov. 17:17
Geniality.
Prov. 18:24.

"The greatest human blessing is a true friend."

FIGURE 29. Paul E. Holdcraft, "Qualities of a Worth While Friend," in *Outline Chalk Talks* (Indianapolis: Meigs Publishing Co., 1921), 41.

edition of *Cobbin's Commentary on the Bible for Young and Old* (1876), is a case in point (fig. 30).[13] The story of the friendship began when David appeared before Saul, Jonathan's father, after killing Goliath. The smitten Jonathan, whose soul was immediately "knit to the soul of David [whom] he loved as his own soul[,] . . . stripped himself of the robe that was upon him, and gave it to David, and his armor, and even his sword and his bow and girdle" (1 Sam. 18:1, 4). The two "made a covenant" with each other on the basis of their love, which Jonathan consecrated by giving David his clothing. After it became clear to Saul that his son had allied himself with David and surrendered his rightful claim to the throne, he publicly disgraced Jonathan with these words: "You son of a perverse, rebellious woman, do I not know that you have chosen the son of Jesse to your own shame, and to the shame of your mother's nakedness?" (20:30). Jonathan then went to David's hiding place to warn his friend of Saul's wrath. In a manner that no doubt recalled to evangelicals Christ's soteriological act, the friendly son inserted himself in the place of the angry father. The two friends "kissed one another, and wept with one another, until David recovered himself" (20:41).

Doré pictured the two friends in a secluded gardenlike space (not unlike the secret meeting in "In the Garden"), one friend comforting the other with an intimate embrace. How do we known which figure is David and which Jonathan? The biblical text indicates that David bowed to Jonathan when the latter came to see him (20:41), so the seated figure may represent David. One popular commentator wrote that Jonathan loved his friend "with the tenderness of a woman" (note Jonathan's

FIGURE 30. Gustave Doré, *David and Jonathan*, engraving, in Rev. Ingram Cobbin, *Cobbin's Commentary on the Bible for Young and Old*, ed. E. J. Goodspeed, vol. 1 (New York: Selmar Press, 1876), facing p. 329. Courtesy of Dover Publications.

hand beneath David's hair).[14] In fact, David later lamented his friend's death in battle with this verse: "I am distressed for you, my brother Jonathan; very pleasant have you been to me; your love to me was wonderful, passing the love of women" (2 Sam. 1:26). Doré's contrast between David's rustic clothing and Jonathan's finery, including the dagger at which their hands meet, recalls their first encounter. Rev. Cobbin's *Commentary* explained Jonathan's removal of his clothing as an attempt to make David, who had been dressed as a shepherd, "fit to appear among the people of [Saul's] court."[15] Yet this was an interpolation in no way justified by the biblical text, which stated that Jonathan's act was a personal seal of the covenant that Jonathan made with David: "because he loved him as his own soul" (1 Sam. 18:3).

Anxieties about male relationships rose following the Civil War as homosexuality became legally and medically defined as a perverse disorder and was increasingly prosecuted as a criminal act. Homosexuality attracted the attention of psychologists, and gay populations and male

brothels in larger cities became the object of popular contempt in jokes, cartoons, journalistic accounts, and moral reform.[16] This new consciousness among middle-class Americans was intensified by feminists who, laboring for women's equality, redefined the traditional image of women in American society. The "New Woman," as she was called, challenged older notions of the subservient Victorian woman who was urged to accept her proper place as being in the home. The New Woman embraced a much more public life of political and benevolent activities, attended college, and enjoyed a professional career, notably even forgoing marriage and investing in important friendships with women companions. Visually broadcasting this shift, advertising and women's fashions celebrated the new image, most noticeably by appropriating men's apparel and abandoning such restrictive dress as the Victorian corset. As Betty DeBerg has pointed out, the departure of the New Woman "from the private sphere to the public realm constituted yet another significant threat to American masculinity and became the cause of a great alarm."[17]

The theme of Jonathan and David's friendship was widely invoked by advocates of male friendship among schoolboys and young men, but it was also hailed as exemplary by Oscar Wilde and J. A. Symonds in honor of Platonic friendship as well as in justification of homoerotic love.[18] As legal and medical concepts of homosexuality became established and Muscular Christianity was embraced by evangelicals on both sides of the Atlantic, the iconography of the biblical friendship began to change. Earlier in the century the friendship was portrayed in the visual terms of Romanticism. For instance, in a drawing by John Chapman, engraved by Joseph Adams for the monumental *Illuminated Bible* (1843–46; fig. 31), the intimacy of the friendship is suggested by the placement of one figure's right leg within the receptive spread of the other figure's legs. Although the relationship seems free of anything sensual, it is fascinating that the image offers no indisputable clue about the identity of each person. The figure on the left wears breast armor, leading us to wonder if this is Jonathan, who was doomed to die in battle and who was practicing archery as a pretext for his clandestine visit to David's hiding place. Or is the armored figure David, future king, slayer of Goliath, and recipient of Jonathan's gift of armor? The only hint may be the submission of one figure to the other, since the armored figure, whom we might read as David, lays his head against the other's head.

Doré's image departed from an older, classicizing academic practice still evident in Chapman's drawing, and pursued an orientalizing

FIGURE 31. John Chapman, engraved by Joseph
Adams, "David and Jonathan," in *The Illuminated
Bible* (New York: Harper Bros., 1843–46).

Romantic idiom that stressed exoticism and refined theatricality. The
delicacy of the friendship in Chapman's illustration and the sensual am-
biguity of Doré's image clearly differ from James Tissot's depiction of
the subject in the 1890s (fig. 32).[19] Tissot portrayed the pair of friends
embracing in a tent after David's victory over Goliath. Again, the iden-
tity of each figure is ambivalent. Is David dressed in the armor Jonathan
gave him? Or is David the meek lad who is about to receive Jonathan's
gift? The two form a coupled set of antitheses: the bearded, helmeted
figure embraces the beardless one, who is hatless, shorter, and slighter
in build. The taller figure stands rather precariously between the legs of
his less masculine friend, perhaps suggesting a certain discomfort. The
two friends gaze intently into each other's eyes, sharing an intimacy, per-
haps even a secret, that contrasts markedly with the noise and celebra-
tion of those about them. The account of the relationship in *The Young
Folks Bible* (1925), in which Tissot's image later appeared, presented
the friendship as a model of generosity and selflessness. The editor of the
children's Bible commented of Jonathan's submission to David's king-
ship: "Wasn't that generous of Jonathan?"[20]

The contrast between Tissot's image and Doré's is telling. Tissot configured the friendship as the submission of a weaker, effeminate partner to a ruggedly masculine one. Doré had shown David in the inferior position, enjoying Jonathan's delicate gesture of consolation. The effeminate image was replaced by the sharper distinction of masculinities in

FIGURE 32. James Tissot, *The Friendship of Jonathan and David*, in *The Young Folks Bible*, ed. Jennie Ellis Burdick (New York: University Society, 1925), 25.

FIGURE 33. Gustave
Doré, *Saul Attempts the
Life of David*, in *The Doré
Bible Illustrations* (New
York: Dover, 1974), 76.
Courtesy of Dover
Publications.

Tissot, even if the identity of each remains indeterminate. In depicting
Saul's attempt on David's life (1 Sam. 18:11), Doré blurred the raging
king's gender as if to show him as a jealous lover about to slay the ob-
ject of his (or her) obsession (fig. 33). Doré's decadent pageantry, Tissot's
this-worldly but uneasy masculinity, and the Romantic sublimation of
desire in the cult of friendship each represent a different way of config-
uring the three kinds of love. Although each of these formulations was
crafted within the fine-art tradition of Europe, they were deployed as
commercial products in the popular marketplace of American Chris-
tianity.[21] These depictions of biblical friendship found a place in the vi-
sual culture of American belief because they were received within the ma-
trix of the popular christology of friendship and the domestic practice of
Christianity. These circumstances intermingled (homo)erotic love with
the selfless love of charity and the love of one's friend, varying in accor-
dance with gender and the politics of popular revival, as we shall see.

The image of Jonathan and David as conjured by Tissot, and particularly the avid use of Tissot's work among American religious publications, reflects the late-nineteenth-century emphasis on virility and a belief in the necessity of physical culture for the successful formation of male character. But as the twentieth century opened, the lingering ambivalence of identities in the biblical story of David and Jonathan's friendship was eliminated. Two Sunday-school lesson picture cards produced in the Midwest display the figures' gradual resolution. In figure 34, produced in 1895 by a firm in Chicago, the pair's identities are still unclear. The boy who came with Jonathan to collect his arrows is seen to the right returning home, toting his master's weapons like an errant cupid. Once again, we assume that David is the figure who, resting his head against the chest of the other man, submits to sorrow at leaving his beloved friend. But we cannot be sure. The royal clothing of the taller figure may signify Jonathan's princely status, but it might also refer to David's royal destiny. Nothing from the lesson outline on the back side of the card offers assistance in decoding the identity of the figures. The caption on the front of the card, "Jesus is our truest friend," may do more to suggest the allegorical identity of the figure in the purple robe: this is Christ, true friend of the sinner, comfort to those who come to him.

The depiction of the friendship produced in 1902 (fig. 35) resolves any uncertainty by placing the bow and arrows on Jonathan, in sharp contrast to the biblical text, which states that he gave them to the boy to take home in order that the two friends might be left secretly alone. In this image the boy has been left out, and he is not mentioned in the lesson outline on the verso of the card. Jonathan is older, fully bearded, armed, and protective, his arm slung over the younger man's shoulder. There is now an unmistakable delineation of dominant and submissive roles. In fact, the image is less one of friendship between equals than of a paternal relationship or one between an older brother and his younger sibling. David is indisputably younger than Jonathan, in both stature and facial features. While these differences are not new, they were never before used so unambiguously.

The Muscular Christianity that arose in Britain and the United States in the 1880s posited as its chief concern the security of a manly experience of the Christian faith. In the United States the discourse on rugged masculinity was tied by such a prominent advocate as Theodore Roosevelt to national success and imperialist dominance in the world. But the patriotic concern for national dominance was not new among

DAVID AND JONATHAN.

Dec. 15.——1 Sam. 20: 32-42.

GOLDEN TEXT.—There is a friend that sticketh closer than a brother.—Prov. 18: 24.

TRUTH.—Jesus is our truest friend.

FIGURE 34. *David and Jonathan,* Lesson Picture Card, 1895, color lithograph, 4 × 2 7/8 inches. David C. Cook Publishing Co., Elgin and Chicago, Illinois. Courtesy of the Billy Graham Center Museum.

FIGURE 35. *Friendship of David and Jonathan,* Christian Picture Lesson, copyright 1902, color lithograph, 4 × 2 7/8 inches. Christian Publishing Co., St. Louis, Missouri. Courtesy of the Billy Graham Center Museum.

COPYRIGHTED 1902 BY PROVIDENCE LITHOGRAPH CO.

FRIENDSHIP OF DAVID AND JONATHAN

I Sam. 20:30-42.

GOLDEN TEXT:—A friend loveth at all times, and a brother is born for adversity.

Prov. 17:17.

American Christians. Horace Bushnell had insisted in *Christian Nurture* (1847; rev., 1861) that religion "never thoroughly penetrates life, till it becomes domestic. Like that patriotic fire which makes a nation invincible, it never burns with inextinguishable devotion till it burns at the hearth."[22] As we saw in the last chapter, Bushnell argued that nurture in the family was a means of grace that would eventually transform the world by populating the nations with Christians. Bushnell expressed the need to draw the wagons around the family hearth in order to safeguard the Anglo-Saxon stock as the basis of national religious identity and its global proliferation. By the end of the century, Teddy Roosevelt and others conceived of attaining dominance by very different means. Instead of domestic nurture, Roosevelt stressed the importance of strenuous activity outside the mother's domestic domain: "If we stand idly by, . . . if we shrink from the hard contest where men must win at hazard of their lives and at risk of all they hold dear, then the stronger and bolder peoples will pass us by, and will win for themselves the domination of the world."[23] The social order was characterized as intensely competitive, with the male role properly formed in strenuous competition such as sports. What separated Bushnell's text and Roosevelt's speech of 1899 was of course the Civil War and the postbellum explosion of industry, unprecedented urbanization, the shift from an economy of production to one of mass consumption, and the formation of dynastic wealth among the so-called captains of industry, an appellation that carries the residue of the Civil War and its masculinization of values.[24] Yet the quest for racial dominance in Bushnell remained in force for Roosevelt, who yoked it to his masculinist gospel of the strenuous life. As Gail Bederman has shown, Roosevelt "yearned to be the virile leader of a manly race and to inspire his race [of white men] to wage an international battle for racial supremacy."[25] The prize for which men competed was not simply manhood, but American Caucasian manhood.

Following the war, journalists and popular writers portrayed the close of the American frontier and the final conquest of Indian nations in the western territories as acts of virile courage and heroism that bonded Anglo military men one to the other. This brand of man was sharply contrasted to eastern effeminates, on the one hand, and Indian "savages," on the other. John F. Finerty (1846–1908), a Chicago-based journalist sent to the Black Hills by his editor in 1876 to cover the Sioux uprising, wrote regular accounts for his paper, which he later gathered together into a single narrative. Finerty was enamored of military men and peppered his account with heroic descriptions and allusions. "Custer," we are told, "at

the head of his three hundred died like Leonides at Thermopylae." Finerty also likened Custer to Samson and a Napoleonic general.[26] Numerous individual portraits of officers conveyed Finerty's admiration for their gallant manliness: "Captain Van Vliet . . . was tall, thin, and good-looking," and "[General] Mackenzie was then a noble specimen of the beau sabreur—tall, well built, and with a frank, handsome face."[27] A distinct nostalgia runs throughout Finerty's text that suggests an elegiac pining for former days of male virtue and battle-tested fraternity.[28]

In effect, the violence and massive destruction of the Civil War and the valorization of an increasingly jingoistic ideal of masculinity (codified in Finerty's and others' historical accounts and in the emergent literary genre of the western) proved the failure of Bushnell's naive optimism, suggesting that American dominance would not come through the slow process of Anglo-Saxon proliferation but only under storm—in the same manner that the Union had defeated the rebellious South: in the physical struggle of military conquest or its symbolic equivalent. As Finerty put it: "God and the United States hate non-combatants."[29] In the place of Bushnell's genetic diffusion, Roosevelt called for the formation of young men through the regimen of physical competition and the practices of rugged manliness. Boys and young men needed to hunt, play sports, and join the military to become men. The world would be manhandled and dominated by the work of one's own hands rather than pampered by the nurturing organism of the family.

THE CHRISTOLOGY OF FRIENDSHIP
AND TWENTIETH-CENTURY VISUAL PIETY

Friendship with Jesus in twentieth-century Protestant piety was likewise private, passionate, and sexually contested. The manly authority of Jesus was promoted for a young and popular twentieth-century audience by two Chicago-based authors who took interest in visual depictions of Christ, Dr. R. Warren Conant and Bruce Barton. Although he did not include a portrait of Jesus in his book *The Virility of Christ: A New View,* Conant dedicated an entire chapter to Christ's physical appearance. Conant despised the manner in which artists had portrayed Jesus: "Hardfisted men who are used to giving and taking hard knocks," he insisted, " . . . are not likely to be impressed or attracted by a feminine Christ."[30] Conant's book was a self-styled advice book for preachers, teachers, and enterprising young Christian men who wished to become more effective in leadership and rhetorical power. Character and personality were the

key, and communicating Christ's character and person was the only way to achieve the masculine renewal of the church: "There is a grand opportunity awaiting the preacher who will portray adequately to his congregation that neglected side of Christ's personality; he will see that rarest of sights in these days—his pews filling up with *men*."[31]

Conant briefly reviewed the history of visual depictions of Christ and concluded that the "monkish Christ" of medieval art led to the extreme reaction of effeminate portrayals of Jesus that had dominated art ever since. The overall result was a surprisingly simple method of representation: "Artists subjoin a silky, curly beard to a woman's face and hair and label it 'The Christ.'" Conant argued that the influence Christ enjoyed over his contemporaries "he never would have won with a weak, womanish face. Contact with him as with every strong soul was a touchstone of character." Lacking any authentic visual document of Christ's appearance, Conant was convinced that Christ's features could be deduced from the testimony of his contemporaries regarding his "character." He was amazed that throughout the history of Christian art no one had ever visualized "the Son of Man as he must in the very nature of the case have appeared to his contemporaries." So certain of the character of Christ were Conant and those who sought to remasculinize the church that they seemed to know just what he would look like. "From his character we know that his face was neither smooth nor vacant but lined and stamped . . . by the strong lines of thought and thoughtfulness; of patiently endured toil, hardship, and obloquy; of courage, serenity, and self-reliance." Conant rebuked the judgment of early patristic writers who concluded that Christ was "short of stature and homely" based on the supposedly prophetic description of the Messiah by Isaiah as possessing "no form or comeliness." He longed for an artist to "catch the inspiration" and portray Christ as he felt the New Testament clearly portrayed him, and at the same time dismissed all previous portraiture of Jesus as "merely a reflex of the artist's fancy, or of religious and economic conditions."[32] Actually matching an image to this character, however, was the accomplishment of Bruce Barton.

If late nineteenth-century treatments of Christ displayed ambiguity regarding his masculinity, Bruce Barton did not. He opened his 1914 manifesto on Christian virility, *A Young Man's Jesus,* with this line: "It is time for those of us who are this side of thirty-five to unite and take back our Jesus."[33] Barton targeted what was, in his mind, the Victorian image of Jesus as withdrawn and neurasthenic. He deplored the popular depictions in art and hymnody and mustered countless one-liners in the attempt to rally a social uprising: "We have looked on unprotestingly

while painters have made Him soft-faced, and effeminate; and hymn-writers have written of His sufferings as though that were all in His life worth writing about." Barton argued that Jesus belonged to those beneath the age of thirty-five "in a special sense" because "He had our bounding pulses, our hot desires." Blaming the feminization of Christianity with the loss of this identity, Barton urged (male) readers to recover it by reversing the ill effects of their religious training:

> The trouble starts in the Sunday schools. Who of us does not remember the fine thrill of appreciation with which he welcomed Samson into his list of heroes—and David? They were regular men's men: we knew how they felt and what they struggled against. When they killed a lion or a giant, or wiped out an army, they had our admiration, every bit of it. They were real flesh and blood me and we liked them.[34]

Compared to David and Samson, Barton complained, "Jesus seemed hardly more than the shadow of a man." The avenue of access to Christ nurtured by what Barton imagined were thoughtful, refined, sentimental people misled by women teachers needed to be replaced by the cult of machismo and manly identity. Protestant liberals could embrace a christology of friendship, but it must be one that conveyed Christ's courageous compassion. As one Social Gospel advocate put it, "God has grown in our thinking from a giant who makes worlds to a heart that suffers with ours, a soul that seeks ours, a being who is man's friend, and who cannot be satisfied until all humanity is embraced in that friendship."[35] This was not an evangelical christology of friendship, which stressed human dependence on the redemptive Friend. The friendship with Christ that Barton hailed was the backslapping, vigorous male bonding promoted by Teddy Roosevelt and exemplified in the physical culture and military values of the later nineteenth century. Barton and other liberals could identify with Jesus only if he conformed to the masculine ideal of a rugged hero. Barton's assimilation of Christ to the cult of virility was complete: "We are His age: we know Him: He is ours."[36] To provide a visual counterexample to Sunday school images of Jesus, Barton included a frontispiece in his book; entitled "The Master" and painted by Darius Cobb, the portrait of Christ confronts the viewer with his stare (fig. 36).[37] Recalling such looming heads as Washington Allston's Daniel or Michelangelo's Moses, the heavy brow, piercing eyes, and full beard attempt to summon grand authority and masculine power to the task of proclaiming Christ's unambiguous machismo and appeal to the self-proclaimed fraternity of young men.

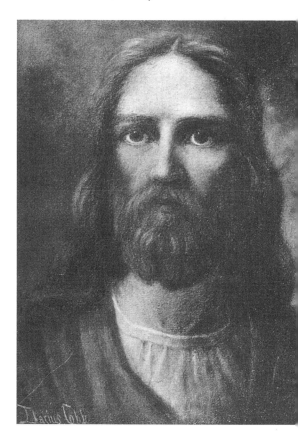

FIGURE 36. Darius Cobb, *The Master*, 1914; in Bruce Barton, *A Young Man's Christ* (Boston: Pilgrim Press, 1914), frontispiece.

The identical tone and subject occupied Barton in his best-selling and much better known book of ten years later, *The Man Nobody Knows*. Once again, Barton faulted artists for perverse, misleading images of the Savior, whom Barton now portrayed as an executive authority, magisterial salesman, and accomplished advertiser. Although Barton did not begrudge Mary her importance, he saw a telling symptom in her fame: "With the glorification of Mary, there has been an almost complete neglect of Joseph. The same theology which has painted the son as soft and gentle to the point of weakness, has exalted the feminine influence in its worship, and denied any large place to the masculine."[38] Barton objected to what he considered the typical representation of Jesus as a delicate "lamb of God": "A physical weakling! Where did they get that idea? Jesus pushed a plane and swung an adze; he was a successful carpenter. He slept out doors and spent his days walking around his favorite lake. His

FIGURE 37. Warner Sallman, *Christ Our Pilot*,
1950, oil on canvas, 40 × 30 inches. Courtesy of
Jessie C. Wilson Galleries, Anderson University.

muscles were so strong that when he drove the money-changers out, no-
body dared to oppose him!"[39] The feminine influence of the mother
needed to be displaced by the physical culture and strenuous life of
young men. Barton and many of his contemporaries mapped their own
desires over the Scriptures in order to find there authorization for the so-
cial changes they sought to effect in the contemporary world.[40]

The subtext of male bonding in Barton's popular books and in Tissot's
Jonathan and David (see fig. 32) appears once again in Sallman's *Christ
Our Pilot* (1950; fig. 37), where a privileged relationship exists between

an older and a younger male. Like the hymn it seems to illustrate ("Jesus, Savior, Pilot Me"), Sallman's picture envisions Christ piloting the faithful lad "over life's tempestuous sea." Yet no reference is made to the maternal element in the hymn: "As a mother stills her child, / Thou canst hush the ocean wild; / Boistrous waves obey Thy will, / When Thou say'st to them, 'Be Still!'"[41] Instead, Sallman's picture stresses the masculine character of the relation: a male bonding between the monumental Jesus and the tight-shirted young sailor. In the postwar period of the 1940s and 1950s, Sallman and his appreciative public were probably concerned to find in this and other images talismans that addressed the problem of securing adolescent males within the community of faith by conducting them through crucial rites of passage. Evangelical efforts to lodge youths (particularly young men) within the church occupied church leaders and showed up frequently in the media. Male Christian athletic and boys clubs were especially popular. Images from this time reveal the important task of male bonding: Sallman's *Head of Christ* oversaw YMCA induction rituals, and athletic activities at the YMCA situated young men and boys under the tutelage and authority of clergy and church leaders (fig. 38).[42]

But Sallman's work no longer treated the formation of male character in terms of rigorous competition and jingoistic masculinity. The task for *Christ Our Pilot* to perform as a gift to a young man consisted of visualizing his proper relationship with God and serving as a marker in the passage from youth to young adulthood. The image commemorated and therefore preserved the relationship between the gift giver and the young male despite the transit from a lower age and social status to a superior one. In images such as *Christ Our Pilot* and *Teach Me Thy Way* (fig. 39) Jesus befriends boys and young men in order to guide them or to teach them about his Father. Sallman never portrayed God the Father in his paintings, stressing instead the benevolent Son, everyone's Friend. The christology of friendship represented Jesus as the focal point of a devotion that understood the believer's relationship to the distant or invisible Father as mediated through the intercessory Son. In effect, the friendship of Jesus and his visualization in Sallman's devotional images have accomplished for many Protestants what Mary and her votive images (as well as those of other saints, male and female) have done for Roman Catholics: mitigate the wrath of God and ensure his benevolent presence in one's daily life. Although Protestants have insisted on representing this intercessory relationship in the singular, male figure of Jesus, his depiction in many images with softened, gentle, quiet features—so offensive to those who insist on his brute masculinity—is likely an attempt to imbue

FIGURE 38. *Top:* YMCA induction ceremony; *bottom:* YMCA Leadership, Davenport, Iowa. From unidentified Sunday newspaper magazine, 1950s.

a Protestant Savior with maternal, feminine characteristics suitable for a benevolent intercessor. When the categories of male and female are blurred, homophobic viewers associate the image with gay sexuality.

In fact, Sallman's *Head of Christ* has evoked a stark divergence of response. The same face has inspired diametrically opposite reactions among viewers. One writer, for instance, responded to a query about the

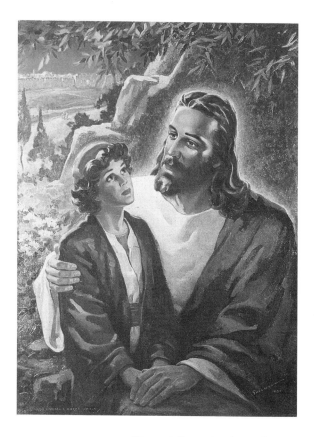

FIGURE 39. Warner Sallman, *Teach Me Thy Way,*
1951, oil on canvas, 40 × 30 inches. Courtesy of
Jessie C. Wilson Galleries, Anderson University.

image with a story told to him by a local clergyman who claimed that the
image could not be placed in the church building because it was "too
much of a come-on for the homos in the parish and the community"
(331). By contrast, a tradition of reception among conservative Christians
has seen the *Head of Christ* as a distinctly "manly" portrayal of Jesus. In
1943 the Methodist preacher T. Otto Nall quoted Sallman as stating his
intention thus: "I wanted to make my crayons picture a virile Christ for
these rough days."[43] Another writer speculated in the same year, when the
image had already been distributed to millions of American GIs, that the
picture had gained widespread acceptance because all of Sallman's de-
pictions of Christ "are uniform in one respect—in emphasizing the 'hu-

manness' of the character. As a Sallman devotee once said, 'He makes Christ a He-Man—not soft and effeminate.' This factor, above all others, has contributed to the success of his work."[44] Here the very humanness of Christ was identified with his virility. Otto Nall observed that "all types of people, many of them not professing Christians, have been attracted by the high brow, searching eyes, firm lips, forceful chin of the Sallman head. There is something in all of us that seeks out its strong manliness."[45]

Sallman recalled in the early 1940s, after the early success of the *Head of Christ,* that he had received initial encouragement for his vocation as a Christian artist and for his future project of depicting Jesus from a faculty member of Chicago's Moody Bible Institute, E. O. Sellers. In an unpublished biography of Sallman, Jack R. Lundbom dates the conversation with Sellers to 1914.[46] The date remains unspecified, however, in the frequently published and variant accounts that appeared from 1943 on.[47] The fullest version was published in 1947 by a friend of Sallman's:

> One Saturday afternoon [Sallman] was called into the dean's office where the conversation went something like this:
> "I understand that you're an artist, Sallman, and I'm interested in knowing why you are attending the institute."
> "Well, I'm here because I wanted to increase my knowledge of the Scriptures. I want to be an illustrator of biblical subjects."
> "Fine! There is great need for Christian artists. Sometime I hope you give us your conception of Christ. And I hope it's a manly one. Most of our pictures today are too effeminate."
> "You mean to say you think Jesus was a more rugged type? More of a man's man?"
> "Yes, according to the way I read my Bible. We know he walked great distances and slept out under the stars; he was rugged and strong. He preached in the desert, so he must have been tanned. More than that, the Word says he set his face 'like a flint' to go down to Jerusalem, so he wasn't soft or flabby. We need a picture of that kind of Christ, Sallman, and I hope you will do it some day."[48]

Another version of the story added that Jesus was "the Man who drove the moneychangers from the Temple, and faced Calvary unafraid and triumphant."[49] The account suggests that Sallman's destiny was to respond to the need for an authentic depiction of Jesus who had suffered emasculation at the hands of artists. The account resembles a treatment of Jesus that appeared that same year in *The Man Nobody Knows.* Barton, like Conant before him, repeatedly complained of the inadequacy of artistic depictions of Christ. Almost all painters, he stated, "have misled us" on the appearance of Jesus. "They have shown us a

frail man, under-muscled, with a soft face—a woman's face covered by a beard—and a benign but baffled look."[50] Barton identified a problem that Sallman, whether or not he was familiar with Barton's or Conant's books, came to consider his mission as a Christian artist to solve. In the popular accounts of the history of the *Head of Christ*, Sallman's conversation with Sellers at Moody is presented as his warrant and call.[51]

Ironically, the popular discourse on Jesus' virility was eventually turned against Sallman's picture. While many have considered the virility of Sallman's Christ to be the measure of its authenticity, others have found the image unacceptably effeminate, what one Lutheran seminary professor, echoing Conant and Barton, denounced as "a pretty picture of a woman with a curling beard who has just come from the beauty parlor with a Halo shampoo . . . [not] the Lord who died and rose again!"[52] How shall we account for this dramatic change in Jesus—from he-man to cross-dresser? Historical analysis of the reception of Sallman's image during the 1940s and 1950s should compare the positive and negative response to the picture with the conflicting conceptions of Jesus Christ as the historical figure and personal Savior of evangelical Christianity. Disagreement centered on the masculinity of Sallman's Jesus; in some instances, as we have seen, even his gender was called into question. By the same token, many Christians embraced it because their personal Savior, while necessarily masculine, was nevertheless a Jesus befriended in the personal relationship, indeed, in the private walk "in the garden" of one's faith-life, where "He walks with me, and He talks with me, and He tells me I am his own." The hardiness and virility that many have claimed to see in Sallman's Christ may be a psychological construction necessary to allow for a feminine, nurturing relationship with Jesus that conceives of salvation not in the angry terms of traditional Calvinist atonement, but as the persistent and faithful love of a friend.[53] This God offers guidance and friendship, not judgment and retribution, as the motive for belief.[54] The principal appeal of this Jesus was consolation in an untrustworthy and brutal world, as the words of a popular hymn by the evangelical composer George Stebbins suggest: "Closer yet, O Lord, my Rock, Refuge of My Soul; / Dread I not the tempest-shock, Tho' the billows roll. / Wildest storm cannot alarm, For to me, can come no harm, Leaning on Thy loving arm; / Closer, Lord, to Thee."[55]

While some might define masculinity in terms of paternal gentleness and consider the determined look of the *Head of Christ* to signify the figure's divinity, most admirers of Sallman's picture seem to view it through an ideological filter that predisposes them to see what they want to see.

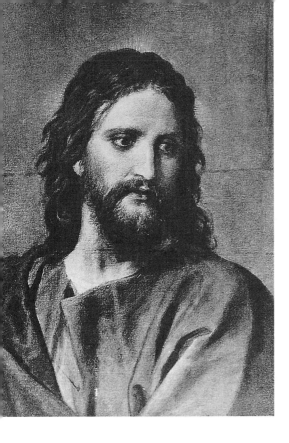

FIGURE 40. Heinrich Hofmann, *Head of Christ,* detail from *Jesus and the Rich Young Man,* 1889, oil on canvas. Riverside Church, New York City.

Consider a 1948 article in the evangelical weekly *Christian Life* entitled "Did Christ Look Like This?" The author illustrated the article with Sallman's *Head of Christ* and a head of Jesus by Heinrich Hofmann (fig. 40) that was often excerpted from Hofmann's large painting *Jesus and the Rich Young Man* (1889). "Hoffman [*sic*]," she wrote, "in another day portrayed Christ as an appealing, almost feminine character. In contrast, Warner Sallman, a contemporary, has drawn from the scripture 'He set his face like a flint to go down to Jerusalem' a firm, more masculine figure."[56] While it is true that use of Hofmann's image belonged to an earlier generation in the visual culture of American piety, it is difficult to see the difference that this author discerns.[57] But she was writing within twentieth-century conservative Protestantism's discourse of Christ's virility, which derived from the earlier fundamentalist concern to secure Christianity from the dominance of women.[58] In this preoccupation with virility, visual evidence could take secondary importance. The article in *Christian Life* blissfully ignored the appearance of both pictures, indeed, their striking likeness to one another, because of the

need to posit an *other*, a feminine opposite that would be used to define the masculine. Since the visual evidence was lacking, the discourse moved to provide the appropriate polarity. The image conformed to its description, rather than the reverse.

The discourse about virility appropriates images to itself, assimilates them such that one sees what one is told to see, what is ideologically significant. Although the discourse may claim that its representation of reality is unadulterated, even authorized by divine revelation—as in the case of a late-night dream that Sallman reported was the source of his image[59]—such representation is of course ideologically engaged. In fact, one wonders whether popular religious art is not as a rule premised on discourse that precedes it and predisposes its reception. Many popular images operate in tandem with an oral culture or printed text: devotional literature, Bible passages, hymns, prayers, and teaching guides. To see discursively is to see what discourse has prepared one to recognize as true. In this case the likeness of Christ—his femininity or his masculinity—is defined discursively. Word and image intermingle in the social construction of appearance. Likeness as physical resemblance amounts to seeing what one presumes should be there and ignoring or forgetting what in fact is. In other words, people believe an image looks like Jesus because they conform the image's features to their expectations about him. Popular religious art like Sallman's is received because it reinforces what people *already* believe, tells them what they *already* know. That is why they recognize the image, why it seems so *like* Jesus.[60]

I do not wish to imply by the notion of vision directed by discourse that the popular image is neutral or a blank slate, an unresistant medium that receives whatever believers wish to see limned there. Discourse does not simply invent a state of affairs; it interprets existing conditions, often resolving an ambivalent situation in favor of one meaning over another. Thus, Sallman's and Hofmann's pictures might be made to signify any number of christologies given the fact that the images themselves are rather inexplicit. As we shall examine in the next chapter, discourse seeks to eliminate this lack of semantic completeness by settling on a reading that extends the interests of a discourse by positing a direct match between an image and itself.

Believers of any creed—religious, political, or scientific—are inclined (though not fated) to see what they are taught to see and scorn what they are taught to fear. The lessons of socialization take deep root and are extracted only at great effort and personal expense. The map of a human world is drawn over a topography of need and fear. As scholars of pop-

ular culture and the history of gender have pointed out, masculinity is inherently unstable and must constantly be reasserted in an ongoing ideological construction of identity.[61] Masculinity is not biologically determined like gender is; rather, it is socially constructed from the verbal, textual, visual, and behavioral signs that contribute to the composition of a world. Defined in terms of a shifting field of categories—for example, virile, macho, masculine; feminine, wimpy, effeminate—masculinity is the product of time and place and thus forever subject to change. Within this constantly reconnoitered terrain, the body and its genders are politically contested and the identity of Jesus is as varied and unstable as the history of the search for him. Those who embrace Sallman's images of Jesus attempt to naturalize the discourse that informs their fears and needs. The devout seek in his depictions an image of what they wish the world to be. The function of the devotional image for many Protestants is to resist change, to fix the protean character of experience by merging map and territory. But the attempt to privilege one code by inscribing it over the surface of experience is doomed to failure. To shift metaphors, the attempt to secure an anchor against the storms that rage without is forever compromised by ambivalence within: believers need more than one Jesus, and they have found him, uneasily, in the same image—Warner Sallman's *Head of Christ*.

\\\|///

CHAPTER FOUR

READING THE
FACE OF JESUS

With relatively few exceptions, artists and their patrons through-
out the history of Christianity have understood the physical
likeness of Jesus to conform to their own race, nationality, and
local customs. The robes or tunics that Christ often wears in art since the
Middle Ages generally have more to do with Western notions of me-
dieval spirituality or neoclassical beauty than first-century Palestinian
dress. Christ is clothed, as it were, in the cultural rhetorics of monastic
reform, mystical devotion, antipagan polemics, courtly protocol, na-
tional ideals, or devotional piety. In every instance, his likeness is coded
to resemble the interests of those who depicted him. At least one art his-
torian has remarked that it was not until the middle of the seventeenth
century in Europe that Jesus was portrayed as Jewish.[1] In other words,
the likeness of Jesus has meant his similarity to rather than difference
from those who put his image to such tasks as establishing a collective
identity or visualizing social order. The pious conception of the icon as
a transparent avenue to and from the divine ignores the cultural politics
of image making.[2] The social history of images requires us to understand
likeness as a social and not only an ontological matter. This chapter an-
alyzes one aspect of the social function of images in popular religious
culture in the United States in the twentieth century. The first portion de-
scribes an extraordinary form of response to a popular picture of Jesus;
the second and third sections explore the operation of word and image
in the reception of popular religious art and develop a comparative
analysis of "high" and "low" in visual culture.

THE *HEAD OF CHRIST* IN CATHOLIC
AND LUTHERAN RESPONSE

In elite and popular culture expectations about who Jesus was and what he was like as a person have always informed artistic conceptions of his physical appearance. Thus, although response to Sallman's widely disseminated *Head of Christ* (see fig. 1) varies according to gender, age, religious affiliation, and individual disposition, it is no surprise that devout viewers repeatedly report that this image *looks like* Jesus. Many correspondents expressed in letters how the *Head of Christ* comforted them as children, comforted their own children, provided consolation after the death of a loved one, and served to transmit the faith to Christian youth—all because this picture of Jesus presents a portrait, what some even consider a photograph of the man.[3]

It is clear from the letters sent to me that envisioning Jesus has been a way of appropriating him, personalizing one's relation to the Savior. Among the many devices of appropriation that viewers employ is an astonishing practice of finding images hidden within Sallman's *Head of Christ*. As I hope to show, this practice, which inscribes on the image of Jesus a discourse of Christian piety, operates in certain forms of modern American Protestant and Catholic visual culture and is rooted in the deepest ideological concerns among conservative Christians. Word and image are made to conspire in constructing an identity between what people see and what they expect to see.

In 22 out of 531 letters I received from readers of Christian periodicals, respondents indicated that they could discern distinct images nestled within the features of Christ's body and face. The *Head of Christ* thus became a sort of spiritual Rorschach blot replete with concealed or subliminal imagery. One woman even spotted the *Head of Christ* figure "unmistakenly in the clouds" one day as she sunbathed (243). Such sitings are not limited to Sallman's images. In recent years the face of Christ is said to have appeared on homemade tortillas in New Mexico and in spaghetti advertisements in Atlanta.[4] The eccentric Baptist preacher-artist Howard Finster has said that his ministry of evangelical painting began in 1976 when a spot of paint on his finger spoke to him.[5] And in a much publicized account, the crucified body of Christ appeared in 1992 on a tree in New Haven, Connecticut.[6]

These visual phenomena are not unprecedented in the history of art: as a way of "arousing the mind to various inventions," Leonardo encouraged artists to find images of landscapes, battles, faces, and figures

in stained walls and the configurations of stones. In the late eighteenth century a British painter, Alexander Cozens, developed a method of landscape painting that relied on quickly applied blots of ink from which mountains and trees were made to appear. In the nineteenth century, religious symbols and script were sometimes discerned in geological and meteorological phenomena, such as the often-reproduced Mountain of the Holy Cross in Colorado, where snow filled perpendicular grooves to appear as a cruciform. Atmospheric events in the 1830s and 1840s attracted wide attention in the religious and secular press and were frequently diagrammed to show crosses, snakes, and hermetic script. In the twentieth century, surrealist artists exploited the "accidental" appearance of imagery in the development of "automatic drawing," the celebrated technique of visual free association indebted to Freud.[7] Salvador Dalí frequently used concealed imagery in his paintings and drawings because he believed it exhibited the fruits of a paranoia controlled by the artist. His ability to see the world in the grip of paranoid delusion, he claimed, in turn became the unique resource for the creation of his artistic images. According to André Breton, the metamorphosis of appearances "permits the paranoiac to regard the very images of the external world as unstable and transitory."[8] Breton urged the surrealist to embrace this practice in the service of the "omnipotence of desire" that promised to transform the conscious world in spite of the bourgeois constraints laid in the artist's path. Looking very much like an inkblot, Dalí's *St. Luke* (fig. 41) exploits an unstable reversibility which seems to proclaim that human consciousness is anything but unitary and rationally controlled.[9]

Yet according to those who claim to do so, there is nothing avantgarde, eccentric, or deviant about finding images concealed in Sallman's picture of Jesus. Indeed, in contrast to surrealist art, the images found in Sallman's picture are interpreted by their viewers as emblematic of security and familiarity: they affirm the moral, theological, and social status quo of middle-class American Christians rather than challenge or subvert it. The images believers see are encoded with both their collective religious and their personal identities. What do they see? Virtually every respondent (21 of 22) made reference to a chalice on the temple and a circular wafer on the forehead of Christ (fig. 42, areas a and b). Six respondents reported seeing a prophet, priest, monk, or minister in the left shoulder (c); five located a cross, dove, or lamb's head beneath the right eye (d); and two writers found a nun or group of nuns gathered

FIGURE 41. Salvador Dalí, *St. Luke*, 1959, ink
on paper, 9 3/4 × 11 1/2 inches. Collection of the
Salvador Dalí Museum, St. Petersburg, Florida.
Copyright 1996, Salvador Dalí Museum, Inc.

on the right shoulder (e). Sitings reported by single respondents included
an angel in prayer (f), the Blessed Mother kneeling in prayer (g), a dove
(h), and a serpent (i).[10]

Accounting for the imagery is not difficult. Letters indicate that the
concealed images have often been discussed by priests, pastors, and in-
structors in Bible classes and Sunday school sessions since the 1950s.
The popular religious press has also included discussion of the imagery.
The oldest published reference with which I am familiar appeared in the
Monitor, a San Francisco Catholic newspaper, in 1956, where the author
wrote that the *Head of Christ* exhibited the following images:

FIGURE 42. Diagram of hidden images in
Sallman's *Head of Christ,* by the author.

On the forehead of this popular work is a light circle, representing the Eu-
charist, near the right brow the shining outline of the chalice, beneath the
right eye the outline of a dove, representing the Holy Ghost, and on the left
shoulder, the outline of a priest bending over at consecration. On the right
side of the tunic, an angel is outlined in prayer and farther to the right, the
cowl of a monk is seen and farther, yet, the dim outlines of three nuns in
prayer.[11]

In fact, Sallman told his family that he did not paint such imagery into
the picture.[12] But the persistence of response apparently impressed Sall-
man, who, a pious Christian himself, was not prepared to dismiss the au-
thenticity of the concealed images in the faith-lives of those who claimed
to see them. Consequently, instead of denying that he had placed the im-
ages within the picture, Sallman claimed publicly that he had not *con-*

sciously painted them when he created the work. He proclaimed this at countless "chalk talks" given around the country for church groups and Christian youth organizations such as the YMCA. During the chalk talk Sallman, after providing a personal testimony, reproduced in pastel or colored chalk a large version of the *Head of Christ*.[13] He made brief comments about the image as he sketched it, which, according to witnesses, included mention of the hidden imagery. A woman recalled his appearance at a Lutheran church outside Chicago in 1959:

> He told of how the hidden images in the painting were not planned, but appeared as he was drawing. From that point on, I have always seen those images, they were not hidden any longer. To this day, I am reminded of His gift of communion as I see the chalice and wafer. The gift of new life in Him is shown in the cross upon His cheek. I am mindful of the prophets of all time when I see the image on His shoulder. Those prophets of the past, which told of His coming, and those now, which tell us to be watchful of His second coming. I cannot look at the image without seeing the others. Maybe it is so strong because I watched him render this large pastel in the school gym so long ago. (362)

A letter from another person present at the same event corroborated this report: the artist "said that without conscious thought the following items appeared in the picture":

1. Chalice located on the right temple of the face.
2. Communion wafer displayed in the center of the forehead.
3. Cross on the right cheek of the face just below the eye.
4. Image of a monk [rather than "prophet" of the previous respondent] with head bowed lower right corner of the picture located on the left shoulder of the garment, facing the heart area.
5. The three nuns walking, appear on the right shoulder of the garment and into the hair of the head. Most people have indicated a problem picking out the nuns. I for one do not have that problem. (391)

This writer added that, as he understood it, the artist "did not know these items were in the picture at the time he drew the original drawing. It appears the images were pointed out to him over time by different people telling him what they saw in the picture."[14]

The imputed presence of such imagery is supported by the fact that Sallman did insert hidden images into other works. In *The Boy Christ*

FIGURE 43. Warner Sallman, *The Boy Christ,* 1944, oil on canvas, 40 × 30 inches. Courtesy of Jessie C. Wilson Galleries, Anderson University.

(fig. 43) and *Christ in Gethsemane* (see fig. 9), a clearly outlined cross is projected as a shadow against a rock. In *Christ at Heart's Door* (see fig. 3), a heart-shaped illumination is formed about the door at which Christ knocks. But in each of these instances there is nothing ambiguous about the identity of the image: it stands out with a clarity that cannot be mistaken for brushwork or light effects. The images reported by respondents, however, remain ambiguous. Even the widely recognized chalice and wafer do not exhibit the geometrical clarity of the heart shape in *Christ at Heart's Door.* The remainder of the configurations are differently identified by writers. For instance, the outline of a dove beneath Christ's right eye as interpreted by the author of the 1956 article quoted above was read as a cross by several other respondents (200, 362, 391, 494) and a lamb's head by yet another (322).

Such ambiguity may help to explain the popularity of Sallman's work: the image is readily adapted to either the church tradition or the personal

need of the viewer. This amounts to a fascinating hermeneutical device for tailoring the image to one's experience. Often different interpretations of the same configuration fall along ecclesiastical lines. While Lutherans tend to limit themselves to seeing the chalice and host as symbols for what they understand Holy Communion to be, Catholics not only identify them as symbols of the Eucharist but also discern in them members of the priesthood and religious orders (319, 322, 380, 494, 522, 523). Similarly, what Catholics identify as a priest or monk saying the *Confiteor* in a gesture from pre–Vatican II liturgical practice (319, 322, 494, 523), a Lutheran woman saw as a prophet in the Jewish Bible (362).[15] Another writer (notably a Disciples of Christ clergywoman) was happy to locate "a female priest (minister)" opposite the male figure on the right (32)—what the Catholic writer in 1956 identified as an "angel in prayer" (fig. 42, area f). In each case, people found in the portrait evidence for and vindication of the spirituality they brought to it.

It seems significant that the majority of writers who mentioned the sacramental imagery of chalice and host came from the highly sacramental traditions of Lutheranism and Roman Catholicism (eleven and seven of twenty-two letters, respectively). In both instances, the identity of the elements of the sacrament of the altar with the physical person of Jesus corresponds to the respective doctrines of the sacrament: real presence or transubstantiation. A Lutheran clergyman from Indiana referred to the *Head of Christ* as the "Communion Christ" and wrote that "I remind my first communion class and catechism students that everytime we take communion we meet and see Christ as we have never seen him before" (372). A Passionist nun wrote that the *Head of Christ* hanging in the parlor of her convent in Japan exhibits the chalice and host and "leads one to love Jesus [who is] always present in the Bread and Chalice of the Eucharist" (380).[16] Thus, the mystery of hidden images in the person of Jesus seems an appropriate metaphor for the mystery of the sacrament of the altar to those Christians who search for a way of expressing the embeddedness of the divine in the matter of the Eucharistic meal and its prototype in the incarnation.

An issue at the heart of popular culture studies over the past forty years has been whether popular culture is the expression of the will of the people or the instrument of economic hegemony. It is a bad choice to be sure: a romantic notion of folk culture, on the one hand, or a sensationalistic view of capitalist evil, on the other. The truth, as sober critics have pointed out, is messy and oscillates between the two extremes.[17] The reception of Sallman's image here reflects this situation. Response

ranges from the idiosyncratic to the strictly institutional, from instances of utterly individual constructions of meaning to ecclesiastically sanctioned indoctrination. For example, one peculiar response to the hidden imagery came in a letter that reported the chalice and host to be an indication of Christ's attitude toward the writer. A Lutheran woman wrote that after finishing her morning devotion and prayers one day, she "looked into His face and saw a very stern look. The wafer and chalice even stood out more that morning. Usually I see the face of a Compassionate Savior. I do not recall what was in my prayer or on my heart that morning" (242). Despite her failure of memory, she was prepared to assume that the image changed its appearance in response to something she had felt or said during her prayer.

Rather than keying the hidden imagery to purely private exchanges with the Deity, however, most viewers link the imagery to social forms of organization that distinguish the viewer's identity in a collective sense. For example, Dale Francis, Catholic author of the 1956 article quoted above, lamented the "continuous decline" of art initiated by the Protestant Reformation. In discussing the *Head of Christ,* Francis regarded Sallman as the creator of the "most popular art[work] in religious stores," but a work that "lacks the dimensions of faith," distinguished as it was by "artistic tricks." Francis identified the image as the "Protestant Head of Christ," but mused how few Protestants realized that the picture included "many things that are specifically Catholic." According to Francis, Protestantism had shattered the spiritual tranquillity necessary to create true masterpieces. He contrasted to Sallman, in his view the most popular contemporary Protestant artist, the careers of such eminent Catholic painters of the Renaissance and baroque periods as Van Eyck and Rubens. Francis revealed his political sympathies, however, when he went on to praise the work of Alfonse Ramil, a young Spanish painter "who is a member of the Opus Dei, who has taken vows of chastity, poverty and obedience and yet lives in the world, joins others of this secular community to try to catch the spirit of faith on canvas."[18]

Another example of the use of the hidden imagery in Sallman's *Head of Christ* as a means of distinguishing religious identity along an adjacent axis of social difference occurs in what appears to be a Bible class handout included with a letter from a Catholic woman in New York. The following narrative preceded a list of no less than eleven hidden images, many of which unambiguously reveal a Roman Catholic ethos— for example, a nun, a priest, and the Blessed Mother.

This picture was painted by a Jewish artist named Sallman. He began paint-ing and did all he could before retiring. During the night something com-pelled him to get up and finish the picture. Upon completing it, he realized that it was a masterpiece! So he decided to give it to his dear friend, a Catholic Priest. When the Priest saw the picture, he said it was just beautiful! "Just look at the Host, the Chalice, etc.," said the Priest. Sallman was utterly amazed at the things [the] Father saw, and not what he had painted, THE HEAD OF CHRIST. The Priest told Sallman that truly the Son of God had guided his hand. It is said, that on his deathbed, Sallman asked to be received into the Catholic Church.[19]

This narrative borrows freely (and quite inaccurately) from Sallman's own testimony of the origin of the image and dovetails with popular ac-counts in Protestant media that the *Head of Christ* converted a Jewish woman on her deathbed.[20] Within the appearances of verisimilitude re-sides the deeper vocabulary of authentic Catholic belief, a substratum of true faith quietly at work in artistic inspiration, aimed at the conversion of the unbeliever. These subliminal images are indeed powerful. What Francis called Sallman's "artistic tricks" became for others potent visual devices able to convert the infidel and erect the social distinction that separated "us" from "them." Significantly, the primary means of trans-mitting the code of the hidden images were such institutional structures as Bible class, confirmation class, and Sunday school. In such contexts, the interpretation of images binds a community together, traverses gen-erations, and uses the imagery to inculcate a collective identity.

This pattern of response qualifies the simplistic claim that mass cul-ture serves the interests of an elite that controls production. In the case of Sallman's pictures, there never was an elite at work. Nor was there a church body that assumed such a role in distributing the images. Some churches have appropriated the image by coding the hidden imagery to their own teachings, but this is typically an oral tradition and practiced by individual clergy and lay Sunday school teachers, not taught or en-forced by official bodies. It is, therefore, a genuinely popular culture, that is, a way of converting an item of generic mass culture into a local practice, fitted to the needs of a particular community. As Lawrence Levine has argued, the mass-produced items of popular culture can function as folk culture in urban industrial society when they serve to ar-ticulate the experience of a particular community or individual. Speak-ing of radio audiences, Levine argues that the "gaps" or indeterminacies of material culture encourage "listeners to become not merely partici-

pants but even creators of meaning when the message is not explicit; to project themselves into the text in order to invest the empty spaces with meaning."[21] Other important studies argue that those who purchase popular products, join fan clubs, or listen to mass broadcasting enter into a negotiation with popular culture to extract from it what they want or need.[22] Such consumers do not mindlessly conform to patterns of consumption established by producers but appropriate the product to their own uses and needs, thereby preserving a degree of agency or self-determination in the construction and maintenance of their worlds. Similarly, finding hidden images in Sallman's picture converts this commercial product into what Levine calls folk culture by fitting it to the viewer's own world. While this can occur at the strictly idiosyncratic level of the individual, the evidence of the letters suggests that it is much more likely to occur in the local communities of the congregation or family. Communities of viewers appropriate the image and remake it after themselves, reading its hidden images as emblems of popular theological discourse, even transforming the artist himself into one of their own faith. By their interpretive efforts, the image is made to speak to their situation, to comfort and console them, to image what *they* believe.

Simply because an image is mass produced does not mean that it must be received as a product of little or no local significance. Historians and aestheticians do well when they restrain from imbuing the handcrafted object with an "authenticity" they would deny to the products of mass culture. In light of reception studies and the realization that the production of meanings is open-ended and unstable, authenticity consists in the degree to which an artifact is appropriated. In other words, an artifact is "authentic" by virtue of its integration into a living cultural world regardless of how the item was made. No stage in the history of an object's production should be considered final. Thus, the *Doryphoros* (see fig. 12), a marble sculpture copied many times in the Roman period after an older Greek original, signified something to Romans that it did not to Greeks. Indeed, one may say that repetition is an important condition for appropriation. The fact that the *Doryphoros* and the *Head of Christ* were often copied and were seen repeatedly allowed for diverse uses or interpretations of each image. Although the Greco-Roman sculpture was not a product of mass culture, whereas Sallman's picture was, in each case viewers were able to experience their interpretation of the image as larger than their own community, even as universally significant. This was important because it affixed the particular meanings given the image to a universal symbol ("Jesus" or the "Greek Ideal"),

thus reifying an idea or value. While an attitude shaped by the existentialist longing for authenticity will dismiss this reification as "bad faith" or ideological blindness, naturalizing images that matter is undeniably what builds worlds and articulates the consciousness of everyday life.

THE DISCOURSE OF HIDDEN IMAGES

I began this chapter by alluding to such art historical precedents for accidental imagery as Leonardo and Dalí, but an even more obvious comparison to Sallman's hidden imagery might be the venerable tradition of symbolic, hieroglyphic, emblematic, and hermetic imagery deployed in paintings, prints, and book illustrations from the late medieval to the early modern period.[23] But we may do even better to examine a visual culture closer yet to the public that enjoyed Sallman's art: illustrations in the religious education of children that relied on the deciphering of hidden meanings in images and texts. The rebuses so popular in the nineteenth century, which involved a translation from visual or graphical to textual or alphabetic signs, are a case in point (fig. 44). The title page of *The Hieroglyphic Bible,* published in 1855, for example, states that its selected passages of the Old and New Testaments are "represented with emblematical figures for the amusement of youth: designed chiefly to familiarize tender age, in a pleasing and diverting manner, with early ideas of the Holy Scriptures."[24]

Entrance into the collective identity of a group depends on fluency with its codes of self-recognition. Acquisition of literacy in these codes is a task that begins early on; in fact, the interpretation of hidden images in Sallman's picture may draw from the established practice of using such imagery in the religious instruction of children. Texts like *The Hieroglyphic Bible* served as cultural primers to introduce children both to the master code of the Bible and the numerous visual and graphic means of using it. Young people were meant to puzzle out the meanings of each passage rendered in the collage of graphical and textual signs of the rebus. At the bottom of each page appeared the full passage in written text (see fig. 44). The fun consisted of translating visual forms and symbols into words.[25] As long as the clash of codes was not too great, the process of leaping from one code to another proved amusing to children. In the passage from Baruch reproduced here, as in virtually all the rebuses in *The Hieroglyphic Bible,* the images substitute directly for nouns. The images of the ear, eyes, corpse, and graves present a one-to-one correspondence with their names, and therefore facilitate substitution in re-

Bow down thine [ear] O Lord, to hear us ; Open thine [eyes] and behold ; for the [dead] that are in the [graves] whose souls are taken from their bodies, will give unto the Lord neither praise nor

Baruch ii. 16 17.—Bow down thine *ear*, O Lord, to hear us : Open thine *eyes*, and behold ; for the *dead* that are in the *graves*, whose souls are taken from their bodies, will give unto the Lord neither praise nor *righteousness.*

FIGURE 44. "Baruch 2:16–17," in *The Hieroglyphic Bible* (Hartford, Conn.: S. Andrus & Son, 1855), pl. 78.

constructing the sentence. Special shifts must be allowed the "dead" and "righteousness," however, since, in the first instance, the term is a collective in contrast to the single corpse (which does not appear especially dead) and, in the second, young readers may not have been sufficiently literate in the special allegorical code that, highly arbitrarily, linked abstract concepts with culturally specified symbols. Assuming that this code was secured, the child could proceed to reconstruct the meaning of the rebus, to decipher the hidden message.

In the operation of assigning visual schemata a linguistic value, images were consistently subordinated to the written and spoken word. While this is not surprising in a rebus, the use of symbols coded to biblical texts permeated even such an *apparently* pictorial image as Sallman's *Boy Christ* (see fig. 43). A booklet of interpretations issued by Sallman's publisher provided a legend for this and many other of the artist's pictures. Sallman, it stated, surrounded the boy with "the beautiful things in his Father's world which [Jesus] later used in illustrating his teachings." The interpretation proceeds by enumerating several symbols in the picture. The purity of the boy's heart "is symbolized by the white tunic he is wearing." "As a symbol of the serenity and peace which accompany [a complete surrender to the Father's will], the Artist has pictured the head of Christ enveloped in a radiance." The contrast of flowers and thorns "speak of the pain and grief which are interwoven among the sweet and happy experiences of life." And "in the rock [behind Jesus] may be seen the faint shadow of a Cross, symbolic of the suffering which awaited Him." The lilies may allude to Easter; the lamb to the doctrine of paschal sacrifice and substitutionary atonement; the grapevines and wheat to the sacrament of the altar. The text points to a succession of features that readily evoke biblical sources: among the thistles and thorns, tares of wheat are visible (parable of the sower; Matthew 13); grapevines frame the top of the picture ("I am the vine and my Father is the vinedresser"; John 15:1); what the text identifies as an olive sapling may refer to the Mount of Olives where Jesus would once again meditate on his Father's will; the lamb that Jesus embraces may have "strayed away from the flock grazing on the hillside" (cf. the numerous references to lost sheep, a faithful flock, and the good shepherd in the New Testament Gospels); and there is "a little brook from whose cool waters a hart had been drinking" ("As a hart longs for flowing streams, so longs my soul for thee, O God"; Psalm 41:1).[26]

Sallman employed this visual language of symbols because it spoke both to himself and to his appreciative public. In fact, he drew on an es-

FIGURE 45. Harlan Tarbell, "Jim Blue and Bill Glad," in *Chalk Talks for Sunday Schools* (Chicago: T. S. Denison, 1928), pl. 24.

tablished practice of encoding the image within the discourse of popular devotion. A large body of popular literature published by church presses and evangelical publishing houses during the first half of this century was dedicated to the "chalk talk." Sallman related that he performed as many as five hundred chalk talks for congregations, church groups, the YMCA, and youth camp meetings from the 1930s to the 1960s.[27] According to one practitioner of the subject, "chalk talking" was "the art of drawing chalk pictures offhand during the course of an informal talk or lecture, which the pictures are supposed to illustrate and supplement in various ways. The pictures may furnish the main theme, with the discourse built up around them."[28] This author provided in one manual nearly sixty narratives with accompanying plates, several of which were reversible images or optical illusions such as figure 45. Another manual devoted several illustrations to the gradual metamorphosis of graphic forms and images. In one example (fig. 46), each stage of the transformation was keyed to a narrative about the decline of a boy's moral character as he passed from unrestrained curiosity to smoking to drinking, and ended by making "a hog of himself."[29] Yet another collection of "blackboard illustrations" published in 1880 provided an image-lesson that grounded the meaning of Sallman's *Christ at Heart's Door* (see fig. 3). The rebus (fig. 47) is accompanied by a text from the

FIGURE 46. L. O. Brown, "The Question Mark," in *Crayon Talks* (New York: Fleming H. Revell, 1941), pl. 48.

FIGURE 47. "The Door of the Heart," in *Curiosities of the Bible*, rev. ed. (New York: E. B. Treat, 1880), 272.

evangelist and Sunday school advocate Dwight Moody, based on Revelation 3:20 ("Behold, I stand at the door and knock"), the text for Sallman's painting. "Your heart," Moody explained, "is the door. . . . Open it, and He will come in, and help you and comfort you, and save you at last in His heavenly kingdom."[30] Used in Sunday school instruction, the image and its textual decoding inducted students into a cultural literacy that enabled them to understand their relation to God in terms of mundane analogies, especially the personal relationship with Jesus as one who knocks at the door of their hearts. The purpose of the reversible image used by chalk talk artists was to hold the attention of a young audience and to illustrate the discourse. The hidden imagery of Sallman's picture served priests, pastors, parents, and teachers in the same way.

Given the popularity of symbolic and reversible images in religious education, it is not surprising that Sallman's *Head of Christ* has met with the reception evoked in the letters I cite. The visual language of symbols in popular piety anchors the image to a pedagogical practice and a moralizing devotionalism. The image is inserted into a mode of discourse built on the primary language of the Bible. The discursiveness of the image ties it for the viewer to the preexisting biblical text. I would like to argue that this is a powerful means of corroborating religious belief because it naturalizes the biblical text—or what believers take to be the text, but is actually their preconception of what the text itself means. What we come around to in the hermeneutical circle is the dogma, church practice, social order, and conceptions of gender, authority, and race that tell believers what the Bible means. These *pre-texts* constitute the ideological structures that guide the believer's reading of the Bible and predispose him or her to interpret it in a particular way.

One reason symbolic images appear in the *Head of Christ* is that a discourse finds in them the opportunity to be visualized: a situation is created in which one sees what one has been told to see. Because as children devout viewers of Sallman's picture were taught to textualize images, to treat them as the illustration of devotional or theological discourse, they see graphically cued, abbreviated discourse as concealed figures within the *Head of Christ*. This mapping of propositions over the surface of appearances naturalizes discourse, merges linguistic and material realities, and thereby constructs what appears to be real. This is not to argue that there is a static, ontologically prior "material reality" per se in the portrait of Jesus, but there is the illusion of one. Mimesis is a powerful form of semiosis because it projects the appearance of a purely objective reality, one that exists as such before the observer en-

counters it. In fact, as perceptual psychologists have demonstrated, perception is a much more dynamic, interactive process than passive observation.[31] To this we can add the constructive effect of representation: more than simply tagging percepts with names, discursive thinking proactively organizes the world in the map it produces.

The advantage of linking word and image in religious education and devotion is that the image, while subordinate to the word (just as the created world is subordinate to the creative Logos), gives the appearance of a seamless correspondence between the nouns of grammar and the objects of perception. In other words, the arbitrary code of cultural meanings is equated to the "natural" code of appearances. Sallman's Jesus weds physical appearance to the discursivity of signs with the result that this Jesus is "my" Jesus: this Jesus "speaks" the language of "my" liturgy, theology, church ritual, and, therefore, "my" denominational and ethnic identity—all in a subtle and subliminally persuasive manner. Spoken and written discourse embed within the image the meanings that a community of belief is predisposed to find there.

Yet "arbitrary" and "natural" are the terms of a polar configuration that must be deconstructed if we are to discern in the terms a strong ideological tool at work in the cultural politics of devotional imagery. Neither the arbitrary nor the natural domain may lay claim to ontological priority; neither is the truly real, the foundation of reality. But in its daily life of coping with sickness, child-rearing, alcoholism, and death, popular religious culture has little regard for the insights of poststructuralism. Admirers of Sallman do not consider their belief in Jesus or their perception of the hidden images to be a matter of psychological projection. Indeed, the strategy behind linking word and image relies on the constructive power of the imagination. Reading images in Sallman's Jesus assembles a creative dialogue with the picture that attempts to puzzle out interactively what the picture means by discerning in it coded references to the pre-text of dogmatic belief, religious affiliation, or racial difference. The images are signs that refer to pedagogical rituals, the social knowledge of memory work conducted in religious education during childhood: the paschal sacrifice of Jesus, the Holy Spirit, the doctrine of the real presence in the sacrament of the altar.[32] These signs inscribe onto the image of Jesus a variety of discourses that define one's religious identity. Finding one's own beliefs objectified in Jesus corroborates them.

Is this a matter of mere projection? Not in any simple sense, for the power of linking image and discourse is that it forever conceals priority as in the conundrum of the chicken and egg. Consider the astrological

figures of the zodiac. Are they simply projections, or are they interpretations of minimal circumstances? Did the figures evident to ancient eyes give birth to the stories that narrate them, or did the stories inscribe the figures in the heavens? The answer is lost in prehistory, but the transmission of the myths from generation to generation no doubt involved a dialogical encounter with the world in which inscription and discovery collaborate to root discourse in the world, that encompassing social and cultural domain that one takes as given. Thus, several stars seem to suggest a certain visible structure that human vision is inclined to discern and Western culture has historically referred to as "Sagittarius." With at least a minimal armature to build on, the preconception becomes immediately more than random in appearance and the viewer enters into an imaginative conversation with appearances, gradually transforming them until the gestalt occurs and becomes deeply embedded in the social practices of belief such that discourse is naturalized and nature is rendered discursive. Striking in the response to Sallman's image was the claim that after having the symbols pointed out by teachers, pastors, priests, or parents, people could not avoid seeing them: "they jump out at me whenever I see that picture" (319) and "I cannot look at the image without seeing the [symbols]" (362). Under the influence of ritualized learning, viewers exchanged the accidental quality of the initial projection for a singular or fixed association, with the result that the symbols became more dominant than the picture. The discursive sign became the baseline for interpreting the pictorial sign of the portrait.

Interpretive vision builds on existing material conditions and subjective dispositions such that it subtly reads a preexisting discourse into the "raw" conditions of experience qua "innocent" sensation. In a recent study of anthropomorphism, Stewart Guthrie contends that discerning humanlike forms in nonhuman things results from the "general need to find whatever pattern is most important," which to humans will probably be human characteristics.[33] I wish to argue that a religious discourse (which includes the social acts of its own transmission) informs the visual interpretation of Sallman's image by telling individuals what is important to see, that is, what to find corroborated in the material world they see. Interpretive vision seizes on certain features of a perceived object and ignores others. In this manner, the object is made to materialize or objectify what is significant. The image is powerful precisely because it accomplishes this transformation of the nonsemiotic into the symbolic. Guthrie maintains that most living organisms are hardwired to react to certain stimuli in the interest of vital needs. As animals, humans are pre-

disposed to seek out certain forms in their environment that offer them what they need such as food, protection, comfort, affection, and information. The human face and figure are the most information-laden forms in the ambit of human perception and therefore are potent signs for human beings.

Yet Guthrie's biological account must be elaborated. In the case of any particular anthropomorphic image, his general thesis that "we strive for meaning by scanning and shaping the world with meaningful forms" should be carefully historicized to determine why an individual image appears at a peculiar moment. Those who report hidden images in Sallman's picture have not simply found generic human features: they have fixed on certain forms that tell them something they wish to know. We see faces and figures everywhere, often without assigning a meaning to them. But images become compelling when their appearance speaks in a manner that is tailored to a particular situation. In the case of Sallman's *Head of Christ,* the pious discourse of liturgies, catechisms, and theologies prepares viewers to interpret incidental marks as images of a particular discourse. The hidden figures do not merely appear, they appear meaningfully, as if deployed with a message for the devout viewer. This subliminal linguistic feature of the image makes it revelatory.

AVANT-GARDE AND POPULAR

In the terminology of information theory, viewers have been taught by clergy or by the visual tradition of chalk talks to convert the "noise" of the surface effects of brush and paint in the *Head of Christ* into a channel for the transmission of an additional level of information. The message is not the "art" of painterliness, but rather commentary on the meaning of Jesus, a subliminal complement to the conscious or primary subject of the image. Merely incidental aspects of the picture are made legible, put to the service of delivering a message. It is striking that Sallman's icon of popular piety is not the only place in modern visual culture where conscious and unconscious intermingle. Advertising imagery makes extensive use of subliminal techniques, even if the more spectacular claims (such as nude encounters in ice cubes) of some critics are largely fatuous.[34] Certain avant-garde artists have pursued a balance— albeit very differently charged—of "apparent" and "latent" channels. Surrealist artists Salvador Dalí and René Magritte sought a version of visual realism that eliminated noise in order to enhance the transparency of the medium and thereby intensify the incongruity of manifest and

barely latent features in the image. In the case of Dalí and Magritte, this was done to lend their work a nightmarish immediacy. Sallman's naturalism, in contrast, mimicked the effects of commercial photography in order to deliver the iconic presence of the person depicted. Whatever the technique—whether Dalí's airbrush finish, Magritte's stark illusionism, or the smooth, retouched complexion of Sallman's sacred portraiture—the common aim was to submerge the indices of visual representation beneath the threshold of conscious perception. Instead of allowing the traces of manufacture to call attention to themselves, the artists each sought to efface the act of making the image in the desire to conjure an acheiropoetic image, that is, an image not made by human hands. Dalí strove for eidetic imagery, pictures transposed directly from the mind; Magritte for a *trompe l'œil* illusionism with disturbing incongruities, a mirror image that subtly subverts the notion of reflection; while Sallman claimed that his most famous picture originated in a nocturnal vision given him by God.[35] The power of these images proceeds from the beguiling myth that they were not fashioned by a willful hand, but were almost magical transpositions, apparitions projected by God or the unconscious. Thus, according to Sallman's own argument, the hidden images surfaced in the *Head of Christ* without the artist's conscious intent, as occult emblems bearing witness to the deeper meaning of the picture for those who can properly decode them.

The affinity between surrealism and popular religious art like Sallman's (Dalí's late religious works, widely denounced as kitsch, show how easily the two domains can be conjoined) consists in this mechanical realism, an apparatus of photogenic display which produces an image that seems to hover before us in an uncertain space, a timeless place somewhere between memory and the unconscious. The great difference, of course (and what makes Dalí's religious images no longer surrealist), is the desired effect: whereas viewers of Sallman's image fortify their interpretation of what Jesus means to them by anchoring the portrait to doctrinal emblems, Magritte and the early Dalí sought to undermine the perception of the "natural" world by throwing into question its status as a fixed reality fully accessible to and controlled by the rational operations of the conscious mind and the bourgeois order it served. Avant-garde art destabilizes the doxa of everyday life, whereas Sallman's images seek to secure them.

This contrast and what it has to tell us about popular and elite imagery is illuminated by the status of word and image in surrealism and popular religious art, respectively. This becomes clear when we compare surrealist art with instances of hidden imagery in popular religious painting.

The interdependence of word and image and the importance of this relationship for conservative Christians is at the heart of the popular reception of the *Head of Christ,* but it also seems to have been at work in at least three other of Sallman's images.[36] As we noted earlier, Sallman literalized the idea of the hidden image in several paintings in the 1940s by eliminating the accident and nearly all the ambiguity of the concealed figure. *Christ at Heart's Door* (see fig. 3) concealed a heart symbol; *Christ in Gethsemane* (see fig. 9) and *The Boy Christ* (see fig. 43) had crosses embedded in dark background areas. Sallman used the hidden image of the heart in *Christ at Heart's Door* to fashion a transition from an older allegorical tradition going back to several nineteenth-century paintings, the most widely known and circulated of which was William Holman Hunt's *Light of the World* (fig. 48), to the evangelical American experience of Christ's appeal to enter into each person's heart and become a personal friend and savior.[37] It is as if the redundancy of the heart image concealed in the doorway helped to secure meaning by avoiding any ambiguity. A pamphlet issued by Sallman's publishers in 1944 discussed each aspect of the image—the door, the grill of the door, the garden, Christ, and the light—as laden with particular significance for the modern world. The text explicitly distanced Sallman's picture from the iconography used by Hunt, stressing the "utter simplicity of this [Sallman's] representation." Sallman was praised for deleting the symbolic adornments and allegorical clutter of Hunt's picture: "There is no jeweled robe, no crown of gold or of thorns, no staff or lantern in His hand, no halo about His head."[38] The image was said to appeal directly to the contemporary world of the church "in confusion," the nation "in turmoil," and the world steeped "in the anarchy and the chaos of war." "Through the darkness of night," the pamphlet announced, "there comes a light." The virtue of Sallman's picture was its directness and simplicity. The light about the door, "forming the shape of the human heart," issued from "the mysterious glow coming straight from the heart of the King of Glory to fall upon your own heart."[39] Thus, the hidden image was a device that appealed directly to viewers by updating the older visual rhetoric used to treat the subject. The hidden heart, in other words, facilitated the interpretation of the image, whereas the allegory of Hunt's painting only complicated it for twentieth-century viewers. Like the allegorical devices in Hunt's painting, however, the reversible motif reinforced the meaning of the image as unilateral, assuming a relation between sign and referent that anchored the image to the word.

By contrast, the semiotic instability of metamorphosis was a favorite

FIGURE 48. William Henry Simmons, after
William Holman Hunt, *The Light of the World*,
published 1860, stipple engraving, 29 1/4 × 16 3/4
inches. Courtesy of Victoria & Albert Museum,
London/Art Resource, N.Y.

theme for Magritte: in familiar images such as *The Telescope* (fig. 49), the artist tricked the eye to read the sky both as space and as flat surface, that is, as something seen both *in* and *through* the window. The illusion is both asserted and denied in the placid but disturbing terms so characteristic of Magritte. The Albertian notion of the painting as a window is subverted, as is the implication of this metaphor: if the picture qua window fails to offer the viewer access to the world beyond, then neither may representation gain purchase on reality. Magritte challenged the commonplace that representation (painting, words) is to reality as the window is to the world outside it. Signs are not transparent, but opaque —or as infinitely empty as the black void between the image's window panes.

The Belgian surrealist sought to subvert the traditional view that words represent objects in a stable, ontologically secure network of signs and referents. Magritte's images threaten the viewer with an abyss of meaning, suggesting that signs and things are incongruous. Language is an impermeable membrane of nightmares that never delivers one to reality per se, but keeps consciousness in transit, lost in the indefinite, dark gap between signifier and signified. In Magritte's paradoxes no meaning can bridge the rift to bring sign and referent together. Language never looks out of a window onto reality, but faces the infinite dark nothingness that swallows up all signification.

The effect of unintended hidden images in the *Head of Christ* and the deliberate role they perform in *Christ at Heart's Door* and the other paintings, in contrast, is the apparent coincidence of sign and referent. In the *Head of Christ,* script and Savior, word and divinity, seem to merge: the person of Christ bears the sign of his own being and meaning. By using the conventional symbols of the heart and the cross, and by discerning hidden symbolic images in the brushwork of his paintings, both Sallman and his viewers inserted the discursive forms of language into the visual field. The hidden figures act like latent captions that anchor the image's interpretation. As symbolic rather than preponderantly iconic signs, they narrow the range of signification by prescribing abstract meanings, rather than relying on the less controllable operation of resemblance.[40] In contrast to Michel Foucault's meditation on the deconstruction of resemblance in the image and the referential relation of image and text in Magritte's work, popular religious art is forever affirming its coincidence with text.[41] Whereas Magritte's linguistic negation of the visual likeness of a pipe in the painting *The Betrayal of Images* (fig. 50) stubbornly reassembles itself into the propositional as-

FIGURE 49. René Magritte, *The Telescope (La lunette d'approche)*, 1963, oil on canvas, 69 5/16 × 45 1/4 inches. Courtesy of The Menil Collection, Houston. Copyright 1998 C. Hersovici, Brussels/Artists Rights Society, New York.

FIGURE 50. René Magritte, *The Betrayal of Images (La trahison des images [ceci n'est pas une pipe])*, c. 1928–29, oil on canvas, 25 3/8 × 37 inches. Los Angeles County Museum of Art, purchased with funds provided by the Mr. and Mrs. William Preston Harrison Collection. Copyright 1998 C. Hersovici, Brussels/Artists Rights Society, New York.

sertion that this is indeed a pipe (the French sentence in the painting states: "This is not a pipe"), popular imagery such as Sallman's depends so heavily on accompanying or presupposed discourse as to throw into question the ascription of likeness to an original entity. What is the image more like: the historical Jesus or what the discourse of popular piety says Jesus was like? Both the image and he whom it represents, in other words, resemble the discourse. Put another way, the discourse mirrors itself in the image, creating its own rebus for the believer to decipher.

The construction of "nature" is powerfully bolstered in Sallman's and Hunt's pictures by the use of latent symbols. Sallman was possessed of a piety shaped by a conservative Protestant resistance to a universe without God, a universe where man was no longer the measure. The interpretations accompanying Sallman's *Boy Christ* (see fig. 43) reminded the reader that "throughout life Jesus was a lover of the out-of-doors and of his Father's handiwork." Sallman's painting, the text concludes, challenges "youth the world over . . . to love the Father's world, be concerned about the Father's work and surrender to the Father's will."[42] Nature is a place for religious formation, a quiet garden for meditation, where one reads the book of nature and becomes convinced of God's patriarchal lordship and authority. The belief among conservative American Christians from the later nineteenth century through the twentieth was that the Bible accorded perfectly with the natural order. Nothing written in Scripture could be contradicted by natural events.

To attain the complete correspondence of sign and referent, the harmony of scriptural and incarnate Word, however, Sallman had to fabricate "nature." Hunt's *Light of the World* served as a shining model of symbolic naturalism. In *The Boy Christ* Sallman emulated this model, depicting nature as a place replete with scriptural references, from the symbolic species of plants to what the explanatory text identified as "the faint shadow of a Cross, symbolic of the suffering which awaited Him." The image proclaims that word and image, discourse and world, sign and referent are hierarchically arranged, joined by a sacred covenant. There is no implication, as we find in Magritte's work, that the image can refuse to be dominated by the word, that "nature" can exercise a power that resists domestication by discourse. The boy Christ is at home in his Father's world, a docile lamb like the one on his lap, perhaps the very one, the text proffers, "that had strayed away from the flock grazing on the hillside," but is now retrieved and safely embraced by the young shepherd. All things are in their proper place, orbiting about the radiant face of the boy-Savior. Even the hidden image of the cross takes

its place in the nature of things as the boy submits himself obediently to the Father's will.

This docile submission of signifier to referent underscores an unmistakable difference between some "high" and much "low."[43] Unlike Magritte, Sallman did not seek to call into question the relation between sign and referent, but to knit the two together in a seamless join. Nature in such images as Hunt's *Light of the World* and Sallman's *Boy Christ* is not a place beyond discourse, but the very reflection of it, a kind of open book speaking what the devout viewer already knows. The image and all things visible are founded on the Word; the world is what the Bible says it is.

Whatever the religious tradition within Christianity, discerning hidden images represents one of many interpretive strategies whose purpose is to naturalize a particular configuration of the interrelation of Jesus, the church, and the individual believer. People see hidden images because the act of doing so corroborates the fundamental epistemology of conservative modern Christianity: that things conform to what Scripture and theological discourse have to say about them. This strategy of control subordinates images, and through them the physical world, to the strictures of discourse and implants in the world what believers deploy as the pretext of their experience.

Hidden images are thus another tool in the repertoire of visual piety's social construction of reality. They perform a discursive role in popular reception because of the persuasive effects that images have when they naturalize what the viewer already holds to be true in the preeminent form of the biblical text. Finding concealed figures within popular religious images constitutes a form of response in which viewers discern a likeness between the image of Christ (and therefore Christ himself) and their piety. To invoke the theme of chapter 2, it can be said that seeing hidden images is another way of experiencing sympathies between Jesus and oneself, of tailoring a closer fit between the Deity and one's local circumstances. Images such as Sallman's are not passive illustrations of dogma but, among the devout, compelling interpretations of church teaching. Indeed, they are an unofficial means of conveying and confirming dogma.

Avant-garde art is no less preoccupied with discourse than devotional imagery is, but its self-appointed task is quite different: to join with critical theory in challenging or subverting the status quo, to destabilize our expectations about the visual systems of value and representation to which we have become attached.[44] The avant-garde as a movement or

commitment in the modern age is about articulating human sensation in order to enrich, renew, and transform the connections between discourse, art, and the cultural worlds in which we exist. Like popular devotional art, avant-garde art intermingles what we say and what we see; but the avant-gardist does so with a spirit of experimentation and critical scrutiny, a willingness to call into question everything that has been learned and to begin again. What the devotional artist seems best at is configuring the enclosure of popular piety, the gesture of communal integrity and security, toward which the open-endedness, alienation, and hesitancy of the secular artist's critical probing are unsympathetic.

DOMESTIC DEVOTION
AND RITUAL

Anyone who has enjoyed Garrison Keillor's radio tales of the fictional Minnesota town named Lake Wobegon is familiar with the cultural distinction represented by Father Emil of Our Lady of Perpetual Responsibility and Pastor Ingqvist of Lake Wobegon Lutheran Church.[1] Although German Catholics and Norwegian Lutherans in the Midwest may regard themselves as the two poles of the human cosmos, of course they are not; in fact, as Keillor knows, they have far more in common than they care to acknowledge. But they are fond of distinguishing themselves from one another on the use of images: Catholics rely on them and Lutherans do not. In reality, at least throughout much of North America, this simply is not the case: Lutherans, and Protestants generally, find a very important place for images in their religious lives, particularly in their homes.

Yet the commonplace that images are for Catholics and not for Protestants finds apparent support in recent sociological research. Among the very few quantitative studies of religious imagery is a fascinating chapter in David Halle's *Inside Culture: Art and Class in the American Home.* Halle investigated 160 households in four neighborhoods of Manhattan, Long Island, and Brooklyn ranging from upper to lower-middle social classes. He examined the kinds of images and artistic objects displayed in homes and dedicated one chapter to religious iconography in religious households. Halle found that Catholics in working-class neighborhoods are significantly more likely to display images than those in upper-middle class neighborhoods and that virtu-

ally no white Protestants or Jews in any of the surveyed neighborhoods displayed religious imagery of a devotional nature.[2] In fact, Protestants and Jews expressed an explicit contempt for such imagery and often sharply distinguished themselves from Roman Catholics on this point.

This is a striking finding in view of what hundreds of Protestants told me in their letters. Just over half (54 percent) of the letters came from people living in the Midwest and the South, though most of the magazines in which the ad appeared circulated throughout North America and beyond.[3] Most writers were Lutheran, Evangelical, Methodist, Seventh-Day Adventist or Catholic. In contrast to Halle's study, I found that Protestants (even Protestants from New York State, including a few in the New York metropolitan area) were quite fond of devotional images. I am inclined to hypothesize that Halle's Protestant and Catholic informants regarded religious iconography as a mark of difference within the suburban worlds of metropolitan New York, where ethnicity and class may combine with religion to shape group identity more stringently than in other parts of North America, including the rest of New York State. Halle found that Catholics in his study accommodated their affluent Protestant neighbors in those areas where Protestants were dominant.[4] In contrast to a Catholic woman who refused to display images because they might offend Protestant visitors, the Protestants I studied sometimes go out of their way to display images of Jesus in the home, with the intention of "witnessing" to Catholic or Jewish or Mormon visitors. "Bible-belt" Protestants may be much more evangelical than northeastern Protestants, but the context of neighborhoods and class must help account for the difference between the results of Halle's study and my own, since Catholics in middle- and upper-middle-class neighborhoods in the New York City area were much less apt to display religious images.

Many twentieth-century Lutherans, Methodists, and Baptists, it seems clear to me, have not hesitated to include images in their devotions and prayer. While Protestant churches are widely decorated with stained glass imagery or inexpensive reproductions of pictures of Jesus by such artists as Heinrich Hofmann and Warner Sallman (figs. 51, 52), the much more common site for images among conservative American Protestants has been the home (fig. 53). This chapter will focus largely on the popular reception of devotional art in the home since mid-century. As in the last chapter, the evidence is drawn from the letters sent to me. Careful scrutiny of these letters yields considerable insight into what popular religious images have meant to those who display them in their homes. What becomes apparent is the degree to which these images are configured within an ex-

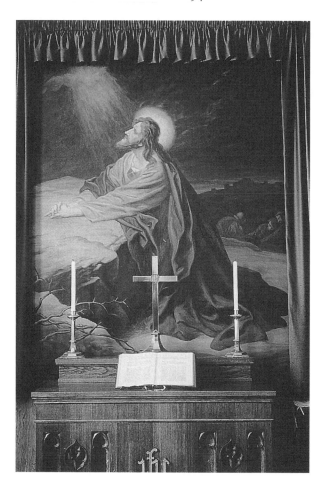

FIGURE 51. Beauford Floyd Jones, after Heinrich Hofmann, *Christ in Gethsemane,* 1933, oil on canvas, 84 × 64 inches. Prayer chapel altar, First Lutheran Church, Freeport, Ill. Photo by author.

perience of the Christian home as a primary means of shaping youth, conducting ritual, and defining the feminine domain of religious life for many Christians. Serving as much more than incidental decoration, these images underscore the sacred function of the family and ground the formation of Christian identity in the everyday life of the home.

Much of what I have to say also applies to Roman Catholic and Orthodox American believers in this century. In fact, the visual pieties practiced by many twentieth-century Protestants and Catholics in North America are much closer than ever before. We have seen that Sallman's images of Christ play a protective role for Protestants in a manner reminiscent of the role images of saints play for Roman Catholics; but the Sallman im-

FIGURE 52. Sunday school altar, Zion Lutheran Church, Ogden, Iowa, 1993, with Warner Sallman's *Head of Christ*. Photo: Phillip Morgan.

FIGURE 53. Living room, Iowa, 1994, with Warner Sallman's *Head of Christ*. Photo: Phillip Morgan.

FIGURE 54. Mother and children with *Head of Christ* after earthquake, California, January 1994. Photo: AP/Wide World.

agery was no less important to the Hispanic woman and her family shown in figure 54 when they escaped with their lives, a rosary, and Sallman's *Head of Christ* as their California home was destroyed by an earthquake in 1994. And it was Sallman's picture that miraculously began secreting oil in 1993 in the bedroom of a Coptic Christian boy in Houston. Several Protestants reported similar miraculous events involving Sallman imagery.[5]

Despite these similarities, the focus in this chapter is primarily on Protestants, who, although they often claim that images are not important for worship, nonetheless make great use of religious pictures. I am especially interested in the way middle-class Protestants rely on devotional images to make the home a sacred space in an age when many in the intelligentsia posit a demythologized universe. One writer indicated that Sallman's *Head of Christ* in her home served as "a focal point for devotions and prayer" (224). Another wrote that the picture was part of her "family devotional center" (209; also 80, 250, 255, 275). Such imagery has been a very important part of the practice of prayer for many believers. Several respondents reported using pictures in some connec-

tion with prayer. While pointing out that she did not think of her copy of *Christ at Heart's Door* (see fig. 3) as a "shrine," an Oklahoma woman related that "many times I have paused in passing [the picture in her living room] and offered up a prayer of thanks that he knocked at my door and is ever present" (164; also 93, 189, 250).[6]

Many Protestants felt the need to accompany their reports with such disclaimers (it's not a "shrine," it's "only a picture"), but this did not preclude them from responding to the image *as if* it were more than an image. Others found such qualms unnecessary. A Methodist clergywomen recalled talking and praying to Jesus "via the picture" (the *Head of Christ*) as a child in her bedroom (93). Few letters, though, demonstrate how intensely an image can become part of devotional life as the account of one Protestant mother's ordeal. When her seven-year-old daughter was diagnosed with leukemia, she wrote:

> Sallman's "Head of Christ" became my friend, my confidant, my crutch. I talked, cried, and pleaded with it for strength, not only for my daughter, but for all of us to cope with the pain and agony we were all going through. . . . Every day I asked God, through the portrait, to keep her safe with us. . . . He heard my pleas and kept her with us. (250)

Eventually the mother conceded the loss of her daughter and asked through the image that she be taken; the girl then passed away.

Whether in the home, hospital, church, or nursing home, religious imagery has enhanced prayer and devotional experience by focusing thought and petitions, by visualizing the *other* of the devotional dialogue. As a Chicago woman put it, "Pictures help me 'see' who it is to whom I pray" (316). A Lutheran woman spoke passionately about a ceramic portrait of Jesus: "I believe that when I die and get to see Jesus, he will look just like that statue. I don't have any proof of that, of course, but it is of great comfort and inspiration to me to believe that, and I do!" (241). Wherever religious pictures may hang, letter writers prize the use of images in the home more than anywhere else.

A Methodist pastor noted that images of Jesus hung in many homes that he visited: "They served to exemplify a Christian holy home where morals were high and His love abounded" (36). When another respondent visited his elderly parents' new home and could not find a familiar picture of Christ on the wall, he told them: "It won't seem like home to me until you hang that picture" (28). Others considered their memory-laden copies of Sallman's *Head of Christ* "more precious . . . than any other item in my house" (95); one referred to her home as "incomplete

without it" (285). In these statements we find the image empowered to represent the home of faith and childhood memory. The devotional image has become identified for many with the house of their Christian upbringing. As one Lutheran housewife put it, Sallman's pictures "tell visitors that this is a Christian home" (238).

For many believers, particularly women, the home is the preeminent symbol of Christian faith. It is perhaps the primary medium for conveying an individual's or family's religious beliefs. Moreover, the home is the site for the Christian formation of children, the building of family unity, and the daily manifestation of divine blessing. As the sign of material success, and therefore as evidence of divine favor, the home stands as the crown jewel in the ideology of bourgeois American Christianity.[7] It is difficult to overemphasize the importance of the concept of home for virtually all classes of Americans, since they consider it synonymous with the American dream of home ownership and domestic happiness.[8] Psychologically, home is a privileged space, an ideal rooted in the earliest consciousness of the self and the family.

The importance of images for this ideal is evident in the letters I received as well as in the history of American home decoration. The notion that pictures exert a suitable influence on the formation of children was set down in the nineteenth century when the technologies of mass production made images such as chromolithographs available to middle- and lower-class homes.[9] Addressing themselves to the middle-class woman and homemaker, the Beecher sisters advocated the use of moderately priced ($6 to $12) chromos in the home, partly because of their economical value for decorating the parlor, but also because of their formative effect on children:

> The educating influence of these works of art can hardly be over-estimated. Surrounded by such suggestions of the beautiful, and such reminders of history and art, children are constantly trained to correctness of taste and refinement of thought, and stimulated—sometimes to efforts at artistic imitation, always to the eager and intelligent inquiry about the scenes, the places, the incidents represented.[10]

THE CHRISTIAN HOME: A DOMESTIC DESCRIPTION OF THE SACRED

According to the evidence of the letters and my examination of several homes, devotional images are placed throughout the living space, though four symbolically charged zones are favored. Thirty-one percent of all

FIGURE 55. Warner Sallman, *Madonna and Child*, 1954, oil on board, 22 × 20 inches. Courtesy of Jessie C. Wilson Galleries, Anderson University.

my respondents indicated where in their homes religious imagery was located. Of these, 39 percent cited the bedroom, 38 percent the living room, 12 percent the dining room, and 11 percent the entrance. The image referred to most often was Sallman's *Head of Christ*. Other pictures by Sallman mentioned were *Christ at Heart's Door, The Lord Is My Shepherd*, and *Christ in Gethsemane* (see figs. 3, 4, 9). Heinrich Hofmann and Richard Hook were other artists cited. Although Sallman developed gender-specific iconography for the rooms of Christian children (*Christ Our Pilot* [see fig. 37] was placed in boys' rooms, the *Madonna and Child* [fig. 55] in the rooms of young girls), all of the favorite Sallman imagery could be found throughout the home. Pictures placed in the bedrooms of children were usually deployed as security objects intended to comfort and protect the child—and parent!—from various fears (32, 40, 104, 215, 259). The same was true of imagery placed in adult bedrooms. An Iowa woman decorated the space above her bed with Charlotte Becker's *Peace on Earth*, a photograph of her deceased mother to its left by the door (fig. 56). A woman who traveled to Saudi Arabia, which she characterized as a "dark spiritual land," reported that the *Head of Christ* brought her "comfort and security" and protected her "against the dark forces" when she kept the picture near her bed (452).

If it is not used for protection against metaphysical dangers, religious imagery in the bedroom often offers comfort and reassurance regarding family members and close friends. Figure 57 foregrounds the theme of friendship in the bedroom of a young woman from a Boston suburb. Placed on the dresser below a mirror, nestled among cosmetics and snapshots of friends and family, a gift from a friend reminds her of the divine purpose and blessing of friendship. The most frequent discussion of bedroom images involved their capacity to measure and mark a regular rhythm of daily life, and thereby to help insure a stable structure for the home and family. The bedroom is, after all, that place in the home where the diurnal cadence of dark and light is experienced. A writer whose parents bought her a copy of *The Lord Is My Shepherd* when she was three years old exemplifies this use of Sallman's imagery: "This picture has hung over my bed since [then]. It is the first thing I see [each morning] and the last at night reminding me that I am in the Lord's care—day and night" (36). Another respondent recalled that she "could see it when I woke up in the morning and when I went to sleep at night" (93). The *Head of Christ* hangs in a Methodist woman's "devotions corner" in her bedroom: "It's there to greet me when I wake up every morning, to remind me that Christ is the head of my house, to console me when I'm down, to send me off to work on a cheerful note" (187). And another woman, whose copy of the picture has hung in her bedroom since she received it as a wedding gift, wrote that she directs her devotions to the picture "every morning and evening."[11] The inherently conservative character of popular religious art is evident in this experience of the imagery: it provides adults the same sense of security that it first carried for them as children. It is no coincidence, then, that more people mention the bedroom as the site for religious images than anywhere else in the home.

This conservative impulse is manifested in the use of the religious imagery in Protestant domestic space generally. Time and again the letters relate the intergenerational continuity that such images have come to symbolize and reinforce: a favorite picture entered the family with the marriage of one's parents, held pride of place in one's own home, and has been passed on to the home of one's children and occasionally even grandchildren.[12] In order to stress the importance of the religious basis of family identity over many generations, religious pictures are frequently displayed with family photographs in hallways and living rooms. Often a copy of the same image is displayed in the identical location in the home of the next generation. One respondent wrote:

FIGURE 56. Bedroom, Iowa, 1994, with
Charlotte Becker's *Peace on Earth*. Photo:
Phillip Morgan.

FIGURE 57. Bedroom, Brookline, Massachusetts,
1995. Photo: John Merrill.

As a child, [the *Head of Christ*] hung inside our living room right by the front door for as long as I can remember. It also hangs by the front door of the home my husband and I now share.

As a child, this picture meant security and dependability knowing that Christ was a daily part of my parents' lives. Today, in my own home, it lets everyone who enters know we are Christians, and in my heart, assures me that our lives as Christians will continue in our home, and someday when we have our own children, will continue in their lives as well. (249)

This woman, who wrote that Sallman's *Head of Christ* had become "a sort of family tradition," revealed how the image of Jesus situated family members within a securely designed, intergenerational community. One generation interlocks with its predecessor and the generation following it by replicating the physical environment of the home replete with the sacred signage of the Divinity.[13] Sallman's portable art accommodates the post-1940s diaspora of the American family. Many conservative Protestants have looked to his ubiquitous imagery as a measure of permanence in this age when the traditional family seems to be breaking up, exchanging mobility for the localization of previous generations. As a woman from Michigan wrote, "The pictures . . . have been rather like familiar pillars that remain constant through the years 'just like' Christ does. . . . In this day of 'changes' we most certainly need to be made aware of the unchanging Lord" (418).

The dining room is for many the appropriate place to locate such well-known iconography as Eric Enstrom's 1918 colorized photograph *Grace* (fig. 58).[14] The dining room is where the family regularly gathers each day, as several respondents made a point of mentioning. Many remarked that placing pictures of Jesus on the dining room wall reminded the family that "Christ was always a guest in our home" (90; also 42, 297, 400). This is not a new idea, of course, but can be found in depictions of the Last Supper or the Supper at Emmaus since the Renaissance. In fact, Sallman based his image of Jesus on Léon Lhermitte's picture of Christ as a guest, the friend of the lowly, in a late-nineteenth-century portrayal of Jesus at a modern-day Emmaus.[15] In contrast to the baroque drama echoed in Lhermitte's picture, however, evidence in the letters I've received indicates that Christ's iconic presence in the modern American home was applied to the more practical task of inculcating manners, proper speech, and a patriarchal piety. A Lutheran woman from New York wrote that the *Head of Christ*, a wedding gift from her pastor in 1948, hangs on her dining room wall as "a wonderful witness to our family and friends and a big influence on the conversation and activities

in our home" (293; also 326). Several writers—all of them women—punned on the title of the picture by stating that Christ was the "head" of their home (187, 236, 251, 310, 400).[16] One might read this only as an index of patriarchal authority in the home; but it may be more complex than that. Women in traditional households often enjoy there the domain of their greatest power. Thus, when women acknowledge the preeminence of Jesus as the "true" head of the house, they effectively unseat their husbands and replace them with a picture that performs the tasks that mothers and wives ascribe to it, namely, benevolent protection and an authoritarian policing of language and conduct.

The placement of an image of Christ at the front entrance of the home appears to serve two purposes, one prophylactic, the other proselytizing or declarative (fig. 59). A Methodist pastor who wrote recalled an account of a thief who accosted a woman when she opened the front door of her home. When he "looked behind [her] there was a picture of Warner Sallman's head of Christ." Upon seeing it, the thief relented and said, "Lady, I can't do it, not with him behind you" (10). The power of the image to protect is often inverted into the power to help convert the infidel, to proselytize the religious other. Thus, one reads letters from evangelical Christians who display their pictures of Jesus at or near the front door to "witness" to Mormon or Jehovah's Witness missionaries. A zealous Lutheran woman from Missouri reported:

> [The *Head of Christ*] purposefully and strategically hangs in the hallway of our home so that upon opening the front door of our home you see the portrait. The reason for that is we want those who enter our home to know that Christ is the head of our household and also, as we live in a strong Mormon community, it gives me an opportunity to witness to them and any others who often knock on our door with the Book of Mormon or their 'Watch Tower' in hand. [251]

One woman said that she first bought the *Head of Christ* when "a Jewish woman was coming to visit me. I wanted her to realize that Christ was God's Son and He was with me" (344). This action may have been motivated by reports in popular religious magazines that the picture had helped convert a dying Jewish woman.[17] One Seventh-Day Adventist woman carefully placed the image in her living room in full view of her visiting Catholic relatives (452). For these Protestants, such imagery authoritatively announces the piety of the home owner, communicating to visitors better than might be done with words the religious ethos of the home, which the occupant is at pains to distinguish from the heterodox faith of certain visitors.

FIGURE 58. Dining room, Indiana, 1994, with Eric Enstrom's *Grace* (1918). Photo by author.

FIGURE 59. Front entrance of home, Iowa, 1994, with C. B. Chambers's *Light of the World* (date unknown). Photo: Phillip Morgan.

For others, religious art at the entrance of the home served as a "welcome" (161) or as a means "to bless us and all those who entered" (226). On the theme of blessing, an Oklahoma woman related that for thirty-five years her copy of the *Head of Christ* has hung by the front door where it suits her family well "because when we leave our home, we take Christ with us" (305). The entrance to the home is understood as a boundary between the private domestic interior and the profane outer world. As such, the image-marker reinforces the bourgeois experience of the home as a nest, as a bastion of homely values such as stability and dependability. The entry image delineates the home as that place where God's presence is evidenced by the preservation of order in the face of change. According to this view, the home is the primary source or channel of divine blessing and presence in the world.

The final room of the home to be discussed, the living room, is for many the heart of the home. When asked where in their residence they felt most at home, adult respondents in a study conducted by Mihaly Csikszentmihalyi and Eugene Rochberg-Halton most frequently cited the living room.[18] This space is typically organized around such architectural features as a fireplace, mantel, or picture window. In lower- and middle-class homes this focal space often enshrines a television set, favorite image or heirloom, or a valued object such as a piano or organ. The focal object within this space directs the family's collective attention as well as any guest's. Characteristic activities and ritual actions occur here such as conversation, entertainment, relaxation, devotions, reading, napping, and watching television. Not surprisingly, this is often the site where religious images are displayed. In fact, several respondents indicated that the *Head of Christ* or works by other artists such as Sallman's competitor Richard Hook hung in their living room in the midst of family photographs (48, 50, 416, 452; figs. 60, 61).[19] A Methodist woman from Texas reported that the picture was centered on the mantel, flanked on either side by pictures of her children and grandchildren. She considered the image "part of our home and family" because she received it thirty-three years ago when she married (50). Another Methodist woman wrote that *Christ in Gethsemane* by Heinrich Hofmann was displayed in her living room with photographs of "all my loved ones who are deceased," over whom he is said to watch (48). Sallman's *Head of Christ* was credited by a Florida man—in whose living room it has hung for over forty years—with keeping three children and six grandchildren within two blocks of his home and members at the local Methodist church (113). In some cases a picture of Jesus was displayed

FIGURE 60. Living room, Iowa, 1994, with Warner Sallman's *Head of Christ*. Photo: Phillip Morgan.

FIGURE 61. Living room, Iowa, 1994, with plaque of Heinrich Hofmann's *Christ in Gethsemane*. Photo: Phillip Morgan.

in the living room as an heirloom, inherited from parents or grandparents, thereby locating at the heart of the home the visual tie that binds the generations together (259, 315).

The *Head of Christ* is also located on or above the television, the "electronic hearth" of many homes (159, 94), and above the fireplace. Indeed, as the source of warmth and security for those who gather together around it, it is no surprise that the fireplace and mantel were frequently cited locations for Sallman's imagery (228, 258, 50, 76, 166). As one person put it, placing the image of Christ on the mantel identifies that place as "the center of the home" (151). The hearth has always been a generative source of light and the source of nourishment and warmth. It has also served the traditionally minded as a symbol of resistance to modernity and a bastion of such traditional values as family cohesion and patriotism. Here, for example, an item from the 1868 *Family Christian Almanac* inveighs against the new technology of steam heating:

> I am a firm believer, says Dr. Cuyler, in the moral and spiritual influence of an open fire. To make home attractive, there must be somewhere in the house a common family rendezvous; and that ought to present a more radiant attraction than a black hole in the floor, through which hot air pours forth from a subterranean furnace. Men will fight for their altars and their firesides; but what orator ever invoked a burst of patriotism in behalf of steam-pipes and registers?[20]

The many illustrations in the *Christian Almanac* of family members gathered about the hearth for conversation or Bible reading confirm the symbolic potency of that locale in popular religious piety (fig. 62).[21] Modern counterparts include familiar objects of veneration such as the parlor organ or various "antiques," which connote tradition and the generations of one's forebears. Other modern substitutes such as the television, picture window, or entertainment center offer a radiant centerpiece for the home, a focal point or "a common family rendezvous." One gazes into them and receives in return an idyllic view: family television, the manicured yard, an album of loved ones. The hearth remains a focal point and a source of radiance. It nurtures a kind of domestic dialogue whose sole topic is the endurance of the family—blessed by the countenance of Jesus in familiar reproductions.

One scholar of the material culture of American domestic interiors has suggested that a loss of the collective memory encoded in Victorian parlors, with their characteristically dense clutter of objects, occurred in the early twentieth century when the parlor was replaced by the living room.[22] In their classic study of Muncie, Indiana, *Middletown,* the Lynds

found that from 1890 to 1924 the interior plans of houses were constant with the exception of a trend "toward fewer and larger rooms, the 'parlor' and the 'spare bedroom' being the casualties. In some working class homes the parlor, living room, and kitchen have become living room, dining room, and kitchen, but in many the parlor survives, in which case the family lives in the dining room."[23] If the principal function of the middle- and upper-class Victorian parlor was to convey to family and visitors the class status and class consciousness of the family, after the turn of the century among low-income families, where formal parlors were a luxury, often one room in the home was established as a "front room" and used (in conjunction with other uses) for entertaining guests.[24]

Yet the evidence is not clear that the loss of parlors means the loss of a domestic space in which to display publicly and formally the family's social identity and aspirations to visitors who are not intimate friends or relatives. The Lynds described the living room of "the working class man" of 1924 in Muncie as follows: "'Knickknacks' of all sorts are about—easeled portraits on piano or phonograph, a paper knife brought by some traveled relative from Yellowstone Park, pictures that the small daughter has drawn in school, or if the family is of a religious bent, colored mottoes: 'What will you be doing when Jesus comes?' or 'Prepare to meet thy God.'"[25] The distinction between kitchen and living room as private and public spaces was still in place among working-class households at midcentury. A 1946 report on public housing stated that the kitchen was

> often the place for family gathering and for the entertainment of intimate friends. . . . Thus, the living room in public housing has taken over many of the attributes of the old-time parlor. The reason is not too obscure. These tenants, having been accustomed to slum conditions, take more than average pride in their homes; and this pride displays its greatest evidence in the care that is lavished upon the living room.[26]

Although it was in the Federal Public Housing Authority's interest to promote a picture of low-income housing tenants as proud of what the government had provided them, the assessments were generally based on statistical data and so do represent more or less how tenants used the housing flats.[27]

Letters from those who display religious imagery in their homes indicate that one has been likely to find inexpensive, mass-produced religious images hanging in the living room from the 1940s to the present.

FIGURE 62. "The Family," in *Family Christian Almanac* (New York: American Tract Society, 1848), 7.

FIGURE 63. Living room, Iowa, 1994, with Richard Hook's *Head of Christ* (1964). Photo: Phillip Morgan.

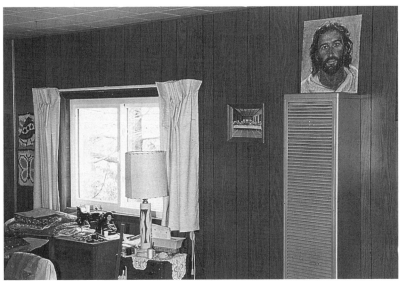

The purpose of the images, as we have seen, is both commemorative and declarative. The shift from parlor to living room has not marked a loss of cultural or collective memory per se, but rather the emergence of a large subgroup of the American populace for whom a mass-produced religious imagery is the bearer of many meanings. This change was motivated by the rise of standardized public and private housing and an attendant popular aesthetic of minimal interior decoration (which is more economical for prefabricated homes and standard building plans). Preframed pictures can be easily affixed to the wall, removed when the family moves, and easily reinstalled in the new residence. Letters show that this was a common practice. This mobile or nomadic imagery assisted two generations of postwar Americans to secure their identities amid frequent residential changes. Unless one is prepared to argue that mass-produced items are inherently less meaningful than handcrafted ones, the claim that collective memory has suffered with the loss of parlors seems nostalgic. The evidence is clear that people invest rich personal, familial, and communal meanings in very common, mass-marketed objects like religious pictures. While the image may not typically be used to signify a status associated with affluence, sophistication, advanced education, or worldliness, and has certainly not been part of an economy of conspicuous consumption so evident in Victorian parlors, the familiar cardboard icons of Jesus have certainly been imbued with such ritualized, communal memories as confirmations, weddings, anniversaries, and funerals. Thanks in part to the display of such commemorative imagery, the Christian home has remained a sacred space, despite broad changes in housing design, interior decoration, and devotional practices. This is especially the case among those who attest that mass-produced religious images participate in the formation of Christian identity in the home.

In addition to carrying commemorative meanings, religious pictures have served as signifiers of middle-class domestic comfort and respectability in both the intimate and formal settings of the home. The means of display helps to define the use of the room; a cue is to be found in the frame in which the picture appears, since the frame helps establish the relationship of the image to its architectural milieu. Compare, for instance, figures 63 (p. 169) and 60 (p. 166). The first, of a multi-use middle-class television room adjoining a dining area, displays images of Leonardo's *Last Supper* and Richard Hook's *Head of Christ*. The *Last Supper* is in a plain frame, while Hook's frameless picture (made from a jigsaw puzzle) rests on a metal heater. In figure 60, by contrast, a very large and decorative frame has been chosen for a relatively inexpensive

print of Sallman's *Head of Christ* in order to present the image in a formal living room (what would have formerly been a parlor) beside an expensive clock. The elaborate frame in figure 60 restricts the image to a particular kind of space and decorum. The same occurs in figure 56, where an ornately framed image of the Christ Child adorns a guest bedroom in an upper-middle-class home. In contrast, the lack of a frame, or use of a generic, low-priced frame, allows the images in figure 63 to serve a space that accommodates many uses. The expensive frame helps to set a certain stage, to use Erving Goffman's terminology, a fixed "social front" where a specified set of roles are performed in accord with the family's presentation of itself as a group and as individual selves.[28] The unframed image in figure 63, however, in refusing to demarcate the space as dedicated to one use or another, communicates an informality appropriate to a cozy living room, den, or television room.

DOMESTIC RITUAL AND IMAGES

We have not laid the groundwork for understanding the significance of popular religious imagery for countless Christians until we have accounted for the rituals that help situate images in the home. Rites of passage such as baptisms, confirmations, first communions, graduations, weddings, and funerals, annual observances such as birthdays and anniversaries, and religious festivals such as Christmas and Easter give Christian life its temporal structure. The lives of believers are measured and shaped—articulated—by a lifelong rhythm of ritual events.[29] Life is also seasoned by such occasional events as conversions, healings, pilgrimages, and calls to ministry, which, though not always ritualized, are characteristically crucial junctures, moments of transformation that often make use of the apparatus of symbolic negotiation that images offer the devout and their communities. Indeed, in such instances images may even serve the important function of maintaining a vital link between what might be an individual's eccentric crisis and the mainstream of the institutional church community. I am thinking here of those incidents related by respondents whose personal crisis led to a miraculous or extraordinary experience of the image, such as its coming to life, being glimpsed in mystical visions, secreting oil, or acting as a protective device in war.[30]

We need not limit ourselves to dramatic instances of ritual, however. The mundane may be even more to the point. Rituals and their material culture are powerful practices that create the meanings that people

experience together as groups and as individuals within groups. Rites enact in the lives of their participants meanings that outside ritual exist only as spoken discourse.[31] It is not enough simply to tell a child that she is no longer a toddler and has reached school age. The sixth birthday party, first communion, or a grand shopping trip to purchase school clothes will accomplish this transformation of consciousness much more memorably. Likewise, all the arcane theology of Holy Communion is enfolded in the young person's experience of worship and membership in the religious community as a result of actually participating in the Eucharist.

I would like to offer an account of ritual that accommodates the central place of popular religious images in twentieth-century American Christianity. That devotional art has been part of domestic and liturgical ritual is quite clear from many letters and is evident in the many uses to which images are put both inside and outside the home (see figs. 14, 15, 38, 64, 65). Most frequently mentioned as occasions for receiving or giving such imagery as a gift are weddings and wedding anniversaries; next is the Sunday school or youth group gift; then is the confirmation, graduation, Christmas, or departure gift. One or two respondents reported receiving religious images on the occasion of their conversion or born-again experience (e.g., 234). Sallman's *Head of Christ* often appears on funeral commemorative cards or is used in some fashion during the funeral rite, such as being displayed with the body or coffin (121). A Catholic priest adorned announcements of his ordination with the image (319), and the daughter of a Protestant pastor reported that her father regularly used reprints of Sallman's pictures on baptismal, confirmation, and marriage certificates in his congregation (75).

One of the most fascinating ritual uses of Sallman's imagery has been in the rite of parting, leave-taking, or sojourn. This was experienced by countless families during World War II and the wars in Korea and Vietnam when young men and women left their spouses and families to serve abroad in the military; more than a dozen of my respondents provided personal accounts of giving or receiving the image as servicemen during these conflicts. In fact, the YMCA, the Salvation Army (through the United Service Organizations), and private parties such as church congregations and individuals were responsible for distributing several million wallet-sized copies of the *Head of Christ* during the Second World War. The Bible and Sallman's art were given and gladly received by so many because of the talismanic and protective power these items were believed to possess, in addition to the comfort they provided as tokens

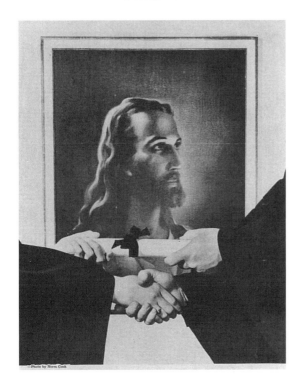

FIGURE 64. Sallman's *Head of Christ* at graduation, in *A.C.T.S.* [Anderson College and Theological Seminary] Alumni News 33 (June 1951): cover.

of the home life being left behind. One World War II veteran recalled that he carried his reproduction of the *Head of Christ* into combat, along with his "shirt-pocket sized, steel covered New Testament" (43). A mother wrote that the night before he joined the navy she gave her son a billfold-sized print of Sallman's Christ with the message "Take my friend with you." Her son died many years later and was buried with the picture still in his billfold (96). A veteran of the Korean War, who was sent the same image by his home congregation, was also buried years later with the print in his wallet (325). In such instances the talismanic power of the image that safely guided the man through his wartime ordeal was applied to the ultimate rite of passage in death as well. Another World War II veteran reported making a pact with four companions during basic training "to stick together and be 'good Christians.'" As a confirmation of their decision, each of the five signed the back of five prints of the *Head of Christ*. After the war, the letter writer lost track of his wartime friends, but was careful to retain the image, fearing that if he disposed of it bad luck might befall him (31).

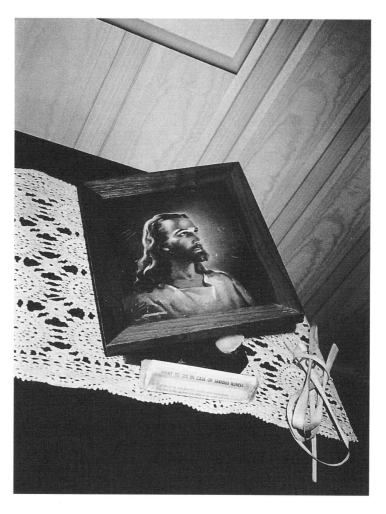

FIGURE 65. Bedside tabernacle with Sallman's
Head of Christ, Staten Island, N.Y., 1993. Photo:
Katherine Mary Contino.

The use of Sallman's Christ in the parting ritual helped ensure the safety of the individual leaving home. The ritual might be very informal, but the gift of the image often had a powerful effect on both giver and receiver, its task being to resist change, to preserve the stability of home life in the midst of fundamental transformation. Images, as portable icons, extend the gravitational pull of a world, as it were. Faced with their children leaving for war—or college, marriage, or professional life—parents, relatives, and local religious groups often sought to reinforce the attraction of their familiar world by making gifts of images. The image, in extending the domain of the home world, was intended to prevent the itinerant believer from drifting or being pulled away by the force of a rival domain. The sameness, the utter familiarity of the image, reassured the newly independent youth of the security and constancy of life in the "real world" back home, in contrast to the chaos of whatever they might be facing.

The war provided a dramatic occasion for the parting ritual, but in essence all rites of passage are designed to safeguard the individual during the critical period of transformation. The purpose of the gift given on the occasion of leave-taking or any other fundamental change in the familiar patterns of life is to preserve the sense of divine presence that is manifested in the rite of passage itself. A Methodist woman from Kansas wrote that the *Head of Christ* was displayed in the dining room of her childhood home, the hub of domestic activity and a room that was "special during holidays and birthdays. It seemed like Jesus was always watching over our family as long as it was hanging there" (150). A Lutheran man from San Diego proudly possessed the *Head of Christ* that his father had given to this mother on the occasion of their third wedding anniversary. On the verso of the image his father had written: "May this small treasure keep in your heart and mind the birth of our Lord, and make you feel His presence in our home" (315). The image has also been used in the Roman Catholic tradition to anticipate the crucial juncture of the last anointing. One long authoritative Catholic catechism explains the rite of extreme unction as comforting those who suffer near death, strengthening them against temptations, remitting venial sins, cleansing the soul of the inclination to sin, and even restoring health if God sees fit.[32] Even the illuminated tabernacle containing a small flask of oil for the last anointing, traditionally located on a wall or dresser near the bedside to assist in this passage and to mark it as a critical exchange between human and divine, has been known to feature Sallman's image of Jesus (see fig. 65).

Generally speaking, all rites of passage dramatize or enact in a community an individual's leaving one mode of being for another. One passes from fetal to postnatal existence; from prepubescence to sexual maturity; from childhood to adulthood; from single to married life; from unregenerate to spiritual life; from earthly life to the afterlife. Each of these transitions constitute moments when an individual's life and relation to his or her community undergoes a basic change. Occasions such as birth, puberty, and procreation threaten either the biological integrity of the mother or the stability or autonomy of the individual. The biological changes involved are invested with mythological significance —a movement from life to death and from death to life. The rite of passage conducting young people through puberty into sexual maturity occurs in many Christian communities about the time of the church's rite of confirmation. In this instance, the child dies as the adult is born. Baptism is also a form of death and resurrection. Marriage—a multivalent rite, not just a rite of passage—likewise brings about, in Jewish and Christian traditions, a new being formed from the flesh of two individuals. Birthdays and anniversaries commemorate additional moments of ontological transformation. Healing, pilgrimage, and conversion experiences are also characterized in terms of death and rebirth and are commemorated by images.

In most cultures these passages, understood in mythical terms of ontological metamorphosis, enshrine change as a mystery, turning a paradox or contradiction into an epiphany, even, in Christianity, into sacraments (Roman Catholicism, indeed, locates a sacrament at many of these junctures: baptism, confirmation, marriage, and extreme unction). To domesticate such critical biological changes as birth, puberty, menstruation, and the procreative act is to transfigure their carnal energies, and the disorientation of identity that they bring, into spiritual mysteries that can be safely installed within the order of communal existence. The rite of passage makes the change negotiable by assuring deliverance from the death of an old form of life to a new one.

The ritualization of material change preserves the integrity of the individual's relation to a community at a time of crisis. As profound as this sounds, many Christians in the modern world of mass culture have observed the mysteries of initiation in the prosaic form of greeting cards and devotional gifts that use religious imagery.[33] In commemorating significant events such as confirmations and weddings, inexpensive ritual gifts such as devotional imagery are able, in connection with ongoing contact, to maintain a network of family and intimate relations. So

emotionally significant are these nominal investments in the moral economy of memory that a few letter writers reported an unwillingness to dispose of a gift picture, even when they no longer cared to display or think about it (12, 31, 217).[34] For nonrelatives and casual acquaintances such as teachers, pastors, or fellow church members, token gifts like images also have the advantage of communicating thoughtfulness without obligating the recipient to reciprocate in anything other than kind on some suitable occasion in the indeterminate future.

Over 20 percent of letters received (108 of 531) indicated that inexpensive religious images were given or received as gifts, the great majority of which served to observe or remember such ritualized events as weddings or wedding anniversaries (52), Sunday school achievements or graduations (11), departures or leave-takings (10), and confirmations (5). The commemorative gifts exchanged in these instances tend to be of little intrinsic value; they serve chiefly to lodge the event in memory and to link the receiver of the gift with all others who have undergone the same transformation. In this sense, the more generic the gift, the greater the assimilation to the normative standard it represents, such as the values of middle-class American Christianity. The gifts given for weddings and anniversaries should be distinguished from the those given at Christmas or for birthdays. Very few respondents cited Christmas or birthdays as the occasion for receiving religious images (only 5 and 1, respectively). It is not difficult to imagine how disappointed children would be to receive an image of Jesus for Christmas instead of a basketball, stuffed animal, or video game. The latter are usable gifts meant for physical enjoyment or entertainment, and generate envy among a young person's friends and siblings. In other words, such gifts configure a very different set of social relations than the commemorative religious image, which ties the recipient through memory to an important ritual event and to the network of family members and church acquaintances who give the confirmation, first communion, or wedding its religious and social significance. These events are memories fixed to (and in part by means of) commemorative objects. As ritualized memories they endure and need not be repeated, whereas Christmas and birthday presents must be bestowed annually and must change as the recipient matures.

Certain rites of passage are best celebrated with inexpensive or even ephemeral images because the gift is not intended to oblige the recipient to reciprocate in kind, though some kind of moral indebtedness is certainly part of the gift-giving.[35] The gift of a picture to a confirmand, graduate, or newlywed is meant to signify a friend's or a relative's sup-

port for the proliferation of the web of belief into the next generation (though the gift may well be part of an ongoing reciprocal exchange between a child's parents and their friends and relatives). On occasions where imagery has been used not as a gift but as part of the staging of the ritual, as in the YMCA induction rite pictured in figure 38, the inexpensive, mass-produced nature of the religious image may even reassure iconophobic Protestants that they have not become preoccupied with the *form* of the ritual. The YMCA manual *Hi-Y Rituals* (1944) cautioned its readers that the "purpose of the ritual is to solemnize, dignify, and crystallize an experience of a club member," and that the "important element in the ceremony is this experience at the heart of it—never its form." Without that experience, "the ritual has no meaning."[36]

As significant as the role of ritual may be in negotiating life passages, many people also report using images in a way that resists such passages, or at least downplays them. An image of Jesus may function to retard change: "I cannot see it without remembering my childhood and the Sunday school days it represents," wrote one respondent (20). Another linked the image in his own youth to its presence in the youth of his child:

> My mother told me stories of Jesus, and I suspect that being able to associate the gentle face in the Sallman painting with the gentle persona being described by my mother helped me to more readily accept and digest the words. . . .
>
> It was one of the truly distinct images which I can recall from my room, and it seems as though it was always there.
>
> I find great contentment, today, in the knowledge that that very same picture hangs in my home. It is on the wall of our nursery, and from that spot Christ's loving gentle gaze has watched over our daughter. [104]

Here ritual is not only a discrete event often repeated, but a long process that connects one's own childhood with the childhood of the next generation in the attempt to perpetuate the security and comfort of a remembered past. The image subdues change by securing a utopian age constructed in memory and reinstalling it in the present. The face of Jesus symbolizes a state of timelessness, coterminous with one's own consciousness ("it seems as though it was always there"); it is as if the apotropaic power of his protective gaze can be transferred from one generation to the next. The ritual consists not only in the repeated act of hanging the image but also in its protracted display and its articulation of memory, always in the context of its power in the present—a subject we will take up in the next chapter.

Other ritual uses of devotional images structure the passage of time in a rhythm that is predictable and reassuring. We saw this in the placement of religious pictures in the bedroom. This idea of ritual may seem so unremarkable and monotonous as to become invisible, so much a part of everyday life that it appears indistinguishable from the merest habitual behaviors of rising and retiring each day and night. But the *apparent* insignificance—familiarity to the point of forgetting—is precisely the point. The enduring presence of an image causes it to be insinuated into the fabric of everyday life. Forgetting has the power to naturalize artifacts, to make them an unquestioned part of the world. Certain kinds of ritual can reinforce this process. Reiterated performance (whether family devotions or watching television) becomes ingrained, almost second nature. The more mundane something is, the more natural, the more worldlike—to play off the etymology of mundane (from *mundus*, world)—it becomes.

Boundaries between the body and the habitat blur in mundane rituals, since ritual action transposes the conventions of human culture onto nature or the nonhuman. Useful here is Peter Berger and Thomas Luckmann's description of the dialectical process of world construction and maintenance as tripartite, involving (1) the externalization of human activity, (2) the objectivation of this activity in the physical and public products of human effort, and (3) the internalization or appropriation of these products "into the structures of subjective consciousness."[37] We can make use of this model to say that in ritual the self and community come to be found outside of the self and return to the self as more than it was to begin with. Ritual, as Theodore Jennings has put it, "creates the world."[38] As we saw in chapter 4, discourse is conducted in the material form of the image and, we must now add, in the ritual actions of its use, which belong essentially to the practices of visual piety. Ritual, it is crucial to understand, does not express or illustrate ideas but is rather a corporeal knowledge, the body's knowledge, whose vocabulary is gesture, fragrance, images, and the placement of a picture of Christ or Mary on the mantel or above the television.

This realization, driven home by students of ritual, conveys the power of rites and ceremonies. One scholar has posed the issue directly: "Why cannot a community of believers just discuss their ideas, instead of gathering to perform all sorts of peculiar actions?"[39] As if in response, another writer has stressed that ritual is rooted in the body: "Physical experiences and action engage consciousness more immediately and irresistibly, and bestow a much stronger sense of reality, than any merely

mental philosophy or affirmation of faith."[40] To this we can add, as discussion in the next chapter will show, that ritual stimulates memory and engages an entire community in an act of social memory in a way that abstract pronouncements never could. Ritual, after all, consists in part of sensations: smells, spectacle, the taste of food, the sound of music, the weight and temperature of architecture—all of which become sensuous symbols of the joy, fear, melancholy, dread, or awe that undergird enduring memories. Ritual uses the body to lodge its contents in the memory. Thus, in the face of a world fraught with unpredictability and lurking panic—the sort that children first learn to fear in a dark bedroom —the cardboard icons of popular art offer a visual piety and domestic ritual of everyday life that sacralize the home as the site of continuing divine benevolence.

MEMORY AND THE SACRED

Although we saw in the last chapter that Protestants do avail themselves of devotional images, often very much in the manner of their Catholic co-religionists, it remains true that many Protestants feel uncomfortable discussing the meaning of images in their religious practice without issuing a disclaimer about their use. One encounters, for example, such recurrent qualifications as "Of course it's true that we worship the Saviour not his picture" (123) or "While we certainly do not worship the picture . . . " (113). Others point out that the image is "only one man's conception" (154) or "I knew this was not an actual picture of Jesus" (132). Once these qualifications are in place, however, the individual feels free to specify what the pictures mean: "Of course it's true that we worship the Saviour not his picture. But how else can we express the feeling within our hearts?" (123) Or "Of course, I knew this was not an actual picture of Jesus, but it gave me strength" (132).

SPACE AND TIME

For many conservative Protestants, such unabashedly material forms of worship as the vestments and objects of formal liturgy, traditional church architecture, and icons and statuary configure the sacred in an all too concrete way. Such forms draw attention to themselves as embodying the holy. Making signs of the transcendent appear so sensuous is inappropriate, even idolatrous, to some. Because it pertains to carved or graven images, the second commandment's condemnation of imagery

(or the worship of imagery, depending on how one reads Exodus 20:4–5) suggests to many believers that what occupies space, what is physically embodied, may be confused with what it signifies. In short, as the basis for human encounter, the sacred should not occupy space. This prejudice against material and spatial terms requires, however, that we reevaluate the practice common among scholars of analyzing architecture, monuments, images, and objects in terms of sacred space. I will therefore do so before proceeding to the record of popular response.

The material culture of religion is widely understood to sacralize space, to delineate in spatial parameters the site or point at which the holy is manifested and made to communicate to believers the crucial signifiers of their identity as believers.[1] The sacred is therefore experienced as invested in a place—a church, altar, or devotional image, for example——as the concrete expression of a community's relationship to the divine. To be at the site in person is to enter the presence of the holy.[2]

This concept of the sacred clearly applies to such highly liturgical forms of Christianity as Roman Catholicism, Anglicanism and Episcopalianism, Lutheranism, and Eastern Orthodoxy, all of which are rooted in a view of the sacrament of the altar as the real presence of the body and blood of Jesus. But it fails to characterize the experience of the holy among those forms of Protestantism in which the holy is encountered not as a thing, modeled ultimately on the relic or the sacrament of Holy Communion, but as another category of existence: time. For many Protestants, the sacred is configured by a rhythm of events, encountered within the ritualized time of worship that culminates in prayer, song, ecstatic experience, the altar call, or the sermon. The "place" of the sacred is thus articulated within a temporal sequence, not a physical site. Certainly the experience of sacred space among Catholics, Lutherans, and Orthodox is also invested within the temporality of ritual and liturgy; but there the holy enters the community of the faithful as an object that remains always present, the reference point for communal experience.[3] For people of these faiths, some essential aspect of the experience of the sacred remains independent of temporal expression. Architecture, liturgy, tabernacle, altar, art, and music house the sacred as physical embodiments. In the case of many Protestants, by contrast, the architecture of the sacred is one of time, in the activities of prayer, song, or testimonial.

I alluded above to the importance of the sacrament of the altar as the basis for the tradition of sacred space. This is certainly true among Lutherans and Orthodox Christians and, when joined with the ancient tradition of relics and their display in the church, for Roman Catholics

as well. The distinction between space and time as modes of the sacred can be traced to the subject of a famous debate in Marburg in 1529 between Luther and Zwingli. Luther vigorously argued for the real presence of the body and blood of Christ in the elements of the Lord's Supper. Zwingli, however, insisted on the rite of communion as a commemoration of Christ's sacrifice and as a celebration of his spiritual presence in the body of believers gathered together in the time of worship. The bread and wine were *signs* of Christ's body and blood given into death, but contained nothing of Christ himself, whose glorified body, Zwingli rationally observed, was now located in heaven at the right hand of God the Father. Sacred space, it would seem, belonged in heaven, in the physical presence of God, not on earth, where one was left instead with ritual remembrance of Christ's presence on earth as celebrated in the community of believers. To claim that Christ was really present in the elements of Holy Communion was to commit cannibalism, according to supporters of the Zwinglian position, who ridiculed Lutherans as "drinkers of God's blood and worshippers of a baked God."[4]

What, then, do Protestants experience as sacred in architecture, images, and altars, if not sacred space? My research indicates that many American Protestants find a central place for images in their piety when the images invoke the faculty of memory. Pictures, in other words, are safe, even commendable, when they teach by assisting the memory; when they serve to recall scriptural events or dogma; and when they help the individual assemble a personal spiritual narrative. In nineteenth- and twentieth-century American Protestantism at least three distinct functions have been ascribed to images in connection with memory: they satisfy the pedagogical purpose of forming memory; they assist the interpretive recollection of the biblical past; and they inform the constructive representation of one's life course.

MEMORY AND THE SACRED

Memory functions in three discrete ways in conservative Protestant uses of imagery. The first, as we have seen, is to articulate the sacred in temporal rather than spatial terms. A second role of images is to help store information in the memory and to apply that information to the interpretation of the Bible. Finally, images have helped many Christians assemble from memory their sense of who they are, and to tell this story to others. Memory-laden images, in other words, help people interpret

both Scripture and their own lives. I will take up each of the remaining two functions in turn.

In her classic book *The Art of Memory*, Frances Yates examined the ancient tradition of training the memory, an operation essential for orators in antiquity and for scholars in the Middle Ages and the Renaissance. In this tradition, the image played a central role in organizing and storing memories in an imaginary space constructed by the speaker or scholar. An illustration of 1619 by the alchemist and hermetic philosopher Robert Fludd portrayed *memoria* as a theater of "memory places," constructed before the mind's eye in the rational order of Renaissance linear perspective.[5] This visualization has a familiar counterpart in the evangelical visual culture of the modern era: namely, the use of images in religious instruction.

The earliest and most popular pedagogical devices in colonial America were pictorial primers that taught students how to read.[6] Among the earliest illustrated Bibles printed on American soil was a collection of Bible-verse rebuses specifically geared to appeal to children.[7] The so-called *Hieroglyphic Bible* remained a popular and frequently reprinted publication into the early twentieth century. The imagery in the biblical rebus triggered the memory and supported the precise memorization of Scripture; the correct version of the text was provided at the bottom of the page (see fig. 44). An early-twentieth-century book entitled *Bible Symbols* stated the importance of the imagery for young readers: "The little one who bends his brow in earnest thought over a pictured text, calling upon mother again and again for help, will thenceforth carry a picture in his thought which will help to imprint the words upon his mind,—to come forth perhaps some future day in a time of stress and supply the needed bread of God for his soul's famine."[8] Memory was the place to store the "bread of God" for later use, and images were the means of installing it there.

The correlation of word and image was not a new phenomenon. The medieval justification of imagery as constituting the illiterate person's Bible was reiterated by Luther and is common throughout Protestantism today. Images are often recommended in Sunday school literature as effective learning aids.[9] Indeed, the letters I received clearly indicated that Sallman's pictures helped not only to commit the stories of the Bible to memory, but also to lodge firmly in place the very experience of one's pious childhood: numerous correspondents wrote that just looking at or thinking of the *Head of Christ* took them wistfully back to days of childhood piety (20, 71, 398).

Even among adults who feel that images are inappropriate within the worship space of the sanctuary, memories of religious education include the profuse use of images; nor did anyone voice opposition to the use of images in training children today. This discriminating iconophobia appears to be connected to an epistemology that regards rudimentary or childish thought as concrete and figurative, and sophisticated or adult thought as immaterial and abstract. This model of cognition clearly informs *The Bethel Series,* a Bible study program in wide use among evangelicals since the late 1950s that includes a series of forty paintings expressly intended as a mnemonic devices. Like figure 66, which depicts God's prophetic intervention in human history, each illustration visually summarizes a number of propositions distilled from the biblical text as God's intention or plan.

A description accompanying the study program indicates that the images are to aid in "the retention of what the student has learned in the study of the Bible itself." The text continues by insisting that the paintings "are not to be classified or labeled as 'art pieces.' They were neither designed nor intended to be so!" The point does not seem to be to apologize for poorly crafted images or to avoid offending the taste of a refined Christian public, but rather to preclude iconophobic suspicions that the imagery serves a function other than memory assistance. The images, the text goes on to say,

> are illustrations or posters which serve to summarize a body of knowledge and which carry specific meanings that have been *imposed* upon them. They have no meaning apart from the purpose which they fulfill in the classrooms where they are used. Merely tools to help the student remember and retain what he has learned, they become secondary to the primary objective, which is to acquaint church members with the message of the Scriptures, and they fall further and further into the background as the study progresses.[10]

The author was at pains to stress the strictly arbitrary, instrumental nature of the images as signs: conventional devices tailored exclusively to the illustrative function at hand, they operate as staunchly unilateral signs in that they yield only one meaning, bearing only that significance which has been "imposed" on them. Subordinated to the text, yoked to its service, *Bethel Series* posters serve only to help fix in memory what the student reads in Scripture. Accordingly, the structure of the imagery is heavily denotative: singular, emblematic signs float in the artificial space of a graphic field, each signifying a single idea within a reading of the Bible, the sum of which makes a coherent history of salvation and so spells out the divine plan for humanity. The range of signification is

FIGURE 66. Walter Ohlson, "History Itself Is the
Judgment of God," in *The Bethel Series* (Madison,
Wis.: Adult Christian Education Foundation,
1960). Courtesy of Rev. Harland Swiggam.

tightly controlled by a literary key that lists each symbol in an image and
provides its concise meaning. Once the denotation of these symbols is
conveyed early on in the study program, the instrumental signs may be
gradually discarded until they are no longer required at all—or so the
reader is assured. The assumption appears to be that the images are most
effective at the lowest levels of knowledge and least helpful at advanced
stages, that is, at those levels where the meaning of the Bible, as the study
series construed it, has been committed to memory. As a commercial en-

terprise, *The Bethel Series* sought to appeal to a broad variety of Christians: while some would be indifferent toward the images, others might be inclined to reject their role in learning unless assured of their purely instrumental value.

As Christians who awaited the imminent end of human history and the second advent of Jesus, nineteenth-century millennialists and dispensationalists might be expected to have rejected as vanity a cultural form such as art, which, by virtue of craft and the singular treatment of the material medium, is designed to draw attention to itself and its manner of creation.[11] But the power of images to assemble an overarching vision of human history was not lost on even the most iconophobic Christians. Indeed, millennialists and dispensationalists themselves developed a fascinating use of imagery that appealed to the memory both as a means of learning what the Bible says about the eschatological prophecies and as a means of interpreting those prophecies. Dispensationalists in Britain and North America stressed the importance of, to use their phrase, "rightly dividing the word," which, as British author John Ashton Savage put it in 1893, means "rightly understanding the scriptural order of truth." To this end, Savage included a "coloured chart or map" in his book *The Scroll of Time* (fig. 67), explaining that, by "appealing to the eye, through which the understanding and memory are more readily and vividly impressed than by mere verbal description—a comprehensive view of the order and relative connections of the several dispensations may be readily seen and remembered."[12]

For dispensationalists and millennialists, the history of time set out in Scripture formed a beauty best conveyed by elaborate charts providing a precise linear diagram of diverse aspects of biblical history and prophecy from Genesis to the Apocalypse. Such charts remained popular into the twentieth century in the work of Clarence Larkin (1850–1924), a Baptist pastor and mechanical engineer from Philadelphia, who wrote long books on biblical prophecy and copiously illustrated them with intricate charts, which he then used in Sunday morning sermons and Bible instruction (fig. 68).[13] Because as an engineer he was trained to visualize and decode schematic diagrams, Larkin found charts especially useful for presenting the series of historical epochs that constituted the divine dispensations of history that he and many evangelical Protestants understood Scripture to reveal. In a single carefully designed image, Larkin could encode an amazing breadth of information, thereby making biblical exegesis and the explication of dispensationalist doctrine very accessible. Larkin was proud to claim in the foreword to his study

FIGURE 67. "The Epochs and Dispensations
of Scripture," in John Ashton Savage, *The Scroll
of Time* (London: G. Morrish, n.d. [1893]),
frontispiece.

of the Book of Revelation that his meticulously executed diagrams contribute much to his discussion "by elucidating the text and saving much explanatory matter." Indeed, he believed that the images condensed a purely textual analysis by half. He insisted, moreover, that they were devoid of editorial opinion or speculation, illustrating in a clear and untrammeled manner what the Bible had to say: "The only Author the writer has sought to follow is the Author of the Book, the Lord Jesus Christ. Therefore the writer lays no claim to originality."[14] As he put it in the foreword to his most important work, *Dispensational Truth* (1918), "The charts had to be thought out and developed under the direction and guidance of the Holy Spirit."[15]

Millennialist visual culture in America is most indebted to the fascinating charts of the Millerites, a short-lived group of Adventists who expected the world to end first in 1843 and then, when it didn't, in 1844. The Millerites, an otherwise anti-iconic millennial group, were very fond of using schematic charts to visualize their interpretations of biblical prophecy.[16] The most famous image shows the apocalyptic arithmetic that moves from ancient Babylon to the final year of 1843, when "God's Everlasting Kingdom" was expected to arrive in accord with a long series of calculations based on figures and symbols from Daniel and the Book of Revelation (fig. 69). The Millerites had no use for pictorial imagery in the post-Renaissance tradition of art, and expressly forbade the naturalistic depiction of such scenes as the Ascension of Christ or the Last Judgment. Nevertheless, they widely used their charts in the public presentation of their prophetic teachings.[17]

A series of charts from 1840 to 1844 demonstrates the important role the Millerite imagery played in a constantly shifting, hotly debated theological discourse. The charts amounted to a method of organizing biblical events into a total gestalt that was best understood as a visual system of graphic, alphabetic, and numeric signs.[18] These images not only diagram prophetic history for the purpose of remembering what the Bible says, but also interpret Scripture in a sweeping manner. Such schematic imagery thus acts as a sort of software that programs memory as a directed information storage and retrieval system—a sacred data base. Memory becomes a visual chain of references, a hermeneutical construction of prophecy and history. Millerite hermeneutics and its visual mnemonics linked diverse parts of Scripture into a single lineage representing successive phases of human history from ancient Israel to the modern world. In contrast to the ancient tradition in which memory was regarded as a passive information dump, a mental wax surface that

THE TRIBULATION PERIOD
— OR —
DANIEL'S "SEVENTIETH WEEK"
THE
REIGN OF ANTICHRIST

FIGURE 68. Clarence Larkin, "Daniel's
'Seventieth Week,'" 1919, in *The Book of
Revelation* (Philadelphia: Rev. Clarence Larkin
Estate, 1946), facing p. 48.

merely receives sensory impressions which are later recalled, memory for the Millerites and later generations of fundamentalists was a dynamic act of interpretation, an explicitly visual process of constructing personal and communal identity.[19]

The activity of the eye as it surveyed a prophetic chart is quite relevant to millennialist iconophobia and the importance of memory. The charts abstracted prophetic imagery from the Bible and displayed it in a chronological framework such that extraordinary and sacred symbols were mapped over ordinary, profane time to emplot a trajectory along which the eye traveled in search of the end of time. The movement of the eye was restless, characterized by what we might call an "apocalyptic glance," in which the eye anticipated what was to come by looking beyond the individual images of the chart, refusing to rest on any one. Discontented with each moment of progress toward the eschaton or end of time, the believer looked impatiently to the next image, and the next. The believer's desire was deferred repeatedly to the future, requiring him or her to yearn with mounting anxiety and expectation for the yet-to-be-made-visible. As the eye arrived at the end of the prophetic chronology the believer arrived at the end of time, which was coincident with the present day—that is, the 1840s. Taking the events portrayed in "at a glance," which its commentators often hailed as the millennial chart's great virtue, meant refreshing the memory along the ceaseless march toward Armageddon. Deprivation of the object of contemplative vision powerfully engaged the imagination. Denied the object on which it might finally rest, the eye was thrust back over the pathways of memory to retrace the prophetically marked road to the long-awaited advent of Christ.

Memory provides a safe use for images. Pictorial images that appeal to time in the form of memory do not confuse sign and referent and therefore escape proscription among even the most iconoclastic Protestants. As noted above, many Protestants build a disclaimer into their response to imagery by insisting that a picture serves only as a reminder. A woman whose mother prohibited the use of "material images" wrote that "the main reason the magnet [with the *Head of Christ* reproduced on it] is on the refrigerator [in her home] is to remind me to thank the Lord for sending his son. Since I spend a lot of time in the kitchen, I figure I'd see it most often there" (165). In this appeal to memory, the visual image conjures a corresponding mental image or, as one respondent put it, an image in the "heart" (240), which is considered the more appropriate means of representing God—provided, that is, that the necessary disclaimers and

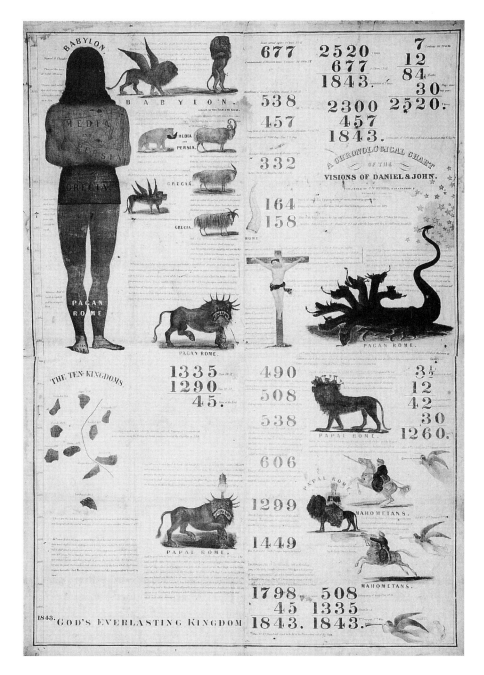

FIGURE 69. "A Chronological Chart of the
Visions of Daniel and John," published by Joshua
V. Himes, 1842, hand-tinted lithograph, B. W.
Thayer & Co., Boston. Courtesy of James R. Nix.

conditions of use are in force. When they are not, Sallman's art becomes idolatrous in no uncertain terms, as one woman wrote: "To my understanding, the picture 'Head of Christ,' when placed where people look at it when praying or worshipping God, is a graven image and we are doing or encouraging what we are told in the [second] commandment NOT to do" (202).

The memory aid and the commemorative image signify across time, through memory, and so preserve the difference between sign and referent. God's immediacy in prayer, worship, or devotion is understood as a personal relationship mediated by the *mental* rather than *material* image of Jesus. Yet the visual image is more than occasionally conflated with the mental image in the very form of a memory, producing such responses as the following from a woman who recalled first seeing Sallman's *Christ at Heart's Door* at age six: "In my 'mind's eye' this will always be the way Christ looks and will be until I see Him face to face!" (116). Many admirers of Sallman's pictures relate that the effect of seeing them in early youth was long lasting: "All of Sallman's impressions of Christ are unforgettable. Just at the mention of the titles of the others . . . a mental image instantly comes to mind. Few pictures are carried around so clearly in people's minds." (71). Another person wrote that the *Head of Christ* provided a great deal of comfort in his youth, and now that he is an adult, the image "brings instanteous peace to my mind when I see it" (206).

Yet memory has been no less important to the Roman Catholic intelligentsia as a justification for the use of images. In a polemical defense of the veneration of saints that omitted any consideration of the saint as a wonder-worker, Orestes Brownson, after quoting the Catholic catechism's proscription against prayer to relics or images, upheld the honor bestowed on such items by the devout as strictly commemorative: "Relics of saints, crucifixes, holy pictures, and images may be honored with an inferior and relative honor, because they are related to our Lord and his saints, and are memorials of them, and serve to keep them afresh in our memories."[20] Brownson then compared holy images and relics to portraits of one's beloved, locks of hair, and childhood keepsakes kept by mothers, none of which could be confounded with the person to whom they referred. The purpose of images of saints was to keep their memory and example "clear, fresh, and living in the heart."[21]

By the same token, memory is a powerful force that does not itself conform to the template of commemoration that church hierarchy would lay down as authoritative. In a special way, "portrait"-style im-

ages of Jesus, Mary, and the saints from the second half of the nineteenth century to the present can be seen to appeal quite strongly to memory. Writing of Maurice Halbwachs's theory of memory, Patrick Hutton has pointed to something "magic about memory," which he ascribes to the fact that memory "conveys a sense of the past coming alive once more. It touches the emotions."[22] Memory operates iconically in the sense that it attempts to recapture and hold on to certain features of the past, to re-present what is past by making it appear to happen again. The act of remembrance is magical because it repeats the past in mental imagery and in the sensations, time, place, and material forms that act as a kind of sensory trace. Memory cancels the temporal difference between past and present. Visual images help concretize or fix the mental imagery and sensations of memory. Some images of Christ and Mary examined in this study (see figs. 1, 55) thus serve as iconic signs of memory because they are images fashioned in what we might call the visual rhetoric of remembrance. Frequently executed in a monochrome and vignette style in which the floating head of the sacred person is rendered in a way that resembles commemorative portrait photography (or its premodern equivalent in this regard, the icon), these portrait-icons strike many devout viewers as concrete acts of memory, as the very image they have in their minds.[23] This commingling, even apparent identity, of subjective and objective domains, of the mental image and the physical one, is noteworthy because it merges idiosyncratic memories with collective ones. The image lodged in one person's mind is simultaneously shared with many others and becomes a material link binding groups together. As formulae passed down from one generation to the next and invested with characteristic feelings and notions, collective memories such as these naturalize a group's sense of the world, performing yet another vital act in the social construction of reality.

This brings us to the final function of memory to be examined here: memory as a narrative or an anecdotal recollection, a self-writing or personal construction of identity. Perhaps the most prominent theme in the positive responses to Sallman's imagery I received was women recalling the persistent role of the *Head of Christ* throughout their lives, its firm and fond placement in memory. The following passage from a woman whose husband had recently died serves as a fine example: "We know we are not to worship the pictures but we can find great solace, comfort and remembrance from [them]. His [Sallman's] picture of Christ hanging in [her husband's] room now reminds me that my husband is now with my Lord" (223). The second sentence in this passage repeats the adverb

"now" in an intriguing way: the *Head of Christ* in her husband's room *now* reminds her that her husband is *now* in heaven. What is it she needs to remember? Her husband's absence? Hardly, but rather his presence, his "now-ness," in heaven, contemporary with (but spatially removed from) her. Time joins the two, even though space separates them. It is time, spanning the gap of physical absence, that connects the two through memory as evoked by the image.

For many of Sallman's admirers, the site of the holy is not construed spatially, in terms of a sacred space, but temporally, as *time* constructed *in memoriam*. Memory constitutes the principal use of Sallman's art among those respondents who make a point of discounting any application of the image to prayer, worship, or devotion. Viewing the image as a temporal marker, as the visual sign of divine action over time in a family, marriage, or personal life, *rationalizes* and therefore defuses what many Christians fear: the spatial confusion of the visual sign with its heavenly referent. This fear originates in the practices of Protestant upbringing, which widely regard memory as the appropriate means of understanding divine presence in human history and individual lives. In other words, because memory or retrospection—looking back from a distance—is for many Protestants the central means for discerning God's activity, idolatry threatens to negate memory by collapsing the distance by which divine action is discerned into a single, atemporal, physical presence. Deprived of the narrative perspective that memory avails, many Protestants find images either meaningless or threatening.

Nevertheless, memory can also be used to conceal the desire to merge sign and referent. Despite the disclaimer—indeed, because of it—the picture of Jesus can be deftly transformed into Christ himself. Consider the following letter from a navy wife who subtly conflates the picture as her anchor with Christ as her anchor:

> This picture [the *Head of Christ*] has been with me since 1959—my high school years, my university years, my many moves as a military wife, and now it has a somewhat permanent place in our home. . . . It has provided me an anchor throughout my life. Not as a picture to worship, more as a shadow under which I could find a resting place amidst the ups and downs of adolescence, the changing of homes with new orders, my husband on a ship off the coast of Viet Nam, the birth of our son, the death of our adopted daughter, the special needs of an emotionally handicapped adopted son—in all of these Christ remains my anchor. (186)

By the close of the passage the picture of Christ has become Christ himself. This slippage from sign to referent can comfortably occur only

when insulated by a thick mantle of memory and under the cover of a plainly stated denial of worshipping the picture. Memory appears to enforce denial, but actually uses it to mask its work of recovery, of representation. Memory in this sense is anything but a passive storehouse, a dead space in which to put things.

MODES OF REMEMBRANCE: NARRATIVE AND ANECDOTAL MEMORY

Of course, for many Sallman's imagery of Jesus is deeply embedded in memory but is not mistaken for the prototype. As these people reflected on Sallman's art, they realized that God's presence in their lives was best viewed over time, in retrospect. This is readily apparent in letters that present a personal narrative in which Sallman's image of Jesus served as a focal point or lens and not merely as a memory aid. I would like to distinguish this narrative mode of memory, with its tendency to construct the past along enduring threads of events keyed to a particular image by Sallman, from what I will call anecdotal memory. By the latter I mean the use of a single, discrete unit of memory, an event-centered memory told and retold by owners of Sallman imagery, but particularly by those around forty years of age or under. This group of respondents, in discussing an image, more often than not raised the memory of a single event, such as a crucial rite of passage or a tender moment or brutal experience from youth. I do not mean to trivialize this kind of memory by calling it "anecdotal"; I use the term only to characterize its structure and to differentiate it from the narrative form of memory more frequently employed by older respondents. The evidence of the letters suggests that anecdotal memories form the units that in old age are gathered together into narratives. Yet there is, as I will show, an important functional difference: anecdotal memory solves discrete problems arising in the individual's life (such as a fearful situation), while narrative memory fabricates an overarching gestalt, the larger meaning of an individual's life course.[24]

Interestingly, women, who responded to my query more than men by a factor of two, portrayed a familiar pattern of tracing their lives by means of Sallman's pictures. A woman from Little Rock, for instance, had this to say of the *Head of Christ:* "A copy of the picture was given to me when I graduated from high school by the counselor of my MYF [Methodist Youth Fellowship] group. That particular copy has been in my home since 1950 until a few years ago [when she gave the picture to

her granddaughter]. It has been there for me from college years to grand-motherhood and all the stages in between." In a remarkable passage this woman reflected on the role Sallman's picture has played for many: "I believe Christ speaks to us through our families, through other people and through the Church with all that it brings to our lives. . . . Some-where intertwined in all of this, without a doubt, Sallman's head of Christ has been there for me as a lovely, brilliant and strong thread wo-ven through the tapestry of my life" (5). This woman and many like her have come to recognize divine presence in their lives through a process of remembering that is both stimulated and guided by the *Head of Christ*. It is no accident, of course, that most respondents were older and therefore in a position to look back on their lives. But not all wrote from that perspective. A recently ordained clergywoman reported that the *Head of Christ* "connects me profoundly with my roots. I cannot see it without remembering my childhood and the Sunday school days it rep-resents. Those days—the churches, pastors and my parents—were to be a deciding factor in surviving hardships in my adult life and then pur-suing the ministry" (20).

Many respondents were women who grew up in the 1940s and 1950s. A Lutheran woman who entered high school in 1949 recalled *Christ at Heart's Door* in her school. She and her sister gave a copy of the image to their parents as a wedding anniversary gift. It hangs today in their mother's home. The respondent's own daughter, who long ad-mired the picture, now displays it in her own home, a gift from her chil-dren. Four generations, the respondent concluded, "have been reminded of our Savior by this very beautiful picture" (265). Sallman's pictures ap-pear to enable women to tell their stories, to find a voice within the do-main of the home, the domain that is their own. Many women find in the imagery a golden thread running throughout their lives. Sallman's imagery provides the means of personal testimony and an intergenera-tional tradition of handing down the same picture from mother to daughter.

I have suggested elsewhere that the largely negative response to Sall-man's work, which is dominantly male and clerical, is in some degree motivated by the imagery's association with women.[25] Many of Sall-man's detractors may recognize in it something that belongs to the tra-ditional domain of women, the home and the Sunday school classroom, and hence that is imbued with a female voice and experience. One Methodist clergyman who expressed a strong dislike for Sallman's im-agery wrote that the pictures "are redolent of mildewed hymn books and

In the Garden sung with a nasal twang" (298). As we saw in chapter 3, it was the association of female authority and effeminate images of Jesus that conjured Bruce Barton's very negative memory of Sunday school. Barton recalled that as a young boy in Sunday school he rebelled instinctively against his teacher, "a kindly lady who could never seem to find her glasses" and who failed to comprehend the boy's inner turmoil; as for the picture of Jesus in the classroom, it "showed a pale young man with flabby forearms and a sad expression."[26] Barton blamed artists for portraying a feminine Christ, and some men who wrote to me stated a preference for not imaging Jesus. This may very well extend the conservative Protestant epistemology cited earlier in which images represent the immature learning of children. For adults, and particularly for men, the assumption seems to go, images can only fail to do justice to Christ. One African-American man stated that the *Head of Christ* is inadequate not only on racial grounds, but also because it is "soft" and "romanticized." He went on to point out that he was not inclined "toward any art which depicts the Christ in such an absolute way, I prefer the more suggestive and symbolic." Although the *Head of Christ* was a "'lovely' work of art" that might be displayed in a museum, it should not be placed in churches and should "NEVER [hang] above the altar" (77). The writer provided a poem entitled "His Hands," which focuses on Christ's hands as the index of his character and life's work: "soft, small and red" at birth, but "strong, calloused and scarred" in manhood. Hands, the fetishized symbol of male action, the instruments of manly labor, serve as the substitute for the countenance of Jesus, which has no place in the worship space. The hands replace Christ's face in obedience to the taboo of looking upon God, and assert Christ's masculinity.

Given many men's insistence on the masculinity of Jesus and the accusation that Sallman's picture feminizes Christ, it is no surprise that virtually three-quarters of respondents expressing a positive view of Sallman's art were women. This is not surprising especially when we consider that domestic memory is a cult whose priesthood has been female. As those who have tended the hearth and home, it is more often women who have collected family photographs (and placed Sallman's Jesus on the wall among portraits of their loved ones [416, 452; see fig. 61]), gathered heirlooms, organized and preserved the paraphernalia of remembrance such as letters, greeting cards, and anniversary gifts, and attended to photo albums; and it is women, after all, who live longer.[27] Outside the home, especially in the public worship space of the church, women are also often the principal participants in devotional acts of

memory. Many of the women who wrote to me were in fact widows who took the opportunity to reminisce.

Mihaly Csikszentmihalyi and Eugene Rochberg-Halton found that the women they interviewed concerning the importance of household objects cited "memories" as the reason for an object's value significantly more often than men did. In fact, the evidence they gathered clearly suggests that American women are formed from childhood by relationships with their parents that stress the importance of memory, and of keeping memories alive.[28] In a recent study of American folklore, one scholar examining the placement of memorial poetry and photographs in local newspapers came to the same conclusion: "It is the women's role to mark family occasions during the calendar year and the life cycle, and they regard it as their privilege, as representatives of the family, to report and publicize joyous and mournful changes in its life by means of the newspaper and column."[29] Sallman's picture, so frequently presented as a wedding or anniversary gift, provides women viewers with a cherished mnemonic device for discerning a narrative order in their lives, the primary function of which is to disclose the benevolent and constant presence of God.

Respondents to my query were not, however, uniformly of middle or older age. A small number were around or less than age forty, and they also discussed the role of the imagery in their memories of youth and religious formation. This suggests that what I have called narrative memory or the retrospective construction of the life course is not the only way memory makes use of popular religious images. Memory is also keyed to devotional images encountered in youth, especially as it is associated with rites of passage. We discussed ritual in the previous chapter in connection with domestic space; let us now consider it in regard to memory.

Of the 531 letters I received, 14 writers stated that they were less than forty years old; 8 writers stated their age as between forty and forty-three, and 8 more provided enough information to indicate a similar age range. From this group of 30 respondents I noted that memories of Sallman imagery tended to have been formed in childhood, typically at less than the age of seven or eight. Frequently the imagery evoked memories of singular events that had a marked emotional character for the respondent. It is noteworthy that, with one exception (104), memories in these letters were not prefaced with the characteristic qualification found in letters by older writers that the image was not worshipped. Why? The disclaimer may not be necessary because the image is already wrapped

safely in memories, the essential means of retrieving episodes of childhood among younger respondents. Youth, after all, is a period of life when images are considered acceptable even by Protestant groups that proscribe or limit their use in adult life. Memories were associated with the imagery when the image assisted the child in negotiating the pain or threat of an unpleasant experience, or symbolized for the child the pleasure of comfort and security from a benevolent heavenly parent. And perhaps the image offers the adult the opportunity to invent or modify certain memories. In the case of memories of negative experiences in particular, Sallman's pictures are often cited as having helped the writer resist temptation, battle fear, endure grief, shock, or separation, undergo religious conversion, or leave a familiar place and move to a new one. One man indicated that he acquired the *Head of Christ* as a young man in the military service during the 1960s. He found the image at a Christian Service Center, which he frequented while in foreign ports rather than "bars and whore houses" (413). A woman associated the picture with her family's deliverance from a household fire during her childhood (527). A seventeen-year-old woman recalled the important role Sallman's picture of Jesus played in her consolation during the successive funerals of two family members (412). Another woman recalled the importance of the image in calming her during a childhood troubled by an alcoholic parent (259). And a thirty-two-year-old woman from Las Vegas saw in the *Head of Christ* a moving reminder of her recent religious conversion (469).

The second most common anecdotal form of association with Sallman's imagery cited by younger viewers were memories of peace and security during youth (40, 104, 171, 259, 443, 463, 488, 527). Many respondents remarked that their own fond childhood memories of the image of Jesus moved them to give the *Head of Christ* as a gift to their children in the hope of securing for them the same emotional benefit (37, 104, 253, 443, 463). Often memories of both difficult or challenging moments and incidents of consolation or protection were closely linked in memory. In these cases, the function of the image at the time and thereafter in the ritual of remembering and recounting for others appears to be to manage change in a way that preserves a sense of self in the face of transformation. On the one hand, memories form and persist in their retelling because unpleasant events are internalized; anxiety over the event is then controlled by affective attachment to Sallman's imagery. On the other hand, pleasant memories endure because they offer a source of comfort, which in turn is symbolized by the image. Among the most per-

vasive forms of visual piety is the image's evocation of a constant benev-
olent presence, something that many respondents associated with the
earliest stages of their childhood consciousness. As one writer said of
Sallman's pictures, "I think [they] represent my Christian foundation,
I've seen them for so long" (411). As we saw in chapter 1, many identi-
fied the *Head of Christ* with the mental image hovering in their minds,
the composite or archetype that corroborates the visual image when they
see it. As a symbol of parental love and benevolence, the image is keyed
to memories buried in what are perhaps the deepest strata of personal
identity. Memories quickly form in periods of crisis and transformation,
and potent symbols appear as the means of accessing and reaccessing the
critical event in order to resolve the conflict it posed and to secure a sense
of self.

By situating the use of images in the operation of memory, it becomes
possible to recognize the importance of each in the economy of the self
and its social life. Anecdotal and narrative memory are operations trig-
gered by images and are therefore a significant aspect of the visual piety
of many believers. As we have seen, memory makes images acceptable
to a broad religious culture that is otherwise given to declaring itself
anti-iconic. But we can extend the role of memory beyond the case of
iconophobic Protestantism. In fact, the sacred happens in the recounting
of the past generally, for it is in such acts of memory that believers en-
counter the social world of relationships, anxieties, and desires that
structure their worlds. As Berger and Luckmann point out, "Only with
the appearance of a new generation can we properly speak of a social
world." It is through the sedimentation of discrete experiences in the ter-
rain of memory "as recognizable and memorable entities," occasioned
as a transmission from parent to child, that moments of early life thicken
into symbols and affix themselves to the objects that attended or have
come to stand for their birth. Such childhood memories are preeminent
in what sociologists call "primary socialization" or the induction of the
children into a social world.[30] Thus, the child's active willing, fearing,
and enjoyment are guided by its parents to the objective form of devo-
tional iconography, which in turn gazes steadfastly back into the world
and the eyes of the waiting child. As we have seen, this exchange, this di-
alectic of world-making conducted as visual piety, does not end with
childhood, but develops into the narratives of adults.

\\\|||///

CONCLUSION

RELIGIOUS IMAGES AND THE
SOCIAL CONSTRUCTION OF
EVERYDAY LIFE

D iscussion in the foregoing chapters has ranged from how viewers
engage devotional images through looking to the embodiment of
the gaze in sympathy and empathy; from the use of images as a
statement of gender ideals and the experience of friendship to the inter-
relations of word and image in popular religious and avant-garde art;
from the placement of images in the home and their significance in rit-
ual to the image's articulation of memory. Vision, passions, gender,
friendship, representation, cultural hierarchy, domestic space, ritual,
memory—we can easily condense these subjects into a smaller configu-
ration of social categories. Embedded in the several topics taken up in
this book are the forms of association, order, and representation that
structure everyday life, and do so in the visual practices of belief we have
examined. I would like to close this study with a reflection on everyday
life and the role of popular religious images in its construction and
maintenance. The German historian Hans Medick has remarked that
what concerns the "historiography of Alltag [the everyday] is the at-
tempt to reveal the cultural and social 'construction,' 'structuration,' and
changes in authority and economy as manifest in everyday circum-
stances and modes of life."[1] Of special interest here is historical analy-
sis of the habitus as constitutive of a world, providing its inhabitants, as
we saw in the Introduction, with the conscious and unconscious codes
and protocols that shape practice in the form of decisions, routines,
ceremonies, and rituals, the acts by which a world is built and made to
cohere.

Analysis of images and their reception indicates that repeated and routine usage of and ritualized interaction with devotional images generates a stability or baseline against which to measure one's well-being. Sallman's *Head of Christ* became a more compelling image for believers each time they saw it and reflected on its place in their lives (chapter 1) and on each ritualized occasion of its use (chapter 5). Pierre Bourdieu asserts that the collective "orchestration" of the habitus, its informing of common practices in a group, is fundamental in "the production of a commonsense world endowed with the *objectivity* secured by consensus on the meaning of practices and the world. . . . The homogeneity of habitus is what—within the limits of the group of agents possessing the schemes (of production and interpretation) . . . causes practices and works to be immediately intelligible and foreseeable, and hence taken for granted."[2]

Ordinary reality takes root as we come to take its familiar features for granted, that is, as we forget or release from conscious attention the conditions that relate us to the world and to one another. The self acquires consistency and character through the repetition of familiar routines. Neither reality nor self is absolute, fixed, or transcendent. Both are constructed over time from roles and routines, and both evolve, smoothly or abruptly, in interaction with new roles, performers, and conditions of performance. The human self and the social reality that we accept as given are carefully, densely built up. They endure, more or less, as tenacious but ever changing formations; as desirous of permanence as they are, they can never be fixed in place.

Debate over the nature of the self in contemporary critical thought warrants further consideration here of the self as socially constructed.[3] When we think of all the duties a person routinely performs, we realize that the self must be a dense, lifelong weave of roles, internalized templates, scripts awaiting completion and performance. We are each relatively unique deposits of enactments, of countless reinforcing strata. Invested in the historical forms that generate it, the self draws in its every act and decision from the habitus, what Bourdieu calls "a matrix of perceptions, appreciations, and actions."[4] As each self's evolved uniqueness in turn interacts with others and with the institutions of society, new roles are created. We each enact roles that we create, rewrite, inherit, or have thrust upon us. The self, then, is not a loose configuration of roles but a vast repertoire cohering around a tightly knit core, itself a historical formation but one whose origin occurred so early in life that it is un-

available to memory and, in its earliest phases, hardly distinguishable from the biology of pleasure and pain that makes up the infant's life.

Religious images are a composite representation of many roles condensed into a single life: the role of the playful child, the rebellious adolescent, the optimistic newlywed, the dutiful spouse, the harried parent, the benevolent grandparent, and so on. Each of these roles may have been instituted with the ritual gift of an image and is easily enshrined in memory by means of it. Images and all forms of material culture that enable remembrance, ritual, and the socialization of key roles in daily life assist one in putting into practice the routines that constitute the symbolic world of an individual. This practice is not a dictation from an ontologically superior spiritual domain, the mind of a culture, as it were, but the embodiment of observed behaviors, stories, images, and material objects. The habitus is not situated above the clouds but in the memory, in the body of each social actor.

We might say that a world or habitus consists of all the roles, scripts, stages, and past performances that form the common fund of a society and are instantiated or remembered in the choices an individual makes when interacting with others. It is the function of religious images in visual piety to secure the world or sense of reality in which the self finds its existence. I stated at the outset of these concluding remarks that the subjects discussed in each chapter are reducible to three categories of social structure: association, order, and representation. The uses of images examined in this study have articulated and reinforced particular kinds of association, order, and representation as structures central to what Peter Berger and Thomas Luckmann call the making and maintenance of everyday reality. For instance, we saw in chapter 4 that Lutherans and Catholics each read their own dogmatic tenets into the images hidden in the *Head of Christ*. Liberal Protestant clergy could see a figure as female, whereas Catholic viewers decoded the same figure as male. By the same token, as we saw in chapter 3, those viewers for whom a jingoistic masculinity was important in order to reassert male dominance in the church discerned like features in their envisioning of Christ. The rhetoric of Christ's masculinity led some to hail Sallman's image as ideal and others to denounce it as exemplary of an effeminate perversion of Christianity. In each case an image served to foster associations within Christian society that symbolized and affirmed discrete group identities.

Closely related to the function of association is the use of popular religious images to reinforce particular forms of social order such as sta-

tus. Chapter 2 explored the development of the affective relation of the viewer to the image as an important part of the way images have been encoded with conceptions of gender, the self, the family, and relations to social inferiors such as the poor, the immigrant, the destitute, and people of another race. Another kind of order installed by images is the creation of a space for role performance and of a stage for ritual celebrations conducted in the home (chapter 5). The ritualized use of religious imagery is especially powerful in preserving order as the believer negotiates change, such as passage from one social status to another (for example, childhood to adulthood, single to married).

Finally, images have contributed vitally to the task of self-representation. Religious images articulate and symbolize roles to be performed among teachers and students, parents and children, clergy and parishioners, bereaved and friends, counselors and clients, as well as a range of relations among family members, relatives, friends, laity, and fellow believers. As noted in chapter 6, images serve many in the creation of personal and family narratives or of an understanding of their relation to their past or family. The image comes to stand as a collective representation of personal relationships or community.

Complementing the importance of the religious image for autobiographical memory is the image's contribution to social or collective remembrance. As suggested in chapter 1, an image draws believers together by interpreting the visual record, coming to stand authoritatively for the Jesus pictured in all previous visual traditions. The social construction of everyday life operates powerfully in the collective memory of visual piety. The historical pattern of change at work here accentuates not radical innovation, but artistic renovation or updating. In this scheme, some change is necessary if social memory is to be strengthened. Moderate change allows the tradition of depicting Christ to be appropriated and assimilated to the situation at hand. The introduction of superficial differences reaffirms underlying unity and assures historical continuity because likeness in this scheme consists of renewing the relationship between the present and the ancient past. This is achieved by estranging the present from its immediate temporal predecessor. Thus, Sallman's *Head of Christ* could be seen by many as much more satisfactory than Hofmann's like-titled image (chapter 3).

It is important to understand that this historical scheme is quite modern. First, it accords nicely with the modern notion of progress: each generation draws closer to the truth; each artistic master builds on the ac-

complishments of his or her forebears and so likewise draws closer to the truth. Second, this notion of history and the social memory it conducts accommodates the modern free market and particularly the dynamics of mass consumption. Product novelty is an economic expression of the everyday as well as a form of social memory that prospers in the ever quickening rhythms of capitalism. Renewing the past instead of radically replacing it, the everyday life of belief that visual piety constructs and maintains leans heavily on imagery rooted firmly in the traditional past.[5] Modern consumption, with its regular patterns of superficial stylistic change and planned obsolescence, has helped many visual pieties to secure a traditionally grounded sense of the world by encouraging successive generations to update existing versions of Christ's image for their use.

The theory of popular religious visual culture advanced here posits that by becoming constant and virtually transparent features of daily experience, embedded in the quotidian rituals, narratives, and collective memories that people take for granted, religious images help form the half-forgotten texture of everyday life. As part of the very fabric of consciousness, religious images participate fundamentally in the social construction of reality. It is not the image itself, as an intrinsically meaningful entity, but the image as it is articulated within social practices that helps to assemble and secure the world of a believer. Religious images, as Durkheim said of religion itself, are "eminently social."[6] They are not, as determined in chapter 1, rarefied things that individuals dispassionately contemplate. Neither are their meanings strictly private; rather, they are inflected within and constitutive of the social world that binds individuals together. Again and again we have found that religious images assist in fashioning the impression of a coherent, enduring, and uniform world in which the self exists meaningfully. Religious imagery anchors everyday life to reliable routines in the home and important relationships and stabilizes and particularizes the historical Jesus as the authority of faith and religious affiliation.

The practice of visual piety, ensconced as it is in everyday life, belongs to the world-making activity of human culture. At the heart of this process is the construction of the self and its social habitat. Hardly reducible to a single performance, the formation of the self in everyday life makes use of popular images in surprising ways. Contrary to the grim cliché of mass-culture automatons, the self in modern mass society still retains the capacity for self-determination. Even mass-produced artifacts like so many of the images studied here have been appropriated and

transformed into the local culture of a specific community of belief, as we saw with the identification of hidden images (chapter 4), or integrated into idiosyncratic and self-affirming life narratives (chapter 6). Yet this process remains a social enterprise, and fundamentally a historical one. It is my hope that this study has demonstrated above all that popular religious images need to be understood as historical traces of the worlds they helped to construct.

\\\|||///

LETTERS AND
DEMOGRAPHICS

Throughout 1993, seventy-three religious publications of diverse confessional and denominational affiliation or orientation were contacted with the request to query for information concerning readers' response to the art of Warner Sallman. The sample was selected almost entirely from the listing of religious periodicals in the United States compiled in the *Yearbook of American and Canadian Churches 1992*, ed. Kenneth Bedell and Alice M. Jones (Nashville: Abingdon Press, 1992), 231–42; colleagues suggested a few other titles. The periodicals queried broke down as follows: 2 African-American, 6 Baptist, 5 Church of God, 10 Roman Catholic, 12 Pentecostal, 4 Lutheran, 5 Methodist, 10 Fundamentalist, 1 Mormon, 1 Salvation Army, 5 Evangelical, 1 Reformed, 2 Presbyterian, 2 Nazarene, 2 Disciples of Christ, 2 Church of Christ, 1 Evangelical Free, 1 Liberal Protestant, 1 Evangelical Covenant. Only twenty of those contacted agreed to run the ad. In addition, at least five other sources—one periodical (Church of God in Christ) and four church bulletins or newsletters (Presbyterian, Independent, Methodist, and United Church of Christ)—ran the advertisement without having been contacted.

The ad consisted of a small black-and-white reproduction of Sallman's *Head of Christ* and some variation on the following text: "Do you know this picture? A group of scholars is studying the role this image and others by the artist Warner Sallman (including 'Christ at Heart's Door,' 'The Good Shepherd,' and 'Christ in Gethsemane') have played in the lives of Christians. Does Sallman's *Head of Christ* or any other of

his works hang in your home, school, or church? What has the imagery meant for your devotions, worship, prayer, family, or friends? Please send response to David Morgan [with my address]."

A total of 531 responses were received. They were numbered in order of receipt and have been deposited in the archives of the Jessie C. Wilson Galleries of Anderson University, Anderson, Indiana, where they may be consulted according to the letter number to which I refer in the text.

An article on the project appeared in the *Chicago Tribune* of March 4, 1994, and subsequently was carried, via the Associated Press wire service, by several papers around the country. Approximately 20 letters in the total of 531 were received from readers of this story, as well as from the audience of a Chicago radio station (WMBI FM-90.1), which aired an interview with the author on the project.

The following information offers some analysis of the raw data, although I hasten to point out that these statistics are not quantitatively rigorous. They merely provide general features of the response and the respondents.

Of the total 531 respondents, 168 (32 percent) were identifiable as men, 351 (66 percent) as women.

Sixty-one respondents (11.6 percent of those who expressed an opinion) had a negative view of Sallman's work. Of these, 30 percent were male clergy; none were female clergy. Thirty-nine respondents expressed no opinion, 427 (80.4 percent) were favorable toward the imagery. Men wrote 60 percent of the unfavorable responses, and women wrote 72 percent of the favorable responses; 15 percent of favorable responses came from people who identified themselves as clergy.

The average age of correspondents who identified their age or provided reliable means for doing so (such as date of graduation from high school) was fifty-nine. Of these 93 respondents (18 percent of the total), the youngest was seventeen and the oldest ninety-three; 14 indicated an age of less than forty, 20 were between forty and fifty-four, and 59 respondents indicated that they were fifty-five or older. An additional 113 respondents (21 percent of the total) provided enough information to determine that their age was over fifty (i.e., by indicating years of marriage, number and age of children or grandchildren, or number of years retired). Of this group, 33 appeared to be over sixty-five. This raises the average age of respondents into the sixties, an age that corresponds meaningfully to the date of Sallman's art: in the early 1940s many of the respondents would have been in their late teens or early twenties; in

other words, they were the generation that fought in World War II and matured in the postwar, baby boom years.

Of the 531 total, 128 respondents either identified themselves as Methodist or responded to the ad placed in the *United Methodist Reporter;* 99 identified themselves as Lutheran or responded to the ad in *Lutheran Witness* or *Lutheran Partners;* 20 identified themselves as Roman Catholic; 21 identified the evangelical *Christian Reader* as the source of their response, 17 identified the fundamentalist *Christian Standard* as the source of their response; 27 identified themselves as Seventh-Day Adventists or responded to the ad placed in the (Adventist) *Signs of the Times;* 14 identified themselves as members of the Evangelical Covenant Church or responded to the ad placed in the *Covenant Companion;* 14 identified themselves as Baptist or responded to the ad placed in the *Beacon;* 10 identified the *Christian Century* as the source of their response; 6 identified themselves as Mormons, 5 as members of the Church of God, 5 as members of the Church of the Nazarene, 4 as Presbyterians, 3 as Anglicans, and 2 as Disciples of Christ. I do not list here church affiliations that occurred only once, nor do I include respondents who did not identify a confessional affiliation.

Of the 531 letters, 512 indicated a point of origin: 203 (40 percent of those that specified) originated in one of twelve midwestern states (Michigan, Ohio, Indiana, Illinois, Missouri, Iowa, Wisconsin, Minnesota, North and South Dakota, Nebraska, and Kansas); 85 (17 percent) in the South (Arkansas, Louisiana, Tennessee, Kentucky, Alabama, Georgia, Florida, North and South Carolina, Virginia, and West Virginia); 73 (14 percent) in the Northeast (the New England states, Maryland, Pennsylvania, New York, and Maine); 65 (12 percent) in the Southwest (Oklahoma, Texas, Arizona, and Colorado); and 63 (12 percent) in the West and Northwest (California, Nevada, Utah, Wyoming, Montana, Idaho, Washington, and Oregon). One letter each came from Hawaii and Alaska. Twelve letters arrived from four provinces of Canada, and a remaining nine from the Philippines, Hong Kong, England, New Guinea, Japan, South Africa, and Tanzania. The only states not represented by letters were Mississippi, New Mexico, Vermont, and Rhode Island. The majority of responses came from the central and northern United States. Sixty percent (306) of the letters with an identifiable origin came from eleven states: Illinois (46), Texas (40), California (38), Pennsylvania (28), Indiana (27), Ohio (25), Missouri (25), New York (22), Florida (20), Wisconsin (18), and Minnesota (17). No

more than twelve letters came from any one of the remaining states. The geographical areas of sparest response were the New England states, with a total of fourteen letters, and a cluster of six western states: fifteen letters altogether originated in Nevada, Utah, Idaho, Montana, Wyoming, and Colorado. Major cities most frequently serving as points of origin were Chicago, St. Louis, and Dallas.

NOTES

PREFACE

1. I take the notion of "commemoration" from the Foucauldian critique of such historiography; see Patrick H. Hutton, *History as an Art of Memory* (Hanover, N.H.: University of Vermont and University Press of New England, 1993), 111–12, 119.

2. Ibid., 123.

3. See, for instance, Alf Lüdtke, "Introduction: What Is the History of Everyday Life and Who Are Its Practitioners?" in *The History of Everyday Life: Reconstructing Historical Experiences and Ways of Life,* ed. Alf Lüdtke, trans. William Templer (Princeton: Princeton University Press, 1995), 3–40.

INTRODUCTION

1. Related by John Shelton Reed; my thanks to John W. Dixon Jr. for the story.

2. Colleen McDannell, *Material Christianity: Religion and Popular Culture in America* (New Haven: Yale University Press, 1995), 4–5.

3. The 531 letters are located in the Sallman Archives of the Jessie C. Wilson Galleries, Anderson University, Anderson, Indiana. I refer to them by number in parentheses throughout this book. An analysis of the letters appears in the Appendix.

4. A Vatican consultant who reviews claims for canonization told Kenneth Woodward that stigmatics and visionaries suffer wounds and see apparitions that reflect in detail the features of images they have seen and used in devotions; see Woodward, *Making Saints: How the Catholic Church Determines Who Becomes a Saint, Who Doesn't, and Why* (New York: Touchstone, Simon & Schuster, 1996), 178.

5. On practice, ritual, and the construction of reality, see Catherine Bell, *Ritual Thinking, Ritual Practice* (New York: Oxford University Press, 1992), 69–93; and Pierre Bourdieu, *Outline of a Theory of Practice*, trans. Richard Nice (Cambridge: Cambridge University Press, 1977).

6. Bourdieu, *Outline of a Theory of Practice*, 164: "When there is a quasi-perfect correspondence between the objective order and the subjective principles of organization . . . the natural and social world appears self-evident. This experience we shall call *doxa*." The habits that structure social life and their dialectical formation through interaction with the "objective order" form the habitus.

7. Mihaly Csikszentmihalyi, "Why We Need Things," in *History from Things: Essays on Material Culture*, ed. Steven Lubar and W. David Kingery (Washington, D.C.: Smithsonian Institution Press, 1993), 22; see also Mihaly Csikszentmihalyi and Eugene Rochberg-Halton, *The Meaning of Things: Domestic Symbols and the Self* (New York: Cambridge University Press, 1981), esp. 90–120.

8. Csikszentmihalyi, "Why We Need Things," 23.

9. See Lee Rainwater, "Fear and the House as Haven in the Lower Class," *Journal of the American Institute of Planners* 32, no. 1 (January 1966): 23–31; Maxine Van de Wetering, "The Popular Concept of 'Home' in Nineteenth-Century America," *Journal of American Studies* 18, no. 1 (April 1984): 5–28; Kirk Jeffrey, "The Family as Utopian Retreat from the City," *Soundings* 55 (1972): 21–39; Colleen McDannell, *The Christian Home in Victorian America, 1840–1900* (Bloomington: Indiana University Press, 1986); Margaret Marsh, "From Separation to Togetherness: The Social Construction of Domestic Space in American Suburbs, 1840–1915," *Journal of American History* 76, no. 2 (1989): 506–27; and Tamara K. Hareven, "The Home and the Family in Historical Perspective," *Social Research* 58, no. 1 (spring 1991): 258–59 (reprinted in *Home: A Place in the World*, ed. Arien Mack [New York: New York University Press, 1993], 227–59).

10. Peter L. Berger and Thomas Luckmann, *The Social Construction of Reality: A Treatise in the Sociology of Knowledge* (Garden City, N.Y.: Doubleday, 1966), 48.

11. Ibid., 123. Csikszentmihalyi and Rochberg-Halton say the same: "The relationship between social systems and personal consciousness, each structuring and being structured by the other, is so delicate as to appear circular" (*Meaning of Things,* 7). The status of the self in constructivist thought is the subject of contemporary debate; see, for instance, *Constructions of the Self,* ed. George Levine (New Brunswick, N.J.: Rutgers University Press, 1992). I explore this subject at greater length in the Conclusion. For theoretical, philosophical, and historical considerations of constructivism, see *Constructions of the Self;* and John R. Searle, *The Construction of Social Reality* (New York: Free Press, 1995); for an intellectual history of the development of concepts of individuality and the self, see Georg Simmel, "Freedom and the Individual," in Simmel, *On Individuality and Social Forms: Selected Writings,* ed. Donald M. Levine (Chicago: University of Chicago Press, 1971), 217–26; Charles Taylor, *Sources of the Self: The Making of the Modern Identity* (Cambridge, Mass.: Harvard Univer-

sity Press, 1989); and Irving Howe, "The Self in Literature," in Levine, ed., *Constructions of the Self,* 249–67.

12. Berger and Luckmann, *Social Construction of Reality,* 62, 123.

13. Grant McCracken, *Culture and Consumption: New Approaches to the Symbolic Character of Consumer Goods and Activities* (Bloomington: Indiana University Press, 1990), 73. For other recent studies of the process of externalization from a material culture perspective, see Daniel Miller, *Material Culture and Mass Consumption* (Oxford: Basil Blackwell, 1987), who has examined the concept of objectification from Hegel to Simmel and applied insights from this intellectual history to the anthropological study of modern mass culture; and Simon Coleman, "Words and Things: Language, Aesthetics, and the Objectification of Protestant Evangelicalism," *Journal of Material Culture* 1, no. 1 (1996): 107–28.

14. Pierre Bourdieu, *Outline of a Theory of Practice,* 72–95; Bourdieu, *Distinction: A Social Critique of the Judgement of Taste,* trans. Richard Nice (Cambridge, Mass.: Harvard University Press, 1984), 169–75. For a discussion of the habitus and the study of material culture, see Miller, *Material Culture and Mass Consumption,* 102–6. For a consideration of Bourdieu's idea in regard to *Alltagsgeschichte,* see Harald Dehne, "Have We Come Any Closer to *Alltag*? Everyday Reality and Workers' Lives as an Object of Historical Research in the German Democratic Republic," in *The History of Everyday Life: Reconstructing Historical Experiences and Ways of Life,* ed. Alf Lüdtke, trans. William Templer (Princeton: Princeton University Press, 1995), 130–31. Bourdieu asserts that the habitus is revealed in the objects it structures. Thus a house "lends itself as such to a deciphering, but only to a deciphering which does not forget that the 'book' from which the children learn their vision of the world is read with the body, in and through the movements and displacements which make the space within which they are enacted as much as they are made by it" (*Outline of a Theory of Practice,* 90).

15. Bourdieu, *Outline of a Theory of Practice,* 95.

16. Ibid., 82–83, 72. Vera L. Zolberg, *Constructing a Sociology of the Arts* (Cambridge: Cambridge University Press, 1990), simplifies Bourdieu's definition of the habitus by referring to it simply as "internalized role preferences" (135).

17. Bourdieu, *Outline of a Theory of Practice,* 91. This would be paradoxically circuitous if it were not a process rooted in time as a historical sequence of "objectification and embodiment," that is, the generation of practices that produce objects that are in turn embodied or reabsorbed into the set of habits implicit in practice.

18. Ibid., 78. Historians of everyday life have insisted that the habitus is not fixed or transcendent, but historical, its contents changing over time. Several have sought to correct Bourdieu on this point; see, for example, Lüdtke, ed., *History of Everyday Life,* 14, 60–61, 109, 131, and 147*n*.57. Yet Bourdieu explicitly warns against ignoring "the dialectical relationship between the objective structures and the cognitive and motivating structures which they produce and which tend to reproduce them," as well as against forgetting that "these objective structures are themselves products of historical practices and are constantly reproduced and transformed by historical practices whose productive principle

is itself the product of the structures which it consequently tends to reproduce" (*Outline of a Theory of Practice,* 83).

19. See, for example, John Dillenberger, *The Visual Arts and Christianity: From the Colonial Period to the Present,* expanded ed. (New York: Crossroad, 1989); Joseph Sciorra, "Yard Shrines and Sidewalk Altars of New York's Italian Americans," in *Perspectives in Vernacular Architecture,* vol. 3, ed. Thomas Carter and Bernard L. Herman (Columbia: University of Missouri Press, 1989), 185–99; Gregor T. Goethals, "Ritual and the Representation of Power in High and Popular Art," *Journal of Ritual Studies* 4 (summer 1990): 149–77; Ewa Kuryluk, *Veronica and Her Cloth: History, Symbolism, and Structure of a "True" Image* (Cambridge, Mass.: Basil Blackwell, 1991); Colleen McDannell, "Interpreting Things: Material Culture and American Religion," *Religion* 21 (1991): 371–87; David Morgan, "Imaging Protestant Piety: The Icons of Warner Sallman," *Religion and American Culture* 3, no. 1 (winter 1993): 29–47; Sally Promey, *Spiritual Spectacles: Vision and Image in Mid-Nineteenth-Century Shakerism* (Bloomington: Indiana University Press, 1993); Leigh Eric Schmidt, *Consumer Rites: The Buying and Selling of American Holidays* (Princeton: Princeton University Press, 1995); McDannell, *Material Christianity;* and David Morgan, "Introduction," in *Icons of American Protestantism: The Art of Warner Sallman* (New Haven: Yale University Press, 1996), 1–23.

20. Frederica Beard, *Pictures in Religious Education* (New York: George H. Doran, 1920), 83–84.

21. Ibid., 129.

22. This is the subject of a study in progress, tentatively entitled "The Printed Image and American Protestant Piety."

23. Beard, *Pictures in Religious Education,* 138. The image Beard reproduced was manufactured by Underwood & Underwood, one of the most popular suppliers of stereoscopic imagery—on photography of the Holy Land and its uses among Americans in the nineteenth century, see John Davis, *The Landscape of Belief: Encountering the Holy Land in Nineteenth-Century American Art and Culture* (Princeton: Princeton University Press, 1996), 73–97. For further discussion of stereographs, see Jonathan Crary, *Techniques of the Observer: On Vision and Modernity in the Nineteenth Century* (Cambridge, Mass.: MIT Press, 1990); and Edward Earle, ed., *Points of View: The Stereograph in America—A Cultural History* (Rochester, N.Y.: Visual Studies Workshop, 1979).

24. For a discussion of the historical construction of the "Holy Land" in nineteenth-century United States, see Davis, *Landscape of Belief.* See also Lester I. Vogel, *To See a Promised Land: Americans and the Holy Land in the Nineteenth Century* (University Park: Pennsylvania State University Press, 1993); Yehoshua Ben-Arieh, "Perceptions and Images of the Holy Land," in *The Land That Became Israel: Studies in Historical Geography,* ed. Ruth Kark (New Haven: Yale University Press; Jerusalem: Magnes Press of the Hebrew University, 1990), 37–53; and Naomi Shepherd, *The Zealous Intruders: The Western Rediscovery of Palestine* (San Francisco: Harper & Row, 1987). For a collection of important primary materials, see *The Holy Land in American Protestant Life, 1800–1948: A Documentary Reader,* ed. Robert T. Handy (New York: Arno Press, 1981). A seminal study of the Holy Land in terms of the formation of collective memory

is Maurice Halbwachs, *The Legendary Topography of the Gospels in the Holy Land,* partially translated in Halbwachs, *On Collective Memory,* ed. and trans. Lewis A. Coser (Chicago: University of Chicago Press, 1992), 193–235.

25. Roland Barthes, *Camera Lucida: Reflections on Photography,* trans. Richard Howard (New York: Hill & Wang, 1981), 88. What makes the photograph so powerful is the subtlety with which codes are naturalized, made to appear coterminous with the emanated "thatness" of the image. For a similar consideration of the daguerreotype, see Alan Trachtenberg, "Likeness as Identity: Reflections on the Daguerrean Mystique," in *The Portrait in Photography,* ed. Graham Clarke (London: Reaktion Books, 1992), 173–92.

26. Roland Barthes, "The Photographic Message" (1961), in Barthes, *The Responsibility of Forms,* trans. Richard Howard (Berkeley: University of California Press, 1991), 20.

27. See, for instance, David Freedberg, *The Power of Images: Studies in the History and Theory of Response* (Chicago: University of Chicago Press, 1989); and Stewart Elliott Guthrie, *Faces in the Clouds: A New Theory of Religion* (New York: Oxford University Press, 1993), esp. chap. 4.

28. Barthes, *Camera Lucida,* 87.

29. See Roland Barthes, "The Rhetoric of the Image" (1964), in Barthes, *Responsibility of Forms,* 21–40.

30. For an insightful discussion of the "maintenance" of worlds, see Peter L. Berger, *The Sacred Canopy: Elements of a Sociological Theory of Religion* (Garden City, N.Y.: Doubleday, 1967), 29–51.

31. Ibid., 51. For Csikszentmihalyi and Rochberg-Halton's view of the importance of cultivation, see *The Meaning of Things,* 145, 173–77, 187–88, 195.

32. Berger and Luckmann, *Social Construction of Reality,* 94.

33. Alfred Schutz and Thomas Luckmann, *The Structures of the Life-World,* 2 vols., trans. Richard M. Zaner and H. Tristram Engelhardt Jr., Northwestern University Studies in Phenomenology and Existential Philosophy (Evanston, Ill.: Northwestern University Press, 1973), 1:3.

34. On the concept of the world as it applies to the social production of art, see Howard S. Becker, *Art Worlds* (Berkeley: University of California Press, 1982), 1–39; and Janet Wolff, *Hermeneutic Philosophy and the Sociology of Art* (London: Routledge & Kegan Paul, 1975), 53–64.

35. For instructive reflections on the status of the artist and sociological views of the artist, see Zolberg, *Constructing a Sociology of the Arts,* 107–35; and Becker, *Art Worlds,* 226–71. For a Marxist-deconstructionist view, see Janet Wolff, *The Social Production of Art* (New York: New York University Press, 1984), 117–36.

36. This has been referred to as the "romantic notion of ritual as a central, transformative process" in an insightful essay by Michael B. Aune, "The Subject of Ritual: Ideology and Experience in Action," in *Religious and Social Ritual: Interdisciplinary Explorations,* ed. Michael B. Aune and Valerie DeMarinis (Albany: State University of New York Press, 1996), 155. Like Aune, I will argue against privileging this romantic approach.

37. Erving Goffman, *The Presentation of the Self in Everyday Life* (New York: Anchor Doubleday, 1959), 85.

38. Ibid., 17.

39. Csikszentmihalyi and Rochberg-Halton, *Meaning of Things,* 184–87.

40. Sigmund Freud, *The Psychopathology of Everyday Life,* trans. Alan Tyson, ed. James Strachey (New York: W. W. Norton, 1965).

41. Alf Lüdtke, "Introduction: What Is the History of Everyday Life and Who Are Its Practitioners?," discussing Peter Borscheid's work, in *History of Everyday Life,* 5.

42. For further discussion of this theme, see David Morgan, "Secret Wisdom and Self-Effacement: The Spiritual in Art in the Modern Age," in *Negotiating Rapture,* ed. Richard Francis, exhibition catalogue (Chicago: Museum of Contemporary Art, 1996), 34–47.

43. The quoted passage is in Csikszentmihalyi and Rochberg-Halton, *Meaning of Things,* 179. For Csikszentmihalyi's notion of flow, see ibid., 186–88; Mihaly Csikszentmihalyi, "Attention and the Wholistic Approach to Behavior," in *The Stream of Consciousness,* ed. K. S. Pope and J. L. Singer (New York: Plenum, 1978); and idem, *Flow: The Psychology of Optimal Experience* (New York: Harper & Row, 1990).

44. Csikszentmihalyi and Rochberg-Halton, *Meaning of Things,* 181, 179.

CHAPTER ONE: THE PRACTICE OF VISUAL PIETY

1. See Richard Egenter, *The Desecration of Christ,* trans. Edward Quinn (Chicago: Franciscan Herald Press, 1967); John Dillenberger, *A Theology of Artistic Sensibilities* (New York: Crossroad, 1986); John W. Dixon Jr., "What Makes Religious Art Religious?" *Cross Currents* 43, no. 1 (spring 1993): 5–25; Franky Schaeffer, *Addicted to Mediocrity: Twentieth-Century Christians and the Arts* (Westchester, Ill.: Crossway Books, 1981); Kenneth A. Myers, *All God's Children and Blue Suede Shoes: Christians and Popular Culture* (Westchester, Ill.: Crossway Books, 1989). For an illuminating historical discussion of liberal Protestant contempt for popular religious art, see Sally Promey, "Interchangeable Art: Warner Sallman and the Critics of Mass Culture," in *Icons of American Protestantism: The Art of Warner Sallman,* ed. David Morgan (New Haven: Yale University Press, 1996), 148–80.

2. See, for instance, Morgan, ed., *Icons of American Protestantism;* David Morgan, "Imaging Protestant Piety: The Icons of Warner Sallman," *Religion and American Culture: A Journal of Interpretation* 3, no. 1 (winter 1993): 29–47; and idem, "Sallman's *Head of Christ:* The History of an Image," *Christian Century* 109 (October 7, 1992): 868–70. For a critique of popular aesthetics on the basis of easiness and several other points, see Abraham Kaplan, "The Aesthetics of the Popular Arts," *Journal of Aesthetics and Art Criticism* 24, no. 3 (spring 1966): 351–64.

3. Spokesmen on this point are well known: Clement Greenberg, Dwight Macdonald, Theodore Adorno, and Ernest van den Haag. Essays by each author appear in *Mass Culture: The Popular Arts in America,* ed. Bernard Rosenberg and David Manning White (New York: Free Press, 1957). I have also found very helpful the collection of essays on this subject edited by Peter Davidson, Rolf Meyersohn, and Edward Shils, *Culture and Mass Culture,* Literary Taste, Cul-

ture, and Mass Communication, vol. 1 (Cambridge: Chadwyck-Healey; Tea-neck, N.J.: Somerset House, 1978). Very useful discussions of religious "kitsch" are Celeste Olalquiaga, "Holy Kitschen: Collecting Religious Junk from the Street," chapter 3 in her *Megalopolis: Contemporary Cultural Sensibilities* (Min-neapolis: University of Minnesota Press, 1992), 36–55; and Colleen McDannell, *Material Christianity: Religion and Popular Culture in America* (New Haven: Yale University Press, 1995), 163–97.

4. This sounds like the objection that John Calvin raised against images of God in *Institutes of the Christian Religion,* trans. Henry Beveridge (Grand Rapids, Mich.: Eerdmans, 1962), 90–103, but it is no less the charge of some modern Roman Catholics. See, for instance, Egenter, *Desecration of Christ,* who claimed that certain prayer cards dealing with the gifts of the Holy Spirit visualize "a great theological doctrine reduced to the trivial and cozy" (40) and that "through kitsch we use God himself and our personal meeting with him to serve selfish ends" (91). Egenter argued that a holy card could become "an idol" and that religious kitsch in general "has reduced God to a commodity for the purposes of spiritual pleasure" (92). For a modern-day Calvinist proscription of images, see Peter Barnes, *Seeing Jesus: The Case Against Pictures of the Lord Je-sus Christ* (Edinburgh: Banner of Truth, 1990). By contrast, for a reaffirmation of traditional images in Roman Catholic piety, see Jeffrey Rubin, "A Legacy Re-claimed," *Latin Mass* 5, no. 1 (winter 1995): 16–20, 21, 23–24.

5. Robert C. Solomon, "On Kitsch and Sentimentality," *Journal of Aesthet-ics and Art Criticism* 49, no. 1 (winter 1991): 1–14.

6. Jorge Durand and Douglas S. Massey, "Doy Gracias: An Iconography of Mexican Migration to the United States," unpublished paper, 1990; David Freedberg, *The Power of Images: Studies in the History and Theory of Response* (Chicago: University of Chicago Press, 1989), 99–135; Victor Turner and Edith Turner, *Image and Pilgrimage in Christian Culture: Anthropological Perspectives* (New York: Columbia University Press, 1978), 140–71; Virginia Chieffo Raguin, *Santos: Devotional Images from the American Southwest,* exhibition catalogue (Worcester, Mass.: Irsi and B. Gerald Art Gallery, College of the Holy Cross, 1992); and William Wroth, *Images of Penance, Images of Mercy: Southwestern Santos in the Late Nineteenth Century,* exhibition catalogue, Taylor Museum for Southwestern Studies, Colorado Springs Fine Arts Center (Norman: University of Oklahoma Press, 1991).

7. Jerome Stolnitz, "On the Origins of 'Aesthetic Disinterestedness,'" *Jour-nal of Aesthetics and Art Criticism* 20, no. 2 (winter 1961–62): 131–44.

8. For a previous attempt at this, see David Madden, "The Necessity of an Aesthetics of Popular Culture," *Journal of Popular Culture* 7, no. 1 (summer 1973): 1–13.

9. Important treatments of disinterestedness are Stolnitz, "On the Origins of 'Aesthetic Disinterestedness'"; and Martha Woodmansee, "The Interests in Dis-interestedness: Karl Philipp Moritz and the Emergence of the Theory of Aesthetic Autonomy in Eighteenth-Century Germany," *Modern Language Quarterly* 45, no. 1 (1984): 22–47. A perceptive study of aesthetic impurity, Christian theology, and religious belief is Frank Burch Brown, *Religious Aesthetics: A Theological Study of Making and Meaning* (Princeton: Princeton University Press, 1989).

10. Arthur Schopenhauer, *The World as Will and Representation*, 2 vols., trans. E. F. J. Payne (Indiana Hills, Colo.: Falcon's Wing Press, 1958), 1:208.

11. Karl Philipp Moritz, "On the Concept of That Which Is Perfect in Itself" (1785), trans. Timothy J. Chamberlain, in *Eighteenth-Century German Criticism*, ed. Timothy J. Chamberlain (New York: Continuum, 1992), 245–51.

12. For a discussion of Kant's view, see David A. White, "The Metaphysics of Disinterestedness: Shaftesbury and Kant," *Journal of Aesthetics and Art Criticism* 32, no. 2 (winter 1973): 239–48.

13. The satisfaction provided by what is pleasant, in contrast, which "always has reference to the faculty of desire," according to Kant, concerns the gratification that the object offers (*Critique of Judgment*, trans. J. H. Bernard [New York: Hafner, 1951], 38).

14. For Schiller's philosophy of appearance, see Friedrich Schiller, *On the Aesthetic Education of Man*, trans. Reginald Snell (New Haven: Yale University Press, 1954), Letter 26, pp. 124–31. For Schiller, the selflessness of aesthetic free play in the realm of appearance (*Schein*), in other words, a disinterested use of mental faculties, became the necessary prototype for political freedom, the propaedeutic to suspending self-interest. For a more nuanced assessment of Kant's views, see Brown, *Religious Aesthetics*, 63–73, who underscores the fact that Kant described two kinds of beauty, the free and the dependent. Judgment of the latter was not disinterested because dependent beauty lacked the purity of free beauty. My concern here focuses on free beauty because this concept was far more influential in the ascendancy of disinterestedness in modern aesthetics.

15. On Moritz and the mysticism of German Pietism, see Woodmansee, "Interests in Disinterestedness," 31–33; on Shaftesbury and anti-egoist ethics, see Stolnitz, "On the Origins of 'Aesthetic Disinterestedness,'" 132–34. I have discussed these ideas in connection with avant-garde art and art theory in "Secret Wisdom and Self-Effacement: The Spiritual in Art in the Modern Age," in *Negotiating Rapture*, ed. Richard Francis, exhibition catalogue (Chicago: Museum of Contemporary Art, 1996), 34–47.

16. Schopenhauer, *World as Will and Representation*, 1:185–87

17. Ibid., 1:187.

18. On the populism of American Christianity in the early nineteenth century (contemporary with Schopenhauer), see Nathan O. Hatch, *The Democratization of American Christianity* (New Haven: Yale University Press, 1989); on the significance of nineteenth-century popular Christianity and the explosion of the mass media, which led to an unprecedented popular visual culture among American Christians, see David Morgan, "Millennial Progress: Mass-Produced Imagery and American Protestant Piety, 1825–1925" (in preparation).

19. Jonathan Edwards, *Religious Affections*, ed. John E. Smith, vol. 2 of *The Works of Jonathan Edwards* (New Haven: Yale University Press, 1959), 248.

20. Ibid., 252–53.

21. Ibid., 250.

22. Ibid., 376.

23. Quoted in William A. Clebsch, *American Religious Thought: A History* (Chicago: University of Chicago Press, 1973), 26.

24. The quotation is from Edwards's most famous (and infamous) sermon,

"Sinners in the Hands of an Angry God" (1741), in *A Jonathan Edwards Reader,* ed. John E. Smith, Harry S. Stout, and Kenneth P. Minkema (New Haven: Yale University Press, 1995), 92.

25. See Edwards, *The Nature of True Virtue,* chapter 4, "Of Self-Love and Its Various Influence to Cause Love to Others, or the Contrary," in *The Works of Jonathan Edwards,* vol. 8: *Ethical Writings,* ed. Paul Ramsay (New Haven: Yale University Press, 1989), 575–88; *Religious Affections,* 244–47; and *Charity and Its Fruits,* in *Works* 8:258.

26. Edwards, *Religious Affections,* 243, 247.

27. Jonathan Edwards, "Concerning the End for Which God Created the World," in *Two Dissertations* (1765), *Works* 8:531, 533–34.

28. David Hume, "Of the Delicacy of Taste and Passion" (1742), in *Essays Moral, Political, and Literary,* rev. ed., ed. Eugene F. Miller (Indianapolis: Liberty Classics, 1987), 7.

29. Edward Bullough, "'Psychical Distance' as a Factor in Art and as an Aesthetic Principle," *British Journal of Psychology* 8 (1912): 87–98; reprinted in *Art and Its Significance: An Anthology of Aesthetic Theory,* 3d ed., ed. Stephen David Ross (Albany: State University of New York Press, 1994), 459–60.

30. Ibid., 462.

31. Soloman, "On Kitsch and Sentimentality," 9.

32. Thomas Merton, *Contemplative Prayer* (Garden City, N.Y.: Image Books, 1969), 89, 84, 85. Thanks to Paul Contino for bringing this text to my attention.

33. On transcendence in the aesthetics of popular music, see Simon Frith, "Towards an Aesthetic of Popular Music," in *Music and Society: The Politics of Composition, Performance, and Reception,* ed. Richard Leppert and Susan McClary (Cambridge: Cambridge University Press, 1987), 144.

34. Stuart Hall and Paddy Whannel, *The Popular Arts* (New York: Pantheon Books, 1965), 66; quoted in John G. Cawelti, "Notes Toward an Aesthetic of Popular Culture," *Journal of Popular Culture* 5, no. 2 (fall 1971): 266.

35. See Wassily Kandinsky, *Concerning the Spiritual in Art,* trans. M. T. H. Sadler (New York: Dover, 1977), 23–45.

36. On the issue of race in depictions of Christ, see Morgan, ed., *Icons of American Protestantism,* 178–80, 197–98. For several examples of Christian imagery by artists of diverse races, see Daniel Johnson Fleming, *Each with His Own Brush: Contemporary Christian Art in Asia and Africa* (New York: Friendship Press, 1938); and "Native Religious Art," *Life* 29, no. 10 (September 4, 1950): 63, 66.

37. Sir Wyke Bayliss, *Rex Regum: A Painter's Study of the Likeness of Christ from the Time of the Apostles to the Present Day* (London: Society for Promoting Christian Knowledge; New York: E. S. Gorham, 1905), 19–20.

38. The best study of the tradition of Veronica's Veil is Ewa Kuryluk, *Veronica and Her Cloth: History, Symbolism, and Structure of a "True" Image* (New York: Basil Blackwell, 1991).

39. For a good introduction to the trade of mechanically producing portrait likenesses in antebellum America, see David Jaffee, "'A Correct Likeness': Culture and Commerce in Nineteenth-Century Rural America," in *Folk Art and Art*

Worlds, ed. John Michael Vlach and Simon J. Bronner (Ann Arbor: UMI Research Press, 1986), 53–84. Mechanical devices were also used in the twentieth century to produce an "authentic" likeness of George Washington for the 1932 Washington Bicentennial by photographing a marble bust and printing it to look like a portrait photograph of Washington. For a discussion and reproduction of the image, see Karal Ann Marling, *George Washington Slept Here: Colonial Revivals and American Culture, 1876–1986* (Cambridge, Mass.: Harvard University Press), 337–41.

40. Plotinus, *The Enneads,* trans. Stephen MacKenna, 2d rev. ed., ed. B. S. Page (London: Faber & Faber, 1956), 423; Cicero, *De Inventione,* trans. H. M. Hubbell, Loeb Classical Library (Cambridge, Mass.: Harvard University Press; London: William Heinemann, 1949), 167–69. For the relevant passage from Raphael's letter to Baldassare Castiglione, in which the artist mentions his means of invention, see Erwin Panofsky, *Idea: A Concept in Art Theory,* trans. Joseph J. S. Peake (New York: Harper & Row, 1968), 60.

41. Kant, *Critique of Judgment,* 70–71, §17; Sir Joshua Reynolds, *Discourses on Art,* ed. Robert R. Wark (New Haven: Yale University Press, 1975), 44–45. I have discussed each of these authors on this issue in "The Rise and Fall of Abstraction in Eighteenth-Century Art Theory," *Eighteenth-Century Studies* 27, no. 3 (spring 1994): 449–78.

42. Reproduced and discussed in Miles Orvell, *The Real Thing: Imitation and Authenticity in American Culture, 1880–1940* (Chapel Hill: University of North Carolina Press, 1989), 88–94.

43. H. P. Bowditch, "Are Composite Photographs Typical Pictures?" *McClure's,* September 1894, 336.

44. Ibid., 340.

45. David Morgan, "Introduction," in *Icons of American Protestantism,* 8–11.

46. Kant, *Critique of Judgment,* 71, 70. Ideal beauty, according to Kant, could only be human in form.

47. Emile Durkheim, *The Elementary Forms of Religious Life* (1912), trans. Karen E. Fields (New York: Free Press, 1995), 9, 229, 227, 436.

48. Maurice Halbwachs, *On Collective Memory,* ed. and trans. Lewis A. Coser (Chicago: University of Chicago Press, 1992), 112. A very helpful discussion of Halbwachs's understanding of memory is Patrick H. Hutton, *History as an Art of Memory* (Hanover, N.H.: University of Vermont and University Press of New England, 1993), 73–90.

49. Halbwachs, *On Collective Memory,* 117.

50. Ibid., 119.

51. Pierre Bourdieu, *Outline of a Theory of Practice,* trans. Richard Nice (Cambridge: Cambridge University Press, 1977), 159–71.

52. For discussion of black depictions of Christ and the Afrocentric movement among black Christians who believe Christ was African and Jewish, see Cain Hope Felder, "Introduction," in *The Original African Heritage Study Bible,* ed. Rev. Cain Hope Felder (Nashville: James C. Winston, 1993), v–xv; Laurie Goodstein, "Religion's Changing Face: More Churches Depicting Christ as Black," *Washington Post,* March 28, 1994, A1, A6; and Kristin E. Holmes,

"A New Christian Vision Unfolds: An Afrocentric Aesthetic Is Taking Hold, amid Some Debate," *Philadelphia Inquirer,* August 21, 1994, B1, B4.

53. For a superb study of the participatory character of popular response to radio broadcasts, photography, and cinema in the American 1930s, see Lawrence W. Levine, "The Folklore of Industrial Society: Popular Culture and Its Audiences," *American Historical Review* 97, no. 5 (1992): 1369–99; for a fascinating examination of the same kind of participation in the first half of nineteenth-century American theater and music and the gradual elimination of audience response in the second half of the century in what the author calls the "sacralization of art," see Levine, *Highbrow/Lowbrow: The Emergence of Cultural Hierarchy in America* (Cambridge, Mass.: Harvard University Press, 1988). Another fine study of the audience is James Lull, "Listeners' Communicative Uses of Popular Music," in *Popular Music and Communication,* ed. James Lull (Newberry Park, Calif.: Sage, 1987), 140–74.

54. The author visited the cathedral on January 18, 1995, and September 28, 1996.

55. For a sociological analysis of the images, see Durand and Massey, "Doy Gracias."

56. The text on the retablo of figure 9 reads in translation: "In the year 1895, Toribio Guguen, having been with his workers, suffered the misfortune of misplacing an expensive knife. They encouraged him to seek aid from San Luis de Paz. Observing his grief, his wife prayed to God, the Lord of the Fields, and, hoping that such a great miracle will take place, presents to him this retablo in care of San Luis de la Paz—January 1896" (Object file, Brauer Museum of Art, Valparaiso University).

57. In their study of retablos from San Juan de Los Lagos, "Doy Gracias," Durand and Massey included retablos made from social security cards, driver's licenses, and family photographs. Thus, the Polaroids in the Cathedral of San Fernando are only the latest photographic technology to be used.

58. An excellent discussion of the St. George Madonna is Nina Schmit, "Narratives of the Weeping Icon in an Arab Orthodox Church," paper presented at the annual meeting of the Society for the Scientific Study of Religion, Nashville, Tennessee, November 9, 1996. My thanks to the author for sharing her paper with me.

59. Michael Camille, book review, *Art Bulletin* 74, no. 3 (1992): 514.

CHAPTER TWO: EMPATHY AND SYMPATHY
IN THE HISTORY OF VISUAL PIETY

1. For discussions of *Schaufrömmigkeit* and relevant bibliographies, see R. W. Scribner, *For the Sake of Simple Folk: Popular Propaganda for the German Reformation* (Oxford: Clarendon Press, 1994), 4; Hans Belting, *The Image and Its Public in the Middle Ages: Form and Function of Early Paintings of the Passion,* trans. Mark Bartusis and Raymond Meyer (New Rochelle, N.Y.: Aristide D. Caratzas, 1990); and Eugène Honée, "Image and Imagination in the Medieval Culture of Prayer: A Historical Perspective," in Henk van Os with Eugène Honée, Hans Nieuwdorp, and Bernhard Ridderbos, *The Art of Devotion in the*

Late Middle Ages in Europe, 1300–1500 (Princeton: Princeton University Press, 1994), 157–74.

2. For a study of the history of the Resurrection in art, see Wolfgang Braunfels, *Die Auferstehung* (Düsseldorf: Schwann, 1951); on Byzantine iconography of the Resurrection, see Anna D. Kartsonis, *Anastasis: The Making of an Image* (Princeton: Princeton University Press, 1986); and for early Christian depictions of the Resurrection, see Claudia Nauerth, *Vom Tod zum Leben. Die christlichen Totenerweckungen in der spätantiken Kunst* (Wiesbaden: Otto Harrassowitz, 1980); and Caroline Walker Bynum, *The Resurrection of the Body in Western Christianity, 200–1336* (New York: Columbia University Press, 1995).

3. For an excellent discussion of this subject and one to which I am indebted, see Caroline Walker Bynum, "Bodily Miracles and the Resurrection of the Body in the High Middle Ages," in *Belief in History: Innovative Approaches to European and American Religion*, ed. Thomas Kselman (Notre Dame, Ind.: University of Notre Dame Press, 1991), 68–106.

4. See Belting, *Image and Its Public*, 203–21, for a helpful discussion of the relation between relics, reliquaries, images, and cathedrals in the fourteenth century.

5. See Honée, "Image and Imagination," 164.

6. Heinrich Seuse (or Suso), *Büchlein der Wahrheit* (c. 1327), in Seuse, *Deutsche Schriften*, ed. Karl Bihlmeyer (Stuttgart: Kohlhammer, 1907), 168: "Ein gelassener mensch müss entbildet werden von der creatur, gebildet werden mit Cristo, und úberbildet in der gotheit." A significant text that also documents the visual nature of popular piety in the thirteenth century is the Pseudo-Bonaventure, *Meditationes Vitae Christi*, a Franciscan text written around 1300; for a discussion of this work, see Honée, "Image and Imagination," 164–65.

7. F. W. Wentzlaff-Eggebert, *Deutsche Mystik zwischen Mittelalter und Neuzeit* (Berlin: Walter de Gruyter, 1969), 120*n*.155.

8. For a discussion of the image and an extensive study of Suso's visual piety, see Jeffrey F. Hamburger, "The Use of Images in the Pastoral Care of Nuns: The Case of Heinrich Suso and the Dominicans," *Art Bulletin* 71, no. 1 (March 1989): 20–46.

9. Suso, *Büchlein der Wahrheit*, 334.

10. See Meister Eckhart, *The Essential Sermons, Commentaries, Treatises, and Defense*, intro. and trans. Edmund Colledge and Bernard McGinn (New York: Paulist Press, 1981).

11. For good treatments of this topic and an extensive bibliography, see Bynum, "Bodily Miracles and the Resurrection"; and Elizabeth Alvilda Petroff, *Body and Soul: Essays on Medieval Women and Mysticism* (New York: Oxford University Press, 1994), esp. chapter 11: "Writing the Body: Male and Female in the Writings of Marguerite D'Oingt, Angela of Foligno, and Umiltà of Faenza," 204–24. For a broad-ranging reflection on the body in recent thought, see Caroline Bynum, "Why All the Fuss About the Body? A Medievalist's Perspective," *Critical Inquiry* 22, no. 1 (autumn 1995): 1–33.

12. Bynum, "Bodily Miracles and the Resurrection," 74–77.

13. On Christ as magus, see Thomas F. Mathews, *The Clash of the Gods: A Reinterpretation of Early Christian Art* (Princeton: Princeton University Press,

1993), chap. 3. For further discussion on the use of images in healing, see David Freedberg, *The Power of Images: Studies in the History and Theory of Response* (Chicago: University of Chicago Press, 1989), 136–60.

14. For an excellent discussion of Grünewald's altarpiece and its social situation, see Andrée Hayum, *The Isenheim Altarpiece: God's Medicine and the Painter's Vision* (Princeton: Princeton University Press, 1989).

15. I am much indebted to Hans Belting's careful study of the *imago pietatis* and its relation to Passion imagery, *The Image and Its Public*.

16. Ibid., 145–47; see also Honée, "Image and Imagination," 164, 167.

17. For an excellent study of the range of images of the Passion in late medieval art and piety, especially on blood and wounds, see van Os, *Art of Devotion,* 104–29.

18. On the late medieval practice of indulgences, see Belting, *Image and Its Public,* 132, 192–94, 214; van Os, *Art of Devotion,* 110–13.

19. Quoted in Elizabeth G. Holt, ed., *A Documentary History of Art,* vol. 1: *The Middle Ages and the Renaissance* (Garden City, N.Y.: Doubleday, 1957), 122.

20. Martin Luther, *Against the Heavenly Prophets in the Matter of Images and Sacraments* (1525), in *Luther's Works* (Philadelphia: Muhlenberg Press, 1958), 40:99. For a penetrating study of Protestant conceptions of vision and imagery during the Reformation, see Lee Palmer Wandell, *Voracious Idols and Violent Hands: Iconoclasm in Reformation Zurich, Strasbourg, and Basel* (Cambridge: Cambridge University Press, 1995). For a good discussion of Protestant and Catholic views on the image, see Margaret Miles, *Images as Insight: Visual Understanding in Western Christianity and Secular Culture* (Boston: Beacon Press, 1985), chap. 5.

21. For a discussion of imagery of the Meditation on the Crowning with Thorns, for example, see Michael Baxandall, *The Limewood Sculptors of Renaissance Germany* (New Haven: Yale University Press, 1980), 158; for more on this subject, see F. O. Büttner, *Imitatio Pietatis. Motive der christlichen Ikonographie als Modelle zur Verähnlichung* (Berlin: Gebr. Mann Verlag, 1983), 43–62, and plates 42–53 for images of participation in Christ's Passion, one of which portrays a nobleman gripped in his meditation of the crucifix and Christ's crown of thorns.

22. For imagery associated with the Passion, see *Luther und die Folgen für die Kunst,* ed. Werner Hofmann (Munich: Prestel-Verlag, 1983); on penitential images and practices in the American Southwest, see William Wroth, *Images of Penance, Images of Mercy: Southwestern Santos in the Late Nineteenth Century,* exhibition catalogue, Taylor Museum for Southwestern Studies, Colorado Springs Fine Arts Center (Norman: University of Oklahoma Press, 1991).

23. Jo Lemoine, *Rita: Saint of the Impossible,* trans. Sr. Florestine Audette, R.J.M. (Boston: St. Paul's Books and Media, 1992). For a fuller account and a pictorial biography, see Vittorio Peri, *Rita of Cascia: Priceless Pearl of Umbria,* trans. Matthew J. O'Connell, ed. John E. Rotelle (Gorle, It.: VELAR, 1995).

24. Lemoine, *Rita,* 53; Peri, *Rita of Cascia,* 126–28.

25. For a discussion of modern stigmatics, mystical participation in Christ's suffering, and sainthood, see Kenneth L. Woodward, *Making Saints: How the*

Catholic Church Determines Who Becomes a Saint, Who Doesn't, and Why (New York: Touchstone Books, Simon & Schuster, 1996), 156–90.

26. Quoted in *St. Thérèse of Lisieux by Those Who Knew Her: Testimonies from the Process of Beatification,* ed. and trans. Christopher O'Mahony (Dublin: Veritas Publications, 1975), 48. For an extended reflection on the importance of suffering in Thérèse's spirituality, see Rev. François Jamart, O.C.D., *Complete Spiritual Doctrine of St. Thérèse of Lisieux,* trans. Rev. Walter van de Putte, C.S.S.P. (New York: Alba House, 1961), 167–221.

27. Discussed in Wroth, *Images of Penance, Images of Mercy,* 17, 50–51.

28. Marta Weigle, "José Benito Ortega: Bultos and Retablos, and Other Retablo Makers," in Wroth, *Images of Penance, Images of Mercy,* 63.

29. Ibid., 71.

30. One source lists no fewer than 420 different saints as patrons for specific vocations—which can be as particular as cab drivers, florists, dentists, and cooks—countries, and localities; see John J. Delaney, *Pocket Dictionary of Saints,* abr. ed. (New York: Doubleday, 1983), 519–25. Saints for special causes (for example, hopeless causes: St. Jude or St. Rita; lost objects: St. Anthony) add many more significant connections between a believer's circumstances and the saint beseeched for intercession.

31. Ann Taves, *The Household of Faith: Roman Catholic Devotions in Mid-Nineteenth-Century America* (Notre Dame, Ind.: University of Notre Dame Press, 1988), 47–49. See also, on the subject of Catholic devotionalism, Jay Dolan, *The American Catholic Experience: A History from Colonial Times to the Present* (Garden City, N.Y.: Doubleday, 1985), 221–40.

32. Quoted in Taves, *Household of Faith,* 49; emphasis added.

33. Woodward, *Making Saints,* 225–26.

34. Ibid., 70–71.

35. Francis de Sales, *Introduction to the Devout Life* (1609), trans. and ed. John K. Ryan (New York: Doubleday, 1989), 107.

36. "Triduo a Sta. Rita de Casia," prayer card produced by Fratelli Bonella, Italy, purchased by the author in Chicago, 1996: "¡Gloriosa Santa Rita de Casia! Aceptad el Triduo que con fervor os dedico; alcanzadme la gracia que os pido y haced que aprenda la práctica de las virtudes que tanto os adornaron. En la hora de las contrariedades y de los trabajos de al vida quiero recordar el dolor que toda la vida sentisteis con la herida de la santa Espina en vuestra frente, y que despedía tan mal olor que os obligaba a vivir sola. Sed mi consuelo en las penas, gloriosa Santa; haced que todo lo sufra por amor a Dios, pensando en la cruz y corona de espinas del buen Jesús, que eran vuestro consuelo y vuestro amor." My thanks to Professor Robert M. Quinn for assistance with the translation.

37. For an illuminating study of the devotion to St. Jude among twentieth-century Roman Catholic women in the United States, see Robert A. Orsi, "What Did Women Think They Were Doing When They Prayed to Saint Jude?" *U.S. Catholic Historian* 8, nos. 1–2 (winter–spring 1989): 67–79; also Orsi, "'He Keeps Me Going': Women's Devotion to Saint Jude Thaddeus and the Dialectics of Gender in American Catholicism, 1929–1965," in *Belief in History: Innovative Approaches to European and American Religion,* ed. Thomas Kselman

(Notre Dame, Ind.: University of Notre Dame Press, 1991), 137–69; and, most recently, Orsi, *Thank You, St. Jude: Women's Devotion to the Patron Saint of Hopeless Causes* (New Haven: Yale University Press, 1996).

38. Peri, *Rita of Cascia,* 65, 128.

39. "Solemn Casket," 1462, wood, Monastery of St. Rita, Cascia, Italy; reproduced in Peri, *Rita of Cascia,* 58, 125. For Rita before the crucifix, see *Ten Episodes in the Life of St. Rita,* 1575, oil on canvas, Monastery of St. Rita, Cascia, Italy; reproduced in ibid., 69.

40. "Prayer to St. Rita," printed by J. B. Co., United States; purchased in Chicago by the author, 1996. Although official doctrine and church liturgy have long directed prayer and praise to Christ and God the Father, it is among the laity and the religious orders that direct invocation of the saints has thrived.

41. It is important to note, however, that the Augustinian Press of Villanova, Pennsylvania, has produced images with prayers of both types and has kept both in circulation. It may be that the distinction noted here is one that only certain Catholic clergy, Protestants, and art historians are inclined to notice. For a study of Italian holy cards, see Elisabetta Gulli Grigoni and Vittorio Pranzini, *Santi: Piccole immagini devozionali a stampa e manufatte dal XVII al XX secolo* (Ravenna: Edizioni Essegi, 1990); for an excellent history of French holy cards and their production, see Jean Pirotte, "Les images de dévotion du XVe siècle à nos jours. Introduction à l'étude d'un 'media,'" in *Imagiers de paradis. Images de piété populaires du XVe au XXe siècle,* exhibition catalogue, Musée en Piconrue (Bastogne: Crédit Communal, 1990), 11–76.

42. Woodward, *Making Saints,* 189.

43. *Vatican Council II: The Conciliar and Post-Conciliar Documents,* ed. Austin Flannery, O.P. (Wilmington: Scholarly Resources, 1975), 412–13.

44. Jonathan Edwards, *Religious Affections,* ed. John E. Smith, vol. 2 of *The Works of Jonathan Edwards* (New Haven: Yale University Press, 1959), 212, 213.

45. William A. Clebsch has provided a fine discussion of Edwards's aims and intellectual and theological development in connection with his principal text, *Religious Affections,* in *American Religious Thought: A History* (Chicago: University of Chicago Press, 1973), 11–56.

46. Edwards, *Religious Affections,* 214–15.

47. For a discussion of the theory of the passions and its relationship to the arts, see Brewster Rogerson, "The Art of Painting the Passions," *Journal of the History of Ideas* 14 (January 1953): 68–94.

48. Edwards, *Religious Affections,* 181.

49. See Clebsch, *American Religious Thought,* 40–49.

50. On Edwards's Neoplatonism, see Clyde A. Holbrook, *The Ethics of Jonathan Edwards: Morality and Aesthetics* (Ann Arbor: University of Michigan Press, 1973), 104–12.

51. Edwards, *Religious Affections,* 240, 248.

52. Ibid., 311, 340, 345, 355.

53. Ibid., 281.

54. Ibid., 445, 394.

55. Joseph A. Conforti, *Jonathan Edwards, Religious Tradition, and American Culture* (Chapel Hill: University of North Carolina Press, 1995), 78.

56. Conforti, *Jonathan Edwards,* 75; see also Joseph A. Conforti, *Samuel Hopkins and the New Divinity Movement: Calvinism, the Congregational Ministry, and Reform in New England Between the Great Awakenings* (Grand Rapids, Mich.: Academie Books, 1981), chaps. 7–9. Conforti (*Jonathan Edwards,* 62–86) has discussed how important the legacy of Edwards was for the establishment of disinterested benevolence among New England evangelicals—including David Brainerd—in the late eighteenth and early nineteenth centuries.

57. Samuel Hopkins, *System of Doctrines,* in *The Works of Samuel Hopkins,* 3 vols. (Boston: Doctrinal Tract and Books Society, 1852), 1:386.

58. Oliver Wendell Elsbree, "Samuel Hopkins and His Doctrine of Benevolence," *New England Quarterly* 8, no. 4 (December 1935): 540. Moravian Pietism in eighteenth-century Pennsylvania is a different Protestant version of self-effacing empathy, one rooted in vicarious identification with Christ's suffering. This piety gave special place in its devotional practices to meditation of the wounds of Christ. Count Zinzendorff, leader of the group, expressed the spiritual ideal of the Moravians thus: "Like wax before the fire, I / Want to melt in Jesus' suffering"; quoted in Craig D. Atwood, "Blood, Sex, and Death: Life and Liturgy in Zinzendorff's Bethlehem," Ph.D. diss., Princeton Theological Seminary, 1995, p. 97; on Christ's wounds, see 93–107. My thanks to Rachel Wheeler for pointing out this study to me.

59. Jonathan Edwards, *The Life of David Brainerd,* ed. Norman Pettit, vol. 7 of *The Works of Jonathan Edwards* (New Haven: Yale University Press, 1985), 300. Cf. Paul's Letter to the Philippians: "My desire is to depart and be with Christ, for that is far better. But to remain in the flesh is more necessary on your account" (1:23–24).

60. Edwards, *Life of David Brainerd,* 331.

61. Ibid., 315.

62. Ibid., 310–11.

63. Conforti, *Jonathan Edwards,* 33.

64. For an informative study of the debate, see William G. McLoughlin, "Introduction," in Charles Grandison Finney, *Lectures on Revivals of Religion,* ed. William G. McLoughlin (Cambridge, Mass.: Belknap Press, Harvard University Press, 1960), vii–lii. Sandra Sizer has helpfully examined the debate as a controversy over the rhetoric of social control and the use of emotions to secure or subvert control; see her *Gospel Hymns and Social Religion: The Rhetoric of Nineteenth-Century Revivalism* (Philadelphia: Temple University Press, 1978), 50–82.

65. For Finney's rejection of protracted conversion, see Finney, *Lectures on Revivals of Religion,* 139, 373–74. Finney was critical of Brainerd's prolonged self-contempt (374) and stated outrightly that "protracted seasons of conviction are generally owing to defective instruction" (378).

66. Finney, *Lectures on Revivals of Religion,* 125, 128, 104, 68, 116.

67. McLoughlin, "Introduction," *Lectures on Revivals,* vii–xx.

68. The literature on this subject is vast; for a recent consideration and some of the relevant bibliography, see R. Laurence Moore, *Selling God: American Religion in the Marketplace of Culture* (New York: Oxford University Press, 1994), 12–65.

69. For further discussion of this christology, see chapter 3. The only instances in which Edwards discussed "friendship toward Christ" in *Religious Affections* occur on pages 410 and 453.

70. [?] Adams, "Sympathy," in *Family Christian Almanac* (New York: American Tract Society, 1860), 20. Henceforth, references to this almanac will be rendered by title and date only; the publisher remained the American Tract Society throughout. See the following tracts produced by the American Tract Society: *Fashionable Amusements*, No. 73, *Tracts of the American Tract Society*, vol. 3 (New York: American Tract Society, n.d.); *Theatrical Exhibitions*, No. 130, *Tracts*, vol. 4; *A Time to Dance*, No. 172, *Tracts*, vol. 5; *A Lady in Fashionable Life*, No. 289, *Tracts*, vol. 8; *Dancing, as a Social Amusement*, No. 491, *Tracts*, vol. 12; *Beware of Bad Books*, No. 493, *Tracts*, vol. 12; and *Novel-Reading*, No. 515, *Tracts*, vol. 12.

71. See the insightful essay by Thomas W. Laqueur, "Bodies, Details, and the Humanitarian Narrative," in *The New Cultural History*, ed. Lynn Hunt (Berkeley: University of California Press, 1989), 176–204.

72. Van Os, *Art of Devotion*, 40.

73. "Person of Our Lord," *Midnight Cry*, July 27, 1843, 183. Ascribed to a mythical figure named Publius Lentulus (a well-known family name in Rome at the time of Christ), the description of Christ's features reads as follows: "His person is tall and elegantly shaped; his aspect amiable and reverend; his hair flows into those beauteous shades which no united colors can match, falling into graceful curls below his ears, agreeably couching on his shoulders, and parting on the crown of his head like the head dress of the Sect of Nazarines; his forehead is smooth and large; his cheeks without either spot, save that of a lovely red; his nose and mouth are formed with exquisite symmetry; his beard is thick and suitable to the hair of his head, reaching a little below his chin and parting in the middle like a fork; his eyes are bright, clear and serene." For a historical analysis of the letter, see John McClintock and James Strong, *Cyclopaedia of Biblical, Theological, and Ecclesiastical Literature* (New York: Harper, 1891), 5:348–50.

74. Cf., for instance, a translation provided by Henry Ward Beecher in *The Life of Jesus, the Christ* (New York: J. B. Ford, 1871), 140–41n.2; and another translation in William E. Barton, *Jesus of Nazareth: The Story of His Life and the Scenes of His Ministry* (Boston: Pilgrim Press, 1903), 38–39.

75. For a discussion of the cult of sentiment and the artistic fashion of "sensibility," see Hugh Honour, *Neo-classicism* (Harmondsworth, Eng.: Penguin Books, 1973), 141–46; John Mullan, *Sentiment and Sociability: The Language of Feeling in the Eighteenth Century* (Cambridge: Cambridge University Press, 1988); and Janet Todd, *Sensibility: An Introduction* (New York: Methuen, 1986). For an overview of these literary and artistic tastes in the United States, see James D. Hart, "The Power of Sympathy," in *The Popular Book: A History of America's Literary Taste* (New York: Oxford University Press, 1950), 51–66. For treatments of sympathy and empathy (usually conflated with sympathy) in eighteenth- and nineteenth-century literature, see Walter Jackson Bate, "The Sympathetic Imagination in Eighteenth-Century Criticism," *Journal of English Literary History* 12 (1945): 144–59; Thomas J. McCarthy, "'Epistolary Inter-

course': Sympathy and the English Romantic Letter," *European Romantic Review* 6, no. 2 (winter 1996): 162–82; and Fred Kaplan, *Sacred Tears: Sentimentality in Victorian Literature* (Princeton: Princeton University Press, 1987). According to Bate, the difference between sympathy and empathy in learned discourse of eighteenth-century Britain is that with sympathy the imagination perceives "the fundamental reality and inner working, the peculiar 'truth' and nature of its object," whereas empathy consisted of "the dissolving of the boundary between the artist and his object, and his identification with it" (145). Bate further distinguished between the eighteenth-century idea of sympathetic identification with inanimate objects and aesthetic form, on the one hand, and their animation through the projection of human feelings, on the other (160–61).

76. [?] Robertson, "The Good Shepherd," in *Family Christian Almanac* (1860), 42.

77. Jacob Abbott, *The Young Christian; or, A Familiar Illustration of the Principles of Christian Duty*, stereotype ed. (Boston: William Peirce, 1935), 32, 37; emphasis in original.

78. Sympathy was not, however, a strictly Protestant affair. It is noteworthy that the first Catholic religious order founded in the United States was Elizabeth Ann Seton's Sisters of Charity of St. Joseph (1809), an organization dedicated not to ascetic mortification but to educating children, establishing orphanages, and ministering to the sick and poor.

79. For further discussion of the political and religious aims of early nineteenth-century Christian benevolence in the United States, see Lois Banner's important essay "Religious Benevolence as Social Control: A Critique of an Interpretation," *Journal of American History* 60, no. 1 (June 1973): 23–41.

80. Although evangelicals are the focus of my analysis, they were not of course the only Christians in the nineteenth century to embrace benevolent causes. Catharine Beecher and her sister, Harriet Beecher Stowe, represented a somewhat more liberal Christian view of benevolence, one committed to a millennial vision of the dignity of women in what the Beecher sisters considered a woman's distinctive sphere, the home. For the Beechers, Christianity endorsed a benevolent sympathy that began in the home: "The discipline of the family state is one of daily self-devotion of the stronger and wiser to elevate and support the weaker members" (Catharine E. Beecher and Harriet Beecher Stowe, *The American Woman's Home; or, Principles of Domestic Science* [New York: J. B. Ford, 1869], 18).

81. "Amusement," in *Family Christian Almanac* (1861), 36.

82. *Family Christian Almanac* (1861), 45.

83. *Family Christian Almanac* (1863), 18. Another item in the *Almanac* of 1852, for instance, quoted a Massachusetts physician's diagnosis of a young lady's incurable insanity, caused by reading "volumes of fictitious trash" over which she is said to have pored "day after day and night after night . . . until her cheeks grew pale, her eyes became wild and restless, and her mind wandered and was lost" (40).

84. "Amusement," in *Family Christian Almanac* (1861), 36.

85. On the operative Victorian metaphor of the human body as a reservoir of energy and its significance for the understanding of health and sexuality, see

Joseph F. Kett, *Rites of Passage: Adolescence in America, 1790 to the Present* (New York: Basic Books, 1977), 106.

86. Beecher and Beecher Stowe, *American Woman's Home,* 342.

87. On sympathy and friends, see *Family Christian Almanac* (1861), 20.

88. Helen Cross Knight, "Domestics," in *Family Christian Almanac* (1863), 39–40.

89. "Washing the Disciples' Feet," *Family Christian Almanac* (1860), 33.

90. *Family Christian Almanac* (1865), 41–2.

91. *Family Christian Almanac* (1860), 42.

92. "A Christian Family Exposed to the Wild Beasts in the Arena," in *Family Christian Almanac* (1853), 19.

93. As it applied to aesthetics, empathy was formulated by German and British writers in the eighteenth and nineteenth centuries as a projection of the self into an external circumstance, to "feel oneself into" (*sich hineinfühlen*) a landscape, a painted figure, or another person. On the history of empathy in German art theory, see *Empathy, Form, and Space: Problems in German Aesthetics, 1873–1983,* intro. and trans. Harry Francis Mallgrave and Eleftherios Ikonomou (Santa Monica, Calif.: Getty Center for the History of Art and the Humanities, 1994); Wilhelm Perpeet, "Historisches und Systematisches zur Einfühlungsaesthetik," *Zeitschrift für Aesthetik und allgemeine Kunstwissenschaft* 11 (1966): 193–216; and David Morgan, "The Enchantment of Art: Abstraction and Empathy from German Romanticism to Expressionism," *Journal of the History of Ideas* 57, no. 2 (April 1996): 317–41. For a phenomenological analysis of empathy, see the student of Edmund Husserl, Edith Stein (subsequently a convert, Carmelite, and a martyr, Sister Teresa Benedicta of the Cross), *On the Problem of Empathy,* trans. Waltraut Stein, vol. 3 of *The Collected Works of Edith Stein* (Washington, D.C.: ICS Publications, 1989). In his widely influential study of the sublime and beautiful from 1757, Edmund Burke defined sympathy as "a sort of substitution, by which we are put into the place of another man, and affected in many respects as he is affected" (*A Philosophical Enquiry into the Origin of Our Ideas of the Sublime and Beautiful,* ed. J. T. Boulton [Notre Dame, Ind.: University of Notre Dame Press, 1958], 44). At the end of the eighteenth century Friedrich Schiller used sympathy and empathy interchangeably in his discussion of the sublime and the experience of pity in theatrical presentations of tragedy; see "On the Sublime" (1793), in Friedrich Schiller, *Essays,* ed. Walter Hinderer and Danile O. Dahlstrom, The German Library, vol. 17 (New York: Continuum, 1993), 41–42.

94. H[elen] C. K[night], "Pictures in a Sick-Room," in *Family Christian Almanac* (1862), 48.

95. See Horace Bushnell, *Christian Nurture,* intro. John Mulder (Grand Rapids, Mich.: Baker Book House, 1979), 30–31 (contra the long conversion); 77, 62–63 (contra revivals and their sudden conversions).

96. Ibid., 287.

97. Ibid., 121, 341.

98. Rev. S[amuel] Phillips, *The Christian Home, as It Is in the Sphere of Nature and the Church* (New York: Gurdon Bill, 1862), 151.

99. Ibid., 156.

100. Ibid., 162.

101. Ibid., 167, 153, 151.

102. Ibid., 26.

103. Bushnell, *Christian Nurture*, 212.

104. Ibid., 211, 219.

105. Ibid., 213, 218.

CHAPTER THREE: THE MASCULINITY OF CHRIST

1. For discussion of the many ideals of masculinity in the nineteenth century, see the important article by Charles E. Rosenberg, "Sexuality, Class, and Role in Nineteenth-Century America," *American Quarterly* 35, no. 2 (May 1973): 131–53; reprinted in *The American Man*, ed. Elizabeth H. Pleck and Joseph H. Pleck (Englewood Cliffs, N.J.: Prentice-Hall, 1980), 219–54; E. Anthony Rotundo, "Learning About Manhood: Gender Ideals and the Middle-Class Family in Nineteenth-Century America," in *Manliness and Morality: Middle-Class Masculinity in Britain and America, 1800–1940*, ed. J. A. Mangan and James Walvin (New York: St. Martin's Press, 1987), 35–51; Clyde Griffen, "Reconstructing Masculinity from the Evangelical Revival to the Waning of Progressivism: A Speculative Synthesis," in *Meanings for Manhood: Constructions of Masculinity in Victorian America*, ed. Mark C. Carnes and Clyde Griffen (Chicago: University of Chicago Press, 1990), 183–204; and Susan Curtis, "The Son of Man and God the Father: The Social Gospel and Victorian Masculinity," in Carnes and Griffen, eds., *Meanings for Manhood*, 67–78.

2. See Jonathan M. Butler, *Softly and Tenderly Jesus is Calling: Heaven and Hell in American Revivalism, 1870–1920* (Brooklyn, N.Y.: Carlson Publishing, 1991), 41–61.

3. Ira D. Sankey, James McGranahan, and George C. Stebbins, *Gospel Hymns* (Chicago: Biglow & Main, 1894), nos. 583, 660, and 589. Stanzas from each hymn convey the importance of friendship in evangelical faith:

What a Friend We Have in Jesus
What a friend we have in Jesus,
All our sins and griefs to bear;
What a privilege to carry
Everything to God in prayer.

I Am Praying for You
I have a Saviour, He's pleading in glory,
A dear, loving Saviour tho' earth-friends be few;
And now He is watching in tenderness o'er me,
But oh, that my Saviour were your Saviour too.

Saviour, Like a Shepherd
Saviour, like a shepherd lead us,
Much we need Thy tend'rest care;
In Thy pleasant pastures feed us,
For our use Thy folds prepare.
We are Thine, do Thou befriend us,
Be the Guardian of our way;
Keep Thy flock, from sin defend us,
Seek us when we go astray.

Ira Sankey accompanied the Chicago evangelist Dwight Moody on his national and international evangelical missions, joining affective music with Moody's new style of preaching.

4. Sandra S. Sizer, *Gospel Hymns and Social Religion: The Rhetoric of Nineteenth-Century Revivalism* (Philadelphia: Temple University Press, 1978), 172.

5. For a helpful discussion of this in regard to nineteenth-century hymns and evangelical theology, see ibid., 83–110. See also Maxine Van de Wetering, "The Popular Concept of 'Home' in Nineteenth-Century America," *Journal of American Studies* 18, no. 1 (April 1984): 5–28; and Colleen McDannell, *The Christian Home in Victorian America, 1840–1900* (Bloomington: Indiana University Press, 1986).

6. Horace Bushnell, *Christian Nurture*, intro. John M. Mulder (Grand Rapids, Mich.: Baker Book House, 1979), 374.

7. Adams, "Christ's Friendships," in *The Illustrated Family Christian Almanac for 1860* (New York: American Tract Society, 1860), 38.

8. C. W. Fry, "The Lily of the Valley," arr. J. R. Murray and I. D. Sankey, in Sankey, McGranahan, and Stebbins, *Gospel Hymns,* no. 367.

9. "In the Garden," in *Christian Service Songs,* ed. Homer Rodeheaver et al. (Winona Lake, Ind.: Rodeheaver, Hall-Mack, 1939), 187.

10. Robert Wells Veach, *The Friendship of Jesus* (New York: Fleming H. Revell, 1911), 18.

11. E. Anthony Rotundo, *American Manhood: Transformations in Masculinity from the Revolution to the Modern Era* (New York: Basic Books, 1993), 84; for a careful reflection on the need to historicize the volatile and protean issue of masculinity, see Jeffrey Richards, "'Passing the Love of Women': Manly Love and Victorian Society," in Mangan and Walvin, eds., *Manliness and Morality,* 92–122.

12. Rotundo, *American Manhood,* 85.

13. Rev. Ingram Cobbin, *Cobbin's Commentary on the Bible for Young and Old,* ed. E. J. Goodspeed (New York: Selmar Hess, 1876), vol. 1.

14. Rev. A. T. Pierson, "Saul-David-Jonathan," in *Half Hours with the Lessons of 1883* (Philadelphia: Presbyterian Board of Education, 1883), 453.

15. *Cobbin's Commentary,* 273.

16. For the legal, psychological, and popular constructions of homosexuality and heterosexuality in the late nineteenth and early twentieth centuries, see George Chauncey, *Gay New York: Gender, Urban Culture, and the Making of the Gay Male World, 1890–1940* (New York: Basic Books, 1994), 99–127; idem, "From Sexual Inversion to Homosexuality: Medicine and the Changing Conceptualization of Female Deviance," *Salmagundi* 58–59 (fall 1982–winter 1983): 114–46; Carroll Smith-Rosenberg, *Disorderly Conduct: Visions of Gender in Victorian America* (New York: Knopf, 1985), 265ff.; and Rotundo, *American Manhood,* 83–84, 274–75.

17. Betty A. DeBerg, *Ungodly Women: Gender and the First Wave of American Fundamentalism* (Minneapolis: Fortress Press, 1990), 27. On fashion and the New Woman, see Lois W. Banner, *American Beauty* (Chicago: University of

Chicago Press, 1983), chaps. 8 and 9; for a detailed treatment of the New Woman, see the chapter entitled "The New Woman as Androgyne: Social Disorder and Gender Crisis, 1870–1936" in Smith-Rosenberg, *Disorderly Conduct,* 245–96.

18. Richards, "'Passing the Love of Women,'" in Mangan and Walvin, eds., *Manliness and Morality,* 94, 101.

19. Tissot produced 365 watercolors of New Testament subjects between 1886 and 1896. These were published in two volumes, the rights for which were purchased from Tissot for one million francs by a Parisian publisher in an attempt to capitalize on the market first established by Gustave Doré's illustrated Bible of 1865. He was at work on the Jewish Bible when he died in 1902. On Tissot, see Albert E. Bailey, *Art Studies in the Life of Christ* (Boston: Pilgrim Press, 1917), 215; and Cleveland Moffett, "J. J. Tissot and His Paintings of the Life of Christ," *McClure's* 12, no. 5 (March 1899): 587–96. On Doré, see Millicent Rose, "Introduction," in *The Doré Bible Illustrations* (New York: Dover, 1974).

20. The editor concluded the lesson in Christ-like friendship with this observation: "Yes, Jonathan's love was wonderful, for he loved David better than he loved himself" (*The Young Folks Bible,* ed. Jennie Ellis Burdick [New York: University Society, 1925], 26).

21. Sixteen illustrations by Tissot appeared in an American edition of the Bible called *The Picture Bible* (New York: Bible Corporation, 1926[?]); Doré's work appeared in countless illustrated lives of Christ in the late nineteenth and early twentieth centuries as well as in Sunday school literature and illustrated Bibles such as *The Holy Bible* (New York: P. J. Kennedy & Sons, 1945[?]).

22. Bushnell, *Christian Nurture,* 63.

23. Quoted in Rotundo, *American Manhood,* 235. See also Joe L. Dubbert, *A Man's Place: Masculinity in Transition* (Englewood Cliffs, N.J.: Prentice-Hall, 1979), 122–62, for an informative overview of the "Bull Moose" masculinity around the turn of the century; and, for an exceptional study of Roosevelt and masculinity, Gail Bederman, *Manliness and Civilization: A Cultural History of Gender and Race in the United States, 1880–1917* (Chicago: University of Chicago Press, 1995), 170–215.

24. For a discussion of causal factors in the emergence of rugged masculinity, see Rotundo, "Learning About Manhood," 47–48; and Michael S. Kimmel, "The Contemporary 'Crisis' of Masculinity in Historical Perspective," in *The Making of Masculinities: The New Men's Studies,* ed. Harry Brod (Boston: Allen & Unwin, 1987), 137–49. On the Civil War and masculinity, see Dubbert, *A Man's Place,* 55–79; and Griffen, "Reconstructing Masculinity," 191–94.

25. Bederman, *Manliness and Civilization,* 171, 178ff.

26. John F. Finerty, *War-Path and Bivouac, or The Conquest of the Sioux* (1890; Norman: University of Oklahoma Press, 1994), xxi, 137, 104. On the ethos of military manliness, see Donald J. Mrozek, "The Habit of Victory: The American Military and the Cult of Manliness," in Mangan and Walvin, eds., *Manliness and Morality,* 220–41; and T. J. Jackson Lears, *No Place of Grace: Antimodernism and the Transformation of American Culture, 1880–1920* (Chicago: University of Chicago Press, 1981), 97–139.

27. Finerty, *War-Path and Bivouac,* 43, 219.

28. Cf. this passage in Finerty: "Captain Vroom was then a magnificent specimen of the human race, tall, well-built, and good-looking. He has grown much stouter, the result, doubtless, of the absence of Indian campaigns, which would now seem to be almost at an end" (ibid., 40).

29. Ibid., 81.

30. Dr. R. Warren Conant, *The Virility of Christ: A New View,* 2d ed. (Chicago: Dr. R. Warren Conant, 1915), 92–93.

31. Ibid., 93; emphasis in original.

32. Ibid., 94–97 passim.

33. Bruce Barton, *A Young Man's Jesus* (Boston: Pilgrim Press, 1914), ix. For an excellent discussion of the liberal Protestant (Social Gospel) notion of masculinity, see Curtis, "Son of Man and God the Father." A fine study of Barton and religion is Leo P. Ribuffo, "Jesus Christ as Business Statesman: Bruce Barton and the Selling of Corporate Capitalism," *American Quarterly* 33, no. 2 (summer 1981): 206–31.

34. Barton, *A Young Man's Jesus,* ix–xi.

35. Henry Cope, *The Friendly Life* (New York: Revell, 1909), 50; quoted in Curtis, "Son of Man and God the Father," 76.

36. Barton, *A Young Man's Jesus,* xvii.

37. For other advocates of the Boy Scout and businessman Jesus, see Curtis, "Son of Man and God the Father," 75–76.

38. Bruce Barton, *The Man Nobody Knows* (Indianapolis: Bobbs-Merrill, 1925), 40–41.

39. Ibid., prologue, n.p.

40. Barton takes his place in the now familiar pattern of "men's Christianity" in the twentieth century and its domination by sports figures from Billy Sunday to Bill McCartney, former football coach at the University of Colorado and founder of Promise Keepers, an evangelical men's movement; see Kenneth L. Woodward, "The Gospel of Guyhood," *Newsweek,* August 29, 1991, 60–61. For a discussion of masculinity in the nineteenth century, see Ann Douglas, *The Feminization of American Culture* (New York: Knopf, 1977); Kimmel, "Contemporary 'Crisis' of Masculinity," 143–49; Jan Lewis, "Motherhood and the Construction of the Male Citizen in the United States, 1750–1850," in *Constructions of the Self,* ed. George Levine (New Brunswick, N.J.: Rutgers University Press, 1992), 143–63; and Mark C. Carnes, "Middle-Class Men and the Solace of Fraternal Ritual," in Carnes and Griffen, eds., *Meanings for Manhood,* 37–66; on the early twentieth century, see Margaret Lamberts Bendroth, *Fundamentalism and Gender, 1875 to the Present* (New Haven: Yale University Press, 1993); DeBerg, *Ungodly Women,* 75–98; Gail Bederman, "'The Women Have Had Charge of the Church Work Long Enough': The Men and Religion Forward Movement of 1911–1912 and the Masculinization of Middle-Class Protestantism," *American Quarterly* 41 (1989): 432–65; and Bederman, *Manliness and Civilization.*

41. Sankey, McGranahan, and Stebbins, *Gospel Hymns,* no. 366.

42. For an overview of developments on the role of sports in the history of American masculinity from 1880 to 1920 and its link to military rhetoric, see

Dubbert, *A Man's Place,* 163–90; on the Boy Scouts, see Jeffrey P. Hantover, "The Boy Scouts and the Validation of Masculinity," in Pleck and Pleck, eds., *The American Man,* 285–301; on the Boys Scouts and the YMCA, see David I. Macleod, *Building Character in the American Boy: The Boy Scouts, YMCA, and Their Forerunners, 1870–1920* (Madison: University of Wisconsin Press, 1983). For a discussion of how members were directed to conduct YMCA rituals, see the organization's manual, *Hi-Y Rituals* (New York: Association Press, 1944), 3–9. Sallman's *Head of Christ* was distributed by the YMCA to its members and enthusiastically used as one of its "methods of advertising"; see "Philadelphia Central Uses Sallman's 'Christ' to Spread Christian Message," *National Council Bulletin,* May 1947, 10.

43. T. Otto Nall, "He Preaches As He Paints," *Classmate* 50, no. 50 (December 1943): 6.

44. Bruce Baylor, "A Man's Artist," *Sunday School Promoter* 5, no. 2 (May 1943): 26.

45. Nall, "He Preaches As He Paints," 6.

46. Jack R. Lundbom, "Masterpainter: Warner E. Sallman," typescript, 26. The biographical note on the back cover of *Religious Masterpieces,* published by Kriebel and Bates in 1956, states that Sallman attended Moody from 1912 to 1917 (Bates material, Sallman Archives, Wilson Galleries, Anderson University, Anderson, Ind.).

47. See, for instance, Howard Ellis, *Story of Sallman's "Head of Christ"* (Indianapolis: Kriebel & Bates, 1944), 5–6; and Nall, "He Preaches As He Paints," 7.

48. Sylvia E. Peterson, "The Ministry of Christian Art," *Lutheran Companion* 55, no. 14 (April 2, 1947): 11. Ernest O. Sellers was at Moody from 1908 to 1918, where he served first as an assistant in the music department and then, from 1913 until 1918, as director of night classes; he taught courses in pedagogy and child study and conducted Sunday school classes during the day; see the "Introduction" by George H. Crutcher to Sellers's book *Personal Evangelism: Studies in Individual Efforts to Lead Souls into Right Relations to Christ* (New York: George H. Doran, 1923), vi–vii. Although Sellers was never dean, his position of director of night classes and the fact that he left Moody in 1918 to serve as a member of the Speaker's Bureau of the YMCA in Europe dates his conversation with Sallman (who had enrolled in a Saturday evening Bible class—see Lundbom, "Masterpainter," 26) to the war years.

49. Katherine Bevis, "He Painted a Religious Masterpiece," *Sunday School Messenger,* March 21, 1965, 5. Depictions of the violent Jesus cleansing the temple are as common in Sunday school illustration as they were in the academic religious art of the nineteenth century that inspired so much devotional and instructional imagery in the twentieth century. Heinrich Hofmann produced a drawing of the scene; see *The Hofmann Gallery of Original New Testament Illustrations* (Philadelphia: A. J. Holman, 1891). Julius Schnorr von Carolsfeld also produced a well-known version of the theme in *Die Bibel in Bildern* (Leipzig: Georg Wigland Verlag, [1870s]).

50. Barton, *Man Nobody Knows,* 42–43.

51. I do not wish to overemphasize the similarity between the Sallman ac-

count and Barton's book or to argue for a direct influence. Barton's low chris-
tology was certainly not acceptable to Sallman or evangelicals. Barton offered a
psychological account of Christ's life, one that was meant to appeal to its read-
ership by describing the motives and instincts that drive all "manly men."
Christ's miracles were explained by the force of his magnetic personality, not as
the supernatural events that Sallman and most conservative Christians would
have insisted they were.

52. Robert Paul Roth, "Christ and the Muses," *Christianity Today* 2, no. 11
(March 3, 1958): 9.

53. In a recent study of popular response to the imagery of Warner Sallman,
I discerned a prominent tendency among those who admired Sallman's work
(largely women) to see in his pictures of Jesus a visualization of a christology of
friendship; and among those who disliked his images (primarily men and male
clergy) a strong contempt for what they considered the imagery's effeminate
and/or homosexual characteristics. The latter often espoused what I call a chris-
tology of the sublime, a gendered theological discourse that understood Jesus as
unambiguously masculine and, often, best left unvisualized. Each of these re-
sponses is an interpretation rooted in American religious history and has made
effective use of images to promote its experience of Christian piety. See David
Morgan, "'Would Jesus Have Sat for a Portrait?': The Likeness of Christ in the
Popular Reception of Sallman's Art," in *Icons of American Protestantism: The
Art of Warner Sallman,* ed. David Morgan (New Haven: Yale University Press,
1996), 181–203. Discussions of the sexuality of Christ in the visual arts are in-
frequent. Two of the most interesting are Leo Steinberg, *The Sexuality of Christ
in Renaissance Art and Modern Oblivion* (New York: Pantheon Books, 1983);
and Thomas F. Mathews, *The Clash of the Gods: A Reinterpretation of Early
Christian Art* (Princeton: Princeton University Press, 1993), 115–41.

54. Sallman rarely depicted a crucified Christ, and his audience did not want
him to do so. When asked by a colleague, while producing Sunday bulletin cov-
ers for the Methodist Publishing House in the 1930s, whether he had ever con-
sidered portraying Christ as the terrible judge of the Apocalypse as described in
the first chapter of the Book of Revelation, Sallman is said to have replied:
"There would be no appeal for such a version" (Letter 8, Sallman Archives, An-
derson University).

55. "Closer, Lord, to Thee," composed by George Stebbins, words by E. G.
Taylor, in Sankey. McGranahan, and Stebbins, *Gospel Hymns,* no. 277.

56. Beth Lindberg, "Did Christ Look Like This?" *Christian Life,* December
1948, 19.

57. Hofmann (1824–1911), a teacher at Dresden's important Academy of Art,
produced *Jesus and the Rich Young Man* in 1889. Reproductions of the face of Je-
sus from this image circulated widely in the United States, appearing on all man-
ner of devotional items in religious supply house catalogues. It is no exaggeration
to say that Hofmann's image of Jesus was *the* representation of Jesus from c. 1920
to World War II, when Sallman's image largely replaced it in popularity. Even so,
many Christians are still familiar with "Hofmann's *Head of Christ.*"

58. See Bederman, "'The Women Have Had Charge of the Church Work
Long Enough.'"

59. There are numerous versions of the dream and its inspiration; for a discussion, see David Morgan, "'Would Jesus Have Sat for a Portrait?'" 184–87.

60. This is not to suggest that "high art" is free of discourse, but that its function may be more one of generating, extending, or even negating rather than corroborating existing discourse. Yet Tom Wolfe's satirical *The Painted Word* (New York: Farrar, Straus, Giroux, 1975), 62 and passim, argues that midcentury American avant-garde art followed from critical discourse rather than vice versa. In her blistering critique of minimalist sculpture in the 1960s, Anna C. Chave has perceptively pointed out that "[Carl] Andre's metal plates and [Robert] Morris's cage could only be regarded as works of art in the context of a discourse in which they stood as compelling proof of the unfolding of a certain historical inevitability" ("Minimalism and the Rhetoric of Power," *Arts Magazine* 64, no. 5 [January 1990]: 44–63; reprinted in *Art in Modern Culture: An Anthology of Critical Texts,* ed. Francis Frascina and Jonathan Harris [New York: HarperCollins, 1992], 266).

61. See Michael S. Kimmel, *Manhood in America: A Cultural History* (New York: Free Press, 1996), 120.

CHAPTER FOUR: READING THE FACE OF JESUS

1. Jakob Rosenberg, *Rembrandt: Life and Work,* rev. ed. (London: Phaidon, 1964), 116–18. Rosenberg overlooked, however, the sixth-century genre of icons that portrayed Christ as Semitic—on this "Semitic type," see Hans Belting, *Likeness and Presence: A History of the Image Before the Era of Art,* trans. Edmond Jephcott (Chicago: University of Chicago Press, 1993), 137, 139.

2. For a lucid analysis of the political function of icons and iconoclasm in eighth- and ninth-century Byzantium, see Jaroslav Pelikan, *The Christian Tradition,* vol. 2: *The Spirit of Eastern Christendom (600–1700)* (Chicago: University of Chicago Press, 1974), 91–145; for a penetrating and very suggestive discussion of the nature of debates over the role of images, see W. T. J. Mitchell, *Iconology: Image, Text, Ideology* (Chicago: University of Chicago Press, 1986), esp. 7–52. In his rich study of the history of icons, Belting has commented on the social embeddedness of icons in ancient and modern societies where such images wielded great power: "It would be artificial to draw a distinction between religious, patriotic, and political convictions. Images symbolized questions of identity to such an extent that they became the objects of symbolic actions (to which they lend themselves in any age) and were treated by the opposing party as enemies" (*Likeness and Presence,* 45).

3. One correspondent referred to Sallman's image as "a true photo of Jesus" (292).

4. Two owners appear with their enshrined tortillas in *National Geographic,* September 1993, 50. For the appearance of a face of Jesus in an advertisement for Pizza Hut spaghetti (as well as many other examples of anthropomorphic hidden images in popular culture), see Stewart Elliott Guthrie, *Faces in the Clouds: A New Theory of Religion* (New York: Oxford University Press, 1993), fig. 5–37.

5. Howard Finster, as told to Tom Patterson, *Howard Finster: Stranger from*

Another World, Man of Visions Now on this Earth (New York: Abbeville Press, 1989), 123: "One day I was workin' on a patch job on a bicycle, and I was rubbin' some white paint on this patch with this finger here, and I looked at the round tip o' my finger, and there was a human face on it. I could see it plain as day. And right then a warm feelin' come over my body, and a voice spoke to me and said, 'Paint sacred art.'"

6. Edie Clark, "Every Once in a While Something Happens . . . ," *Yankee* 58, no. 6 (June 1994): 88–93, 132–34.

7. *The Notebooks of Leonardo da Vinci,* ed. Edward MacCurdy (New York: George Braziller, 1958), 873–74 For examples of reversible images, see R. W. Scribner, *For the Sake of Simple Folk: Popular Propaganda for the German Reformation* (Oxford: Clarendon Press, 1994), figs. 134, 186. For a discussion of Cozens and his method of landscape painting, as well as an instructive examination of perceptual projection, see Ernst Gombrich, *Art and Illusion: A Study in the Psychology of Pictorial Representation* (Princeton: Princeton University Press, 1960), 181–202. John Onians, in "Abstraction and Imagination in Late Antiquity," *Art History* 3, no. 1 (March 1980): 1–23, has examined the "heightened visual imagination enabling one to see things that were not there" (17) in the Greco-Roman world. For a treatment of "visual accidents" in eighteenth-century art and visual culture, see Peter J. De Voogd, "Laurence Sterne, the Marbled Page, and the 'Use of Accidents,'" *Word and Image* 1, no. 3 (July–September 1985): 279–87. For a discussion of images of the Mountain of the Holy Cross, see Linda C. Hults, "Pilgrim's Progress in the West: Moran's *The Mountain of the Holy Cross,*" *American Art* 5, nos. 1–2 (winter/spring 1991): 69–85; my thanks to Anne Morand for bringing this essay to my attention. For diagrams and discussion of atmospheric phenomena, see "Signs—Men's Heart's Failing," *Midnight Cry* 4, nos. 1–2 (April 13, 1843): 9; Henry Jones, *Modern Phenomena of the Heavens* (New York: Piercy & Reed, 1843); and S. S. Brewer, *The Last Day Tokens,* 21st ed. (Yarmouth, Me.: Scriptural Publication Society, n.d.), 8–12, 51–59. For a discussion of artistic theory as it relates to the ideas of the Swiss psychiatrist Hermann Rorschach and his use of inkblots as a means of psychoperceptual measurement, see Diane E. Jonte-Pace, "Religion and Psychology in the Thought of Hermann Rorschach" (Ph.D. diss., University of Chicago, 1984), 104–35; for Rorschach's own observations on the artistic personality and his experiments, see Hermann Rorschach, *Psychodiagnostics,* trans. Paul Lemkau and Bernard Kronenberg, ed. W. Morgenthaler (Bern: Hans Huber, 1942), 107–10. For an excellent bibliography on anthropomorphism in art, see Guthrie, *Faces in the Clouds,* 249–71. I have also found helpful an unpublished paper by James Elkins, "Aleamorphs, Anamorphs, and Cryptomorphs."

8. Quoted in Pierre Nadeau, *The History of Surrealism,* trans. Richard Howard (Cambridge, Mass: Belknap Press, Harvard University Press, 1989), 184.

9. In another reversible image by Dalí, the stark juxtaposition of a bearded man (an imposing portrait of Freud?) and the young woman from a Vermeer painting violently suggests that behind the surfaces of the ordinary lurk the brutal violations that occupy "normal" people in the constant task of repression; see *The Image Disappears,* 1938, oil on canvas, private collection; reproduced in

Robert Descharnes, *Salvador Dalí: The Work, the Man,* trans. Eleanor R. Morse (New York: Harry N. Abrams, 1984), 240.

10. All descriptions of hidden images that were unclear were confirmed by a photocopy of the image provided to the letter writers and returned to the author.

11. Dale Francis, "Protestant Revolt Sent Religious Art into a Continuous Decline," *San Francisco Monitor,* June 1, 1956, 1.

12. Reported to the author by James Sallman, in a telephone conversation of July 8, 1993.

13. A video transfer from 16mm film exists entitled "Son of Man" (1954, © North Park College and Theological Seminary, Chicago), in which Sallman appears recreating the *Head of Christ.* An unidentified newsclipping from 1960 estimated that Sallman had reproduced the *Head of Christ* about five hundred times in chalk talk settings (Hiley H. Ward, "Stern or Tender? Artist Undertakes Job of Drawing Jesus at Worship Service," in Sallman Archives, Wilson Galleries, Anderson University, Anderson, Ind.).

14. Sallman drew a charcoal portrait called "The Son of Man" in 1924, which appeared on the cover of the *Covenant Companion* in February 1924. Although he later claimed that the face appeared to him in a dream or vision, the image strongly resembles the face of Christ painted in 1892 by Léon Lhermitte and reproduced in the *Ladies' Home Journal* in December 1922. Responding to charges that he copied the Lhermitte picture, Sallman acknowledged having seen the reproduction of the Frenchman's image but said, not without interest to the present discussion, "I don't wonder that people say the Lhermitte painting influenced my drawing. Isn't everything we create a composite of what we have subconsciously stored through the years?" (Margaret Anderson, "His Subject Shaped His Life," *War Cry,* December 9, 1961, 8). For a different view on Sallman and Lhermitte, see Jack R. Lundbom, "Warner Sallman and His 'Head of Christ,'" *Swedish-American Historical Quarterly* 47, no. 2 (April 1996): 69–83.

15. For a photograph by Carl Mydans of a priest saying the Confiteor before Vatican II, see *Life* 4, no. 12 (March 21, 1938): 35.

16. The following passage from a well-known Roman Catholic catechism popular in the late nineteenth and early twentieth centuries helps explain the perception of the chalice and host among Catholics and the power of the image to make present the person of Jesus: "The Holy Eucharist is the same living body of Our Lord which He had upon earth; but it is in a new form, under the appearances of bread and wine. Therefore Our Lord in the tabernacle can see and hear us" (Thomas L. Kinkead, *An Explanation of the Baltimore Catechism of Christian Doctrine,* 6th ed. [New York: Benziger Bros., 1891], 221).

17. See, for instance, Herbert Gans, "Popular Culture in America: Social Problem in a Mass Society or Social Asset in a Pluralist Society?" in *Culture and Mass Culture,* ed. Peter Davison, Rolf Meyersohn, and Edward Shils, Literary Taste, Culture, and Mass Communication, vol. 1 (Cambridge: Chadwyck-Healey; Teaneck, N.J.: Somerset House, 1978), 233–304; and Lawrence W. Levine, "The Folklore of Industrial Society: Popular Culture and Its Audiences," *American Historical Review* 97, no. 5 (December 1992): 1369–99.

18. Francis, "Protestant Revolt," 1. Notably, Francis misidentified Sallman

as a Lutheran artist from Alabama; in fact, Sallman spent his life in Chicago and was a member of the Swedish Evangelical Covenant church. On the Opus Dei, see Kenneth L. Woodward, *Making Saints: How the Catholic Church Determines Who Becomes a Saint, Who Doesn't, and Why* (New York: Touchstone, Simon & Schuster, 1996), 8–12, 384–87.

19. Letter 494; a variation on this account was sent by another person from New York, which testifies to the use of Sallman's picture in religious instruction: "Twenty-five years ago this August my husband-to-be and I went to see the priest who was going to marry us the following December and he had a copy of the *Sallman Head of Christ* hanging on the wall in the rectory. He said to us, 'I'll bet you think this is a Protestant picture but it is a very Catholic picture.' He then explained how Sallman had painted this picture overnight and that it had 5 or 6 hidden symbols in it that made it Catholic" (517).

20. William McDermott, "The Miracle Picture," *Christian Life* 24, no. 11 (March 1963): 28. On Sallman's account of the origin of the *Head of Christ,* see note 14.

21. Levine, "Folklore of Industrial Society," 1386

22. Among the best and most influential studies of appropriation in the reception of mass culture are Gans, "Popular Culture in America"; Michel de Certeau, *The Practice of Everyday Life,* trans. Steven Randall (Berkeley: University of California Press, 1984), 29–42; John Fiske, "Television: Polysemy and Popularity," *Critical Studies in Mass Communication* 3 (1986): 391–408; Henry Jenkins, *Textual Poachers* (New York: Routledge, 1992); Grant McCracken, *Culture and Consumption: New Approaches to the Symbolic Character of Consumer Goods and Activities* (Bloomington: Indiana University Press, 1995); and Levine, "Folklore of Industrial Society." For a cautionary view to the contrary, see Celeste Michelle Condit, "The Rhetorical Limits of Polysemy," in *Television: The Critical View,* ed. Horace Newcomb, 5th ed. (New York: Oxford University Press, 1994), 426–47.

23. For examples of such imagery, see Werner Hofmann, ed., *Luther und die Folgen für die Kunst,* exhibition catalogue, Kunsthalle Hamburg (Munich: Prestal Verlag, 1983); Charles Moseley, *A Century of Emblems: An Introductory Anthology* (Aldershot, Hants., Eng.: Scolar Press, 1989); Cesare Ripa, *Iconologie,* trans. Jean Baudouin (1644; repr. New York: Garland, 1976); and Joscelyn Godwin, *Robert Fludd: Hermetic Philosopher and Surveyor of Two Worlds* (Boulder, Colo.: Shambhala, 1979).

24. *The Hieroglyphic Bible* (Hartford: S. Andrus & Son, 1855). The rebus Bible remained popular in the United States into the twentieth century; see, for instance, Frank Beard, *Bible Symbols* (Chicago: John A. Hertel, 1904).

25. One study has characterized the relationship between word and image in certain formative stages of childhood development as reductive translation: "By this is meant that the child may work on the assumption that all non-verbal semiotic systems, including painting, are without significant loss reducible or translatable to verbal symbolic format" (Ciaran Benson, "Art and Language in Middle Childhood: A Question of Translation," *Word and Image* 2, no. 2 [April–June 1986]: 129).

26. "Sallman's 'The Boy Christ,' an Interpretation," in *A Series of Interpre-*

tations of the Sallman Religious Masterpieces (Indianapolis: Kriebel & Bates, n.d. [1955 or after]), n.p.

27. Ward, "Stern or Tender?" Sallman said that he learned how to draw the "simple figures . . . used today in sketching for chalk talks" from his mother; see the early biographical essay by Sylvia E. Peterson, "The Ministry of Christian Art," *Lutheran Companion* 55, no. 14 (April 2, 1947): 10.

28. Harlan Tarbell, *Chalk Talks for Sunday Schools* (Chicago: T. S. Denison, 1928), 11.

29. L. O. Brown, *Crayon Talks* (New York: Fleming H. Revell, 1941), 103. For other examples of visual transformation and a discussion of its use, see Rev. Robert F. Y. Pierce, *Pictured Truth: A Hand-Book of Blackboard and Object Lessons* (New York: Fleming H. Revell, 1895), 20; and William Allen Bixler, *Chalk Talk Made Easy* (Anderson, Ind.: Warner Press, 1932), 64–65.

30. [T.B.E.], *Curiosities of the Bible,* rev. ed. (New York: E. B. Treat, 1880), 272–73. Sallman enrolled in a Bible study course at the night school of Moody Bible Institute in 1914 and later identified a conversation with a faculty person there as inspirational for the creation of his image of Jesus (see chapter 3 in this volume). The Warner Press, a religious publisher for which Sallman provided illustration work, published several books on chalk talks, including Bixler's *Chalk Talk Made Easy,* which also included reversible images, e.g. p. 127.

31. See Guthrie, *Faces in the Clouds,* 91–121.

32. As one woman was told by a former altar boy in the Catholic church: the "light shadows on the forehead (round like the host) and on the temple (in the shape of the chalice) [serve] as reminders of Jesus' body and blood shed for us . . . " (293).

33. Guthrie, *Faces in the Clouds,* 90.

34. Wilson Bryan Key, *Subliminal Seduction* (New York: New American Library, 1973); Kerry L. Johnson, *Subliminal Selling Skills* (New York: AMACOM, 1988).

35. See above, note 14.

36. Sallman was not the only popular religious artist of his day to create hidden images. Harry Anderson, who both influenced and was influenced by Sallman's art in the early 1940s when he lived in Chicago and worked as a free-lance commercial illustrator for religious publications, produced a fascinating image in 1968 called *God's Two Books,* in which an image of Christ's face appears in a dense cluster of foliage before a woman in a garden, who pauses from her Bible reading to spy God's presence in his "other book"; see Raymond H. Woolsey and Ruth Anderson, *Harry Anderson: The Man Behind the Paintings* (Washington, D.C.: Review & Herald Publishing Association, 1976), 112.

37. See *Knocking at the Door: An Appeal to Youth,* no. 31, *Tracts of the American Tract Society,* vol. 1 (New York: American Tract Society, n.d.).

38. Howard W. Ellis, *Story of Sallman's "Christ at Door"* (Indianapolis: Kriebel & Bates, 1944), 8, 6. For a discussion of Hunt's image and the literary apparatus in which he constructed the picture such that "the symbolical and the natural combine," see George P. Landow, *William Holman Hunt and Typological Symbolism* (New Haven: Yale University Press, 1979), 34–46.

39. Ellis, *Story of Sallman's "Christ at Door,"* 9.

40. On the anchoring power of text and the polyvalence of images, see two classic essays by Roland Barthes, "The Photographic Message" and "The Rhetoric of the Image," in *The Responsibility of Forms: Critical Essays on Music, Art, and Representation,* trans. Richard Howard (Berkeley: University of California Press, 1991), 3–40.

41. Michel Foucault, *This Is Not a Pipe,* trans. and ed. James Harkness (Berkeley: University of California Press, 1983).

42. "Sallman's 'The Boy Christ,' an Interpretation," n.p.

43. The terms "high" and "low" are objectionable because they impute a value of cultural significance to the difference they mark—that is, that Magritte's work is important and Sallman's is not. Yet these terms register important intentional, historical, and social differences that must be recognized. An alternative pair such as "elite" and "popular" does not escape being prescriptive. I doubt that value-free descriptors exist because the cleavage between what Magritte and Sallman are each doing is so highly charged, imbued as it is with the tensions of class and cultural identity, that no nomenclature will elude—indeed, should be able to elude—the political nature of this conflict.

44. For further discussion of the avant-garde and its purpose, see David Morgan, "Secret Wisdom and Self-Effacement: The Spiritual in Art in the Modern Age," in *Negotiating Rapture,* ed. Richard Francis, exhibition catalogue (Chicago: Museum of Contemporary Art, 1996), 34–47. For an insightful consideration of the interrelation of critical discourse and abstract art in the twentieth century, see W. J. T. Mitchell, *"Ut Pictura Theoria:* Abstract Painting and the Repression of Language," *Critical Inquiry* 15, no. 2 (winter 1989): 348–71; and an essay by Stephan Bann, who argues that abstract art "stimulates the structure of meaningful discourse and borrows its functions in a parasitic fashion," "Abstract Art—A Language?" in *Towards a New Art: Essays on the Background to Abstract Art, 1910–20* (London: Tate Gallery, 1980), 125–45.

CHAPTER FIVE

1. Garrison Keillor, *Leaving Home: A Collection of Lake Wobegon Stories* (New York: Viking, 1987).

2. David Halle, *Inside Culture: Art and Class in the American Home* (Chicago: University of Chicago Press, 1993), 172–73.

3. See Appendix for the demographics of the letters.

4. Halle, *Inside Culture,* 174.

5. See David Morgan, ed., *Icons of American Protestantism: The Art of Warner Sallman* (New Haven: Yale University Press, 1996), 29–30, 189, 192, 203*n*.50.

6. The use of images in church interiors, particularly in sanctuary and altar spaces, is by no means infrequent; see, for instance, letters 6, 8, 13, 24, 43, 44, 78, 84, 91, 109, 121, 122, 142, 177, 188, 198, 203, 245, 264, 301, 342, 369, 378, 408, 417, 430, 466, 508.

7. On the family and domestic religion in the nineteenth century, see the important article by Maxine Van de Wetering, "The Popular Concept of 'Home' in Nineteenth-Century America," *Journal of American Studies* 18, no. 1 (April

1984): 5–28; also Colleen McDannell, *The Christian Home in Victorian America, 1840–1900* (Bloomington: Indiana University Press, 1986); McDannell, "Parlor Piety: The Home as Sacred Space in Protestant America," in *American Home Life, 1880–1930: A Social History of Spaces and Services,* ed. Jessica H. Foy and Thomas J. Schlereth (Knoxville: University of Tennessee Press, 1992), 162–89; Kathryn Kish Sklar, *Catharine Beecher: A Study in American Domesticity* (New York: W. W. Norton, 1976); and Ann Douglas, *The Feminization of American Culture* (New York: Doubleday, 1977), 80–117.

8. Tamara K. Hareven, "The Home and the Family in Historical Perspective," *Social Research* 58, no. 1 (spring 1991): 282; reprinted in *Home: A Place in the World,* ed. Arien Mack (New York: New York University Press, 1993), 227–60.

9. On chromos as a new technology and a popular commodity, see Peter C. Marzio, *The Democratic Art: Chromolithography, 1840–1900—Pictures for a Nineteenth-Century America* (Boston: David R. Godine, with Amon Carter Museum of Western Art, 1979).

10. Catherine E. Beecher and Harriet Beecher Stowe, *The American Woman's Home; or, Principles of Domestic Science* (New York: J. B. Ford, 1869), 94.

11. Letter 250; see also 80 and 275 for similar accounts.

12. See, for instance, letters 42, 75, 104, 105, 208, 209, 249, 305, 317, 443, 459.

13. See also letters 391, 443, and 459.

14. Peg Meier, "Grace: Masterpiece Depicting Prayerful Thanks Began as a Photograph in Bovey, Minn.," *Minneapolis Star Tribune,* August 19, 1993, 1E, 3E.

15. For a reproduction of the image and a discussion of its relationship to Sallman's portrait of Jesus, see David Morgan, "Introduction," in Morgan, ed., *Icons of American Protestantism,* 10–11.

16. A 1950 home and church supplies catalogue offered a "Rustic 'Art-Wood' Plaque" with Sallman's *Head of Christ* and the text: "Christ is the HEAD of this HOUSE / The Unseen Guest at every meal / The Silent Listener to every Conversation" (Gospel Trumpet Company, catalogue no. 51, Anderson, Indiana, p. 141). Gospel Trumpet had employed Anthony Kriebel and Fred Bates, who in 1940 formed a partnership to sell Sallman's imagery. Kriebel and Bates worked closely with the Gospel Trumpet Company (the publishing house of the Church of God, later called Warner Press) in the production and sales of the Sallman line. See Fred M. Bates, "History of Kriebel and Bates, Publishers of Sallman's Masterpieces," typescript, Sallman Archives, Wilson Galleries, Anderson University, Anderson, Indiana.

17. See William McDermott, "The Miracle Picture," *Christian Life* 24, no. 11 (March 1963): 28.

18. Mihaly Csikszentmihalyi and Eugene Rochberg-Halton, *The Meaning of Things: Domestic Symbols of the Self* (Cambridge: Cambridge University Press, 1981), 135–36.

19. For a discussion of the proximity of religious mottoes and family photographs in Victorian America, see Kenneth Ames, *Death in the Dining Room and Other Tales of Victorian Culture* (Philadelphia: Temple University Press,

1992), 100–101; on the use of the parlor organ to display photographs and cartes-de-visite, see Ames, "Material Culture as Non-Verbal Communication: A Historical Case Study," *Journal of American Culture* 3, no. 4 (winter 1980): 619–41. In a fascinating sociological study of living room decor, Edward O. Laumann and James S. House showed through statistical analysis of the contents and placement of items in 897 households in the Detroit metropolitan area that religious paintings were often located very near family photographs; see "Living Room Styles and Social Attributes: The Patterning of Material Artifacts in a Modern Urban Community," *Sociology and Social Research* 54, no. 3 (April 1970): 321–42, esp. 326.

20. "The Open Fire," *Family Christian Almanac* (New York: American Tract Society, 1868), 38.

21. For other images of the hearth and family, see *Family Christian Almanac* (1857), 23; (1861), 21, 25; (1865), 21, 27.

22. Katherine C. Grier, "The Decline of the Memory Palace: The Parlor After 1890," in Foy and Schlereth, eds., *American Home Life*, 69.

23. Robert S. Lynd and Helen Merrell Lynd, *Middletown: A Study in American Culture* (New York: Harcourt, Brace & World, 1929), 98–99.

24. For observations on working-class homes and the parlor and front room, see the classic study by Margaret F. Byington, *Homestead: The Households of a Mill Town*, ed. Paul Underwood Kellogg (New York: Charities Publication Committee, 1910), 55; also Lizabeth A. Cohen, "Embellishing a Life of Labor: An Interpretation of the Material Culture of American Working-Class Homes, 1885–1915," in *Common Places: Readings in American Vernacular Architecture*, ed. Dell Upton and John Michael Vlach (Athens: University of Georgia Press, 1986), 261–78.

25. Lynd and Lynd, *Middletown*, 100.

26. *Public Housing Design: A Review of Experience in Low-Rent Housing* (Washington, D.C.: National Housing Agency, Federal Public Housing Authority, June 1946), 103. For a discussion of "class differentials in family rituals" and the homes of the lower, middle, and upper classes in Philadelphia during the 1930s and 1940s, see James H. S. Bossard and Eleanor S. Boll, *Ritual in Family Living: A Contemporary Study* (Philadelphia: University of Pennsylvania Press, 1950), 105–34.

27. For a rich ethnographic study of a late-twentieth-century living room, see Stephen Harold Riggins, "Fieldwork in the Living Room: An Autoethnographic Essay," in *The Socialness of Things: Essays on the Socio-Semiotics of Objects*, ed. Stephen Harold Riggins (Berlin: Mouton de Gruyter, 1994), 101–47.

28. Erving Goffman, *The Presentation of Self in Everyday Life* (New York: Anchor Doubleday, 1959), 22–30; see also the Introduction in this volume.

29. Three particularly rich essays on ritual in regard to its purpose and power in human life are Theodore W. Jennings, "On Ritual Knowledge," *Journal of Religion* 62, no. 2 (April 1982): 111–27; Roland A. Delattre, "Ritual Resourcefulness and Cultural Pluralism," *Soundings* 61, no. 3 (fall 1978): 281–301; and Michael B. Aune, "The Subject of Ritual: Ideology and Experience in Action," in *Religious and Social Ritual: Interdisciplinary Explorations*, ed. Michael B. Aune and Valerie DeMarinis (Albany: State University of New York

Press, 1996), 147–73; the latter is especially good on the concepts of subject, self, and world. An excellent bibliographical source on ritual is Ronald L. Grimes, "Sources for the Study of Ritual," *Religious Studies Review* 10, no. 2 (April 1984): 134–45. Two authoritative studies of method and conceptual paradigms in the study of ritual are Ronald L. Grimes, *Ritual Criticism: Case Studies in Its Practice, Essays on Its Theory* (Columbia: University of South Carolina Press, 1990); and Catherine Bell, *Ritual Theory, Ritual Practice* (New York: Oxford University Press, 1992).

30. Morgan, *Icons of American Protestantism*, 29–30, 189, 192, 203*n*.50.

31. For an illuminating study of how different forms of ritual practice allow consumers to transfer meaning, through the material good, from the shared world to the consumer's own life, see Grant McCracken, *Culture and Consumption: New Approaches to the Symbolic Character of Consumer Goods and Activities* (Bloomington: Indiana University Press, 1990), 84–87.

32. Rev. Thomas L. Kinkead, *An Explanation of the Baltimore Catechism of Christian Doctrine* (New York: Benziger Bros., 1891), 221.

33. A rich study of holidays and their material culture is Leigh Eric Schmidt, *Consumer Rites: The Buying and Selling of American Holidays* (Princeton: Princeton University Press, 1995); see also Jack Santino, *New Old-Fashioned Ways: Holidays and Popular Culture* (Knoxville: University of Tennessee Press, 1996).

34. For an insightful discussion of "moral economy," see David Cheal, *The Gift Economy* (London: Routledge, 1988), 1–19. Cheal explores the gift as articulated within a social or moral economy that organizes fundamental aspects of life in modern capitalist society. His analyses of social relations and the reproduction of social forms of order through gift exchange are especially relevant for the study of visual piety.

35. For the classic discussion of gift-giving and reciprocation, see Marcel Mauss, *The Gift: The Form and Reason for Exchange in Archaic Societies*, trans. W. D. Halls (London: Routledge, 1990), 41. The ephemeral images I have in mind here are greeting cards; for a discussion of the history of their use, see Leigh Eric Schmidt, *Consumer Rites: The Buying and Selling of American Holidays* (Princeton: Princeton University Press, 1995); see also idem, "Practices of Exchange: From Market Culture to Gift Economy in the Interpretation of American Religion," in *Lived Religion in America,* ed. David D. Hall (Princeton: Princeton University Press, forthcoming). An excellent study of ephemeral religious images is *Imagiers de paradis. Images de piété populaires du XVe au XX siècle,* exhibition catalogue, Musée en Piconrue (Bastogne: Crédit Communal, 1990).

36. *Hi-Y Rituals* (New York: Association Press, 1944), 3.

37. Peter L. Berger, *The Sacred Canopy: Elements of a Sociological Theory of Religion* (Garden City, N.Y.: Doubleday, 1967), 4; Peter L. Berger and Thomas Luckmann, *The Social Construction of Reality: A Treatise in the Sociology of Knowledge* (Garden City, N.Y.: Doubleday, 1966), 56–58.

38. Jennings, "On Ritual Knowledge," 116.

39. Christopher Crocker, "Ritual and the Development of Social Structure: Liminality and Inversion," in *The Roots of Ritual,* ed. James D. Shaughnessy (Grand Rapids, Mich.: Eerdmans, 1973), 61.

40. Evan M. Zuesse, "Ritual," in *The Encyclopedia of Religion*, ed. Mircea Eliade (New York: Macmillan; London: Collier Macmillan, 1987), 12:406.

CHAPTER SIX: MEMORY AND THE SACRED

1. See, for instance, David Chidester and Edward T. Linenthal, eds., *American Sacred Space* (Bloomington: Indiana University Press, 1995).

2. Recent studies of sacred space include: ibid.; Jonathan Z. Smith, *To Take Place: Toward Theory in Ritual* (Chicago: University of Chicago Press, 1987); Lisa Stone and Jim Zanzi, *Sacred Spaces and Other Places: A Guide to Grottos and Sculptural Environments in the Upper Midwest* (Chicago: School of the Art Institute of Chicago Press, 1994); and Kevin M. Sweeney, "Meetinghouses, Town Houses, and Churches: Changing Perceptions of Sacred and Secular Space in Southern New England, 1720–1850," *Winterthur Portfolio* 28, no. 1 (spring 1993): 59–93.

3. For a fascinating discussion of the new importance of time for Roman Catholic devotion to St. Jude, in regard particularly to twentieth-century American Catholicism's need to relocate the center of devotion from the local and ethnic realm to the entire nation, see Robert A. Orsi, "The Center Out There, In Here, and Everywhere Else: The Nature of Pilgrimage to the Shrine of Saint Jude, 1929–1965," *Journal of Social History* 25, no. 1 (fall 1991): 221–23.

4. Quoted in B. A. Gerrish, "Discerning the Body: Sign and Reality in Luther's Controversy with the Swiss," *Journal of Religion* 68, no. 3 (July 1988): 378. An especially insightful study of the Swiss Protestant iconoclasm is Lee Palmer Wandel, *Voracious Idols and Violent Hands: Iconoclasm in Reformation Zurich, Strasbourg, and Basel* (Cambridge: Cambridge University Press, 1994).

5. The image of the memory theater is from the second volume of Fludd's *Tractatus Primi Sectio Secunda, De Technica Microcosmi Historia*, 1620, and is reproduced in Joscelyn Godwin, *Robert Fludd: Hermetic Philosopher and Surveyor of Two Worlds* (Boulder, Colo.: Shambhala, 1979), 89; see also Frances Yates, *The Art of Memory* (Chicago: University of Chicago Press, 1966). A fine study of the history of thought about memory as a historical mode is Patrick H. Hutton, *History as an Art of Memory* (Hanover, N.H.: University of Vermont and University Press of New England, 1993).

6. For an excellent introduction to the illustrated primer, see Patricia U. Bonomi, *Education and Religion in Early America: Gleanings from the New England Primer*, Thirteenth Annual Phi Alpha Theta Distinguished Lecture on History (State University of New York at Albany, 1993), 1–11. An informative history of religious publications and children is Ruth B. Bottigheimer, *The Bible for Children: From the Age of Gutenberg to the Present* (New Haven: Yale University Press, 1996).

7. *Curious Hieroglyphic Bible* (Worcester, Mass.: Isaiah Thomas, 1788).

8. Frank Beard, *Bible Symbols* (Chicago: John A. Hertel, 1904), 4. A German edition was prepared by a professor in Fort Wayne, Indiana, and published by Hertel in 1909 as *Biblische Symbole oder Bibelblätter in Bildern*.

9. Two of the most extensive and systematic manuals on the use of images in religious instruction are Frederica Beard, *Pictures in Religious Education*

(New York: George H. Doran, 1920); and Albert Edward Bailey, *The Use of Art in Religious Education* (New York: Abingdon Press, 1922). A very large body of literature that developed between the 1880s and the 1950s for use in religious instruction demonstrated the application of blackboard and chalk drawings, which were promoted as a way of keeping children's attention and helping them remember lessons. For an early example of one of these many "how-to" manuals, see Rev. Robert F. Y. Pierce, *Pictured Truth: A Hand-Book of Blackboard and Object Lessons* (New York: Fleming H. Revell, 1895).

10. "A Description of the Bethel Series and a Statement of Its Objectives," in *The Bethel Series* (Madison, Wis.: Adult Christian Education Foundation, 1961), 2; emphasis added.

11. Millennialists looked for the dawn of the final thousand years of history (either before or after Christ's Second Coming), which they believed could be deduced from the prophetic symbolism of such books of the Bible as Daniel and Revelation. Dispensationalists refined millennialist interpretation in the late nineteenth century by discerning a distinct succession of phases of human history.

12. John Ashton Savage, *The Scroll of Time or Epochs and Dispensations of Scripture* (London: G. Morrish, n.d. [1893]), 2.

13. The most encyclopedic collection of Larkin's diagrams appears in his *Dispensational Truth or God's Plan and Purpose in the Ages,* rev. ed. (Philadelphia: Rev. Clarence Larkin Estate, 1920). Several images are reproduced in George M. Marsden, *Fundamentalism and American Culture: The Shaping of Twentieth-Century Evangelicalism, 1870–1925* (Oxford: Oxford University Press, 1980), 53, 58–59, 64–65.

14. Clarence Larkin, *The Book of Revelation: A Study of the Last Prophetic Book of Holy Scripture* (Philadelphia: Rev. Clarence Larkin Estate, 1919), ix–x.

15. Larkin, *Dispensational Truth,* 1.

16. The Millerites shared with their contemporaries, the Shakers, an intense millennial vision and an iconophobia that eschewed pictorial imagery. Yet both groups produced a schematic imagery in the early 1840s that eluded the stern proscription of pictures. For a brief period of time in the mid-1840s, the two groups came into close contact when former Millerites became members of Shaker communities. With the failure of the Millerite predictions and its own eschatological crisis, the Shaker community adopted in 1845 an explicit ban on "charts," in addition to other images. This apparently unprecedented injunction against charts was adopted by the community during a period when disillusioned Millerites joined the Shakers. For a quotation of the text of the ban, see Sally M. Promey, *Spiritual Spectacles: Vision and Image in Mid-Nineteenth-Century Shakerism* (Bloomington: Indiana University Press, 1993), 34. For a discussion of the Shakers and Millerites, see Lawrence Foster, "Had Prophecy Failed? Contrasting Perspectives of the Millerites and Shakers," in *The Disappointed: Millerism and Millenarianism in the Nineteenth Century,* ed. Ronald L. Numbers and Jonathan M. Butler (Bloomington: Indiana University Press, 1987), 173–88; for an insightful discussion of the crucial role of memory in Shaker culture and images, see Promey, *Spiritual Spectacles,* 107–31.

17. The following article appeared in the Millerite weekly *Signs of the Times*

5, no. 10 (May 10, 1843), 76: "'End of the World.' A large sheet has been hawked about for the last few weeks, entitled, 'Illustration of Miller's views of the end of the world in 1843.' The sheet is compiled entirely from our own illustrations, with the exception of a large cut to illustrate the Advent and Ascension. In consideration of this last representation, we take this opportunity to give our unqualified dissent, to this, or any attempt to represent by cuts, future scenes of such awful interest, which are beyond the province of man to delineate. We also feel that we are expressing the views of our friends, when we say that they would also shrink from such attempts of the fancy, contrary to good taste, and presumptuous in the extreme." By characterizing the pictorial portrayal of Christ in advent and ascension as an act of vanity and surpassing the human imagination, the Millerite leadership recalls Calvin's vociferous objections to images of the divine; see John Calvin, *Institutes of Religion,* trans. Henry Beveridge (Grand Rapids, Mich.: Eerdmans, 1962), 90–103.

18. I take up this "visual theology" at much greater length in a study, currently in preparation, of images in nineteenth- and twentieth-century popular religious culture, "The Printed Image and American Protestant Piety," in a chapter on Millerism.

19. On this dynamic or constructive view of memory, see *Images of Memory: On Remembering and Representation,* ed. Susanne Küchler and Walter Melion (Washington, D.C.: Smithsonian Institution Press, 1991), 3, 7. For a bibliographical essay on research in memory and images, see H. Howard Levie, "Research on Pictures: A Guide to the Literature," in *The Psychology of Illustration,* ed. Dale M. Willows and Harvey A. Houghton (New York: Springer-Verlag, 1987), 1–50, esp. 9–14.

20. Orestes Brownson, *Saint-Worship: The Worship of Mary,* ed. Thomas R. Ryan, C.PP.S. (Paterson, N.J.: St. Anthony Guild Press, 1963), 76.

21. Ibid., 76–77, 80, 82 (quotation).

22. Hutton, *History as an Art of Memory,* 76.

23. For the relation of Sallman's *Head of Christ* to commercial photography, see David Morgan, "Warner Sallman and the Visual Culture of American Protestantism," in *Icons of American Protestantism: The Art of Warner Sallman,* ed. David Morgan (New Haven: Yale University Press, 1996), 31–38.

24. Whether narrative or anecdotal, memory and writing are of course not exclusive to modern Protestants. Robert Orsi has discussed the importance of memory and writing among Catholic devotees of St. Jude, for example, in "The Center Out There," 223–24; and Barbara Meyerhoff has explored the connection of memory and writing among elderly Jews in *Remembered Lives: The Work of Ritual, Storytelling, and Growing Older,* ed. Marc Kaminsky (Ann Arbor: University of Michigan Press, 1992), 231–47.

25. For a discussion of the gender statistics of the letters as well as an interpretation of the data on this issue, see Morgan, ed., *Icons of American Protestantism,* 204–6; also 201–3.

26. Bruce Barton, *The Man Nobody Knows: A Discovery of the Real Jesus* (Indianapolis: Bobbs-Merrill, 1924), n.p. Women could also express contempt for Sallman's images on the basis of negative memory associations from childhood. The following, written by a Protestant woman, is remarkably similar to Barton's

contemptuous memories of Sunday school: "I associate the head of Christ mainly with the dreary Sunday school classrooms of my childhood and youth in the 1940's and 1950's. The rooms were all painted institutional-green. Each one contained a tinny-sounding upright piano, a shaky yellow-oak lectern, and stacks of yellowing, outdated Sunday school literature on makeshift wooden shelves. On a wall, in addition to the Sallman head of Christ there was often an almost colorless print of Naomi and Ruth embracing melodramatically, or some other such picture. The classes that met in these bleak rooms were presided over by a succession of prim, stocky, shapeless, middle-aged women, mostly unmarried, who habitually wore dark crepe dresses and black lace-up oxfords with clunky Cuban heels (generally known as 'sensible shoes'). They led yukky devotionals that made overly generous use of the word 'meaningful,' always spoken in a hushed, sticky-sweet voice. With closed eyes they sang dreary hymns like 'Sweet Hour of Prayer,' in shrieking, swooping voices. One of them regularly played McDowell's insipid 'To a Wild Rose' on the piano in an effort to create a worshipful atmosphere. My memories of this scene are far from pleasant. I feel that I am an active church participant today in spite of them, not because of them" (170).

27. See Marilyn Motz and Pat Browne, eds., *Making the American Home: Middle-Class Women and Domestic Material Culture, 1840–1940* (Bowling Green, Ohio: Bowling Green State University Press, 1988); and Marilyn F. Motz, "Visual Autobiography: Photograph Albums of Turn-of-the-Century Midwestern Women," *American Quarterly* 39 (1989): 63–92. Not surprisingly, Mihaly Csikszentmihalyi and Eugene Rochberg-Halton found that heirloom plateware was "significantly more special to women than to men" (*The Meaning of Things: Domestic Symbols of the Self* [Cambridge: Cambridge University Press, 1981], 82). Despite women's preeminence at home, in terms of the public culture of commemoration, male image makers have dominated the historiography; see, for instance, Michael Kammen's *Meadows of Memory: Images of Time and Tradition in American Art and Culture* (Austin: University of Texas Press, 1992), a lucid examination of the "high" arts of sculpture and painting since the eighteenth century as defining the visual culture of American memory. Virtually all of the artists discussed are male. Barry Schwartz's fine study of commemorative iconography in the Congress building in Washington, D.C., "The Social Context of Commemoration: A Study in Collective Memory," *Social Forces* 61, no. 2 (December 1982): 374–402, also reveals an overwhelming majority of male subjects in public and national commemoration.

28. Csikszentmihalyi and Rochberg-Halton, *The Meaning of Things*, 106, 115.

29. Linda Dégh, "Letters to the Dead," in Dégh, *American Folklore and the Mass Media* (Bloomington: Indiana University Press, 1994), 170. Dégh continues: "Since these women are the custodians of family values, they compose the texts for occasional poetry, mark and record important family events, initiate family reunions, write diaries, travelogues, family histories, and genealogies, create almanacs, and fill autograph and photograph albums and scrapbooks, mixing and matching self-authored, adapted, and copied pieces of traditional poetry. These writings cultivate tradition and respect for ancestry, particularly for the parental generation" (172).

30. Peter L. Berger and Thomas Luckmann, *The Social Construction of Reality: A Treatise in the Sociology of Knowledge* (Garden City, N.Y.: Doubleday, 1966), 58; 63; 120.

CONCLUSION

1. Hans Medick, "'Missionaries in the Rowboat?' Ethnological Ways of Knowing as a Challenge to Social History," in *The History of Everyday Life: Reconstructing Historical Experience and Ways of Life,* ed. Alf Lüdtke, trans. William Templer (Princeton: Princeton University Press, 1995), 55.

2. Pierre Bourdieu, *Outline of a Theory of Practice,* trans. Richard Nice (Cambridge: Cambridge University Press, 1977), 80.

3. Erving Goffman readily gives the impression of decentering the self, of pinning its identity to the dynamics of individual performances, thereby suggesting that there is a distinction between the self as individual and the self as performer but without stating just what the relationship between the two is; see *The Presentation of the Self in Everyday Life* (New York: Doubleday, 1959), 252–53. Anthony Giddens insists that Goffman adheres to the idea of an enduring self, although Giddens concedes that it is a concept that Goffman never bothered to elaborate because what interested him most was the dynamics of interactional performances; see "Goffman as Systematic Social Theorist," in *Erving Goffman: Exploring the Interaction Order,* ed. Paul Drew and Anthony Wootton (Boston: Northeastern University Press, 1988), 258–59, 278. For a more positive and no less constructivist view of the formation of the self, see Mihaly Csikszentmihalyi and Eugene Rochberg-Halton, *The Meaning of Things: Domestic Symbols and the Self* (New York: Cambridge University Press, 1981), 189–96, who link the self to the material culture of objects more than to dramaturgy. Bourdieu takes a position between existentialist freedom and rigid determinism: "Because the habitus is an endless capacity to engender products . . . whose limits are set by the historically and socially situated conditions of its production, the . . . freedom it secures is as remote from a creation of unpredictable novelty as it is from a simple mechanical reproduction of the initial conditionings" (*Outline of a Theory of Practice,* 95). For a discussion of the social construction of the self as it relates to problems of power and knowledge, see Dennis K. Mumby, "Two Discourses on Communication, Power, and the Subject," in *Constructions of the Self,* ed. George Levine (New Brunswick, N.J.: Rutgers University Press, 1992), 81–104.

4. Bourdieu, *Outline of a Theory of Practice,* 83.

5. It is left for avant-garde artistic culture to cultivate radical innovation and to risk no financial recompense because the artistic result lies outside of existing markets, however unlikely that may be in the art world today.

6. Emile Durkheim, *The Elementary Forms of Religious Life,* trans. Karen D. Fields (New York: Free Press, 1995), 9.

SELECT BIBLIOGRAPHY

Abbott, Jacob. *The Young Christian; or, A Familiar Illustration of the Principles of Christian Duty.* Stereotype ed. Boston: William Pierce, [1832] 1935.

Banner, Lois. "Religious Benevolence as Social Control: A Critique of an Interpretation." *Journal of American History* 60, no. 1 (June 1973): 23–41.

Barthes, Roland. *The Responsibility of Forms: Critical Essays on Music, Art, and Representation.* Translated by Richard Howard. Berkeley: University of California Press, 1991.

Barton, Bruce. *The Man Nobody Knows.* Indianapolis: Bobbs-Merrill, 1925.

———. *A Young Man's Jesus.* Boston: Pilgrim Press, 1914.

Bederman, Gail. *Manliness and Civilization: A Cultural History of Gender and Race in the United States, 1880–1917.* Chicago: University of Chicago Press, 1995.

Beecher, Catharine E., and Harriet Beecher Stowe. *The American Woman's Home; or, Principles of Domestic Science.* New York: J. B. Ford, 1869.

Bell, Catherine. *Ritual Thinking, Ritual Practice.* New York: Oxford University Press, 1992.

Belting, Hans. *The Image and Its Public in the Middle Ages: Form and Function of Early Paintings of the Passion.* Translated by Mark Bartusis and Raymond Meyer. New Rochelle, N.Y.: Aristide D. Caratzas, 1990.

———. *Likeness and Presence: A History of the Image Before the Era of Art.* Translated by Edmond Jephcott. Chicago: University of Chicago Press, 1993.

Berger, Peter L. *The Sacred Canopy: Elements of a Sociological Theory of Religion.* Garden City, N.Y.: Doubleday, 1967.

Berger, Peter L., and Thomas Luckmann. *The Social Construction of Reality: A Treatise in the Sociology of Knowledge.* Garden City, N.Y.: Doubleday, 1966.

Bottigheimer, Ruth B. *The Bible for Children: From the Age of Gutenberg to the Present.* New Haven: Yale University Press, 1996.

Bourdieu, Pierre. *Outline of a Theory of Practice*. Translated by Richard Nice. Cambridge: Cambridge University Press, 1977.

Brown, Frank Burch. *Religious Aesthetics: A Theological Study of Making and Meaning*. Princeton: Princeton University Press, 1989.

Brownson, Orestes. *Saint-Worship. The Worship of Mary*. Edited by Thomas R. Ryan, C.PP.S. Paterson, N.J.: St. Anthony Guild Press, 1963.

Bushnell, Horace. *Christian Nurture*. Grand Rapids, Mich.: Baker Book House, 1979.

Bynum, Caroline Walker. *The Resurrection of the Body in Western Christianity, 200–1336*. New York: Columbia University Press, 1995.

———. "Why All the Fuss About the Body? A Medievalist's Perspective." *Criticial Inquiry* 22, no. 1 (autumn 1995): 1–33.

Carnes, Mark C., and Clyde Griffen, eds. *Meanings for Manhood: Constructions of Masculinity in Victorian America*. Chicago: University of Chicago Press, 1990.

Chauncey, George. *Gay New York: Gender, Urban Culture, and the Making of the Gay Male World, 1890–1940*. New York: Basic Books, 1994.

Cheal, David. *The Gift Economy*. London: Routledge, 1988.

Chidester, David, and Edward T. Linenthal, eds. *American Sacred Space*. Bloomington: Indiana University Press, 1995.

Clebsch, William A. *American Religious Thought: A History*. Chicago: University of Chicago Press, 1973.

Coleman, Simon. "Words as Things: Language, Aesthetics, and the Objectification of Protestant Evangelicalism." *Journal of Material Culture* 1, no. 1 (1996): 107–28.

Conforti, Joseph A. *Jonathan Edwards, Religious Tradition, and American Culture*. Chapel Hill: University of North Carolina Press, 1995.

Csikszentmihalyi, Mihaly, and Eugene Rochberg-Halton. *The Meaning of Things: Domestic Symbols and the Self*. New York: Cambridge University Press, 1981.

Curtis, James R. "Miami's Little Havana: Yard Shrines, Cult Religion, and Landscape." In *Rituals and Ceremonies in Popular Culture*, edited by Ray B. Browne, 105–19. Bowling Green, Ohio: Bowling Green University Popular Press, 1980.

Davidson, Peter, Rolf Meyersohn, and Edward Shils, eds. *Culture and Mass Culture*. Literary Taste, Culture, and Mass Communication, vol. 1. Cambridge: Cahdwyck-Healey; Teaneck, N.J.: Somerset House, 1978.

Davis, John. *Landscape of Belief: Encountering the Holy Land in Nineteenth-Century American Art and Culture*. Princeton: Princeton University Press, 1996.

DeBerg, Betty A. *Ungodly Women: Gender and the First Wave of American Fundamentalism*. Minneapolis: Fortress Press, 1990.

Doss, Erika. "Elvis Culture: Fans, Faith, and Image in Contemporary America." In progress.

Douglas, Ann. *The Feminization of American Culture*. New York: Doubleday, 1977.

Durkheim, Emile. *The Elementary Forms of Religious Life.* Translated by Karen E. Fields. New York: Free Press, 1995.

Edwards, Jonathan. *The Life of David Brainerd.* Edited by Norman Pettit. Vol. 7 of *The Works of Jonathan Edwards.* New Haven: Yale University Press, 1985.

———. *Religious Affections.* Edited by John E. Smith. Vol. 2 of *The Works of Jonathan Edwards.* New Haven: Yale University Press, 1959.

Elsbree, Oliver Wendell. "Samuel Hopkins and His Doctrine of Benevolence." *New England Quarterly* 8, no. 4 (December 1935): 534–50.

Family Christian Almanac. New York: American Tract Society, 1821–77.

Finney, Charles Grandison. *Lectures on Revivals of Religion.* Edited by William G. McLoughlin. Cambridge, Mass.: Belknap Press, Harvard University Press, 1960.

Fiske, John. "Television: Polysemy and Popularity." *Critical Studies in Mass Communication* 3 (1986): 391–408.

Flannery, Austin, O.P. *Vatican Council II: The Conciliar and Post-Conciliar Documents.* Wilmington, Del.: Scholarly Resources, 1975.

Fleming, Daniel Johnson. *Each with His Own Brush: Contemporary Christian Art in Asia and Africa.* New York: Friendship Press, 1938.

Foucault, Michel. *This Is Not a Pipe.* Translated and edited by James Harkness. Berkeley: University of California Press, 1991.

Foy, Jessica H., and Thomas J. Schlereth, eds. *American Home Life, 1880–1930: A Social History of Spaces and Services.* Knoxville: University of Tennessee Press, 1992.

Freedberg, David. *The Power of Images: Studies in the History and Theory of Response.* Chicago: University of Chicago Press, 1989.

Geertz, Clifford. *The Interpretation of Cultures.* New York: Basic Books, 1973.

Goethals, Gregor T. *The Electronic Golden Calf: Images, Religion, and the Making of Meaning.* Cambridge, Mass.: Cowley Publications, 1990.

———. *The TV Ritual: Worship at the Video Altar.* Boston: Beacon Press, 1981.

Goffman, Erving. *The Presentation of the Self in Everyday Life.* New York: Anchor Doubleday, 1959.

Guthrie, Stewart Elliot. *Faces in the Clouds: A New Theory of Religion.* New York: Oxford University Press, 1993.

Gutjahr, Paul Charles. "Battling for the Book: The Americanization of the Bible in the Antebellum Publishing Market." Ph.D. diss., University of Iowa, 1996.

Halbwachs, Maurice. *On Collective Memory.* Translated by Lewis A. Coser. Chicago: University of Chicago Press, 1992.

Halle, David. *Inside Culture: Art and Class in the American Home.* Chicago: University of Chicago Press, 1993.

Hunt, Lynn, ed. *The New Cultural History.* Berkeley: University of California Press, 1989.

Hutton, Patrick H. *History as an Art of Memory.* Hanover, N.H.: University of Vermont and University Press of New England, 1993.

Imagiers de paradis. Images de piété populaires du XVe au XXe siècle. Exhibition catalogue, Musée en Piconrue. Bastogne: Crédit Communal, 1990.

Jaffee, David. "'A Correct Likeness': Culture and Commerce in Nineteenth-Century Rural America." In *Folk Art and Art Worlds,* edited by John Michael Vlach and Simon J. Bronner, 53–84. Ann Arbor: UMI Research Press, 1986.

Kett, Joseph F. *Rites of Passage: Adolescence in America, 1790 to the Present.* New York: Basic Books, 1977.

Kselman, Thomas, ed. *Belief in History: Innovative Approaches to European and American Religion.* Notre Dame, Ind.: University of Notre Dame Press, 1991.

Küchler, Susanne, and Walter Melion, eds. *Images of Memory: On Remembering and Representation.* Washington, D.C.: Smithsonian Institution Press, 1991.

Kuryluk, Ewa. *Veronica and Her Cloth: History, Symbolism, and Structure of a "True" Image.* New York: Basil Blackwell, 1991.

Levine, George, ed. *Constructions of the Self.* New Brunswick, N.J.: Rutgers University Press, 1992.

Levine, Lawrence W. "The Folklore of Industrial Society: Popular Culture and Its Audiences." *American Historical Review* 97, no. 5 (December 1992): 1369–99.

———. *Highbrow/Lowbrow: The Emergence of Cultural Hierarchy in America.* Cambridge, Mass.: Harvard University Press, 1988.

Lubar, Steven, and W. David Kingery, eds. *History from Things: Essays on Material Culture.* Washington, D.C.: Smithsonian Institution Press, 1993.

Lüdtke, Alf, ed. *The History of Everyday Life: Reconstructing Historical Experiences and Ways of Life.* Translated by William Templer. Princeton: Princeton University Press, 1995.

Marling, Karal Ann. *George Washington Slept Here: Colonial Revivals and American Culture, 1876–1986.* Cambridge, Mass.: Harvard University Press, 1988.

Mauss, Marcel. *The Gift. The Form and Reason for Exchange in Archaic Societies.* Translated by W. D. Hall. London: Routledge, 1990.

McCracken, Grant. *Culture and Consumption: New Approaches to the Symbolic Character of Consumer Goods and Activities.* Bloomington: Indiana University Press, 1990.

McDannell, Colleen. *The Christian Home in Victorian America, 1840–1900.* Bloomington: Indiana University Press, 1986.

———. *Material Christianity: Religion and Popular Culture in America.* New Haven: Yale University Press, 1995.

Miles, Margaret. *Image as Insight: Visual Understanding in Western Christianity and Secular Culture.* Boston: Beacon Press, 1985.

Miller, Daniel. *Material Culture and Mass Consumption.* Oxford: Basil Blackwell, 1987.

Mitchell, W. T. J. *Iconology: Image, Text, Ideology.* Chicago: University of Chicago Press, 1986.

Moffett, Cleveland. "J. J. Tissot and His Paintings of the Life of Christ." *McClure's* 12, no. 5 (March 1899): 387–96.

Moore, R. Laurence. *Selling God: American Religion in the Marketplace of Culture.* New York: Oxford University Press, 1994.

Morgan, David. "Imaging Protestant Piety: The Icons of Warner Sallman." *Religion and American Culture* 3, no. 1 (winter 1993): 29–47.

———. "Secret Wisdom and Self-Effacement: The Spiritual in Art in the Modern Age." In *Negotiating Rapture,* edited by Richard Francis, 34–47. Exhibition catalogue. Chicago: Museum of Contemporary Art, 1996.

———, ed. *Icons of American Protestantism: The Art of Warner Sallman.* New Haven: Yale University Press, 1996.

Motz, Marilyn, and Pat Browne, eds. *Making the American Home: Middle-Class Women and Domestic Material Culture, 1840–1940.* Bowling Green, Ohio: Bowling Green State University Press, 1988.

Numbers, Ronald L., and Jonathan M. Butler, eds. *The Disappointed: Millerism and Millenarianism in the Nineteenth Century.* Bloomington: Indiana University Press, 1987.

Orsi, Robert A. *Thank You, St. Jude: Women's Devotion to the Patron Saint of Hopeless Causes.* New Haven: Yale University Press, 1996.

Os, Henk van, with Eugène Honée, Hans Nieuwdorp, and Bernhard Ridderbos. *The Art of Devotion in the Late Middle Ages in Europe, 1300–1500.* Princeton: Princeton University Press, 1994.

Peri, Vittorio. *Rita of Cascia: Priceless Pearl of Umbria.* Translated by Matthew J. O'Connell, edited by John E. Rotelle. Gorle, Italy: VELAR, 1995.

Petroff, Elizabeth Alvilda. *Body and Soul: Essays on Medieval Women and Mysticism.* New York: Oxford Unversity Press, 1994.

Phillips, Samuel. *The Christian Home, as It Is in the Sphere of Nature and the Church.* New York: Gurdon Bill, 1862.

Pleck, Elizabeth H., and Joseph H. Pleck, eds. *The American Man.* Englewood Cliffs, N.J.: Prentice-Hall, 1980.

Promey, Sally M. "Sargent's Truncated *Triumph:* Art and Religion at the Boston Public Library, 1890–1925." *Art Bulletin* 79, no. 2 (June 1997): 217–50.

———. *Spiritual Spectacles: Vision and Image in Mid-Nineteenth-Century Shakerism.* Bloomington: Indiana University Press, 1993.

Ribuffo, Leo P. "Jesus Christ as Business Statesman: Bruce Barton and the Selling of Corporate Capitalism." *American Quarterly* 33, no. 2 (summer 1981): 206–31.

Rotundo, E. Anthony. *American Manhood: Transformations in Masculinity from the Revolution to the Modern Era.* New York: Basic Books, 1993.

Sankey, Ira D., James McGranahan, and George C. Stebbins. *Gospel Hymns.* Chicago: Biglow & Main, 1894.

Schiller, Friedrich. *The Aesthetic Education of Man.* Translated by Reginald Snell. New York: Frederick Ungar, 1965.

Schmidt, Leigh Eric. *Consumer Rites: The Buying and Selling of American Holidays.* Princeton: Princeton University Press, 1995.

———. "Practices of Exchange: From Market Culture to Gift Economy in the Interpretation of American Religion." In *Lived Religion in America,* edited by David D. Hall. Princeton: Princeton University Press, 1997.

Schmit, Nina. "Narratives of the Weeping Icon in an Arab Orthodox Church." Paper presented at the Society for the Scientific Study of Religion, November 9, 1996.

Schwartz, Barry. "The Social Context of Commemoration: A Study in Collective Memory." *Social Forces* 61, no. 2 (December 1982): 374–402.

Scribner, R. W. *For the Sake of Simple Folk: Popular Propaganda for the German Reformation.* Oxford: Clarendon Press, 1994.

Simmel, Georg. *On Individuality and Social Forms: Selected Writings.* Edited by Donald M. Levine. Chicago: University of Chicago Press, 1971.

Sizer, Sandra S. *Gospel Hymns and Social Religion: The Rhetoric of Nineteenth-Century Revivalism.* Philadelphia: Temple University Press, 1978.

Smith-Rosenberg, Carroll. *Disorderly Conduct: Visions of Gender in Victorian America.* New York: Alfred A. Knopf, 1985.

Solomon, Robert C. "On Kitsch and Sentimentality." *Journal of Aesthetics and Art Criticism* 49, no. 1 (winter 1991): 1–14.

Stolnitz, Jerome. "On the Origins of 'Aesthetic Disinterestedness.'" *Journal of Aesthetics and Art Criticism* 20, no. 2 (winter 1961–62): 131–44.

Taves, Ann. *The Household of Faith: Roman Catholic Devotions in Mid-Nineteenth-Century America.* Notre Dame, Ind.: University of Notre Dame, 1988.

Tweed, Thomas. *Our Lady of Exile: Diasporic Religion at a Cuban Catholic Shrine in Miami.* New York: Oxford University Press, 1997.

Van de Wetering, Maxine. "The Popular Concept of 'Home' in Nineteenth-Century America." *Journal of American Studies* 18, no. 1 (April 1984): 5–28.

Woodmansee, Martha. "The Interests in Disinterestedness: Karl Philipp Moritz and the Emergence of the Theory of Aesthetic Autonomy in Eighteenth-Century Germany." *Modern Language Quarterly* 45, no. 1 (March 1984): 22–47.

Woodward, Kenneth L. *Making Saints: How the Catholic Church Determines Who Becomes a Saint, Who Doesn't, and Why.* New York: Touchstone, Simon & Shuster, 1996.

Wroth, William. *Images of Penance, Images of Mercy: Southwestern Santos in the Late Nineteenth Century.* Exhibition catalogue, Taylor Museum for Southwestern Studies, Colorado Springs Fine Art Center. Norman: University of Oklahoma Press, 1991.

Zolberg, Vera L. *Constructing a Sociology of the Arts.* Cambridge: Cambridge University Press, 1990.

Designer: Nola Burger
Compositor: Integrated Composition Systems
Text: 10/13 Sabon
Display: Matrix
Printer: Edwards Brothers, Inc.
Binder: Edwards Brothers, Inc.